ON THE FASCINATION OF OBJECTS

In memory of
Brian Benjamin Shefton (1919–2012)
and Jutta Shefton (1929–2014)

ON THE FASCINATION OF OBJECTS
GREEK AND ETRUSCAN ART
IN THE SHEFTON COLLECTION

Edited by

John Boardman, Andrew Parkin and Sally Waite

Oxbow Books
Oxford & Philadelphia

Published in the United Kingdom in 2016 by
OXBOW BOOKS
10 Hythe Bridge Street, Oxford OX1 2EW

and in the United States by
OXBOW BOOKS
1950 Lawrence Road, Havertown, PA 19083

Hardcover Edition: ISBN 978-1-78570-006-4
Digital Edition: ISBN 978-1-78570-007-1

A CIP record for this book is available from the British Library

Library of Congress Cataloging-in-Publication Data

On the fascination of objects: Greek and Etruscan art in the Shefton collection / Edited by John
Boardman, Andrew Parkin and Sally Waite.
 pages cm
 Includes bibliographical references.
 ISBN 978-1-78570-006-4 (hardback)
 1. Art, Greek--Themes, motives. 2. Art, Etruscan--Themes, motives. 3. Art--Private collections-
-England--Newcastle upon Tyne. 4. Shefton, Brian B.--Art collections. 5. Great North Museum
(Hancock, Newcastle upon Tyne, England) I. Boardman, John, 1927- editor. II. Parkin, Andrew
(Andrew R.), editor. III. Waite, Sally, editor.
 N5630.O5 2015
 709.495--dc23
 2015035985

Printed in Wales by Gomer Press

For a complete list of Oxbow titles, please contact:

UNITED KINGDOM UNITED STATES OF AMERICA
Oxbow Books Oxbow Books
Telephone (01865) 241249, Fax (01865) 794449 Telephone (800) 791-9354, Fax (610) 853-9146
Email: oxbow@oxbowbooks.com Email: queries@casemateacademic.com
www.oxbowbooks.com www.casemateacademic.com/oxbow

Oxbow Books is part of the Casemate Group

Contents

Contributors

PROFESSOR JUDITH M. BARRINGER
Professor of Greek Art and Archaeology,
Department of Classics,
University of Edinburgh

PROFESSOR EMERITUS SIR JOHN BOARDMAN
Emeritus Lincoln Professor of Classical
 Archaeology and Art,
Oxford University

PROFESSOR DAVID W. J. GILL
Director of Heritage Futures,
Suffolk Business School,
University Campus Suffolk

PROFESSOR FRANÇOIS LISSARRAGUE
Directeur d'études,
Ecole des Hautes Etudes
 en Sciences Sociales, Paris

SUSAN B. MATHESON
Molly and Walter Bareiss
 Curator of Ancient Art,
Yale University Art Gallery,
New Haven, Connecticut

PROFESSOR EMERITA ELIZABETH MOIGNARD
Professor Emerita of Classical Art
 and Archaeology,
University of Glasgow

PROFESSOR DR ALESSANDRO NASO
Consiglio Nazionale delle Ricerche,
Istituto di Studi sul Mediterraneo Antico
Roma

ANDREW PARKIN
Keeper of Archaeology,
Great North Museum: Hancock,
Newcastle upon Tyne

PROFESSOR EMERITUS JOHN PRAG
Hon. Professor in the Manchester Museum
 and Professor Emeritus of Classics,
University of Manchester

DR DIANA RODRÍGUEZ PÉREZ
Research Assistant,
CARC-The Beazley Archive,
University of Oxford

EMERITUS PROFESSOR BRIAN A. SPARKES
Emeritus Professor of Classical Archaeology,
University of Southampton

EMERITUS PROFESSOR ANTONY SPAWFORTH
Emeritus Professor of Ancient History,
School of History, Classics and Archaeology,
Newcastle University

PROFESSOR ATHENA TSINGARIDA
Centre de Recherches en Archéologie
 et Patrimoine,
Université libre de Bruxelles (ULB)

DR SALLY WAITE
Teaching Fellow in Classics,
School of History, Classics and Archaeology,
Newcastle University

DR DYFRI WILLIAMS
Former Keeper of Greek and Roman
 Antiquities, British Museum;
Gerda Henkel Marie Curie Senior Research
 Fellow and Professeur invité,
Université libre de Bruxelles (ULB)

Acknowledgements

This volume is a testament to the significant contribution Professor Brian Shefton made to Greek and Etruscan archaeology, both during a lifetime dedicated to scholarship and through the creation of a notable collection of artefacts. All the contributors to the conference held in honour of Brian Shefton in April 2013 and to this volume are to be thanked for highlighting the importance of the Collection and producing stimulating papers on some of the objects within it.

There are several organisations to thank for the support they have provided in the production of this volume. They are the Great North Museum, the Society of Antiquaries of Newcastle upon Tyne, Tyne and Wear Archives and Museums and Newcastle University. The editors are also indebted to a number of individuals who have helped at various stages in the publication process; we would like to thank Joanne Anderson, Colin Davison, Sarah Glynn, Monica Hughes, Jacob Parkin, Sajidah Saleem and Tony Spawforth for their invaluable help. Penny Shefton has provided steadfast support and encouragement throughout.

Abbreviations

ABV Beazley, J. D. (1956) *Attic Black-Figure Vase-Painters*. Oxford.

Agora XII Sparkes, B. and Talcott, L. (1970) *The Athenian Agora XII, Black and Plain Pottery of the 6th, 5th and 4th Centuries BC*. Princeton.

Agora XXIII Moore, M. B. and Philippides, M. Z. P. (1986) *The Athenian Agora XXIII, Attic Black-Figured Pottery*. Princeton.

Agora XXX Moore, M. B. (1997) *The Athenian Agora XXX, Attic Red-Figured and White-Ground Pottery*. Princeton.

ARV¹ Beazley, J. D. (1942) *Attic Red-Figure Vase-Painters*. Oxford.

ARV² Beazley, J. D. (1963) *Attic Red-Figure Vase-Painters* (Second Edition). Oxford.

Add Burn, L. and Glynn, R. (1982) *Beazley Addenda. Additional References to ABV, ARV² and Paralipomena*. Oxford.

Add² Carpenter, T. H. *et al.* (1989) *Beazley Addenda. Additional References to ABV, ARV² and Paralipomena* (Second Edition). Oxford.

BAPD *Beazley Archive Pottery Database*
 www.beazley.ox.ac.uk

CSE *Corpus Speculorum Etruscorum.*

CVA *Corpus Vasorum Antiquorum.*

LIMC *Lexicon Iconographicum Mythologiae Classicae.* (1981–1997) Zürich, Munich and Dusseldorf.

Para Beazley, J. D. (1971) *Paralipomena. Additions to Attic Black-Figure Painters and Attic Red-Figure Painters*. Oxford.

Foreword: Memories of Brian Shefton

John Prag

It must be nearly fifty years since my path first crossed with Brian's. Like so many people who got to know him, the meeting of ways will have been in the Ashmolean library – me an earnest (sometimes) student, fascinated by this man with the camera and the chest-pod furiously photographing book after book before disappearing back to Newcastle to read his home-made microfilms. Once I had started on my doctoral research we often discussed those books and the pictures in them, for my research was on the iconography of the Oresteia, which was a subject that interested him deeply too. My favourite memory of Brian is of a scene that took place in early 1969 in Room 2 of the Ashmolean library: as a research student I was working there as usual with Brian busily photographing books in the background (also as usual). A young woman came over to ask my advice on something on which she was working. As ever, Brian couldn't resist coming over to see what it was since he and I did after all have very similar interests. But the real reason wasn't the book at which we were looking at: full of excitement he turned and asked me (out of the blue) 'and is this your fiancée?' He was of course right, to his great delight and pleasure, and he and Kay became very good friends in the years that followed.

It was typical of Brian's passionate interest in people: there was the occasion some years later when he was coming over to Manchester to stay with us before a lecture, and I went to meet him at an unstaffed and dimly-lit little station near our house off the two-coach train that in those days shuttled between the Transpennine line and Stockport. The train arrived, a man with a bicycle got off, and that was it, apparently, but just before it pulled out again a door was flung open, several briefcases appeared followed by Brian, who had become so engrossed in his conversation with the student sitting opposite that he had failed to notice how far the train had travelled.

When the British Museum organised their exhibition of Thracian Treasures we asked Brian over to give an evening lecture for a large audience of Extra-Mural students. He accepted enthusiastically, but on the day of the lecture there was a wildcat train strike at Leeds, the signal-box was closed, and no trains could get through Leeds, a crucial staging-post on the Newcastle–Manchester line. I rather expected that like any normal mortal Brian would abandon the trip and send his apologies. No word came from him, and when I rang his department they said he had left Newcastle for Manchester, and they thought he was perhaps coming via Carlisle. Yes, indeed: he took the slow train across Northumberland, and then travelled down the west coast via Preston to Manchester (all this of course long before high-speed Pendolinos). He did eventually get word to me, and his train arrived at Manchester Victoria station at the time he should have started lecturing in the university on the other side of town, so I held the audience at bay until a taxi pulled up outside our building, out tumbled the customary battery of briefcases and Brian, who hurried inside and handed a huge box of slides to the projectionist before disappearing for a quick wash. He reappeared, I introduced him and he started his lecture without delay, until stopped by frantic signals from the projectionist who was still trying to load around 200 slides. It was a brilliant lecture, which would have overrun wildly even if it had not started late, and when I had to bring it to a close because the porters were locking the building for the night there

was a great sigh from the audience. I think he really relished the challenge, and he certainly was not going to let either his friend and colleague or his audience down, even though he knew well that this was not a 'serious' academic audience, just a very enthusiastic one. He was a very loyal friend and supporter of younger colleagues who shared his passion for Greece and its history and archaeology, and enormously generous with his knowledge if you cared as much about the subject as he did.

I do miss him.

1. Introduction

Antony Spawforth

Emeritus Professor of Ancient History, Newcastle University
Curator of the Shefton Museum (1984–1998)

I first met Brian Shefton when I arrived in Newcastle early in 1982 as a temporary lecturer in ancient history. Brian at that time had just under two years to go before retirement. I knew little about what was then called the Greek Museum before I arrived, but it gradually dawned on me, when I had had time to get to know the holdings, then housed in the Percy Building of Newcastle University, that this was an outstanding collection for its size, and that its creator, my new colleague Brian, was a scholar of exceptional calibre and energy.

In Brian's mind the collection was above all meant for teaching and research. This was brought home to me one term-time weekday when I bumped into Brian about to wheel into a lecture theatre full of expectant students one of his metal trolleys loaded with artefacts from the collection, including a modern cast of a Roman plaster cast of the head of Harmodios from the famous bronze group by Kritios and Nesiotes. It was typical of Brian that somehow he had obtained this fragile treasure from Italian colleagues who found the ancient casts in question at Baiae on the Bay of Naples.

By 1982 the great period of expansion for the collection was already in the past; so was the phase of consolidation initiated by Brian with the help of a team of young and loyal job creation placements as well as volunteers whom he brought together to help him improve the conservation, display and recording of the collection. It is a measure of the tight bonds forged between Brian and his helpers that Penny Shefton, Brian's daughter, flew from Poland in October 2014 to represent her father – as she put it – at the thanksgiving service in Suffolk for Dr Juliet Horsley, an Etruscologist fresh out of Cambridge when Brian recruited her for the team.

A lasting monument to this phase was the publication in 1978 of *Greek Arms and Armour*. This little booklet was the fruit of an exemplary collaboration between Brian and Pat Foster, one of the team. A handy introduction to the broader subject, it publishes in an accessible format, the Shefton Collection's impressive acquisitions in this area. Typically these include – once again – a rare and intriguing object which somehow, one feels, only Brian could have lit upon, a bronze spear butt into which are etched the Greek letters MAK, revealed upon cleaning: seemingly evidence for an official aspect to the production of weapons in fourth-century Macedonia.

Eighteen months later, and weeks before his retirement, Brian's energies were put to the test when an arsonist started a deliberate fire – using a tyre and petrol – in front of the collection's main showcase. The damage to the showcase's contents was considerable (Fig. 1.1). Not daunted, Brian threw himself into the task of farming out bronzes and ceramics for repair and conservation. Once more he showed his genius for getting people to help out with the collection, persuasive powers that over the years had done so much to turn it into the fine museum that it now was. I well remember myself collecting some of these repaired objects from the experts in the conservation laboratories of the Institute of Archaeology in Gordon Square – part of Brian's support network.

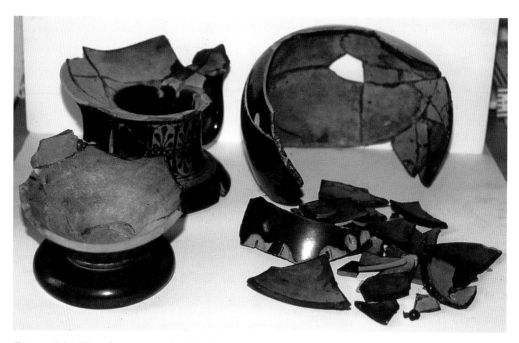

Figure 1.1: Fire damage to the Greek Museum in the Percy Building, Newcastle University. Photograph: Shefton Archive.

After his retirement, and with some understandable reluctance, Brian gradually relinquished the small empire of storerooms and annexes in the Percy Building which he had acquired over the years (although he held on to one, a final repository for books, cameras and other museum-related paraphernalia, for well over a decade). Brian now channelled his energies mainly into publication. I can still hear him telling bemused undergraduates at his farewell party in the University in the summer of 1984: "You may think that I shall miss teaching. Do you know, I won't. I can now get on with my research." Over the next – nearly – thirty years he published an impressive list of highly scholarly articles triggered by his curiosity about, and investigations into, the context of such-and-such an item in the collection. Typically a Brian article of this type would contain almost as much – if not more – footnoting as it would text, and the real "hook", the Newcastle object in question, might seem in the end to be almost buried under the weight of telling observations on wider matters that Brian would let drop. These articles displayed his phenomenal memory for things that he had seen in his travels to museums all over the world over a period of many years.

Brian remained "research-active" until his final illness. He also continued, throughout his long "retirement" – never was this term less apt than in Brian's case – to do what he could to build up Newcastle University's library holdings in Greek and Etruscan classical archaeology. Brian's method was to swoop on whatever he saw on his travels that he felt was needed for Newcastle – he knew exactly what the holdings were at any one time – and then to get these acquisitions back to the front desk of the university library and expound their quality to braced library staff, who were expected to welcome with open arms these scholarly gems. The research resource that he painstakingly built up on the university's behalf was, for its size, truly remarkable. I remember

myself, not so many years ago, bringing down to London from the Newcastle library, at the request of a certain Fellow of the British Academy, the only copy in a UK university library of a particularly esoteric Italian exhibition catalogue. Once again Brian built up his networks to support this endeavour – the King's Cross hotel which allowed him to store there the wheeled contraption used for transporting his hauls from purchase points to mainline station; and the ever-helpful staff at the Library of the Institute of Classical Studies in Senate House who found in Brian an enthusiastic purchaser of their duplicate accessions.

In retirement Brian continued to lecture in the UK and abroad. I witnessed the public lecture he gave, aged ninety, in the British Museum's BP Lecture Theatre one Friday evening. Despite a hip operation he stood unaided throughout, and he spoke without notes. The adage never seemed more true that a good wine improves with age. Brian had a natural, almost Herodotean, gift for storytelling. He was master of the well-timed pause and the dramatic denouement. The tale he told that evening, of his exploration many years earlier of the then little-known museum collections of eastern Italy in search of evidence for imported Athenian pottery, and of what these imports told us about ancient trade, held a packed room spellbound. The audience, many of them young people, knew that they were hearing – and watching – something special, a kind of scholar, and a kind of scholarship, from a near-vanished era.

Here I would like to pay my personal tribute to Brian's sheer indefatigability –indomitability is perhaps the better word – right to the end. He was unstoppable. He was the last person whom you would ever hear referring, even obliquely, to the tribulations of older age. He was ever bright-eyed and passionate about his subject, ever curious about who younger scholars were and what they were working on, and ever tireless in his travels despite, in the last years, needing to walk with two sticks. This did not prevent him from flying to lecture in Switzerland, on his own, only months before his death. He was a constant presence in his old department, and seemed always to know – somehow – a great deal about what was going on within it. Aged ninety, he remained a regular attendee and interlocutor at Newcastle classics research seminars and, if need be, a reliable corrector of any mistyped German in the speaker's handout (*credite experto*).

Sally Waite, an editor of this volume, knows the Shefton Collection intimately. She first encountered it as an undergraduate at Newcastle taking courses in Greek art and archaeology; then, as a Newcastle PhD student, she included a number of vases from the collection in her thesis on the imagery of Athenian painted pottery. It was she who gave Brian so much academic and practical help and support in his last years, playing a crucial role in enabling him to remain active until the end. Apart from more or less weekly meetings on matters academic, they also travelled together. There were, for instance, memorable trips to Broomhall, the seat of the current Lord Elgin, and Newby Hall (Fig. 1.2).

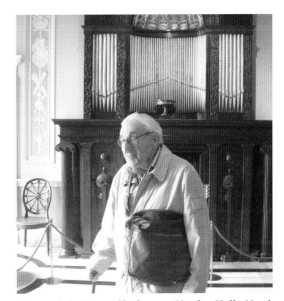

Figure 1.2: Brian Shefton at Newby Hall, North Yorkshire. Photograph: Andrew Parkin.

Sally organised a superb conference in 2013 with the very specific aim of inviting to Newcastle many of Brian's academic colleagues and friends to talk about the objects in Brian's collection to which he had devoted so much of his professional life. This aim was met with resounding success. The audience listened as a succession of experts expounded on such-and-such an object or class of object in the collection and brought us to a much better understanding of the specialness of Brian's acquisitions, by now splendidly rehoused in a gallery named after him in the Great North Museum.

It was a particular pleasure for Sally, and for Brian's many friends present, to see in the audience Brian's widow, Jutta, and their daughter Penny. All that was missing was a familiar figure, binoculars in hand, peering hard at an object on the screen, or making a telling point from the floor in the theatrical cadences of that extraordinary voice.

This volume contains the fruits of that conference and additional papers, specially commissioned to promote Brian's remarkable collection to a wider audience.

Andrew Parkin

Keeper of Archaeology, Great North Museum

My first encounter with Brian was as a postgraduate working in Newcastle University's Robinson Library sometime in 1990. At the time I was making extensive use of some of the Greek archaeology books acquired by Brian for the library. When he spotted me he came over to introduce himself, find out who I was and what I was working on. Brian's interest in my studies and his enthusiasm were obvious from that first meeting and I feel privileged to have known and worked with him during the last two decades of his life.

It also continues to be a privilege to have curatorial responsibility for the collection of Greek and Etruscan artefacts that Brian established at Newcastle. The more closely I work with the collection the greater my appreciation of what a remarkable achievement it is, particularly as Brian could never call upon large financial resources to develop the collection. I would go as far as to say it was Brian's foremost academic attainment, of which he was justifiably proud.

It is to the collection that I now want to turn, providing a brief outline of its emergence and its different homes within Newcastle University. Brian arrived in Newcastle upon Tyne in 1955 after his appointment as a lecturer in ancient history at what was then King's College. The Vice-Chancellor at the time, Charles Bosanquet, encouraged Brian to establish a collection of classical antiquities that would support the teaching of Greek archaeology. He was given a grant of £25 to begin collecting and acquired three Greek pots. Since then the collection has expanded, thanks to a combination of University acquisitions, grants from other bodies, and bequests and loans from external benefactors, into a collection of nearly 1,000 objects, the breadth of which is illustrated by the range of papers in this volume. Brian always conceived of the collection as a research resource, as well as a teaching collection, and his acquisitions were often chosen because of their research potential.

Over the years the collection has moved about the University campus. The first display of Greek material was in the Hatton Gallery, where Brian, in association with Ralph Holland, who taught art history at Newcastle, organised an exhibition in 1956 (Fig. 1.3). By the 1960s the

Figure 1.3: Exhibition of Greek Art in the Hatton Gallery, Kings College, Newcastle. Photograph: Shefton Archive.

collection, which was now known as the Greek Museum, had a permanent home alongside the Classics Department in the Percy Building of the University. This was to be its location until the 1990s when the Classics Department moved to the Armstrong Building and the Shefton Collection moved with it. A museum space was created in an area that had originally been chemistry laboratories and in 1994 this space was named the Shefton Museum of Greek Art and Archaeology in honour of Brian's outstanding contribution to classical archaeology at Newcastle (Fig. 1.4).

The Collection's most recent move was in 2009 when it was transferred to the Great North Museum as part of a major development which saw the University concentrate all its archaeology collections in the completely refurbished Hancock Museum. The Hancock was traditionally a natural history museum, but this £27 million redevelopment saw natural science collections displayed alongside archaeology and ethnography. All the collections associated with the University are now housed under one roof and managed by Tyne and Wear Archives and Museums, the local authority museum service, on behalf of the University. In 2010 to mark Brian's 90th birthday the Greek Gallery in the Great North Museum was renamed the Shefton Gallery of Greek and Etruscan Archaeology (Fig. 1.5).

Figure 1.4: The Shefton Museum of Greek and Etruscan Art and Archaeology, Armstrong Building, Newcastle University. Photograph: Glyn Goodrick.

Brian remained actively involved in the collection right up to his death in 2012. He never held back from sharing his views on the way objects were displayed and he was often on hand to help out with any enquiries that were proving difficult to resolve. His interventions were usually perceptive and frequently helpful. Brian, although he was never formally my teacher, taught me to really value museum-based archaeology and the rewards to be gained from the close study of artefacts. He remained committed to his discipline and the Collection and was continually looking at ways to enhance its profile. One of the projects we frequently discussed was a volume of papers based on the Shefton Collection. Brian even had a title for this proposed book. It was to be called *On the Fascination of Objects*.

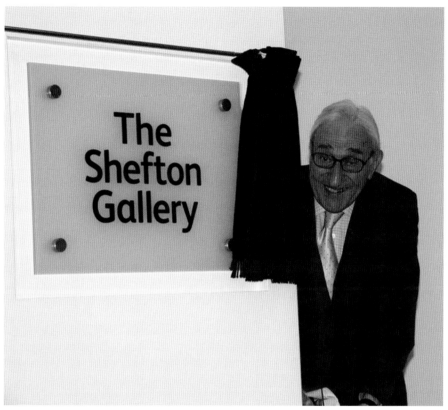

Figure 1.5: Naming the Shefton Gallery in the Great North Museum in Brian Shefton's ninetieth year. Photograph: Anne Paterson.

2. Little Boxes, Little Boxes

Elizabeth Moignard

> Leporello: Madama – veramente – in questo mondo, conciossia quando fosse che il quadro non è tondo…
> Madam – really – in this world, when it happens that a square is not a circle…
> Libretto for Mozart, *Don Giovanni*, Act 1, Lorenzo da Ponte, *c.* 1787.

This paper is intended as 'a short exploration of the significance of circular lidded boxes, ancient and modern, in relation to the group of ancient Greek examples in the Shefton Collection.' As it turns out, it reflects on an emotional strand of the collecting habit, rather than adding to an existing and growing body of scholarship[1] on the ancient vase-type which triggered the reflection.

The group photograph (Fig. 2.1) illustrates the ancient Greek examples in the Shefton Collection, which are catalogued here by explicit quotation from the collection's original index cards:

Ceramic Pyxides:

1. inv. no. TWCMS: G12678 (a, b) *Attic Middle Geometric pyxis with lid*

H. with lid, 18.5, D. 20.4 cm.

Pale reddish-brown clay, black-glaze; shallow turned ring foot. Squat body with flat conical lid, supported on inset rim. The lid-handle is in the form of a miniature pyxis-knob supported on a tall pillar.

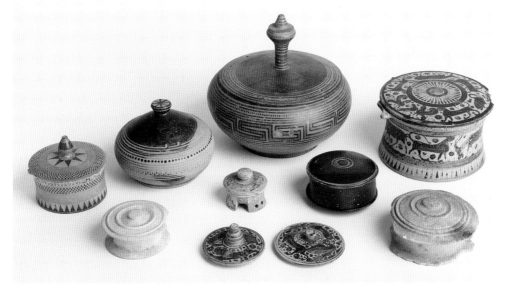

Figure 2.1: A group of pyxides, Newcastle upon Tyne, Shefton Collection. Photograph: Colin Davison.

Body: broad base-band, two narrow bands, dots, two narrow bands, dots, two narrow bands, hatched meander, two narrow bands, dots, two narrow bands.

Lid: black edge, two narrow bands, dots, three narrow bands, black to base of handle, narrow bands on stalk and lower body of miniature pyxis, dots on upper body, narrow bands on 'lid'. Pierced at edge of lid and interior body-rim for suspension.

Attic Middle Geometric, mid-eighth century BC.
Purchased 1957

2. inv. no. 10 *Attic Late Geometric pyxis with lid*

H. 10.2, D. 13.7 cm.

Pale reddish-brown clay, black-glaze lost in many places. Turned ring foot. Squat body with conical lid, supported on inset rim. Simple button-knob handle, with two holes on each side of lid for suspension through lid and interior flange. Signs of the formative use of a cutting tool for lid and body-rims.

Body: black-glaze on lower half including outer base surface. Two narrow bands, interlocking spike band, two narrow bands. Row of dots, three narrow bands.

Lid: exterior, three narrow bands, solid black to halfway up knob, two narrow bands. Asterisk on top surface of knob.

Late eighth century BC.

3. inv. no. 27 *Pyxis with lid*

H. 9.5, D. 15 cm.

Broken and restored. Chips out of lid and handles missing, stubs left. Floor of body restored. Plain buff clay. Brown/black-glaze with added red (not on lid).
Flat-bottomed – cut in at edge.

Walls taper in at the middle but widen again so that diameter at top and bottom about the same. Narrow fat rim. At each side, remains of handles, 2 horizontal double horn-like projections. Lid: slightly convex with straight edge and inner ridge for fitting. Knob lost – central hole remains.

Base: reserved. Body: rays; broad band of glaze – once with added red and white and red bands on top. Animal frieze: bull to left, panther to right, boar to left, panther to right, goat to left, panther to right. Added red on chests, necks and bellies; incised details. Filling ornament: incised blob-rosettes. Broad black band with added red and white as below. Lip zone: row of intersecting horizontal Ls, onto outer sides of horns; black band between. Rim: narrow band. Inside: broad black bands – 2 on walls, 1 at meeting of base and walls. Slight trace of fourth band towards centre of base.

Lid: reserved underside. Rim edge: black. Top surface: band as baseline for animal frieze: panther to right, deer to left, panther to right, sphinx to right, eagle to right (head left), sphinx to left, panther to left, swan to right. Filling ornament: blob rosettes (incised). Broad black band. Tongues, band round base of knob. Animals on lid more elongated and poorly drawn than on body.

Early Corinthian, *c*. 626–600 BC. Cf. Payne 1931, 292, no. 652; p. 305.

4. inv. no. 221 *Pyxis lid*

H. 4, W. 7.6 cm.

Labelled 159/4 and 26 Apr. 1971

Complete but chipped, especially on inner ridge. Yellow-buff clay, black-glaze, added red, and incision. Slightly convex, with concave interior. Simple knob with ridges left from turning process. Interior, reserved. Exterior: two narrow bands, animal frieze: elongated goat to right and panther to left. Filling ornament: incised rosettes and blobs. Red on haunches, bellies and necks, and forehead of panther. Two narrow bands round foot of knob. Knob: three bands and a fourth on top.

Early Corinthian, *c.* 625–600 BC. Cf. Payne 1931, 292, EC. Pyxides with concave sides, I; p. 305f., MC pyxides with concave sides.

5. inv. no. 222 *Pyxis lid*

H. 2.4, D. 8.6 cm.

Labelled 57s and 159/4 and 26 Apr. 1971

Complete and intact save for 1 large chip on upper edge, smaller ones on edge underneath, and reattachment of central knob. Pale cream clay. Brown/black-glaze with incised details and added red. Underside 'stained'. Convex surface, low button knob. Underside, reserved. Topside: band of glaze on edge; one brown, one red band. Animal frieze: long-necked water-bird with upraised wing to right: incised details on wing, tail and face, red on wing, tail and dots down neck and body. Elongated grazing deer with outsize ears to right: red on neck, stomach and rump, incised details on body and head. Elongated panther to left: red on neck and stomach, incised details on body and face. Filling ornament: blob rosettes and dots. One red, 1 brown band, rough tongues. Knob: black on side and top, reserved edge.

Early Corinthian *c.* 625–600 BC. Cf. Payne,1931, 292, EC. Pyxides with concave sides, I; p. 305f., MC pyxides with concave sides.

6. inv. no. 467a–c *Pyxis with lid and fragment*

Pyxis: H. 4.4, W. 9.2 cm.

Complete and intact; surface wear; small surface holes and minor pitting; small buff-light brown surface deposits on inside junction of walls and base; glaze worn off on underside of foot. Pale orange clay, black-glaze. Low ring foot; walls spreading sharply outwards to wide horizontal flange; vertical walls. Black-glaze inside and out.

Lid: H. 3.9, W. 9.2 cm.

Simple lid fitting over body – over half of side walls broken; surface wear; small surface holes; much pitting; cream-buff surface deposits on inside; small chips on rim and glaze worn off. Pale orange clay, black-glaze. Near-vertical side walls inclining very slightly inwards to horizontal flanged rim; small groove; small ridge; groove; slightly curved flattened top; central raised circle; circular groove; small circular ridge; circular groove; circular ridge; circular groove; flat area; circular groove. Interior, black-glazed; exterior: black-glazed except for reserved circular groove near edge of top; three concentric circular reserved grooves on centre of top.

Lid fragment: H. 2.5, W. 5.3 cm.

Fragment of lid with broken edges on three sides, bottom edge intact. Surface wear; small surface holes and pitting; cream-white surface deposits on bottom edge. Pale orange clay, black-glaze. Part of overhanging side wall of lid. Black-glazed overall.

Attic, fourth century BC? Beazley type B.
Gift of C.I.C. Bosanquet.

7. inv. no. 478 (a, b) *Miniature tripod pyxis with lid*

Lid: H. 2.3, D. 5.7 cm.

Complete and intact apart from chips on outer and inner rims; surface pits; pinkish-brown deposit especially around knob and within inner rim. Cream clay, black/brown glaze, red paint. Outer shallow vertical rim rising gently to knob on short stem with vertical sides and slightly convex top. Inside: slightly concave surface rising to vertical wall of inner rim. Groove at base; concave circular depression at centre. Outside: golden brown glaze; battlement meander in black/brown glaze around outer edge (one drawn out of place to give rectangle); concentric circles, one of pale glaze, one of dark; concentric circle of short strokes, concentric circle of red paint; black ring at base of knob; bottom and top edges of knob wall outlined with black ring. Inside: traces of reddish golden brown glaze.

Pyxis: H. 2.7, D. 5.7 cm.

Complete save for several large chips, particularly on rim and one of the feet. Surface pitting, one large deep hole under rim; almost completely covered in pink-brown surface deposit. Cream clay, black-brown glaze. Splayed tripod legs with concave inner surfaces: one has two irregularly placed manufactured holes; sides of legs cut vertically to give almost triangular profile; flaring rim in two degrees with flat upper surface, steep sided concave interior. Remains of reddish golden brown glaze all over including inside. Upper surface of rim black-glazed; possible traces of other black-glaze.

Probably Late Corinthian, Payne 1931, 331ff. and Stillwell and Benson 1984, 318 and pl. 68, no. 1796.

8. inv. no. 542 *Pyxis with lid*

H. 8.6, D. 9.5 cm.

Complete except for chips on lid and base; handles missing. Fine pink clay, red glaze. Flat bottom, slightly concave walls, no lip; handle-stumps; convex lid with knob and inner ridge.

Underneath: thin circles, 2 close to centre point; 1 at mid-radius, 2 at edge. Walls: thin red band, rays on red band, 11 narrow bands; frieze of four rows of chequered squares. Two narrow bands. Handle zone: band of crosshatched lozenges alternating with solid double axes between grouped verticals. Inside: red glaze with two reserved bands at top. Lid: reserved underneath. Upper surface: 2 narrow bands, 5-row chequerboard; ten bands, rays at base of knob, two bands. Knob: 4 narrow bands on lower part; 3 above, 1 broad band, 3 narrow, 1 on top.

Protocorinthian *c.* 700–650 BC. Johansen 1923, pls 12.3, 18.3 and 4, p. 83 (subgeometric). Payne 1933, pls 8.2 and 10.2.

Marble Pyxides:

9. inv. no. 368 *(a, b) Pyxis with lid*

Pyxis: H. 3.5, D. *c.* 10.8 cm.

Edge of base severely chipped; surface wear, friable. Cream with yellow/grey/black discolourations. Flat spreading base; concave sides with vertical inner face; short inset upper edge, creating ledge for lid to rest on; outer face of lip thickened for short distance on two opposed sections; floor slightly domed.

Lid: H. 2.5, D. 11.7 cm.

Chipped outer edge, severely on one side; surface worn, pitted and friable. Cream, discoloured grey on upper surface, brown/yellow patches. Lightly domed, with central raised flat knob, lathe-turned concentric ridges. Vertical flange around underside *c.* 1.3 cm from edge.
Fourth century BC.

10. inv. no. 145 *(a, b) Pyxis with lid*

Pyxis: H. 3.6, D. 9.2 cm.

Pinkish-cream, minor discolourations, surface chips, pitted, friable. Flat spreading base; concave sides with vertical inner face; short inset upper edge, creating ledge for lid to rest on; outer face of lip thickened for short distance on two opposed sections; floor slightly domed.

Lid: H. 2.7, D. 10.3 cm.

Large chip on outer edge; surface worn and slightly pitted. Pinkish-cream. Flat lid, with central flat raised knob, two concentric lathe turned ridges. Vertical flange on underside, *c.* 1.1 cm from edge.
Fourth century BC.

Above are 'official' catalogue entries, deliberately, as I say, acquired directly from the catalogue cards, for a group of vessels in the Shefton Collection, or related to and displayed with it in the gallery or in the study collection of the Great North Museum, Newcastle. They sit in a class of object to which specialists working on ancient Greek material refer to as a pyxis. This is used to denote a circular lidded vessel, more frequently made of pottery than of other materials, and often cited as a cosmetic or trinket box, not least because examples often appear among the grave goods for a female burial. They also feature as votives in sanctuaries and in their inventories; in this context they may be physicians' medicine containers. Inventories cite pyxides made of bronze, ivory, stone, marble, silver and wood.

These little boxes are not made of ticky-tacky, they are not all the same, and they do not correspond very closely with Malvina Reynolds' colour chart,[2] but they do provoke some thought about the box-form, especially when they are not rectilinear, but circular in format.

A view of the Shefton Collection, both before the move to the Great North Museum and now, has spoken to me since I first saw it in the late 1970s, of a fascination with objects for their own sake, and a strong sense of their magic, which always dovetailed both for Brian Shefton and for me with professional typological categorisation. In that mindset, the collector has a problem with control over the acquisition instinct, whether collecting for institutional or private purposes; display space, lighting and storage are a serious consideration, and the control agents may eventually be chronological, origin, material, or repetition of a form (the Conran[3] display ethos at its most essential level) in varying combinations. Identifiable makers, in any sense, can

often fuel another major strand of collecting, whatever the nature of the object. How can the collector not be a hoarder, in the end? And proud of it…

The Great North Museum, as we see, has a number of ancient Mediterranean versions of the circular lidded box we label as a pyxis; all but two are ceramic, the exceptions are made of marble. All but one belong to the Shefton Collection; the outsider belongs to the Tyne and Wear Museums' collection, but clearly deserves inclusion with its friends, and is on display with them. The spread of conventional dates for them and their differing origins makes it evident that they were acquired as examples of a class of object which has interesting variations of form and fabric, but shares the lid and the commitment to the circle.

Our term box tends to stand for a container for storage or transport of goods; it may be made of wood, metal, cardboard, plastics. It may be designed to protect or carry a particular type of content. Occasionally it may also be a decorative object in its own right, a collectable with a fine surface, carved or veneered; it may have interior fittings and trays or interesting permanent contents; its inside may be greater than its outside. Its maker may have used contrasting colours or mixed its materials. The usual expectation, though, is that a box will be rectilinear, with carefully engineered joints and corners, often a key manifestation of the designer's or maker's craft in themselves, and giving the object defined straight edges and angles.

The term pyxis, which we now use as a classificatory label for the ancient Greek lidded vessels exemplified in the Shefton Collection, also relates to the sacred container, or *pyx*, used in some Christian practices to hold consecrated wafers, and to the box-tree which provides a particularly fine wood, especially for makers who turn their boxes rather than joining them. The *Oxford English Dictionary* traces the use of the term, for 'a small box or casket' as far back as 1390 AD, and the entry in the *Concise OED* has later entries which refer to ivory examples, and to the use of the pyxis as a container for valuables or supposedly holy objects. We might note the sacred, or magic, connotations, and the sense that the lid has an important role as the protector of the contents, perhaps even more than the lid of a rectilinear box. It may drop over the body of the box, or fit into a rim, or sit on a ledge around the top of the body, but lifting it to look at the inside and what sits there is a quiet commitment to a magical act. We hold a round box, especially a small one, in a different way from one with angles and corners, and the sense that we hold a small world in our hands is very strong. The tactile value of such an object is a crucial part of its charm, and it is worth noting that all the examples described above are fascinating to handle, and their interaction with the holder was evidently part of the design. They vary in the thickness of their walls, the presence or absence of handles on the body, the way in which their lids fit, but they all want a pair of hands to hold them, and to lift the lid.

It is not difficult to link the pyxides in the Shefton Collection to ancient and modern parallels in other materials: a short electronic search will confirm the existence of ancient Greek examples in wood, for example from the sanctuary of Artemis at Brauron, and ivory, from the Athenian Agora. In my study I can see equivalents of the ancient pottery shapes and some of their surface patterns in wood, ceramic, basketwork, leather, paper, and metal, all of them exhibiting shapes and surface textures or patterns which grow naturally out of their materials and fabrication methods. Turned wooden boxes, in particular, might be expected to echo pottery ones, just because they share a forming technique which, even though one involves extraction from its material on a lathe, and the other stretching and raising it on a wheel, results not only in their circular format, but will also produce torus profiles or exterior ridges on the body, spike-handles on the lid, interior flanges, vertical or horizontal, to hold the lid, and often ridged circles or doming on the floor, inside or out. The body of the box can be supported on a ring foot or an integral stand, or

just sit on a flat base. The use of hand-raising or forming and soldering, rather than casting, to make a circular metal box will influence the form taken by its sides and the junctions of base and walls and the fit of the lid in rather the same way: as with clay, the forming process stretches the metal, and contributes to the profile.

In the photograph (Fig. 2.2) of a group of contemporary pyxides we can see that they appear in a range of shapes which match across to the ancient ones very easily: a conical lidded basket from Botswana, a double cone in corrugated paper by Anne Finlay, and a torus-walled flat sycamore piece with a spike lid-handle signed 'Adams'. Emily Myers made the striped matte ceramic example, with its striped lid, Frank Goddard the oval form with a tight-fitting drop-over lid in burr ash and hidden inlays inside; at the front are a silver cylinder with a fitted lid by Marion Kane, and a cone-lidded miniature in burr walnut by Jason Breach, at the right a Victorian turned ivory cylinder, with ridges which echo the ones which appear on the ancient marble examples.[4] All of them have features of shape or decoration which speak to the ancient ones in the Great North Museum. Few, if any of them, were derived by their makers from their ancient predecessors in any way: they share that same commitment to the circle and the inherent interaction with the holder who looks inside. And their presence together came from an instinct which looks to variants on an essential shape as both inspiration and a control mechanism, as I suspect the ancient Greek ones did for Brian Shefton. The examples here assembled cross periods, regional origins and materials, but form a distinctive and satisfyingly related family.

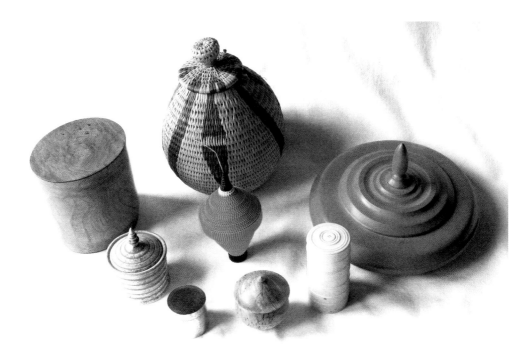

Figure 2.2: A group of contemporary pyxides. Photograph: Carol Primrose.

Notes

1 E.g. Roberts, S. R. (1978) and more recently Gaunt, J. (2013) and his substantial bibliography. His discussion section, 390ff. in the cited article, discusses the probability of ancient cross-referral between materials.
2 A reference to Malvina Reynolds' song 'Little Boxes' (1962) made famous by the late Pete Seeger: a comment on growing homogenisation of everyday life and conformist middle-class attitudes, symbolised by the then increasingly common single-design (with colour variations) mass housing estate.
3 A reference to an ornamental aesthetic based on repetition of a single form across multiple objects, very much part of Terence Conran's design aesthetic as implied both in his many publications, from *The House Book* (1974) onwards, and in the whole ethos of his Habitat chain.
4 Not all of the named makers here are readily traceable. Anne Finlay can be found productively via the Contemporary Applied Art website (www.caa.com), Emily Myers at www.emilymyers.com, Marion Kane at www.marionsilversmith.com, Jason Breach at www.jasonbreach.co.uk, Frank Goddard's box was bought at the Dansel Gallery in Abbotsbury, Dorset, www.danselgallery.uk.

Bibliography

Beazley, J. D. (1946) *Potter and Painter in Ancient Athens*. London.
Britton, A. (2013) The Work of Jim Partridge in *Seeing Things* 62ff. London.
Conran, T. (1974) *The House Book*. London.
Gaunt, J. (2013) The Classical Marble Pyxis and Dexilla's Dedication. In Koehl, R. B. (ed.) *Amilla, the Quest for Excellence, Studies Presented to Guenther Kopcke in Celebration of his 75th Birthday*, 381ff. Philadelphia.
Johansen, K .F. (1923) *Les Vases Sicyoniens*. Paris.
Milne, M. J. (1939) Kylichnis. *American Journal of Archaeology* 43, 247ff.
Payne, H. G. (1931) *Necrocorinthia*. Oxford.
Payne, H. G. (1933) *Protokorinthsche Vasenmalerei*. Berlin.
Rutherfurd Roberts, S. (1978) *The Attic Pyxis*. Chicago.
Sparkes, B. A. and Talcott, L. (1970) *Black and Plain Pottery of the Sixth, Fifth and Fourth centuries BC, Athenian Agora XII*. Princeton.
Stillwell, A. N. and Benson, J. L. *et al.* (1984) *The Potters' Quarter, The Pottery, Corinth XV pt. III*. Princeton.

3. Evocative Objects. The Attic Black-Glazed Plemochoai (Exaleiptra) between Archaeology and Vase-Painting

Diana Rodríguez Pérez

The description of the unpublished object inv. no. 204 (Figs. 3.1–3.3) in the records of the Shefton Collection[1] of Newcastle University reads as follows: 'Attic black-glazed plemochoe (exaleiptron). Tongue pattern around mouth'. Neither the find-spot nor the place of acquisition are recorded. This vase is one of some hundred examples of the shape housed in museums worldwide that passed to the art market without a secure archaeological context attached to them.

It is the aim of the present contribution to publish this vase for the first time, addressing the question of the origin and evolution of the shape, and to present some brief conclusions resulting from a comprehensive and integrated contextual approach to the available data on the Athenian black-glazed plemochoai, touching upon several issues of current concern to modern scholarship, such as the relationship between 'art' and 'life', the interaction between human beings and material culture, and the fundamental question of how to understand Greek imagery.

The Newcastle Plemochoe

The example in Newcastle is of a fine Attic fabric, light, pale-red clay, well-potted, intact but for a minor chip on the foot and some occasional losses and crackles of the black-glaze on the exterior surface of the vase. It has been executed in two parts: a flattened, evenly convex body with a peculiar in-turned, dipping lip, and a tall flaring concave stem ending in a likewise flaring disc foot with slightly concave vertical face and lower incipient torus moulding, hollow stand. A sharp fillet marks the junction between bowl and stem.

The black-glaze is good but rather thin and shows some imperfections, including a misfiring to brownish red on the outside, and clouds of iridescent misfired black slip on the inside. The underside of the stem is conical in shape and receives a very diluted glaze, the brushstrokes are clearly visible. The glaze is worn out on the ledge of the rim, suggestive of the presence of a lid, which is missing. There are abundant incrustations on the inside of the stem and on the resting surface, and a few on the outside of the vase. The resting surface, outer vertical face of the foot and inside of the incurving rim are all reserved. The decoration consists of a pattern of black tongues on a reserved red background around the rim separated by thin black lines, and circled by two rows of dots between two pairs of diluted concentric red lines above and two diluted red lines below.

The Attic Plemochoai

Name

The vase in Newcastle is recorded in the inventories under two names: plemochoe and exaleiptron. The shape is a particular Athenian development of a wider class of vessels whose main characteristic is the presence of an incurving rim hanging on the interior, most likely aimed

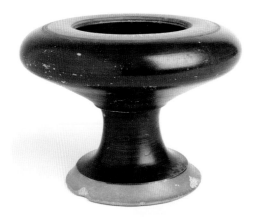

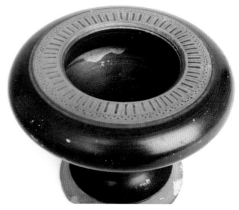

Figure 3.1: Athenian black-glazed plemochoe, type B, Newcastle upon Tyne, Shefton Collection 204. Photograph: Colin Davison.

Figure 3.2: Athenian black-glazed plemochoe, type B, Newcastle upon Tyne, Shefton Collection 204. Photograph: Colin Davison.

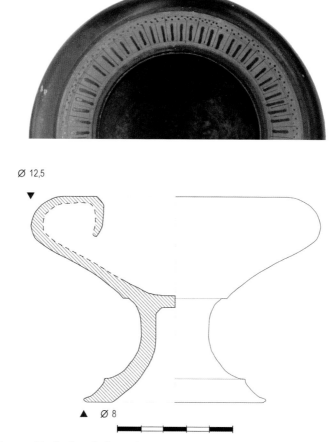

Ø 12,5

▲ Ø 8

Figure 3.3: Athenian black-glazed plemochoe, type B, Newcastle upon Tyne, Shefton Collection 204. Drawing: author.

to prevent the spillage of liquid or semi-liquid contents. The ancient name of the vessel is not known but several options have been suggested by modern scholars, mainly kothon (Pernice 1899, 60; Burrows and Ure 1911, 72; *ABV* 348–349; Sparkes and Talcott 1970, 81), plemochoe (Richter and Milne 1935, 21–22; Rayet 1881, 34–41; Pottier 1883, 67), exaleiptron, and even pyxis (in some entries of the Beazley Archive Pottery Database). Although since Scheibler's 1964 article, exaleiptron is the most convincing name for the class, the name plemochoe is still in use in modern scholarship, mainly in Greece. In fact, there is a tendency to use the name exaleiptron for the stemless version of the vase, in particular for the Corinthian examples, and plemochoe for the Athenian high-footed shape, which is also frequently provided with a lid. For clarity's sake, I am retaining this convention here.

Origin and Evolution of the Shape

The emergence of Attic plemochoai must be put into relationship with the emergence of the Attic versions of a number of oil, perfume and cosmetics containers around the middle of the sixth century BC, such as the shoulder-lekythos or the alabastron. Before this date and from the end of the seventh century there are a number of examples of Attic exaleiptra which follow Corinthian and Euboean models: tripod exaleiptra, low examples with a conical foot, and a model with central support and a flaring foot, which can be understood as a precedent for the plemochoe type. These early examples are all black-figure and have figural decoration.[2]

The appearance of the earliest type of plemochoe, Beazley's type A (*ABV* 348.1–9, 695; *Add*[2] 139), has been established around the years 560 BC on stylistic grounds (Fig. 3.4). As Mommsen (1991, 64) rightly saw, both the tall wide concave flaring foot and the alternating tongue pattern and dots around the rim relate them to the Siana cups.[3] These early examples do not show much

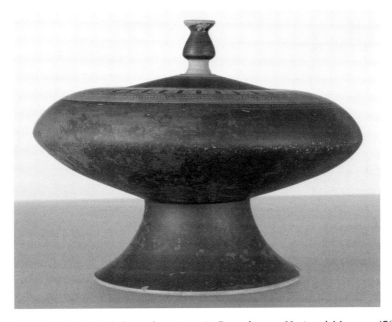

Figure 3.4: Athenian black-glazed plemochoe, type A, Copenhagen, National Museum 4706. (After Scheibler 1964, fig. 27).

evolution, their average height is *c.* 13 cm (without lid), with a maximum diameter of *c.* 20 cm. The bowl is deep and lentoid, with the customary inward rim and a ledge to receive the lid (often preserved). The archaeological contexts available for the type A plemochoai include a deposit from the Heraion on Delos, with the latest objects dating to around 520 BC (Dugas 1928, 6–7). A type A plemochoe bearing the inscription Ηιερὸν Ηέρηι ('sacred to Hera') has been recovered there.[4] Another example comes from the rich chamber tomb 13 from Monte Bubbonia, Sicily (Panvini 2006, 82, pl.1e).

The appearance of the type B plemochoe is relatively well established thanks to a couple of excavated contexts: the male tomb 62 from Sindos,[5] which gives a date of 530–520 BC for our shape, and a tomb from the archaic necropolis of Palinuro[6] whose Attic material has been dated to the decade of 530–520 BC. Stylistic analysis also supports the dating: this type of plemochoe shows influences of the type A cups in the high reserved disc-like foot. It is precisely the foot which distinguishes the early examples of the type B from the previous type A plemochoai. The bowl, separated from the stem by a fillet, is still in line with the earlier examples, including the alternating black and red tongue pattern.[7]

Besides these examples there are a few plemochoai which, on the basis of their shape, could be understood as an intermediate stage between groups A and B, but their archaeological contexts suggest a date later than the first examples of the new type. They should rather be considered products of a different workshop.[8]

The most common version of the type B plemochoe appears shortly after the first examples mentioned above. The stem is now taller and the reserved disc-like foot adopts a slightly concave profile. The bowl is shallower than before and acquires a calyx-like shape: it reaches sharply outward and upward from the top of the stem, turning abruptly inward and upward to a flat or almost flat rim. The alternating tongue and dots pattern is substituted by a single black tongue pattern, rather hastily executed on some occasions. These examples span a chronology of around 30–40 years: the earliest contexts are the tomb 31 from Rhitsona (*c.* 515 BC) and two tombs from Sindos that suggest a date of 510–500 BC and 500–490 BC (Saripanidi 2012b, vol. 2, 83–84, pl. 47, numbers 215, 216). A very badly preserved plemochoe, smashed and mended from many fragments, was recovered from the Marathon tumulus (Shear 1993, 409).[9] The last examples come from two communal – and exceptional – burials from Olynthos whose grave goods range from the late sixth century to the 430s BC (Robinson 1950, 269–270, numbers 488–491). On stylistic grounds, the plemochoai are much earlier than the burial itself: they are in line with the latest example recovered from Sindos and dated to 490–480 BC (Saripanidi 2012b, vol. 2, pp. 84–85, pl. 47, number 217). Some evolution can be seen in the shape within its *c.* 40 years of existence: the later examples show a taller stem and even shallower bowl while maintaining the average height of *c.* 11 cm. The bulk of the production can be placed around 500 BC and shows slight variations suggestive of different workshops or potters/painters within the same workshop. The plemochoe in the Shefton Collection belongs here (Figs. 3.1–3.3).[10]

The archaeological evidence suggests that the clay version stopped being produced during the second quarter of the fifth century. After that date and down to the fourth century, it was manufactured in stone, particularly in marble.[11]

The Big Picture – The Attic Plemochoai between Archaeology and Vase-Painting

The plemochoe is an evocative object that allows us to explore a number of issues of current interest in modern scholarship, such as the relationship between art/ideology and life, the

importance of the 'context', of many sorts, for the interpretation of the remains of the past, and the fundamental question of how to understand Greek imagery.

The problem surrounding this object can be summarized as follows: the plemochoe is one of the vases that most often appears in the realm of women in Attic vase-painting, particularly in the second half of the fifth century, and it has traditionally been assumed that its use was restricted to them (Scheibler 1964, 82–91; Gericke 1970, 83). Furthermore, because of the association of the vessel with the feminine world in vase-painting, when it appears in the archaeological record, in late sixth- and early fifth-century Macedonian and Boeotian tombs, it is taken as a gender marker and the deceased is assumed to be a woman. Assumptions of this sort are deeply affected by two tendencies which, despite having been vigorously contested over the last decades, are still common in modern scholarship: a positivist comparison between art and life – in particular the literal interpretation of the images on pots – and the almost unconscious habit of sexing tombs on the basis of the grave goods they contain. These two tendencies become glaringly obvious in the case of the plemochoe, perhaps because no thorough and contextual study of the shape has been carried out yet. On the other hand, hasty conclusions are also spurred by the fragmentary nature of the evidence: the archaeological artefact itself, most often declared unprovenanced, and the representation of the vase on other pots.

Nature of Evidence

The extant clay plemochoai with an archaeological context come mainly from sixth- and early fifth-century Macedonian and Boeotian tombs. They also appear in South Italian graves and were relatively common in Crete, although so far, only one Attic example comes from the region.[12] The plemochoai are surprisingly very seldom attested in Attica.

A good number of the examples preserved in museums are said to come from Athens, or, at least, to have been bought there during the nineteenth century,[13] but there is no further information about their depositional contexts. It is very surprising that this shape, a very particular Athenian development of a Corinthian vase, is so seldom attested in its homeland. One may want to explain this situation by the fragmentary nature of our evidence and by the extensive grave-robbing that took place in Athens and the Attic demes of the countryside at the end of the nineteenth century – especially in the period between 1860 and 1880 (Galanakis and Skaltsa 2012, 638–644). Many plemochoai could have passed then to the art market with no more explicit reference to their archaeological contexts than the generic designation 'Attica'. Thus, there are almost a hundred plemochoai in museums that might come from Attic cemeteries, among them, the one in the Shefton Collection. Nevertheless, the fact that no examples have been recovered from thoroughly excavated and published cemeteries, such as the Kerameikos, suggests that the issue goes beyond excavation biases. Apart from the absence of the shape from the main cemetery of Athens, what is also remarkable is its limited presence in the Agora. Sparkes and Talcott (1970, 180) refer to a few fragments of 'kothones' of the types A and B from the excavations but no inventory numbers or other information are provided, and thus it has not been possible to locate them.[14]

The second source of information is the representations of the shape in Athenian vase-painting. There are only a few images of the shape on sixth- and fifth-century black-figure vases,[15] but red-figure vase-painting and white ground lekythoi offer abundant material for research. The plemochoe usually appears in beautification and nuptial scenes, and hence most of the examples concentrate in the second half of the fifth century BC and the beginning of the fourth century BC, a time when scenes of this kind became increasingly popular.

These two sources of evidence – archaeological artefact and image – are not comparable: apart from their different internal logic, they do not share the same chronology and not even the same cultural milieu but even so, Athenian vase-painting has been used as too literal a route map for the interpretation of the archaeological record, leading to the assumptions that I have mentioned before, i.e. the exclusive association of the shape with women.

Archaeology vs. *Image*

The plemochoe offers the scholar an opportunity to approach the use of the same object in two different contexts, or better, systems of communication: image and archaeological record, which, if looked at through the wrong lens, often show a puzzling tendency to disagree. Or to put it more appropriately: it lets us contrast the discourses offered by the images painted on vases, best defined as 'cultural constructs that make use of a well-thought language to reflect cultural values and beliefs' (Barringer 2001, 2), and the no less complex world of mortuary archaeology, particularly of grave goods, which is equally affected by the risk of naive direct interpretations.

As mentioned above, the extant plemochoai come mainly from Macedonia and Boeotia, where they are closely associated with the commoner Corinthian and local exaleiptra. Although in absolute terms there is a remarkable concentration of the shape in Macedonia, relatively speaking the plemochoai are just a very restricted phenomenon and appear only very sporadically there – some 20 examples.[16] They concentrate in well-furnished graves in some of the wealthiest cemeteries of the region, such as Archontiko, Sindos, and Thermi, which suggests that they could have been deemed prestigious in that context. Nevertheless, their insignificant number does not make it possible to establish a direct link between a particular level of wealth at the tomb and the consumption of this shape because many wealthy burials lack plemochoai and the deposition of the recovered examples is far from following an established or recognisable pattern. The archaeological record suggests a slightly different – ideological – function for the exaleiptron and the plemochoe, but most probably the same – practical – use for both: as storage containers of specific local products, such as the *nitrum chalastricum*, a compound of great importance in the preparation of different salves and pharmaceutical formulations whose importance among the Macedonians has been recently highlighted (Saripanidi 2012a, 287). The archaeological record suggests that the plemochoe was related to the cleansing of the body of the deceased, maybe being a more prestigious alternative to the exaleiptron found in some Macedonian burials. With some exceptions (grave 117 at Sindos and grave 279 at Archontiko), most often the presence of either exaleiptra or plemochoai in a burial excludes the other; in the particular case of the vases with inward rims, there is no accumulation of shapes that could be understood to perform the same use. Finally, the presence of the plemochoai in the cemeteries under study did not distinguish between genders either, at least for the graves for which we have osteological studies, which, admittedly, are just a few.

The situation differs in Boeotia. Research into Boeotian funerary customs is difficult because most findings are still unpublished. The only site that can be used for my aim is the archaic cemetery of Rhitsona, partially published by Burrows and Ure (1907, 1909, 1910, 1911). From the 41 tombs that fall within the chronology of our shape, 19 of them did not contain either plemochoai or exaleiptra and most of these had less than 100 objects in total.[17] The remaining 22 burials have exaleiptra and 9 of them also include plemochoai, i.e. none of the graves without exaleiptra had plemochoai but the opposite situation is attested. The ratio between the two vessels is interesting: 2:6, 1:2, 4:22, 4:12, 6:53, 1:3, 3:6, 2:5. In other words: the higher the number of exaleiptra, the higher the number of plemochoai, the latter always being less than the former. The

plemochoai concentrate in the best provisioned tombs, those that receive more than 200 objects, while the exaleiptra, although present there, also appear in more 'modest' tombs (for Rhitsona standards) that contained less than 100 objects. The number of plemochoai that a particular deceased received was then clearly dependent on the total number of the objects disposed for them. Contrary to Macedonia, neither the plemochoe nor the exaleiptron were part of the basic set of grave goods at Rhitsona, which was made up of at least one closed oil container and a drinking vessel, usually the *kantharos*. This makes me exclude the possibility that the plemochoe had any practical function in Rhitsona. Nevertheless, it does not follow from here that it had no function at all. In fact, it contributes to convey an idea of wealth, which in this case is not expressed by the introduction of the Athenian shape at the expense of the exaleiptron as seems to be the case in Macedonia, but by the massive accumulation of objects of all sorts. The burials that contained plemochoai in Rhitsona also included metal objects, figurines, glass bottles and, on one occasion, fragments of a silver necklace.

Thus, the archaeological record offers evidence to assess the actual use of the vase in a daily life situation: mortuary practices, yielding the conclusions sketched above. In turn, the images of the vessel on other pots show a more 'ideal(-ised)' use of the vase in which women are deeply involved. The plemochoe occurs in three different types of scenes:

1) Bath and beautification scenes where we can assume that the vase, or better, its content, is actually being or is soon going to be used (Fig. 3.5).[18] They provide clear evidence for the use of the plemochoe as a container of different substances for the cleansing of the body. Its content would complement that of the alabastron – pure perfume, with which it is recurrently paired in the same scenes.[19] It is mainly women who are shown in association with the vase but this is no

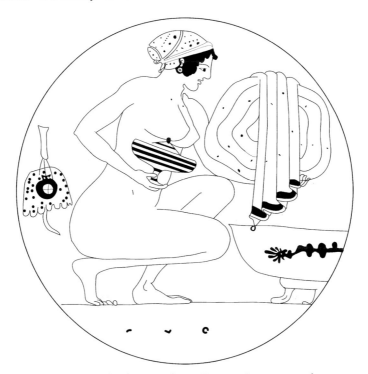

Figure 3.5: Cup by the Triptolemos Painter. Drawing: author.

reason to argue that only they used it. What, in a too positivistic understanding of vase imagery, could be taken as an 'exclusivity rule' for the use of the vessel can be understood in the context of representational choices more generally: what interests vase painters at the time (mid-fifth century) are *women* – and not men – beautification and bathing scenes. In fact, among the few preserved red-figure scenes of the cleansing of a youth, the plemochoe is indeed present.[20]

2) The second type of images are those where the plemochoe and other objects are being presented to a woman in a more or less defined setting, generally in a bridal context, or in more passive beautification scenes, where the object is exchanged and/or displayed (Fig. 3.6).[21] This group points to the wedding as one of the contexts where the vessel would acquire relevance, as it is a moment when the cleansing of the body and the attractiveness of the bride are of the utmost importance. Whether these images would allow an understanding of many of the scenes grouped in the first category in bridal terms or as tinged with nuptial nuances, very broadly speaking, is a possibility that needs to be explored. This group also includes images of women bringing plemochoai to the tomb, mostly on white ground lekythoi.

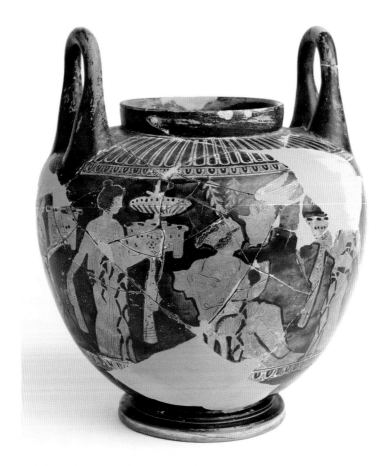

Figure 3.6: Red-figure lebes gamikos, Newcastle upon Tyne, Shefton Collection 369. Photograph: Colin Davison.

Figure 3.7: Athenian red-figure lekanis, New York, Metropolitan Museum of Art 17.230.42. Rogers Fund, 1917. © Metropolitan Museum of Art. Open Access for Scholarly Content Artwork. www.metmuseum. org.

3) Finally, the third group is comprised of late images where the vase – and other objects – become the focal centres of attention in the scene because of their magnified dimensions, becoming extensions of the woman's own body (Fig. 3.7).[22] Vase-painting is a medium which heavily relies on 'things', on attributes, to build *personae,* where particular objects define particular types of persons – the citizen, the barbarian, the wife, the hetaira, etc. The plemochoe, due to its association with the (nuptial) bath, seems to be one of the objects that worked as metonymies of a series of values and characteristics that defined the reputable woman – wife – of the time in the language of Athenian vase-painting, such as the kalathos or the alabastron. The most clear example of the category are the images of running women holding huge objects in highly undefined settings which decorate the lids of lekanides and pyxides in the fourth century BC.[23] In the wave of the current interest of Social Sciences and Humanities in the relationship between humans and things, I believe that these images have much potential to illuminate different aspects of human engagement with the material world, but due to space restrictions, I cannot explore this issue here.

Conclusions – Towards an Integrated Approach
This overview has allowed us to see different ways in which a single object was used in Antiquity, as well as to point to several issues worthy of further exploration. Albeit brief, I hope it suffices to raise awareness of the importance of an evidence-based integrated contextual approach to material culture, as well as of the problems of combining different types of sources without first clarifying their purposes and limitations. This is especially important if we want to write a cultural biography of any given object and to study the interaction of humans with material culture more generally.

The plemochoe was broadly speaking a cosmetics container, but this function does not necessarily place it exclusively in the realm of women, for there are many occasions in which cosmetics and medical products of different sorts were used in the ancient Greek world. The gender connotations that the shape enjoyed in Athenian vase-painting and the ideas that it could have helped convey within that system are not reflected in the archaeological record. As we saw, archaeology reveals regional particularities in the deposition patterns of the plemochoai. Their use and function is likely to have differed from region to region, being subject to local customs, and on some occasions they may not have even served a practical use.

Images on pots are a great source of information about several aspects of ancient Greek life that did not enter official art and contribute to our understanding of the lived realities of women in the ancient world. Nevertheless, if they are approached too literally, if we fail to understand the aims and limitations of the medium, images turn into a major source of misunderstanding. It is always good to remember that Greek vase-painting is just a small biased window through which to explore a much more complex and fluid reality.

Notes

1 This chapter is part of a wider research project whose aim is to explore the relationship between women and objects in ancient Greece from an archaeological and art historical perspective. The project is being carried out at the University of Edinburgh with funding from the Spanish Foundation of Science and Technology (2012–2014). I am grateful to Dr Sally Waite for inviting me to contribute to this volume as well as for her comments on the manuscript and her support, and to Andrew Parkin for the facilities offered to study the vase. Special thanks are due to Professor Judy Barringer and Dr Vasiliki Saripanidi for their suggestions and comments on this manuscript, and to Professor Carmen Sánchez and Professor John Bintliff for their support. I did not have the pleasure of meeting Professor Shefton but I have been able to form a picture of his personality through the testimonials of friends and colleagues who shared with him conferences around the world, and particularly in Spain, where he was very well known for his contribution to the study of the Greek presence in the Iberian Peninsula. The charming and enthusiastic scholar who emerges from the anecdotes of those who met him have made Professor Shefton a familiar and dear figure to me. May this contribution on a fascinating and evocative object from the collection that he so diligently and proudly created be my tribute to the likewise fascinating figure of one of the greatest scholars of the past century.

2 On the early examples, see Alexandridou (2011, 29–30) and, especially, Kreuzer (2009).

3 On dating, see also Scheibler (1964, 102–106).

4 Delos, Archaeological Museum 646; Dugas (1928, 168, 188, pl. XLVIII); *ABV* 348.7; *BAPD* 301955.

5 Thessaloniki, Archaeological Museum 7806; Despini, Misailidou and Tiverios (1985, 274); Saripanidi (2012b, vol. 2, p. 83, pl. 47); *BAPD* 19084.

6 Salerno, Museo Nazionale, inv. no. unknown; Sestieri (1948, 339); *ABV* 349.2; *BAPD* 301959.

7 The disappearance of the alternating pattern can be dated around 520 BC. The plemochoe fragment 1138 from the Deposit III at Tocra, whose latest pieces date to *c.* 530 BC, was considered a possible intrusion from Level 6 (*c.* 500 BC); Boardman and Hayes (1966, 106–107, pl. 85). Nevertheless, the alternating tongue pattern makes more likely its inclusion in the previous level.

8 One of the examples – which might not be Attic – comes from the grave number 31 from Rhitsona, dated to *c.* 515 BC (Sparkes 1967, 129). The same burial included examples of developed versions of the type B. I thank Professor Amy Smith for granting me access to Ure's excavation diaries and personal notes at the Ure Museum of the University of Reading. A similar example is the

plemochoe 213 from Sindos (Thessaloniki, Archaeological Museum 7893; Saripanidi 2012b, vol. 2, p. 82, pl. 47), which was found with a black-figure skyphos of the CHC Group of the late sixth century. I thank Dr Saripanidi for sharing this information with me. Yet another plemochoe of a similar sort but of better draughtsmanship is associated with a column krater of the Group of Oxford 216 dated to 510–500 BC in the chamber tomb 1 at Capodarso (Panvini 2006, 82, pl. 1f.).

9 The exact provenance of this vessel (either the cremation or the offering trench) is not known to me.

10 The closest parallels to the vase are: Thebes, Archaeological Museum 23431. London, British Museum 1931,0216.18. New York, Metropolitan Museum of Art 06.1021.95; *ABV* 349.16. Edinburgh, National Museums of Scotland 1905.342. Oxford, Ashmolean Museum 1938.2. Madrid, Museo Arqueológico Nacional 2002/98/1.

11 Fourteen stone/marble plemochoai are known to me: 1) Berlin, Antikensammlungen 1460 – from the tomb of Aristion – Kekulé 1887, 78. 2–3) Pernice (1899, 71) mentions two further examples in Berlin, which I could not locate. 4) Getty Villa 96.AA.103; Sotheby's, *Antiquities,* sale cat., 14 December, 1990, lot 236; Harris (1994, 106–107, n. 46). 5) Harvard Art Museums 1920.44.16. 6) Art Market; Christie's Sale 9599, 228. 7–10) Athens, National Museum 11362, 11365, 11368, 12292. 11) Amsterdam, Allard Pierson Museum 1612. 12) Boston, Museum of Fine Arts 81.335; Caskey (1939, 75, 77, fig. 6). 13) Brussels, Musées Royaux A.3376. 14) Vergina, Museum of the Royal Tombs of Aigai BΛ 48; Descamps-Lequime and Charatzopoulou (2011, catalogue number 157/1).

12 From the kitchen (B1500) of the Hearth Shrine within the Monumental Civic Building complex of Azoria (Haggis *et al.* 2007, 283–4). Although so far only this example has been attested in Crete, a rather competent Knossian imitation of an Attic-type plemochoe suggests that Cretans were familiar with the Athenian shape (Coldstream 1973, 47, Coldstream *et al.* 2001, 87, Erickson 2010, 119).

13 E.g. Stockholm, NM 397; Copenhagen 4706 and 15424; Heidelberg 275; Boston 97.367; Adolphseck 194; Berlin F2109, F2105, F405, F4014; Bonn 844.

14 I thank Professor Sparkes for checking his box files for me in search of information about these fragments.

15 Laon, Musée Archeologique Municipal 37892; *Para* 217; *Add²* 120; *BAPD* 306700. Athens, Archaeological Museum of the Kerameikos 692; Scheibler (1964, 83, fig. 10). Tübingen, Eberhard-Karls-Universität s/10.1729. Adolphseck, Schloss Fasanerie 16; *ABV* 703.24BIS; *BAPD* 306774. Paris, Musée Auguste Rodin 533; *ABV* 509.112, *BAPD* 05523.

16 Sindos: 1) Thessaloniki, Archaeological Museum 7893; Despini, Misailidou, and Tiverios (1985, 72–73, fig. 104); Saripanidi (2012b, vol. 2, p. 82, pl. 47). 2) Thessaloniki, Archaeological Museum 7806 (repaired in Antiquity); Despini, Misailidou, and Tiverios (1985, 274–275, fig. 449); Saripanidi (2012b, vol. 2, p. 83, pl. 47); *BAPD* 19084. 3) Thessaloniki, Archaeological Museum 8336; Despinis, Misailidou, and Tiverios (1985, 42–43, fig. 52); Saripanidi (2012b, vol. 2, p. 84, pl. 47). 4) Thessaloniki, Archaeological Museum 7815; Saripanidi (2012b, vol. 2, p. 84, pl. 47). 5) Thessaloniki, Archaeological Museum 7781; Saripanidi (2012b, vol. 2, p. 84, pl. 47). 6) Thessaloniki, Archaeological Museum 7858 (lid); Saripanidi (2012b, vol. 2, p. 84, pl. 47). Olynthos: 7–10) Robinson (1950, 269–270, catalogue numbers 488, 489, 490, 491) from burials; 11–12) Robinson (1933, 83), catalogue numbers 77 and 78. Archontiko: 13) Chrysostomou and Chrysostomou (2003, 512–513). Thermi: 14) Tsougaris (2006); Skarlatidou (2007). Agia Paraskevi: 15) Thessaloniki, Archaeological Museum 13171; Sismanidis (1987, 794, pl. 163.2). Akanthos: 16–17) Thessaloniki, Archaeological Museum I.49.85 and 1102/T1427; Kaltsas (1998, 39–40, pl. 22a and 66, pl. 68a); Descamps-Lequime and Charatzopoulou (2011, catalogue number 110). Aiane: 18) Aiane, Archaeological Museum 10705; Karamitrou-Mentesidi (1990, 77, fig. 12); Karamitrou-Mentesidi (2008, fig. 195). 19) Kephalidou (2001, 186, n.9 fragments). Karabournaki: 20) Paris, Musée du Louvre CA2205; Descamps-Lequime and Charatzopoulou (2011, catalogue

number 44). Aphytis: 21) Thessaloniki, Archaeological Museum 11351 (unpublished; fabric doubtful). Find-spot unknown: 22) Thessaloniki, Archaeological Museum 1386 (unpublished). 23) Dr Saripanidi has called my attention to a recently discovered plemochoe at Gorna Porta Tomb 167 in Ohrid (FYROM).

17 For a comprehensive catalogue of the tombs, see Sparkes (1967, 128–130).

18 E.g. Jerusalem, Bible Lands Museum 4647. Tarquinia, Museo Nazionale 87778; *Para* 333.9 BIS; *Add²* 175; *BAPD* 352439. Boston, Museum of Fine Arts 95.21; *ARV²* 1052.19; *BAPD* 213650. New York, Metropolitan Museum of Art 30.11.8; *ARV²* 1248.4.

19 E.g. Gela, Museo Archeologico 40359; *ARV²* 640.7; *Para* 400, *Add* 133; *Add²* 274; *BAPD* 207423.

20 E.g. Warsaw, National Museum 142290; *ARV²* 571.76; *Para* 390; *BAPD* 206567.

21 E.g. London, British Museum E103; *ARV²* 1394.57; *BAPD* 250057. Athens, National Museum A1877; *ARV²* 1707.84BIS; *BAPD* 275718. St. Petersburg, State Hermitage Museum ST1812; *ARV²* 1332.4; *BAPD* 220699. New York, Metropolitan Museum of Art 09.221.40; *ARV²* 1328.99; *Para* 471; *BAPD* 220655.

22 E.g. Athens, Market; *ARV²* 1452.13; *BAPD* 218215; Brussels, Musées Royaux A3549; *ARV²* 1498.2; *BAPD* 230816. St. Petersburg, State Hermitage Museum 230841; *ARV²* 1499.1; *BAPD* 230841.

23 E.g. London, British Museum E778; *ARV²* 1503.2; *BAPD* 230886. New York, Metropolitan Museum of Art 17.230.42; *ARV²* 1499.1; *BAPD* 230843. London, British Museum F138, *ARV²* 1498.2; *BAPD* 230817. Leiden, Rijksmuseum van Oudheden GNV131; *ARV²* 1497.16; *BAPD* 230798. Toronto, Royal Ontario Museum 451; *ARV²* 1497.14; *BAPD* 230796.

Bibliography

Alexandridou, A. (2011) *The Early Black-Figured Pottery of Attika in Context (c. 630–570 BCE)*. Leiden.

Barringer, J. M. (2001) *The Hunt in Ancient Greece*. Baltimore.

Boardman, J. and Hayes, J. (1966) *Excavations at Tocra 1963–1965: The Archaic Deposits I. BSA. Supplementary Volume 4*. London, British School at Athens.

Burrows, R. M. and Ure, P. N. (1907) Excavations at Rhitsóna in Boeotia. *Annual of the British School at Athens* 14, 226–318.

Burrows, R. M. and Ure, P. N. (1909) Excavations at Rhitsóna in Boeotia. *Journal of Hellenic Studies* 29, 308–353.

Burrows, R. M. and Ure, P. N. (1910) Excavations at Rhitsóna in Boeotia (Continued). *Journal of Hellenic Studies* 30, 336–356.

Burrows, R. M. and Ure, P. N. (1911) Kothons and Vases of Allied Types. *Journal of Hellenic Studies* 31, 72–99.

Caskey, L. D. (1939) Greek Marble Vases. *Bulletin of the Museum of Fine Arts* 37.223, 74–80.

Chrysostomou, A. and Chrysostomou, P. (2003) Δυτική νεκρόπολη του Αρχοντικού Πέλλας. *Το Αρχαιολογικό Έργο στη Μακεδονία και Θράκη* 17, 505–516.

Coldstream, J. N. (1973) Knossos 1951–61: Orientalizing and Archaic Pottery from the Town. *Annual of the British School at Athens* 68, 33–63.

Coldstream, J. N. *et al.* (2001) *Knossos Pottery Handbook. Greek and Roman*. British School at Athens Studies 7. London.

Descamps-Lequime, S. and Charatzopoulou, K. (2011) *Au royaume d'Alexandre le Grand: La Macédoine Antique*. Paris, Musée du Louvre éditions.

Despini, A., Misailidou, D. and Tiverios, M. (1985) *Sindos: Katalogos tes ektheses*. Thessaloniki, Archaeological Museum of Thessaloniki.

Dugas, C. (1928) *Les vases de l'Héraion, Exploration archéologique de Delos*. Paris.

Erickson, B. (2010) Crete in Transition: Pottery Styles and Island History in the Archaic and Classical Periods, *Hesperia Supplement 45*. Princeton, American School of Classical Studies.

Galanakis, Y. and Skaltsa, S. (2012) Tomb Robbers, Art Dealers, and a Dikast's Pinakion from an Athenian Grave. *Hesperia* 81.4, 619–653.

Gericke, H. (1970) *Gefässdarstellungen auf griechischen Vasen*. Berlin.

Haggis, D. *et al.* (2007) Excavations at Azoria, 2003–2004, Part 1: The Archaic Civic Complex. *Hesperia* 76.2, 243–321.

Harris, J. (1994) *A Passion for Antiquities: Ancient Art from the Collection of Barbara and Lawrence Fleischman*. Malibu.

Karamitrou-Mentesidi, G. (1990) Ανασκαφή Αιανής 1990. *Το Αρχαιολογικό Έργο στη Μακεδονία και Θράκη* 4, 75–93.

Karamitrou-Mentesidi, G. (2008) *Aiani: a guide to the archaeological sites and the museum*. Aiani, Archaeological Museum of Aiani.

Kekulé, R. (1887) Erwerbungen der Antikensammlungen in Deutschland. Berlin 1892. *Archäologischer Anzeiger* 8, 72–82.

Kephalidou, K. (2001) Late Archaic Polychrome Pottery from Aiani. *Hesperia* 70.2, 183–209.

Kreuzer, B. (2009) The Exaleiptron in Attica and Boeotia: Early Black Figure Workshops Reconsidered. In Tsingarida, A. (ed.) *Shapes and Uses of Greek Vases (7th–4th Centuries B.C.)*, 17–31. Brussels.

Mommsen, H. (1991) *Berlin, Antikenmuseum (ehem. Antiquarium). Vol. 7, Corpus Vasorum Antiquorum. Deutschland*. Munich.

Panvini, R. (2006) Osservazioni su alcuni vasi attici delle Necropoli di Sabucina e Vassaliaggi nel Museo Archeologico di Caltanissetta. In Giudice, F. and Panvini, R. (eds.) *Il Greco, il barbaro e la ceramica attica: immaginario del diverso, processi di scambio e autorappresentazione degli indigeni: atti del convegno internazionale di studi, 14–19 Maggio 2001*, 69–79. Rome.

Pernice, E. (1899) Kothon und Räuchergerat. *Jahrbuch des Kaiserlich Deutschen Archäologisches Instituts* 14, 60–72.

Pottier, E. (1883) *Étude sur les lécythes blancs attiques à représentations funéraires*. Paris.

Rayet, O. (1881) *Catalogue de la collection de O. Rayet*. Paris.

Richter, G. M. A. and Milne, M. J. (1935) *Shapes and Names of Athenian Vases*. New York.

Robinson, D. M. (1950) *Excavations at Olynthus. Volume XIII, Vases found in 1934 and 1938*. Baltimore.

Robinson, D. M. (1933) *Excavations at Olynthus. Volume V, Mosaics, Vases, and Lamps of Olynthus found in 1928 and 1931*. Baltimore.

Saripanidi, V. (2010) Local and Imported Pottery from the Cemetery of Sindos (Macedonia): Interrelations and Divergences. In Tréziny, H. (ed.) *Grecs et indigènes de la Catalogne á la mer Noire. Actes des rencontres du programme européen Ramses (2006–2008)*, 471–480. Paris.

Saripanidi, V. (2012a) The Exaleiptron in the Funerary Customs of Central Macedonia (in Greek). In Kefalidou, E. and Tsiafaki, D. *Kerameos Paides: Studies Offered to Professor Michalis Tiverios by his Students*, 283–289. Thessaloniki.

Saripanidi, V. (2012b) *Imported and Local Pottery in Northern Greece: The Case of Sindos (in Greek)*. Unpublished thesis, University of Thessaloniki.

Scheibler, I. (1964) Exaleiptra. *Jahrbuch des Deutschen Archäölogischen Instituts* 79, 72–108.

Shear, L. (1993) The Persian Destruction of Athens: Evidence from Agora Deposits. *Hesperia* 62.4, 383–482.

Sismanidis, K. (1987) Το αρχαϊκό νεκροταφείο της Αγίας Παρασκευής Θεσσαλονίκης. In *Αμητός. Τιμητικός τόμος για τον καθηγητή Μ. Ανδρόνικο 1–2*, 787–816. Thessaloniki, Aristotle University of Thessaloniki.

Skarlatidou, E. (2007) *Θέρμη. Το αρχαίο νεκροταφείο κάτω από τη σύγχρονη πόλη*. Athens.

Sparkes, B. (1967) The Taste of a Boeotian Pig. *Journal of Hellenic Studies* 87, 116–130.

Sparkes, B. and Talcott, L. (1970) *Black and Plain Pottery of the 6th, 5th and 4th centuries BC. Part 1: Text*. Princeton, American School of Classical Studies.

Tsougaris, Ch. (2006) Gray Kantharoid Cotylae and Exaleiptra from the Ancient Cemetery of Modern Thermi, Thessaloniki (in Greek). *Makedonika* 35, 1–38.

4. An Attic Red-Figure Kalathos in the Shefton Collection

Sally Waite

The focus of this chapter[1] is a fifth-century Attic red-figure kalathos in the Shefton Collection (inv. no. 853, Figs. 4.1 and 4.2).[2] The kalathos, of pale orange clay, has been reconstructed; some fragments are missing and the black-glaze is worn in places. It has a ring foot, flaring sides and out-turned rim and is glazed both inside and out. The resting edge of the foot is reserved with a ring of black-glaze on its inner edge. The decoration consists of a group of six women with an ovolo frieze to the lower base and a palmette frieze beneath the lip. There are some traces of preliminary sketch lines and the figures are rendered both with relief line and dilute glaze.

The kalathos belongs in part to the Society of Antiquaries of Newcastle upon Tyne and part is on loan from the present Earl of Elgin. Brian Shefton (1970, 52) mentioned the kalathos in *Archaeological Reports* as the most impressive piece within the Society of Antiquaries' collection of Greek pottery. It was displayed in the Black Gate Museum in Newcastle until 1951, after which the kalathos was reconstructed, incorporating a large fragment and a few small fragments lent by the 11th Earl of Elgin, and loaned to the Department of Classics at Durham University. The piece was published by Roderick Williams in *Antike Kunst* in 1961 with photographs taken by Brian Shefton. This publication includes a detailed description of the iconography but little attention to interpretation; the history of the kalathos is only briefly touched upon. The kalathos was transferred in 2001, with a number of other vases, to the Shefton Museum within Newcastle University and subsequently to the Shefton Gallery of the Great North Museum.

The kalathos is interesting in terms of both its shape and iconography. As a form the kalathos is rare in Attic black- and red-figure and its function is uncertain. Its iconography is detailed and open to various interpretations. Through a close and contextual analysis of the imagery it is possible to understand the ideology underpinning it and so facilitate an understanding of the role of women, both real and imagined, in fifth-century Athens. Unusually the piece has a provenance: it was excavated from a grave in Athens in the early nineteenth century. Furthermore the kalathos has a fascinating post-excavation history which warrants further exploration and will be examined in the second half of this chapter. The investigation of the form, iconography and historical context of the kalathos alongside its post-excavation history confirms the importance ascribed to it by Brian Shefton.

Attribution

Stylistically it is possible to date the kalathos to *c.* 440 BC. It is noteworthy that Beazley did not attempt to attribute the kalathos to a specific painter although he certainly knew of its existence: he mentions it in 1931 in his Disjecta Membra. Williams (1961, 29) suggested a tentative relationship with the Barclay Painter relating the kalathos to hydriai in Cambridge[3] and Paris.[4] There is a third hydria in Charlecote Park,[5] a National Trust property near Warwick. In ornament and subject matter there are similarities but, having examined all three parallels, I am not convinced they are connected stylistically to the Shefton kalathos.

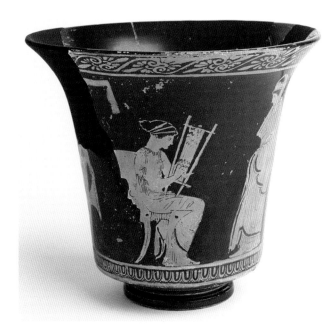

Figure 4.1: Attic red-figure kalathos, Newcastle upon Tyne, Shefton Collection 853. Photograph: Colin Davison.

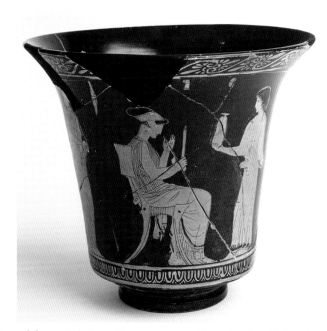

Figure 4.2: Attic red-figure kalathos, Newcastle upon Tyne, Shefton Collection 853. Photograph: Colin Davison.

Form and Function

The clay kalathos as a shape is characterised by its narrow base and wide flaring wall with out-turned rim. It is named after the wickerwork wool basket which is often represented on painted pottery. The size of the Shefton example is noteworthy: at just over 15 cm high, it is unlikely to have been used as a container for wool. In clay the shape is long-lasting, first occurring in Minoan[6] and Mycenaean pottery.[7] Proto-Geometric (Fig. 4.3)[8] and Geometric examples are common (Connor 1973, 58ff.; Desborough 1952, 114ff.). Geometric pottery kalathoi are generally found in graves, often of women, or sanctuaries connected with female deities, where it has been suggested they were used as ritual vessels to hold offerings (Langdon 2005, 12). At least eight cut-work kalathoi were found in the tomb of the rich Athenian lady dating to *c.* 850 BC in the Athenian Agora.[9] A recent re-examination of the cremated remains suggests

that this is the grave of a woman who died in pregnancy or premature childbirth (Liston and Papadopoulos 2004, 7ff.). Clearly this example could not have held liquid, powdery or small items; like contemporary model granaries it is probably to be understood as a model of some object common in daily life, such as a wool basket (Smithson 1968, 98ff.).

Two later clay kalathoi of a similar size to the Shefton kalathos offer a further interesting comparison. A sixth-century BC example found in Athens and now in London[10] (Fig. 4.4) demonstrates an open work basket design, whilst a fifth-century BC example in Athens,[11] (Fig. 4.5) contemporary to the Shefton kalathos,

Figure 4.3: Proto-Geometric kalathos, Newcastle upon Tyne, Shefton Collection 672. Photograph: Colin Davison.

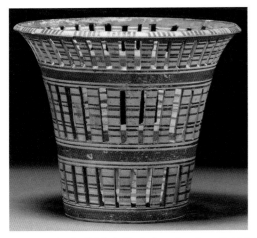

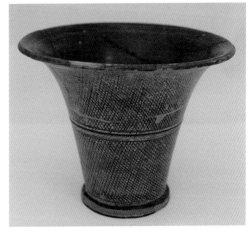

Figure 4.4: (left) Model kalathos, London, British Museum GR 1877.12-7.14.© Trustees of the British Museum.

Figure 4.5: (right) Model kalathos, Athens, National Archaeological Museum 18522. Photograph: Eleftherios A. Galanopoulos. © Hellenic Ministry of Culture and Sports /Archaeological Receipts Fund.

has a painted wickerwork design. In these two examples the connection between clay and basket kalathos is explicit: these kalathoi are clearly intended to represent model wool baskets. The exact provenance of these examples is not known, although given their state of preservation, a funerary context seems most likely.

There are many examples of kalathoi from Corinth and Perachora again associated with female deities.[12] Figured Corinthian examples are less common.[13] Athenian figured examples are extremely rare,[14] and there is some variation in shape, indicating diverse functions. Some kalathoi were clearly used as beakers or vessels for the drinking party: an assumption often confirmed by the decoration (Oakley 2009a, 66ff.).[15] Clearly the red-figure kalathos in Munich[16] with an image of Sappho and Alcaeus on the obverse and Dionysos and maenads on the reverse, is set apart from other kalathoi by its vertical sides, lug handles, spout and foot,[17] and was intended for a sympotic context. Likewise a small red-figure kalathos from Este[18] depicting youths and horses must once have been used as a drinking cup (Oakley 2009a, 69). The iconography of the Shefton kalathos, however, suggests a different use.

Fragments of two red-figure kalathoi were found in the Athenian Agora. The first, of *c.* 460 BC depicts a mythic representation of Boreas and Oreithyia on one side and Peleus and Thetis on the other (Fig. 4.6).[19] The second dating to *c.* 375–350 BC depicts a revel of some kind.[20] The Agora finds indicate that these kalathoi at least were not specifically made for the grave, but their exact function is difficult to determine. Oakley (2009a, 69) suggests a sympotic use for the first and the second example perhaps relates to the earlier black-figure kalathoi depicting a komos.[21]

Figure 4.6: Attic red-figure kalathos fragments, Athens, Agora P 18414 (a–c). Photograph: Craig Mauzy. © American School of Classical Studies at Athens, Agora Excavations.

The iconography of the first Agora kalathos is difficult to relate to a specific context: images of Peleus and Thetis are certainly popular on cups and kraters but also occasionally feature on vessels associated with women such as the pyxis,[22] lebes gamikos[23] or epinetron. On the well-known epinetron in Athens[24] the motif is combined with the wedding preparations of Alcestis and Harmonia. Representations of Boreas and Oreithyia follow a similar pattern, generally appearing on sympotic vessels[25] but with a few examples on pyxides[26] and loutrophoroi,[27] the latter underlining an association with the wedding.

Recently Zarkadas (2009, 318ff.) suggested that a pot of unique shape in Athens (Fig. 4.7)[28] may in fact be the lid to a pottery kalathos. The scene is not dissimilar to that shown on the Shefton kalathos and the wickerwork decoration to the top connects it with the wool basket. The presence of the lid would suggest that the kalathos was used as a container, possibly ruling out a purely ornamental role. Although the sherds of the later red-figure kalathos from the Athenian Agora indicate a socket for a lid[29] (Zarkadas 2009, 324), there is no indication that the Shefton kalathos was ever lidded.

The closest parallel to the Shefton kalathos is a kalathos, thought to be from Greece, now in California (Figs. 4.8–4.10).[30] It is of a similar height although lacking the ring foot and dates to the late fifth century BC. This red-figure kalathos represents women with Eros; one woman holds a chest and scarf, attributes which indicate a wedding context. The presence of

Figure 4.7: Attic red-figure lid, Athens, National Archaeological Museum ΒΣ 58. Photograph: Eleftherios A. Galanopoulos. © Hellenic Ministry of Culture and Sports /Archaeological Receipts Fund.

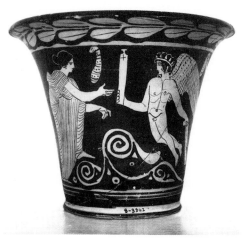

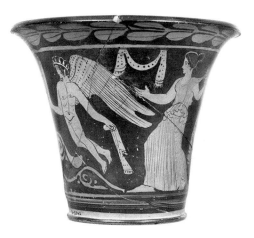

Figure 4.8: Attic red-figure kalathos, Berkeley, P. A. Hearst Museum of Anthropology 8.3342. Photograph: Alicja Egbert. © Phoebe A. Hearst Museum of Anthropology and the Regents of the University of California. Catalogue Number 8.3342.

Figure 4.9: Attic red-figure kalathos, Berkeley, P. A. Hearst Museum of Anthropology 8.3342. Photograph: Alicja Egbert. © Phoebe A. Hearst Museum of Anthropology and the Regents of the University of California. Catalogue Number 8.3342.

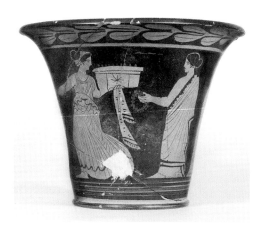

Figure 4.10: Attic red-figure kalathos, Berkeley, P. A. Hearst Museum of Anthropology 8.3342. Photograph: Alicja Egbert. © Phoebe A. Hearst Museum of Anthropology and the Regents of the University of California. Catalogue Number 8.3342.

Eros holding an alabastron and the gesture of anakalypsis performed by one of the women are typically associated with nuptial scenes. Like the Shefton kalathos, a cylindrical reading is encouraged, with three rotations necessary to capture all five figures. The California kalathos has two suspension holes,[31] indicating it had a purpose in daily life or served as a dedication.[32] Smith (1936, 51) suggests that this kalathos is a wedding token or symbolic present, appropriate given its form and decoration.

Could the clay kalathos have served a purely ornamental role? Such a theory seems at odds with the apparent functionality of Athenian painted pottery. However an interesting comparison can be made with the epinetron, another rare form[33] which is also associated with textile manufacture.[34] Bundrick (2008, 308) argues that figured epinetra were not intended to be used but to be given as wedding or grave gifts and votive offerings.[35] The example in Athens[36] representing the wedding preparations of Alcestis and Harmonia alongside Peleus and Thetis was recovered in pristine condition from a tomb context, with the smooth upper surface painted in reference to the rough upper surface of undecorated epinetra.

Wedding imagery was clearly considered appropriate for the grave, a fact no doubt reflecting the conflation of marriage and death in Greek thought. Smith (2005, 8/9) further suggests the Athens epinetron originally served as a wedding gift, only later being deposited in a tomb.

A role for the kalathos associated with the wedding seems the most likely explanation. Specialised pots, such as the loutrophoros and lebes gamikos, were utilised at the wedding[37] and are found almost exclusively in Greece. The loutrophoros is rarely found outside Athens. It has been excavated from cemeteries and in large numbers from the Shrine of the Nymphe where the vessel was dedicated at the completion of the wedding ceremony (Sabetai 2014, 56ff.; Wycherley 1970, 283ff.). There is little to suggest that wedding vessels were made specifically for the tomb, although the loutrophoros clearly doubled as a funerary vessel associated particularly with those who died unmarried (Sabetai 2009, 291ff.). Lebetes gamikoi have been excavated from houses, where they were clearly retained and reused in the domestic setting.[38]

Iconography

A closer examination of the iconography of the Shefton kalathos seems to confirm this possible context of use at the wedding and subsequent suitability for the grave. The scene decorating the kalathos is unique, but it is made up of common elements which appear in varying combinations on many other Athenian pots. The image as a representation rather than a reflection of reality encodes cultural concepts which can be recovered through analysis of visual language: the specific combination of figures and attributes which make up the scene. This methodological approach is concerned particularly with context: the context of the image on the (functional) pot (and therefore the context of viewing); the context of the elements within a single image; and the context of the single image within the collective network of images, as well as finally the context of the image within fifth-century Athenian society. In attempting to interpret the image we need first to understand the significance of the attributes and gestures.

The imagery can be divided into two distinct groupings corresponding to the two sides of the kalathos although when the kalathos is viewed it is not quite possible to see all three figures completely and simultaneously, due to the curvature of the vessel (Figs. 4.1 and 4.2). Interestingly there is no obvious obverse and reverse, both sides apparently carrying an equal weighting; which implies a cylindrical reading as apparent on vessels such as the pyxis and lekanis. There are two groups of three women: in each a seated woman is framed by two standing women who appear back to back (Fig. 4.11).

Figure 4.11: Drawing of kalathos, Newcastle upon Tyne, Shefton Collection 853. (After Daremberg and Saglio 1896 Dictionnaire des Antiquités Grecques et Romaines II, 2, fig. 3684.)

Two women hold attributes associated with wool work (Fig. 4.12); the standing woman is carrying a basket kalathos, the base of which is obscured by her dress.[39] The basket kalathos appears time and again in images of women on red-figure pottery. It may be shown actively in use as here, or simply as an attribute signifying the setting as the women's quarters.[40] It acts as a symbol of domesticity, industry and femininity (Lissarrague 1995, 95), seemingly regardless of the status of the women who use it. In the context of the oikos, textile production represented an important part of the household economy. The cultural exemplar of the productive housewife underlined both the ideal of gender segregation and the virtuous use of time.

The seated woman holds a small frame[41] used for the manufacture of sprang, a net-like material used for the production of sakkoi (hairnets) and also for weaving small items such as scarves, belts and hair bands, examples of which can be seen in the field both in front of and behind the kalathos bearer. Sprang frames have been identified by Jenkins and Williams (1985, 416) as being associated with prostitutes; sprang frames certainly appear in contexts which appear to show prostitutes[42] and there is archaeological evidence from building z in the Kerameikos which suggests that prostitutes also manufactured textiles for their own use or to supplement their income[43] (Davidson 1997, 86ff.; Knigge 1991, 88ff.). However the presence of the sprang frame should not automatically identify a woman as a prostitute.[44] Textile manufacture was one of the key roles for women and this is reflected on painted

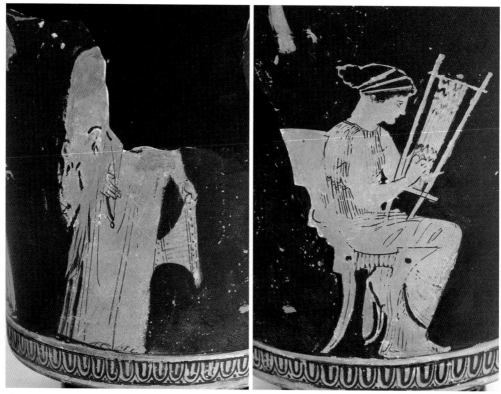

Figure 4.12: Attic red-figure kalathos, Newcastle upon Tyne, Shefton Collection 853 detail. Photograph: Colin Davison.

pottery. Numerous images show women spinning and women are often represented with textiles either held in the hand or hanging in the field. Such images are indicative of the essential and time-consuming nature of textile production, but also of the association of the ideal of industriousness with sexual desirability.

The two standing women (Fig. 4.13) are not associated with specific attributes; rather the focus is on their dress. The first is heavily draped and Williams (1961, 28) suggests she is the protagonist indicated by the concentrated relief line. This same arrangement of the mantle, pulled over the back of the head, is depicted in images of the wedding.[45] The nuptial reference seems prioritised on the kalathos by the addition of the stephane (bridal crown). However, the veil is not restricted to marriage and can be related instead to the covering of the head outside the house, as occasionally indicated by proximity to a door.[46] The contrast between veiled and unveiled women in the same scene perhaps signals the divide between public and private. The veil has a multiplicity of meanings, including the transition of the bride and idealised seclusion of the wife (Llewellyn-Jones 2003, 18, 88/89; Ferrari 2002, 54ff. discusses the mantle as a metaphor for aidos or modesty). Yet on a cup in Chicago[47] a woman wrapped closely in a mantle appears in the context of a brothel where negotiations between men and prostitutes are represented. In the centre of the image we can see a small pouch, probably a purse, although its contents have been much debated.[48] It is noteworthy that this image appears on a drinking cup with a sympotic context of viewing assumed. A direct correlation between veiling and respectability is problematic (Llewellyn-Jones 2003, 315ff.).[49]

The second woman, with folds of drapery falling over her arms is in the process of tying (or untying) her girdle. The girdle, like the veil, can be associated with the transition of marriage and this gesture is often associated with the bride, since loosening the belt was a metaphor for the sexual union of marriage, whereupon the girdle would be dedicated to Artemis[50] (Oakley and Sinos 1993, 14/15; Sabetai 1997, 321ff.; Waite 2000, 118/119). An alabastron in London[51] represents a bride tying the girdle, accompanied by the groom; she also wears the stephane. Sabetai (1997, 321ff.) argues that nuptial connotations are implicit where the girdle tying motif occurs in an image of toilette in the second half of the fifth century BC. A focus on the girdle is not, however, restricted to images of toilette and appears again in the sympotic context.[52] These two figures stand back to back, contrasting and highlighting their relative states of dress and undress.

Figure 4.13: Attic red-figure kalathos, Newcastle upon Tyne, Shefton Collection 853 detail. Photograph: Colin Davison.

The final two women (Fig. 4.14) hold objects associated with adornment and beautification. The seated woman is holding a mirror; the mirror is one of the most common attributes associated with women on Athenian painted pottery and offers a metaphor for the construction of femininity (Waite 2000, 468ff.). An oinochoe[53] (Fig. 4.15) in the Shefton Collection depicts a typical scene of adornment, where possibly both the attendant and the seated woman regard themselves.[54] The identification of the mirror on the Shefton kalathos has been questioned, since the mirror is generally shown rounded. The hand gesture of the woman seems to argue against any alternative interpretation, such as a dipstick or wand.[55] The mirror is shown in profile in other images.[56]

The standing woman carries a plemochoe and an alabastron, vessels used for storing perfumed water or oils. The alabastron was connected particularly with women, as the aryballos was with men, and appears to have been associated with marriage. A well-known alabastron in Paris[57] represents the bride, identified by a kale inscription, sitting beside a kalathos while a diminutive attendant carries an alabastron. The alabastron is explicitly combined with the marital bed on nuptial vessels, perhaps signalling its role in conjugal sex.[58] Other images are more ambiguous.[59] The plemochoe was in all likelihood used for perfumed water (see Rodríguez Pérez in this volume).[60] Often the plemochoe appears in images of funerary ritual[61] or of gift giving associated with the wedding.[62] If the pouch is interpreted as a money bag,[63] often represented in the context of hiring a prostitute, the plemochoe appears in an unexpected environment on a

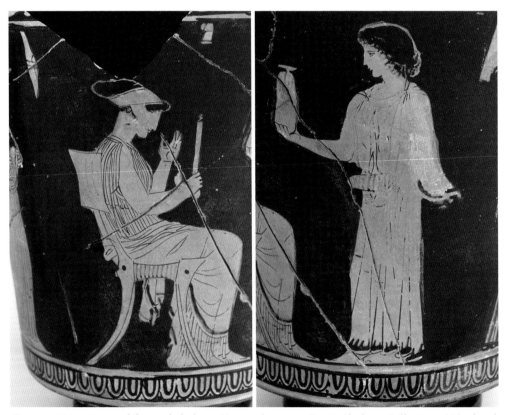

Figure 4.14: Attic red-figure kalathos, Newcastle upon Tyne, Shefton Collection 853 detail. Photograph: Colin Davison.

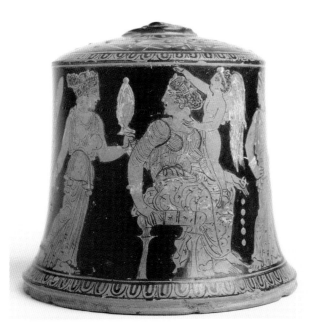

Figure 4.15: Attic red-figure oinochoe, Newcastle upon Tyne, Shefton Collection 195. Photograph: Colin Davison.

pelike in Athens.[64] Here a youth, holding a pouch, approaches a seated woman; behind her an attendant holds a plemochoe. The fact that the pelike is a multifunctional vessel used in a variety of contexts does not aid interpretation here.

Aside from the hanging scarves underlining the association of women and textiles, two other objects appear in the field: a phormiskos and krotala (castanets). The phormiskos is a storage container for knucklebones; it is made of clay with a small opening in the side (Neils 1992, 225ff.; Waite 2000, 103ff.).[65] Knucklebones are associated with childhood and divination and are often found in graves and votive contexts. Women playing with balancing sticks, spinning tops and knucklebones[66] or juggling, perhaps with wool, are commonly represented on painted pottery. Women are particularly associated with the game of knucklebones and it has also been proposed that the game was played prior to marriage as some sort of love oracle (Sabetai 1993, 190).[67] There is some suggestion that knucklebones may then have been dedicated to Artemis before marriage along with other childhood toys (Neils and Oakley 2003, 279). Knucklebones also appear as a gift in images of courtship,[68] where the status of the female recipient is far from clear. Hanging in the field or held in the hand, the phormiskos often appears in images of athletics, education or music (Hatzivassiliou 2001, 116ff.; Kefalidou 2004, 29).[69]

Castanets are frequently associated with the symposion and komos, where they appear in the field or in the hands of a dancing woman.[70] They also feature in images of dancing in a ritual or festival context (Waite 2000, 131ff.).[71] On a white-ground alabastron in Athens[72] a veiled woman holding a mirror stands beside a kalathos; before her there are two women, one with castanets and the other with a flower, perhaps to indicate a wedding context. Castanets appear in a marriage procession on a fragmentary loutrophoros in Karlsruhe[73] and possibly the castanets on the Shefton kalathos are intended to evoke the wedding.[74]

Conclusions

The two groupings of women engaged in wool work and beautification represented on the kalathos appear to offer a synoptic narrative, presenting and conflating key moments in a woman's life: the preparation of the bride and a glimpse of her future role as a wife.[75] The scene is framed by two attendants, distinguished by action as well as dress (they wear the *peplos* not the *chiton*), hair and size (the woman with alabastron and plemochoe is characterised by her short hair and diminutive size). This combination of significant moments for a woman with her attendants is illustrated on the well-known pyxis in New York[76] where the bride is repeated four times in the same image; likewise on a pyxis in Athens,[77] where many of the gestures and attributes found on the Shefton kalathos recur.

Sabetai (2014, 52/55) suggests that whereas the loutrophoros pertains to the transition of the bride the lebes gamikos relates to the wife and oikos. As a grave good the loutrophoros references the missed ideal of marriage whereas the lebes gamikos celebrates the role of the wife within the household. The iconography of the kalathos offers both possibilities to the viewer.

The iconography of the Shefton kalathos, like that of the California kalathos and Agora fragments, suggests a role for the kalathos in the wedding. On a pyxis in Berlin,[78] gifts are brought to the bride; among them are wedding vases and a basket kalathos. As a wedding gift the form of the kalathos would be appropriate as it symbolized femininity and industry. As a model of an attribute so firmly associated with women the kalathos was brought to the grave as an offering[79] or monumentalised in stone as a grave marker.[80] In a secondary funerary context, the iconographic motifs would be equally relevant as we see from representations on grave stelai.[81] The kalathos and the mirror are combined repeatedly in images of wool work and beautification (Figs. 4.16 and 4.17); as attributes their significance is sometimes emphasised by their exaggerated size.[82] Feminine beauty, like skill at wool work, was an essential prerequisite for Athenian women. A lekanis lid in St Petersburg[83] offers an image of the idealised multi-tasking Athenian bride: she spins with distaff and kalathos whilst simultaneously looking in a mirror held by an attendant, an alabastron resting on the ground. The wedding context is confirmed by the presence of a lebes gamikos. Here the bride, actively engaged in wool work, serves as a reminder of her future role in the maintenance of the oikos (Oakley 1995, 72; Sabetai 1993, 128; Sgourou 1994, 107). These are normative images and reveal the values of their time, absorbed by the painters and reflected in the iconography. These images of women act as a means of constructing femininity and reinforcing appropriate gender roles central to the Athenian democracy (Waite 2000, 415ff.). It has been suggested that the proliferation of nuptial images is related to Perikles' citizenship law of 451/450 (Osborne 2004, 38ff.; Waite 2000, 433/434). This is the context in which the Shefton kalathos can be understood.

Athens in the Early Nineteenth Century: Lord Elgin's Artistic Mission

While a careful consideration of the iconography and function of the kalathos reveals much of its significance in fifth-century Athens; an examination of the post-excavation history adds to the current interest in reception and the history of collections.[84] The kalathos was first published by the Estonian Otto Magnus von Stackelberg in 1837 in *Die Gräber der Hellenen* (Fig. 4.18).[85] The drawings for the book were made during Stackelberg's travels to Greece between September 1810 and April 1814. Subsequently these were made into engravings in Rome between 1817 and 1820 (Stackelberg 1837, 26). By the time of publication the items included within it had been widely dispersed. Stackelberg's book includes, alongside the line drawing of the image,

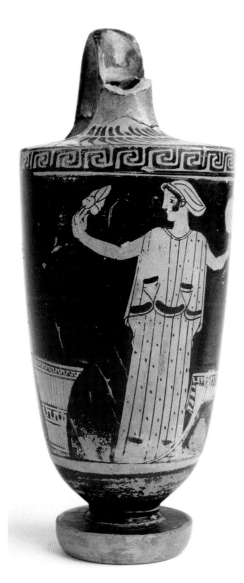

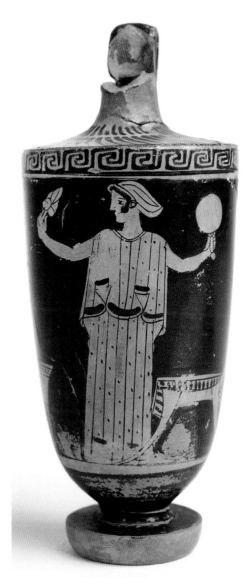

Figure 4.16: Attic red-figure lekythos, Newcastle upon Tyne, Shefton Collection 208. Photograph: Colin Davison.

Figure 4.17: Attic red-figure lekythos, Newcastle upon Tyne, Shefton Collection 208. Photograph: Colin Davison.

a drawing of the pot itself, demonstrating that at the time of publication the kalathos was complete. Now there are fragments missing and the pot has been broken at least twice.

Stackelberg (1837, 28) notes that the kalathos was in the collection of Giovanni Battista Lusieri and had been excavated on the Mouseion Hill in Athens. Lusieri, an Italian landscape painter of much note, had been employed by the 7th Earl of Elgin in 1799 to oversee his artistic mission to Greece.[86] Lusieri was to remain in Elgin's employment until 1819; he died two years

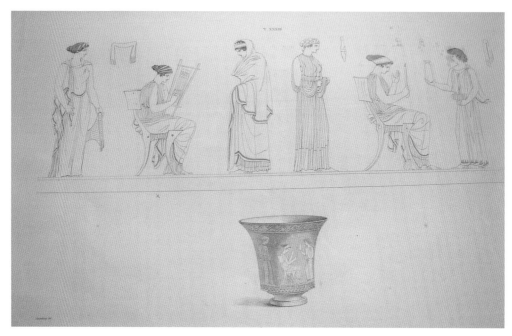

Figure 4.18: Drawing of kalathos, Newcastle upon Tyne, Shefton Collection 853. (After Stackelberg, O. M. von (1837) Die Graeber der Hellenen, plate 33.)

later, in 1821. All Lusieri's drawings and paintings, made in Athens, were to be the property of Elgin and likewise he collected antiquities solely on Elgin's behalf, unlike his rival Fauvel, the French agent, who had his own collection and dealt in antiquities (Bracken 1975, 61; St Clair 1998, 25). Lusieri arrived in Athens in August 1800. He was engaged to supervise the work of recording the ancient monuments on the Acropolis. Initially this project proceeded well, access having been granted, and the removal of sculptures sanctioned, by a firman from the Sublime Porte.[87] However Lusieri was increasingly hampered by the whim of the Turkish officials who, although generally appeased by bribery, were inevitably influenced by the changing political situation.[88] When work was suspended on the Acropolis, attention was turned to excavations elsewhere and a collection of vases began to be amassed for Elgin (Smith 1916, 258ff.).

Early in 1807 the Russo-English war with Turkey prompted Lusieri's decision to leave Athens with the finest of the vases, but before he could do so Ali Pasha ordered that all excavated antiquities in his possession were to be seized; Lusieri escaped empty-handed and fled to Malta and then Sicily, where he was to spend the next two years in exile (Bracken 1975, 43/44). Lusieri's correspondence with Elgin details that the vases, initially impounded inside his house in Athens, were later taken to Ali Pasha, whereupon the collection was apparently divided; some items were sent as a gift to Napoleon, whom they never apparently reached, and the remainder were presented later to William Leake[89] (Smith 1916, 266ff.).[90]

Lusieri returned to Athens in the August of 1809. The majority of the marbles were retrieved and shipped to Malta in 1810, but the vase collection was irretrievably lost. Such was the situation when Stackelberg arrived in Athens in September 1810. The vases Stackelberg was to draw from

Lusieri's collection were therefore found after 1810, when excavations had recommenced and a second collection of vases begun to be assembled. Stackelberg spent various periods in Athens over the next four years, using the city as a base for his wider travels. Lusieri was present in Athens throughout this time, save for a short visit to Malta between 22 April and 4 July 1811.[91]

Stackelberg travelled to Greece with four companions: two Germans, the architect Haller von Hallerstein and Linckh, a painter; and the Danish archaeologist Brøndsted, along with another Dane, Koës. In Athens at this time there was a community of European travellers and artists. They included Byron and his travelling companion Hobhouse[92] and the English architects Cockerell and Foster, who arrived in Athens in December 1810 and soon made the acquaintance of Stackelberg and his four friends (Clairmont 2007, 21; Goessler 1937, 69ff.).[93] These friendships were formalised by membership of a select society that included von Hallerstein,[94] Cockerell, Stackelberg, the two Danish scholars and Foster (Rodenwaldt 1957, 17). Lusieri, like Fauvel, clearly welcomed these visitors,[95] entertaining them and sharing his knowledge of Athens and its antiquities. Lusieri often acted as a guide to these foreign travellers, conducting walking tours of Athens.[96]

Whilst in Athens Stackelberg had ample opportunity to undertake his drawings for *Die Gräber der Hellenen* and there was no shortage of material, especially in the collections of Lusieri and Fauvel. Stackelberg (1837, 26) notes that some of the objects he drew had been excavated in his presence; for the rest, Lusieri and Fauvel had, through excavation over many years, acquired many grave goods; of these Stackelberg chose to draw the most noteworthy and most beautiful. His work was interrupted by his travels, bouts of illness and even kidnap by pirates. It seems that his work on *Die Gräber der Hellenen* was concentrated particularly in early 1813 and the beginning of 1814. Stackelberg's niece and biographer, Natalie von Stackelberg (1882, 231ff.), records that early in 1813 her uncle was in Athens busy with drawings of vases, grave stelai, terracottas and marble thrones[97] in the collections of Fauvel and Lusieri.

At the beginning of 1814, following the pirate episode, Stackelberg was again in Athens and returned to his work of drawing ancient monuments and of completing his collection of Athenian vase paintings and terracottas (Stackelberg 1882, 293/294). It was at this time that he must have seen and drawn the Shefton kalathos. Cockerell made drawings of the kalathos which are now amongst his papers in the British Museum; one is inscribed "vase found in Athens by Mr Lusieri February 1814"[98] (Fig. 4.19). It is possible Cockerell's drawings were copied directly from Stackelberg's rather than from his own direct observation of the pot.[99] Cockerell was in Athens for three protracted periods in 1811, 1813 and 1814. It seems he returned to Athens on 3 February 1814 from a tour of Albania in the company of the Reverend Hughes.[100] He returned to his old lodgings at Madame Masson's that he shared with Stackelberg and von Haller (Cockerell 1903, 224/252; Hutton 1909, 55ff.). Clearly both Stackelberg and Cockerell were in Athens in February 1814, when the kalathos was found. That they were lodging together, along with von Haller, surely explains Cockerell's interest in the piece. Stackelberg left Athens for good shortly afterwards in April 1814.

The Mouseion Hill

We know from Stackelberg that the kalathos was found on the Mouseion Hill, although frustratingly, but not surprisingly, he gives no specific details of its archaeological context. We do not therefore know the exact find-spot or grave assemblage. The Mouseion Hill, which according to Pausanias (1.25.8)[101] was so called because it was there that Mousaios sang and was buried,[102]

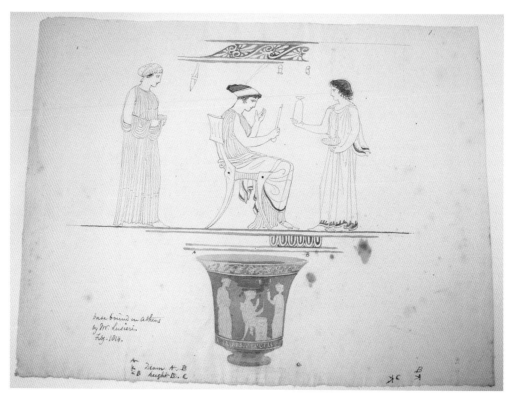

Figure 4.19: Drawing of kalathos, Newcastle upon Tyne, Shefton Collection 853, Cockerell Papers, British Museum. Photograph: Sally Waite.

lies to the southwest of the Acropolis. It is part of the same range as the Hill of the Nymphs and the Pnyx Hill which lie to its north. After the Acropolis it was the highest hill in ancient Athens. On the summit of the hill was the Monument of Philoppapos[103] constructed between AD 114 and 116.

The Mouseion Hill appears to have been popular with early nineteenth-century travellers, due no doubt to the view it afforded of the Parthenon as well as the remains of the Monument of Philoppapos. Stackelberg painted the view of the Acropolis from the Mouseion Hill soon after his arrival in Athens (Eliot 1968, pl. 43b.). Hobhouse who travelled to Athens, with Byron, in 1809 records a walk he took with Lusieri to the summit of the Mouseion Hill:

> Thence walked up the higher hill to the tomb of Phillippapus [*sic*], where all the statues want heads. From this spot, where the city in the flat below the Acropolis to the north is seen to advantage, and every point of view is taken in, Mr Lusieri intends taking two views, each of which is to have half of the tomb in it, so that the two pictures may be joined and represent the whole prospect.[104]

It seems that the Mouseion Hill was a favourite haunt of Lusieri. He finished one drawing of the Monument of Philoppapos in 1805 (Kleiner 1983, 34; Smith 1961, 26; William 2012, 183/206). This was the only completed drawing from Lusieri's time in Athens to reach the collection of Lord Elgin at Broomhall (Smith 1816, 292).[105]

Stackelberg includes another vase in *Die Gräber der Hellenen,* also excavated by Lusieri on the Mouseion Hill.[106] It is a red-figure squat lekythos, now in London (Fig. 4.20),[107] of a later date than the kalathos, *c.* 410–400 BC. It is attributed to the manner of the Meidias painter. Like the kalathos there is also a drawing of the squat lekythos in the Cockerell Papers, annotated "Vase in the collection of Lusieri. Found at the foot of the Museum."[108] This vase seems to have been found at least a year before the kalathos, as we also know of it from a reference in the journal of the Reverend Hughes (1820, 268/269)[109] where he relates a visit to Lusieri's house in late 1813, during which Lusieri showed him his paintings and collection of antiquities, adding that almost all the antiquities were excavated from tombs. Hughes goes on to describe one vase in the collection in some depth:

> amongst his antiquities I was particularly struck with an Attic vase of superlative beauty, which had been discovered in a very superb sepulchre: the figures portrayed upon this valuable relic are red upon a highly polished black-ground, the exquisite folds of drapery being delicately touched with black lines: the subject is Venus surrounded by nymphs in the most varied and graceful attitudes: Cupid in shape of a beautiful boy with large wings, is seated upon her shoulder.

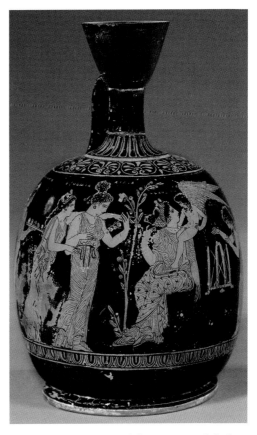

Figure 4.20: Attic red-figure squat lekythos, London, British Museum E697. © Trustees of the British Museum.

Hughes continues to list the inscriptions identifying the women as Aphrodite, Paidia, Eunomia and Kleopatra. The vase is easily identifiable from Hughes' description of the iconography and inscriptions as the British Museum squat lekythos.

Hughes' tantalising journal entry provides clear evidence for a tomb on the Mouseion Hill.[110] He (1920, 269) records that the squat lekythos was found by itself in a niche within the tomb and contained no deposit; unfortunately he makes no mention of any other contents of this tomb. Hughes (1920, 273) goes on to sketch another tomb, referred to as the Cenotaph of Euripides,[111] which lies at one end of the Mouseion Hill.[112] He also mentions the excavations of caves identified with the prison of Socrates and now generally assumed to be a house (Wycherley 1978, 46). There are few references to subsequent excavations on the Mouseion Hill. Homer Thompson and John Travlos excavated on the Mouseion Hill in the 1940s, but this small exploratory excavation was restricted to the area around the Monument of Philoppapos (Travlos 1971, 461). Petrakos (1987, 43) in his survey of excavations carried out by the Greek Archaeological service,

following its foundation in 1837, also refers to the excavation of graves at the back of the Pnyx and the Mouseion in 1860–1861 by Pervanoglou. The crest and front of the Mouseion Hill was certainly within the ancient circuit of the city;[113] should the kalathos have been excavated there, presumably from a tomb, it would be puzzling, as intramural burial was supposedly prohibited from the end of the sixth century until Roman times (Camp 2001, 198; Kleiner 1983, 16; Young 1951, 67ff.). The funerary Monument of Philopappos constructed between AD 114 and 116 was apparently one of the few graves allowed in the city, although by this time there was no clear boundary wall remaining on the Mouseion Hill (Camp 2001, 198; Kleiner 1983, 16; Travlos, 1971, 462). There certainly seem to have been exceptions to the ban on intramural burial in earlier periods as well.[114] It is perhaps more likely that the kalathos came from a tomb on the back of the Mouseion Hill.

Broomhall and the Black Gate Museum

As to how the kalathos eventually reached Broomhall from Athens, it seems likely that it was transported either in August 1817 on the *Tagus*[115] or in April 1818 on the *Satellite*.[116] Both ships sailed from Athens to Malta. It is unclear as to how the cargoes of these two ships were then transported onwards. At some point Lusieri had left two boxes and a case containing antiquities, including some vases, and drawings in Malta with the harbour master. After Lusieri's death in 1821 the boxes were sent to Hamilton in Naples aboard the *Cambrian*. An agreement between Lord Elgin and Lusieri's next of kin was engineered by Hamilton in 1824 and the drawing of the Monument of Philopappos, the gold myrtle wreath[117] from the so-called tomb of Aspasia and a few vases were transported on the *Eurylalus*, reaching London in 1825 (Smith 1916, 294). Perhaps it is not unreasonable to speculate that the kalathos was included in that shipment, irrespective of whether it had previously been amongst the *Satellite* or *Tagus* shipments.[118] The Athenian portion of Lusieri's estate, which consisted of drawings, was lost at sea in 1828.

What happened to the kalathos once it finally reached Broomhall is difficult to ascertain. At some point it was broken, although whether in Athens, in transit or at Broomhall is unclear. It seems that it was first broken into two main pieces (and a few smaller fragments) and at some point between 1825 and 1913 the two parts were separated, exactly when or why is unknown. By 1868 the present (11th) Earl of Elgin's great aunt had made small Indian ink drawings of the major items in the collection; a drawing of the kalathos, if it exists, would confirm that it arrived in one piece at Broomhall and was still there at that time.[119] The scholar Michaelis visited Broomhall to record the marbles in the early 1880s and comments that there were a small number of inconsequential painted vases. He lists a number of vases but the kalathos is not amongst them (Michaelis 1884, 143ff.). If it had still been whole at this time it would surely have been noteworthy.

By 1913 the two main pieces of the kalathos were definitely separated because a large portion of the vase is listed in a catalogue of 1913 by R. C. Clephan. This details Greek vases in the collection of the Society of Antiquaries of Newcastle upon Tyne kept in the Black Gate Museum:[120]

> The neck portion of a *krater* from Magna Graecia. Red figures on black ground, portraying a lady, with her embroidery frame; another in outdoor dress; and a third in her chiton; then, a group of two ladies, one, holding a wand, and the other an alabastron, a vase for precious ointment or perfumes.

From this we can deduce that Lord Elgin's piece incorporated the foot of the vase and the one remaining figure: the kalathos bearer. The next mention of the piece is by Sir John Beazley in a

1931 article in the *Journal of Hellenic Studies* where he mentions that part of the well-known kalathos published by Stackelberg was in the collection of the Earls of Elgin at Broomhall and the rest in the Black Gate Museum, Newcastle upon Tyne. How part of the kalathos came to be in the Black Gate Museum is something of a mystery.[121] At some point subsequent to 1913 the large Black Gate piece was broken into a number of fragments. The reconstructed kalathos consists of fourteen fragments and has three missing fragments.[122]

A Postscript on Reception

In the nineteenth and early twentieth centuries the iconography of the kalathos was well known and its impact is evident in unexpected contexts. The work of the French painter Ingres (1780–1867) shows the influence of Classical themes. He did numerous sketches of figures from Greek vases, often combining a number of figures from various vases onto a single sheet. One such collage of ten sketches on tracing paper or card includes the six women from the Shefton kalathos along the top, with the veiled figure and seated figure with sprang frame repeated in a small sketch on a separate piece of paper to the right.[123] Beneath these figures is a sketch of a woman holding a phiale that was used as a study for Ingres' 1856 painting *The Birth of the Last Muse* (Picard-Cajan 2004, 370). It is dated 1837–1840, and it is no coincidence that Stackelberg's book was published in 1837, since this is undoubtedly where Ingres took his inspiration from. Other sketches focus on vase shapes and the kalathos appears again on another collage: this shows the same view of it that was included in Stackelberg's publication (Fig. 4.21).[124] Ingres was acquainted with Stackelberg and sketched him with Linck[125] in Rome in 1817.[126] He also sketched Cockerell around this time.[127]

A further example of the reception of the kalathos comes from the Villa Kerylos, situated just outside Nice, which was built for the philhellene scholar Theodore Reinach in the early twentieth century (Fig. 4.22). It is decorated with wall paintings taken from Athenian vase paintings. A drawing by the architect of the Villa Kerylos, Pontremoli, is now in the Institut de France in Paris (Fig. 4.23). It includes the six women from the kalathos mixed up and interspersed in a collage of 12 figures in the centre. The three women on the right are completely reversed and the kalathos carrier moved in front of the seated woman holding the sprang frame; the two seated women now face each other and two figures have been added to give a far tighter composition. This collage is taken from three different publications and the eclectic grouping is indicative of different iconographic sources (Arnold 2003, 39; 2004, 279). It was in all likelihood copied from Daremberg and Saglio's dictionary (1896) which reproduced Stackelberg's drawing as figure 3684 (Fig. 4.11). Reinach had a copy of the dictionary in his library.

The drawing was never executed but the feminine nature of the scene would be considered suitable for a room belonging to Reinach's wife

Figure 4.21: Ingres, Montauban, Musée Ingres MIC 39117. Photograph: Andrew Parkin.

Figure 4.22: The Villa Kerylos, Nice. Photograph: Andrew Parkin.

Figure 4.23: Pontremoli's design for the peristyle of the Villa Kerylos, Nice. Photograph: Sally Waite, with kind permission from the Institut de France, Paris.

(Arnold 2003, 39). The paintings which decorate this room are adapted from a pyxis, now in London[128] which shows the adornment of the bride: an equally appropriate scene. Arnold (2004, 279–280) argues that the arrangement of the rectangular panel, in which the six women from the kalathos appear, separated by square panels on either side by doors, would be better suited to the peristyle courtyard.

This subsequent history of the kalathos, its rediscovery and diffusion in the nineteenth and early twentieth centuries when antiquarian interest redefined the status and appropriated the imagery of the vase, make it a fascinating story particularly appropriate for this volume celebrating Brian Shefton and his collection. Here we have a vase which has had an impact on the international stage far beyond Newcastle.

Notes

1 My biggest debt of gratitude is to Brian Shefton who many years ago suggested that the history of this piece would be interesting to investigate. His enthusiasm, encouragement and guidance were an inspiration to me and it was both a privilege and a pleasure to work with him. Much of my initial research was funded by an award from the Catherine Cookson Foundation. I would also like to acknowledge the help of the following: Judith Barringer, Sheramy Bundrick, Lucilla Burn, Maria Chidiroglou, Alicja Egbert, Laura Hall, Monica Hughes, Emma Jones, George Kavradias, Elizabeth Kramer, Elizabeth Langridge-Noti, François Lissarrague, Palma Mackenzie, Craig Mauzy, Lisa Nevett, John Oakley, Costas Papagiannakis, Andrew Parkin, Paulette Pelletier-Hornby, Diana Rodríguez Pérez, Susan Rotroff, Victoria Sabetai, Amy Smith, Tony Spawforth, Dyfri Williams, Angelos Zarkadas and the 11th Earl of Elgin.
2 *BAPD* 9115; height 15.2 cm; diameter at the mouth 17.2 cm. Publications listed on the Beazley archive to which add: Ferrari, G. (2002) *Figures of Speech: Men and Maidens in Ancient Greece.* Chicago (fig. 89); Keuls, E. (1983) Attic Vase-Painting and the Home Textile Industry in Moon, W. G. (ed.) *Ancient Greek Art and Iconography.* Madison (fig. 14.25).
3 Cambridge, Fitzwilliam Museum 4.19, *ARV²* 1068.19, *BAPD* 214391.
4 Paris, Petit Palais 318, *ARV²* 1068.20, *BAPD* 214392.
5 Charlecote Park, *ARV²* 1068.21, *BAPD* 214393. Cf. Class of London E195.
6 Coldstream *et al.* (2001, 57ff.) list Sub-Minoan and early Geometric examples from Knossos, these kalathoi have handles and are identified as containers for food and later are used as 'lids' for cremation pithoi.
7 For example: London, British Museum A950 – kalathos with mourning (?) female figures attached to the rim found in a tomb. Furumark (1941, 52) uses the term conical cup/bowl to refer to the kalathos.
8 Newcastle upon Tyne, Shefton Collection 672; height 11.2, diameter at the mouth 19.5 cm, 1000–900 BC. See Kübler (1954) for examples from the Kerameikos cemetery.
9 Athens, Agora Museum P 27641; P 1645; P 26029; P1646; P 26028; P 26026; P 27642.
10 London, British Museum GR 1877.12-7.14.
11 Athens, National Museum 18522.
12 Pemberton (1989, 19ff.) provides a list of kalathoi and kalathiskoi, including some cut-work examples, from the sanctuary of Demeter and Kore at Corinth where the vessel clearly had a cultic role. The shape occurs both with and without handles. Bookidis and Stroud (1987, 28) suggest the kalathos was copied in clay in a smaller size and left by visitors to the sanctuary as a symbolic gift. Dunbabin (1962, Volume II 87ff.) lists examples from the sanctuaries of Hera Akraia and Limenia at Perachora and suggests the wicker basket kalathos may have been used in cult, prompting imitations in clay as votive offerings.
13 For example: Oxford, Ashmolean Museum 1982.931, *BAPD* 525008.
14 Oakley (2009a, 66ff.) lists seven examples in black-figure and six in red-figure.

15 The Greek word kalathos means wool basket but may also refer to a cup and a psykter (Richter and Milne 1935, 14).

16 Munich, Antikensammlungen und Glyptothek 2416, *ARV²* 385.228, *BAPD* 204129.

17 Oakley (2009a, 68) suggests the foot relates the Munich kalathos to a bell krater. The presence of the foot on the Shefton kalathos is noteworthy in this context and Oakley (ibid.) also notes that the slanted palmette frieze is a common decorative motif on bell and calyx kraters. The kalathos does not usually have a foot (another exception is Copenhagen, National Museum 1633, *CVA* Denmark 2, pl. 82.1.).

18 Este, Museo Atestino (from Capodaglia tomb 5), *BAPD* 17619, Oakley (1996, pl. 9, 3), height 7.5 cm. I thank John Oakley for drawing my attention to this example provided by Constantine Ananiades. All seven of the black-figure examples seem to have served a similar purpose.

19 Athens, Agora P 18414a–e and P 18007, *ARV²* 501.1, Moore (1997, no 1223, pl. 115), estimated diameter 22 cm.

20 Athens, Agora P 16617a–e, *ARV²* 501.1, Moore (1997, no 1224, pl. 116), estimated diameter 25 cm.

21 For example: Athens, National Museum 474, *BAPD* 14432; Toledo, Museum of Art 67.134, *BAPD* 697; New York, Metropolitan Museum of Art 56.171.137, *BAPD* 15022.

22 For example: Copenhagen, National Museum 4735, *ARV²* 625.95, *BAPD* 207251; Munich, Antikensammlungen und Glyptothek 564, *ARV²* 806.93, *BAPD* 209974; Paris, Louvre L55, *ARV²* 924.33, *BAPD* 211247.

23 Mississippi, University 1977.3.91, Blundell (2004, fig. 3, 1–4).

24 National Museum 1629, *ARV²* 1250.34, *BAPD* 216971.

25 Boreas and Oreithyia is a popular motif on the hydria, a shape which often carries images seemingly intended for a female audience, but which may also have been used at the symposion.

26 Athens, National Museum 1586, *ARV²* 798.146, *BAPD* 209855; Chicago, University 92.125, *ARV²* 798.147, *BAPD* 209856.

27 Athens, Acropolis Museum, *ARV²* 506.26, *BAPD* 205688 and *ARV²* 689.260, *BAPD* 208218.

28 Athens, National Museum BΣ 58, *ARV²* 1177.2, *BAPD* 215607 – the lid is 23 cm in diameter.

29 Athens, Agora P 16617a–e, *ARV²* 501.1, Moore (1997, no 1224, pl. 116), estimated diameter 25 cm.

30 Berkeley, P. A. Hearst Museum of Anthropology 8.3342, *BAPD* 9088, Height 13.7 cm, diameter 18.1 cm.

31 It is unlikely these holes were used to fasten on a lid as on some pyxides (see Moignard in this volume).

32 Earlier examples of the form were certainly considered appropriate as a votive offering see n. 12. There is perhaps a connection with the unique unprovenanced red-figure fragmentary krateriskoi (Basel, Herbert A. Cahn HC 501, HC502, HC 503, *BAPD* 16476, 242458) connected with the Arkteia at Brauron.

33 Twenty-nine red-figure examples are listed on the Beazley archive. Brauron has yielded a number of examples which is not surprising given the association of the site with women and textiles.

34 It is shown in use, placed over the thigh and knee, on an epinetron in Athens (National Museum 2179, *BAPD* 865).

35 The iconography of some red-figure epinetra certainly supports an association with the wedding, one fragment (Copenhagen, National Museum 318, *BAPD* 10665) depicts the bride and groom in a chariot. Several fragments of epinetra were found in the Athenian Agora including one with a representation of a seated woman (bride?) beside what appears to be the marriage bed (P18283, *BAPD* 15250 see Moore 1997, 74ff.). See n. 66 for an epinetron depicting women at play, a motif also associated with marriage (Waite 2000, 103ff.) Other epinetra are more ambiguous: Badinou (2003) argues that women in the company of men represented on epinetra are hetairai. An epinetron in Berlin (Antikensammlung F2624, ARV² 1225.1, *BAPD* 216679) depicting a youth with a large purse (or in this case perhaps a pouch for knucklebones given its size) approaching a woman

with an alabastron could be interpreted either as the hiring of a prostitute or the courtship of a bride. Lewis (2002, 197) prefers the latter identification but the presence of a second youth argues against it. Likewise the man carrying a kalathos (with handle), full of wool, on the epinetron in Athens (National Museum 2179, *BAPD* 865) could equally represent a husband (see Sutton 2004, 336/337 on rare representations of the oikos). This ambiguity could of course be deliberate on the part of the painters to increase marketability. For votives, see n. 32 and Kousser (2004, 101), who argues for a link with the transition of girl to woman. A votive is unlikely to then end up in a funerary context.

36 National Museum 1629, *ARV²* 1250.34, *BAPD* 216.971.

37 The loutrophoros (in the wedding context) was used for the nuptial bath. The use of the lebes gamikos has been much discussed, it was perhaps used for the adornment of the bride (Sgourou 1994, 18ff.) or for serving food or drink (Sabetai 1994, 53ff.). Paired examples were found in two Opferrinnen of the later fifth century BC in the Kerameikos (Rutherford Roberts 1973, 435ff.). A pyxis in London (British Museum E774, *ARV²* 1250.32, *BAPD* 216969) representing the preparation of the bride depicts a loutrophoros and pair of lebetes gamikoi filled with decorative sprigs. A loutrophoros fragment in Athens, Agora Museum, P15139, *BAPD* 19701 shows a seated woman holding a loutrophoros filled with sprigs; see too Athens, National Museum 12540, *ARV²* 1256.11, *BAPD* 217053.

38 Dema House, Attika, Jones, J. E., Sackett, L. H. and Graham, A. J. (1962, 100/101. pl. 28a). The lebes gamikos dates to *c.* 430 BC some ten years prior to habitation. Olynthos, house Av7, 34.281,282, Robinson (1950 pl. 71–73). A pyxis fragment in Athens (National Museum 1190, *BAPD* 26161) shows the bride surrounded by bridal gifts including a pair of lebetes gamikoi.

39 The kalathos bearer is a common motif, often the basket is held aloft, for example: oinochoe, Winchester, College Museum GR89, *BAPD* 9027943; hydria, Budapest, Hungarian Museum of Fine Arts 50.154, *ARV²* 1077.3, *BAPD* 214481.

40 The wool (or distaff) may be visible within the kalathos. See, for example: white-ground pyxis, London, British Museum D12, *ARV²* 963.96, *BAPD* 213097; pyxis, Vienna Kunsthistorisches Museum 1863, *BAPD* 12069.

41 For a discussion of sprang frames see Clark (1983, 91ff. and 1984, 65); Jenkins and Williams (1985, 411ff.) provide a list to which Oakley (1990, 44 n. 311) lists five additions (although no. 3 = Jenkins and Williams no. 13). Hydria, Stanford, Stanford University 17.412, *Para* 393.56bis, *BAPD* 275754 can be added. See Bundrick (forthcoming) for an additional example on a hydria in Ferrara.

42 For example: kylix, Chicago, Art Institute 1889.27, *ARV²* 884.77, *BAPD* 211642; other examples also occur on drinking cups. More ambiguous are images including the sprang frame which occur on some hydriai: Stettin, Museum, *ARV²* 116.47, *BAPD* 214773; Heidelberg, Ruprecht-Karls-Universitat 64.5, *ARV²* 1121.14, *BAPD* 214832; Chicago, Art Institute 1911.456, *ARV²* 572.88, *BAPD* 206580 (see Bundrick 2008, 298/299 and 323/324 and Lewis 2002, 35).

43 A good example is the kylix in a private collection (Sutton 2003, fig. 17.6) which shows a woman collecting distaffs in a kalathos as the evening's entertainment begins.

44 Jenkins and Williams (1985, 416) argue that a pyxis in Paris (Louvre CA 587, *ARV²* 1094.104, *BAPD* 216046) offers us a glimpse into the andron. What we see here is surely the thalamos (nuptial chamber) and the seated woman, with frontal face, must be the bride; likewise on the pyxis in Vienna, Kunsthistorisches Museum 3719, *BAPD* 31334. See Bundrick (forthcoming).

45 Paris, Louvre L55, *ARV²* 924.33, *BAPD* 211247.

46 Pyxis, Athens, Kerameikos Museum – a woman, closely wrapped in a mantle, stands by the door and seems simply to have come in from outside. See also pyxis, Sydney, University Nicholson Museum 53.06, *ARV²* 939.32, *BAPD* 212642.

47 Kylix, Chicago, Art Institute 1889.27, *ARV²* 884.77, *BAPD* 211642. Note the sprang frame in the field and the phormiskos and castanets.

48 See Waite (2000, 78ff.) for discussion of 'spinning hetairai.' Ferrari (2002, 12ff.) dismisses the
 construct of the 'spinning hetaira' directly equating spinning with respectability as represented on
 vase paintings (*contra* Sutton 2004, 333ff.).
49 The veil appears in a sympotic context on a calyx krater fragment in Copenhagen (13365, *ARV²*
 185.32, *BAPD* 201684.
50 A lekythos in Syracuse, Museo Arch. Regionale Paolo Orsi 21186, *ARV²* 993.80, *BAPD* 213901
 depicts a woman holding her girdle standing beside Artemis. A small pyxis fragment from Brauron,
 A45, Kahil 1963, pl. 13,1, found in the shrine of Iphigenia, depicts a seated woman tying her girdle.
51 London, British Museum E719, *ARV²* 1560, *BAPD* 275017.
52 Kylix, London, British Museum E44, *ARV²* 318.2, *BAPD* 203219.
53 *Para* 479.44bis, *BAPD* 340045.
54 There is such a double-sided Attic mirror in the Shefton Collection inv. no. 108.
55 For example: stamnos, Munich Antikensammlungen J349, *ARV²* 1051.18, *BAPD* 213649.
 A similar hand gesture, combined with the mirror, is made by a seated woman on a hydria in
 Brussels, Musées Royaux A3090, *ARV²* 493.2, *BAPD* 205554; a woman with her mantle drawn
 over her head stands behind the seated woman.
56 For example: kylix, Goluchow, Czartorski 80, *ARV²* 821.6, *BAPD* 210166; kylix fragment, Adria,
 Museo Archeologico Nazionale 22303, *BAPD* 13934; lekythos, Boston, Museum of Fine Arts
 00340, *ARV²* 309.10, *BAPD* 203180.
57 Cabinet des Médailles 508, *BAPD* 21648.
58 For example: lebes gamikos, Berlin 2406, *ARV²* 1225.1, *BAPD* 216677 (with wrong description);
 a woman approaches the nuptial chamber carrying the alabastron (possibly containing oil used for
 lubrication). The bride is represented on the reverse. The alabastron appears above the marital bed
 in an image of Peleus and Thetis on a pointed amphora in New York (Levy Collection, Oakley and
 Sinos 1993, fig. 108).
59 Kylix, Christchurch AR430, *ARV²* 438.138, *BAPD* 205184; couch, door and alabastron initially
 suggest the nuptial chamber; yet the gestures of the figures indicate an intimacy usually seen in
 the sympotic context. Indeed the positioning of the image inside a drinking cup and the images on
 the exterior of the cup would seem to confirm such a reading.
60 The Shefton Collection plemochoe (inv. no. 204, see Figs. 3.1 and 3.2) is missing its lid.
61 For example: white-ground lekythoi: Newcastle upon Tyne, Shefton Collection 54, see Fig. 5.4
 and Oxford, Ashmolean Museum V545, *ARV²* 998.165, *BAPD* 213986.
62 For example: lebes gamikos, Newcastle upon Tyne, Shefton Collection 369, see Fig. 3.6.
63 There is much debate about the contents of the small pouch: see n. 48. Ferrari's (2002,14ff.)
 suggestion that the bag contains knucklebones rather than coins is problematical (see Neer 2009,
 213/214 for a direct iconographic connection between coinage and the small pouch). Equally
 questionable is Keuls (1985, 224/260) notion of the the hen-pecked husband offering the
 housekeeping money. For further discussion see von Reden 1995, 206ff.
64 Athens, National Museum 1441, *ARV²* 1032.56, *BAPD* 213439.
65 Morgantina 59.215, Neils (1992, fig. 1); see also Hatzivassiliou (2001); Kefalidou (2001 and
 2004). Nets and large pouches are also depicted containing knucklebones on painted pottery – see
 Kefalidou (2004).
66 Lekythos, Naples, Museo Archeologico Nazionale 3123, Hatzivassiliou (2001, fig. 2); pyxis,
 Vienna Kunsthistorisches Museum 1863, *BAPD* 12069; pyxis, New York, Metropolitan Museum
 of Art 06.1021.119, *BAPD* 4193; epinetron, Amsterdam, Allard Pierson Museum 2021, *ARV²*
 1251.35, *BAPD* 216972.
67 On the pyxis in Paris (Louvre, CA 587, *ARV²* 1094.104, *BAPD* 216046) a possible game of
 knucklebones is combined with the thalamos.
68 Hydria, Munich, Antikensammlungen 2427, *ARV²* 189.72, *BAPD* 201720. A phormiskos hangs
 in the field in an image which also appears to show the hiring of a prostitute: kylix, Chicago,

Art Institute 1889.27, *ARV²* 884.77, *BAPD* 211642. See Hatzivassiliou (2001, 119) on the erotic connotations of knucklebones.

69 Hydria, New York, Solow Art and Architecture Foundation, Reeder (1995, no. 45) – here the phormiskos hangs beside a door in an image of women playing instruments (see Hatzivassiliou 2001, 122); London, British Museum E461, *ARV²* 601.20, *BAPD* 206951 and E190, *ARV²* 611.36, *BAPD* 207083. See Waite (2000, 94ff.) for a discussion of the status of women in such scenes. Phormiskos and castanets are combined on a hydria in Copenhagen, National Museum 1942, *ARV²* 1020.88, *BAPD* 214268 which represents a naked dancer.

70 For example: kylikes, London, British Museum 95.5-13.1, *ARV²* 405.1, *BAPD* 204396 and New York, Metropolitan Museum of Art 20.246, *ARV²* 467.118, *BAPD* 204800 (see Waite 2000, 134/135). Castanets also hang in the field in a courtship image which appears to show the hiring of prostitutes: kylix, Chicago, Art Institute 1889.27, *ARV²* 884.77, *BAPD* 211642.

71 For example: pelike, London, British Museum E357, *ARV²* 555.94, *BAPD* 206337. They are particularly associated with female rituals such as the Adonia: London, British Museum E241, *ARV²* 1482.1, *BAPD* 230493 see Castaldo (2009, 290).

72 National Museum 16457, *ARV²* 72616, *BAPD* 208932.

73 Badisches Landesmuseum 69.78, *ARV²* 1102.2, *BAPD* 216155.

74 Castanets appear in the field on the hydria in Cambridge (Fitzwilliam Museum 4.19, *ARV²* 1068.19, *BAPD* 214391) attributed to the Barclay painter, where gestures and attributes likewise point to a nuptial (rather than sympotic) significance and on a hydria in St Petersburg (State Hermitage Museum 4525, *ARV²* 1094.99, *BAPD* 216041) depicting three women with alabastron, kalathos and flower.

75 Bundrick (2008, 322 n.151) suggests that a woman, veiled with a stephane, standing on the periphery on a hydria in New York (Metropolitan Museum of Art 17.230.15, *ARV²* 1104.16, *BAPD* 216183) could represent the bride as household supervisor. Saripanidi (2008, 315) suggests the seated spinner in the same scene alludes to the bride's future role and that the reference to beautification perhaps alludes to the requirement for procreation. The latter perhaps explains the baby boy associated with the bride in some images for example: lebes gamikos, Antikensammlungen und Glyptothek 7578, *ARV²* 1126.3, *BAPD* 214883 which Sabetai (1993, 49/56) sees as conflating the bride and mother, the context of the wedding referencing the purpose of marriage (see Waite 2000, 91/92). Such a reading is dependent on an association of the kalathos with the wife *contra* Ferrari (2002, 57ff.) who identifies the kalathos with the parthenos. Cf. Bundrick (forthcoming) for discussion of a hydria in Ferrara which includes gestures and attributes found on the Shefton kalathos. Bundrick identifies the sprang frame with the parthenos.

76 Metropolitan Museum of Art 1972.118.148, *BAPD* 44750.

77 Ephorate A 1877, *ARV²* 1263.84bis, Lezzi-Hafter (1988, pl. 166/167).

78 Berlin, Antikensammlungen 3373, *BAPD* 430. See too the loutrophoros in Brussels (Musées Royaux A1684, *CVA* Belgium 2, pl. 9, 5). Nike is also represented carrying a kalathos on images of the epaulia (gift giving) represented on lebetes gamikoi, for example: Paris, Louvre MNE 965 and 966, Kauffmann-Samaras (2001, pl. 1).

79 White-ground lekythoi, Vienna, Kunsthistorisches Museum 3746, *ARV²* 998.164, *BAPD* 213987 and Amiens, Musée de Picardie 3057.172.33, *ARV²* 1000.200, *BAPD* 214022. An Apulian pseudo-Panathenaic amphora of the late fourth century BC in Reading (Ure Museum REDMG 1951.159.1) depicts two women within a naiskos flanked on either side by a large kalathos.

80 Athens, National Museum 1052, Lissarrague (1995, fig. 7); surprisingly references to wool working on Attic grave stelai are not very common; Stears (2001, 109 n. 11) lists just ten examples and draws attention to the complexity of interpretation.

81 Beautification, defined by mirror or casket, is not uncommon as a motif on grave stelai, for example: grave stelai of Pausimache and Hegeso, Athens, National Museum 3964 and 3624.

82 For example: Cambridge, Fitzwilliam Museum 1.22, *ARV²* 501, *BAPD* 205628; kylix, Rome, Villa Giulia 25006, *ARV²* 819.35, *BAPD* 210139. On the exaggerated size of attributes see also Rodríguez Pérez this volume.

83 State Hermitage Museum ST1983, *ARV²* 1499.2, *BAPD* 230842.

84 Oakley (2009, 617ff.) and Isler-Kerényi (2009, 16 n. 34) in their respective surveys on the current state of vase-painting studies both point to the value of research on reception and the history of collections. See Nørskov (2002) and Cabrera, P. *et al.* (2004).

85 Plate 33.

86 Hamilton (1811, 4) Lord Elgin's private secretary, notes that Elgin 'was so fortunate as to prevail on Don Tita Lusieri, one of the best general painters in Europe, of great knowledge in the arts, infinite taste and most scrupulously exact in copying any subject he is to represent, to undertake the execution of this plan.' Weston-Lewis (2012, 24) reproduces the contract listing the terms of employment. See Gallo (2009, 18ff.) for discussion of the purpose of the artistic programme and instructions to the artists.

87 The English were in favour at this time due to the French war in Egypt and this favour seems to have initiated a shift from measuring and drawing the monuments to removing the sculptures (Weston-Lewis 2012, 25/26).

88 By 1803 the balance of power was shifting at Constantinople and the French were increasingly in favour. Elgin himself was imprisoned, by Napoleon, in France 1803–1806 (Bracken 1975, 42).

89 Leake (1777–1860) was a member of the 1799 military mission to Turkey before serving in Greece.

90 Lusieri wrote to Elgin (16 August 1808) that part of the vase collection was stolen by Turks who were selling it secretly in Athens.

91 Lusieri sailed aboard the *Hydria*, accompanying five cases of marbles that had remained intact throughout his exile. Ironically he travelled with Byron, a fierce critic of Elgin's mission (Bracken 1975, 45; Larrabee 1941, 618f.; Smith 1916 281ff.). Byron referred to Lusieri as 'the able instrument of plunder' in a footnote to the second canto of his poem 'Childe Harold'.

92 They arrived in Athens in December 1809.

93 von Hallerstein, Cockerell, Foster and Linckh were responsible for the discovery of the pedimental sculptures from the Temple of Aphaia on Aegina and the discovery of the Temple of Apollo at Bassae.

94 von Hallerstein had a particularly close friendship with his fellow architect Cockerell and fellow aristocrat Stackelberg. Hughes (1820, 251) notes that during Cockerell's illness Stackelberg and von Hallerstein devoted themselves to his recovery.

95 Hamilton's note of introduction for Cockerell to Lusieri is recorded on the back of a sketch of the Elgin Museum at Park Lane made by Cockerell (Smith 1916, 298).

96 Hobhouse's journal entry for Tuesday 28 December 1809 refers to one such walk and Hughes (1820, 256) records a tour of the Acropolis on 4 November 1813: 'it was no slight augmentation of our pleasure to visit the Cecropian rock with so intelligent a guide.'

97 Mention of the marble thrones is interesting; a marble throne, with a Tyrannicides motif, was drawn by Stackelberg seemingly when he first arrived in Athens in 1810 and was published in *Die Gräber der Hellenen* (1837, 33). Stackelberg (ibid.) comments that he drew the throne *in situ*. By 1811 the throne had been acquired by Lusieri on behalf of Elgin, unbeknown to Stackelberg. Hamilton (1811, 32) relates that permission was obtained from the Archbishop of Athens to allow Elgin to look in the interior of churches and convents in Athens and 'to carry away several curious fragments of Antiquity' including the Tyrannicides throne. This throne left Athens, aboard the *Satellite*, eventually reaching Broomhall where it remained until sold to The Getty Museum by the present Earl of Elgin. The Archbishop also presented Elgin's parents-in-law with a marble throne now at Biel in Scotland (Bracken 1975, 54). Both thrones are discussed by Seltman (1947, 22ff.). Michaelis (1884, 147) lists the throne in his supplement to *Ancient Marbles in Great Britain* noting that Stackelberg had wrongly restored Harmodios' right arm.

98 I am indebted to Dyfri Williams for bringing Cockerell's drawings to my attention and seemingly confirming a date for the excavation of the kalathos. Stackelberg himself never recorded a date. I am assuming that the date refers to the find although it is possible that the date refers to a drawing made later. Lusieri received a letter from Elgin at the end of 1813 requesting that he cease excavations and Lusieri wrote at intervals during 1814 reporting that excavations were suspended (Smith 1916, 285).

99 Rodcrick Williams (1961, 28) makes interesting comparisons between the kalathos and Stackelberg's drawing but it is instructive to compare Stackelberg's drawings with Cockerell's. In the first drawing Cockerell illustrates the shape of the kalathos, exactly as in Stackelberg's drawing, indeed showing the same three figures. Cockerell's second drawing shows the remaining three figures separated from their context. Certain details suggest Cockerell may have been using Stackelberg's drawing as a model; for example the knob of the plemochoe lid is mistakenly transformed into the line of drapery. Stackelberg's drawing is certainly closer to the kalathos apart from the details of the ornament.

100 The Reverend Thomas Smart Hughes toured Europe between 1812 and 1814 as tutor to R. Townley Parker.

101 "The Mouseion is a small hill, opposite the Acropolis, inside the ancient ring wall, where they say Mousaios used to sing and died and was buried; later a memorial was erected there for a Syrian."

102 The hill is also referred to as the Hill of the Muses and the Museum and now Filopappou.

103 Pausanias' memorial for 'a Syrian' (C. Iulius Antiochus Epiphanes Philopappus, *cos. suff.* AD 109).

104 Cochran, P. extract from Hobhouse's diary for 28 December 1809. See Williams (2012, 183, n. 57/ 206).

105 An oil painting of the monument of Philoppapos was recently acquired by the National Gallery of Scotland. It is almost identical to Lusieri's completed watercolour and appears to have been created using a tracing (Weston-Lewis 2012, 31; Williams 2012, 208). It was probably completed between 1805–1807 or 1809–1811. Unfortunately its provenance before the 1930s is unknown. Financial difficulties seem to have prompted Lusieri to part with works against the terms of his contract although he retained the right to make copies for his own use (Weston-Lewis 2012, 28/31; Williams 2012, 186/208). See Williams (1982, 492ff.) for a discussion of Lusieri's surviving paintings.

106 Plate 29.

107 British Museum, E697, *ARV²* 1324.45, *BAPD* 220599; Burn (1987, pl. 20).

108 Again I am grateful to Dyfri Williams for bringing the Cockerell drawing to my attention.

109 See n. 94.

110 Whether it was found at the foot of the hill on the side of the hill facing the city or to the back of the hill is not clear and determines whether or not it was within the city walls.

111 Hamilton (1811, 29) also refers to the tumulus of Euripides.

112 Hughes writes that this tomb faces the port of Phalerum. This suggests that it is on the far side of the Mouseion Hill and therefore outside the city walls. In a letter of 1805 Lusieri refers to successful excavations beyond the Mouseion Hill (Smith 1916, 261).

113 See Theocharakri (2011, 71ff.) for detailed discussion of the course and construction of the circuit wall.

114 Houby-Nielsen (2000) provides maps showing the distribution of child and adult burials in Athens and there are a small number of graves within the city walls in the fifth century, although none are mapped on the Mouseion Hill.

115 The *Tagus*' cargo included three cases of vases (610 in total) and two fragments of grave stelai (Smith 1916, 286–293).

116 The *Satellite* carried one case of vases (bronze and clay) and the marble Tyrannicides throne (Smith 1916, 294).

117 The excavation of the 'tomb of Aspasia', situated on the way to the Piraeus, is described by
 Lusieri in a letter to Elgin of 18 May 1804 (Smith 1916, 258). Hamilton (1811, 30–31) also
 describes the opening of this tomb. See Smith (1926, 255–256) and Williams (2012, 201) for
 discussion of this wreath (or spray) of myrtle.
118 I am assuming from the shipping records that the cargoes from the *Tagus* and *Satellite* were
 transported from Malta on the *Cambrian* and then the *Euryalus,* although St Clair (1998, 258)
 suggests that the consignment of 610 vases had arrived with Elgin sometime before 1819. The
 present Earl of Elgin informed me that a shipload of marble funerary stelai finally made its way
 to Broomhall around 1823, although he is unsure whether the vases were in this consignment.
119 Unfortunately I was unable to see these drawings when I visited Broomhall as Lord Elgin could
 not locate them.
120 Item 24 – wrongly identified as belonging to a krater.
121 There appears to be no reference to it in the Society of Antiquaries' donation book or in Robert
 Blair's notebooks.
122 Brian Shefton and I visited Broomhall to search through a box of fragments in the hope that
 the missing kalathos fragments would be there. It does not seem impossible that more vases or
 fragments may turn up at Broomhall: the present Earl of Elgin related finding some vases in
 a wardrobe that had not been opened for some time. The missing fragments are perhaps more
 likely to have disappeared at the Black Gate when the vase was broken for a second time; but
 attempts to trace them there have also turned up nothing and the building has now been emptied
 for refurbishment.
123 Montauban, Musée Ingres MIC 39 9 D, Cabrera 2006, catalogue no. 147.
124 Montauban, Musée Ingres MIC 39117.
125 The German painter Linck had also been with Stackelberg in Greece.
126 Vevey, Musée des Beaux Arts A437.
127 Oxford, Ashmolean WA 1998.179.
128 British Museum E774, *ARV²* 1250.32, *BAPD* 216969.

Bibliography

Arnold, A. (2003) Villa Kérylos: Das Wohnhaus als Antikenrekonstruktion. Munich.
Arnold, A. (2004) Un "museo" de imágines de vasos griegos: La Villa Kérylos en Beaulieu-Sur-Mer y su
 decoración interior. In Cabrera, P. *et al.* (eds.) *El vaso griego y sus destinos,* 275–284. Madrid.
Badinou, P. (2003) *La laine et le parfum. Épinetra et alabastres. Form, iconographie et fonction.* Leuven.
Bazant, J. (1984) *Les citoyens sur les vases athéniens du 6e au 4e Siècle Av J-C.* Prague.
Beazley, J. D. (1928) *Greek Vases in Poland.* Oxford.
Beazley, J. D. (1931) Disjecta Membra. *Journal of Hellenic Studies*, 39–56.
Bérard, C. (1989) The Order of Women. In Bérard, C. *et al.* (eds.) *A City of Images. Iconography and
 Society in Ancient Greece,* 88–107. Princeton.
Blundell, S. (2004) Scenes from a Marriage: Viewing the Imagery on a Lebes Gamikos. In Keay, S. and
 Moser, S. (eds.) *Greek Art in View. Studies in Honour of Brian Sparkes,* 39–53. Oxford.
Bookidis, N. and Stroud, R. S. (1987) *Demeter and Persephone in Ancient Corinth.* Princeton.
von Bothmer, D. (1998) La villa grecque Kérylos, domaine d'un collectionneur. *Comptes rendus des
 séances de l'Académie des inscriptions et belles-lettres (Paris),* 527–553.
Bracken, C. P. (1975) *Antiquities Acquired. The Spoliation of Greece.* London.
Bundrick, S. D. (2008) The Fabric of the City: Imaging Textile Production in Classical Athens. *Hesperia*
 77, 283–334.
Bundrick, S. D. (Forthcoming) Reconsidering Hand Looms on Athenian Vases. In Stansbury-O'Donnell,
 M. *et al.* (eds.) *Selected Papers in Ancient Art and Architecture Volume Two.*

Burn, L. (1987) *The Meidias Painter.* Oxford.

Cabrera, P. *et al.* (eds.) (2006) *El vaso griego y sus destinos.* Madrid.

Camp, J. M. (2001) *The Archaeology of Athens.* New Haven.

Camp, J. M. (2013) *In Search of Greece. Catalogue of an Exhibit of Drawings at the British Museum by Edward Dodwell and Simone Pomardi.* The Packard Humanities Institute, Los Altos.

Castaldo, D. (2009) "The Sound of *Krotala* Maddening Women": *Krotala* and Percussion Instruments in Ancient Attic Pottery. In Yatromanolakis, D. (ed.) *An Archaeology of Representations*, 282–297. Athens.

Catling, H. W. and Boardman, J. (1961) Recent Acquisitions by the Ashmolean Museum, Oxford. *Archaeological Reports* 7, 54–59.

Clairmont, C. W. (1993) *Classical Attic Tombstones.* Kilchberg.

Clairmont, C. W. (2007) *Fauvel.* Zürich.

Clark, L. (1983) Notes on Small Textile Frames Pictured on Greek Vases. *American Journal of Archaeology* 87, 91–96.

Clark, L. (1984) Small Textile Frames: An Addendum. *American Journal of Archaeology* 88, 65.

Clephan, R. C. (1913) *Catalogue of the Greek Pottery in the Collection of the Society of Antiquaries of Newcastle, in the Blackgate Museum, Newcastle-upon-Tyne.* Newcastle.

Cochran, P. (ed.) *Hobby-O. The Diary of John Cam Hobhouse.* http://petercochran.wordpress.com/hobbhouses-diary/

Cockerell, S. P. (ed.) (1903) *C. R. Cockerell Travels in Southern Europe and the Levant 1810–17.* London.

Coldstream, J. N. (1995) The Rich Lady of the Areiopagos and her Contemporaries: A Tribute in Memory of Evelyn Lord Smithson. *Hesperia* 64, 391–403.

Coldstream, J. N. *et al.* (2001) *Knossos Pottery Handbook. Greek and Roman.* British School at Athens Studies 7. London.

Connor, P. J. (1973) A Late Geometric Kalathos in Melbourne. *Archäologischer Anzeiger*, 58–67.

Daremberg, C. V. and Saglio E. (1873–1919) *Dictionnaire des antiquités grecques et romaines.* Paris.

Desborough, V. R. d'A (1952) *Protogeometric Pottery.* Oxford.

Dunbabin, T. J. (1962) *Perachora. The Sanctuaries of Hera Akraia and Limenia II.* Oxford.

Eliot, C. W. J. (1968) Gennadeion Notes III. Athens in the Time of Lord Byron. *Hesperia* 37, 134–158.

Ferrari, G. (2002) *Figures of Speech. Men and Maidens in Ancient Greece.* Chicago.

Frel, J. (1976) Some Notes on the Elgin Throne. *Mitteilungen des Deutschen Archäologischen Instituts, Athenische Abteilung* 91, 185–188.

Furumark, A. (1941) *The Mycenaean Pottery. Analysis and Classification.* Stockholm.

Gallo, L. (2009) *Lord Elgin and Ancient Greek Architecture.* Cambridge.

Goessler, P. (1937) Nordische Gäste in Athen um 1810. *Archaiologike Ephemeris* 8, 69–82.

Hamilton, W. R. (1811) *Memorandum on the Subject of the Earl of Elgin's Pursuits in Greece.* London.

Haspels, C. H. E. (1954) A Fragmentary Onos in the Allard Pierson Museum. *Overdruk uit het Bulletin van de Vereeniging tot Bevordering der Kennis van de Antieke Beschaving* 29, 3–8.

Hatzivassiliou, E. (2001) The Attic Phormiskos: Problems of Origin and Function. *Bulletin of the Institute of Classical Studies* 45, 113–148.

Houby-Nielsen, S. (2000) Child Burials in Ancient Athens. In Sofaer Derevenski, J. (ed.) *Children and Material Culture,* 151–166. London.

Hughes, T. S. (1820) *Travels in Sicily Greece and Albania.* London.

Hutton, C. A. (1909) A Collection of Sketches by C. R. Cockerell R. A. *Journal of Hellenic Studies* 29, 53–59.

Isler-Kerényi, C. (2009) The Study of Figured Pottery Today. In Nørskov, V. *et al.* (eds.) *The World of Greek Vases*, 13–21. Rome.

Jenkins, I. and Williams, D. (1985) Sprang Hair Nets: Their Manufacture and Use in Ancient Greece. *American Journal of Archaeology* 89, 411–418.

Jones, J. E., Sackett, L. H. and Graham, A. J. (1962) The Dema House in Attica. *Annual of the British School at Athens* 57, 75–114.

Judeich, W. (1931) *Topographie von Athen.* Munich.

Kahil, L. (1963) Quelques vases du sanctuaire d'artémis a Brauron. *Antike Kunst, Beiheft 1.*

Kauffmann-Samaras, A. (2001) Deux vases de mariage du Ve siècle av. J.-C. *Revue du Louvre*, 33–44.

Kefalidou, E. (2001) Late Archaic Polychrome Pottery from Aiani. *Hesperia* 70, 183–219.

Kefalidou, E. (2004) On Phormiskoi Again. *Bulletin of the Institute of Classical Studies* 47, 23–44.

Kleiner, D. E .E. (1983) The Monument of Philopappos in Athens. *Archaeologica* 30. Rome.

Keuls, E. C. (1985) *The Reign of the Phallus.* Berkeley and Los Angeles.

Knigge, U. (1991) *The Athenian Kerameikos. History – Monuments – Excavations.* Athens.

Kousser, R. (2004) The World of Aphrodite in the Late Fifth Century BC. In Marconi, C. (ed.) *Greek Vases. Images, Contexts and Controversies,* 97–112. Leiden.

Kübler, K. (1954) *Kerameikos. Die Nekropole des 10. Bis 8. Jahrhunderts.* Berlin.

Lamb, W. (1930) *Corpus Vasorum Antiquorum. Great Britain Fascicule 6, Cambridge Fascicule 1.* Oxford.

Langdon, S. (2005) Views of Wealth, a Wealth of Views: Grave Goods in Iron Age Attica. In Lyons, D. and Westbrook, R. (eds.) *Women and Property in Ancient Near Eastern and Mediterranean Societies,* 1–27. Center for Hellenic Studies, Harvard.

Larrabee, S. A. (1941) Byron's Return from Greece. *Modern Language Notes* 56, 618–619.

Leclant, J. *et al.* (2001) *The Villa Kérylos.* Paris.

Lewis, S. (2002) *The Athenian Woman. An Iconographic Handbook.* London.

Lezzi-Hafter, A. (1988) *Der Eretria Maler.* Mainz.

Llewellyn-Jones, L. (2003) *Aphrodite's Tortoise. The Veiled Woman of Ancient Greece.* Cardiff.

Lissarrague, F. (1995) Women, Boxes, Containers: Some Signs and Metaphors. In Reeder, E. D. (ed.) *Pandora. Women in Classical Greece,* 91–101. Princeton.

Liston, M. A. and Papadopoulos, J. K. (2004) The "Rich Athenian Lady" was Pregnant: The Anthropology of a Geometric Tomb Reconsidered. *Hesperia* 73, 7–38.

Michaelis, A. (1884) Ancient Marbles in Great Britain. Supplement 1. *Journal of Hellenic Studies* 5, 143–161.

Moore, M. B. (1997) *The Athenian Agora Volume XXX, Attic Red-Figured and White-Ground Pottery.* Princeton.

Neer, R. T. (2009) The Incontinence of Civic Authority: Pictorial Iambos in Athenian Vase-Painting. In Nørskov, V. *et al.* (eds.) *The World of Greek Vases*, 205–218. Rome.

Neils, J. (1992) The Morgantina Phormiskos. *American Journal of Archaeology* 96, 225–235.

Neils, J. and Oakley, J. H. (2003) *Coming of Age in Ancient Greece.* New Haven.

Nevett, L. C. (1999) *House and Society in the Ancient Greek World.* Cambridge.

Nørskov, V. (2002) *Greek Vases in New Contexts: The Collecting and Trading of Greek Vases. An Aspect of the Modern Reception of Antiquity.* Aarhus.

Oakley, J. H. (1990) *The Phiale Painter.* Mainz.

Oakley, J. H. (1995) Nuptial Nuances: Wedding Images in Non-Wedding Scenes of Myth. In Reeder, E. D. (ed.) *Pandora. Women in Classical Greece,* 63–73. Princeton.

Oakley, J. H. (2004) *Picturing Death in Classical Athens. The Evidence of the White Lekythoi.* New York.

Oakley, J. H. (2009a) Attic Red-Figured Beakers: Special Vases for the Thracian Market. *Antike Kunst* 52, 66–74.

Oakley, J. H. (2009b) Greek Vase Painting. *American Journal of Archaeology* 113, 599–627.

Oakley, J. H. and Sinos, R. (1993) *The Wedding in Ancient Athens.* Madison.

Pemberton, E. G. (1989) *Corinth XVIII part 1. The Sanctuary of Demeter and Kore. The Greek Pottery.* Princeton.

Petrakos, B. X. (1987) Η ην Αθηναις Αρχαιολογικη Εταιρεια. Athens.

Picard-Cajan, P. (2004) El vaso griego en el imaginario de Ingres in Cabrera, P. *et al.* (eds.) *El vaso griego y sus destinos,* 275–284. Madrid.

Picard-Cajan, P. (ed.) (2006) *Ingres et l'Antique.* Montauban.

Plaoutine, N. (1941) *Corpus Vasorum Antiquorum. France Fascicule 15, Palais des Beaux-Arts.* Paris.

von Reden, S. (1995) *Exchange in Ancient Greece.* London.

Reeder, E. D. (ed.) (1995) *Pandora. Women in Classical Greece.* Princeton.

Reilly, J. (1989) Many Brides: 'Mistress and Maid' on Athenian Lekythoi. *Hesperia* 58, 411–444.

Richter, G. M. A. (1905) The Distribution of Attic Vases. *The Annual of the British School at Athens* 11, 224–242.

Richter, G. M. A. and Milne, M. J. (1935) *Shapes and Names of Athenian Vases.* New York.

Robinson, D. M. (1933) *Excavations at Olynthus. Volume V, Mosaics, Vases, and Lamps of Olynthus found in 1928 and 1931.* Baltimore.

Robinson, D. M. (1950) *Excavations at Olynthus, Volume XIII, Vases found in 1934 and 1938.* Baltimore.

Rodenwaldt, G. (1957) *Otto Magnus von Stackelberg. Der Entdecker der Griechischen Landschaft 1786–1837.* Munich.

Rutherford Roberts, S. (1973) Evidence for a Pattern in Attic Pottery Production ca. 430–350 B.C. *American Journal of Archaeology 77,* 435–437.

Sabetai, V. (1993) *The Washing Painter: A Contribution to the Wedding and Genre Iconography.* Unpublished PhD thesis, University of Cincinnati.

Sabetai, V. (1997) Aspects of Nuptial and Genre Imagery in Fifth-Century Athens: Issues of Interpretation and Methodology. In Oakley, J. H. *et al.* (eds.) *Athenian Potters and Painters,* 319–335.

Sabetai, V. (2008) Birth, Childhood and Marriage. Women's Ritual Roles in the Cycle of Life. In Kaltsas, N. and Shapiro, A. (eds.) *Worshiping Women. Ritual and Reality in Classical Athens,* 289–297. New York.

Sabetai, V. (2009) Marker Vase or Burnt Offering? The Clay Loutrophoros in Context. In Tsingarida, A. (ed.) *Shapes and Uses of Greek Vases (7th–4th Centuries B.C.),* 291–306. Brussels.

Sabetai, V. (2014) The Wedding Vases of the Athenians: A View from Sanctuaries and Houses. *Mètis,* N. S. 12, 51–75.

Saripanidi, V. (2008) Red-Figure Hydria, New York, Metropolitan Museum of Art 17.230.15. In Kaltsas, N. and Shapiro, A. (eds.) *Worshiping Women. Ritual and Reality in Classical Athens,* 314–315. New York.

Seltman, C. (1947) Two Athenian Marble Thrones. *Journal of Hellenic Studies* 67, 22–30.

Sgourou, M. (1994) *Attic Lebetes Gamikoi.* Unpublished PhD thesis, University of Cincinnati.

Shefton, B. B. (1960) Some Iconographic Remarks on the Tyrannicides. *American Journal of Archaeology* 64, 173–179.

Shefton, B. B. (1970) The Greek Museum, University of Newcastle upon Tyne. *Archaeological Reports,* 16, 52–62.

Smith, A. C. (2005) The Politics of Weddings at Athens: An Iconographic Assessment. *Leeds International Classical Studies* 4.01, 1–32.

Smith, A. H. (1916) Lord Elgin and his Collection. *Journal of Hellenic Studies* 36, 163–372.

Smith, A. H. (1926) The Tomb of Aspasia. *Journal of Hellenic Studies* 46, 253–257.

Smith, H. R. W. (1936) *Corpus Vasorum Antiquorum. USA Fascicule 5, University of California Fascicule 1.* Cambridge, Massachusetts.

Smithson, E. L. (1968) The Tomb of a Rich Athenian Lady. *Hesperia* 37, 77–116.

Spirito, F. (2003) *Lusieri.* Naples.

von Stackelberg, N. (1882) *Otto Magnus von Stackelberg. Schilderung seines Lebens und seiner Reisen in Italien und Griechenland.* Heidelberg.

von Stackelberg, O. M. (1837) *Die Graeber der Hellenen.* Berlin.

St. Clair, W. (1998/1967) *Lord Elgin and the Marbles.* Oxford.

Stears, K. (2001) Spinning Women: Iconography and Status in Athenian Funerary Sculpture. In Hoffmann (ed.) *Les pierres de l'offrande autour de l'oeuvre de Christoph W. Clairmont,* 107–114. Zürich.

Sutton, R. F. (1981) *The Interaction Between Men and Women Portrayed on Attic Red-Figure Pottery.* Unpublished PhD thesis, University of North Carolina at Chapel Hill.

Sutton, R. F. (2004) Family Portraits: Recognizing the "Oikos" on Attic Red-Figure Pottery. *Hesperia Supplements* 33, 327–350.

Travlos, J. (1971) *Pictorial Dictionary of Athens.* London.

True, M. and Silvetti, J. (2005) *The Getty Villa.* Los Angeles.

Vermeule, C. (1955) Notes on a New Edition of Michaelis: Ancient Marbles in Great Britain. *American Journal of Archaeology* 59, 129–150.

Vermeule, C. and von Bothmer, D. (1959) Notes on a New Edition of Michaelis: Ancient Marbles in Great Britain. *American Journal of Archaeology* 63, 139–166.

Waite, S. A. (2000) *Representing Gender on Athenian Painted Pottery.* Unpublished PhD thesis, Newcastle University.

Webster, T. B. L. (1965) Greek Vases in the Stanford Museum. *American Journal of Archaeology* 69, 63–65.

Weston-Lewis, A. *et al.* (2012) *Expanding Horizons. Giovanni Battista Lusieri and the Panoramic Landscape.* Edinburgh.

Wrenhaven, K. L. (2009) The Identity of the "Wool-Workers" in the Attic Manumissions. *Hesperia* 78, 367–386.

Williams, C. I. M. (1982) Lusieri's Surviving Works. *The Burlington Magazine* 124, 492–6.

Williams, D. (2012) Lusieri in the Eastern Mediterranean, 1800–1821. In Weston-Lewis, A. *et al. Expanding Horizons. Giovanni Battista Lusieri and the Panoramic Landscape*, 177–226. Edinburgh.

Williams, R. T. (1961) An Attic Red-Figure Kalathos. *Antike Kunst* 4, 27–29.

Wycherley, R. E. (1970) Minor Shrines in Ancient Athens. *Phoenix* 24, 283–295.

Wycherley, R. E. (1978) *The Stones of Athens.* Princeton.

Young, R. S. and Lawrence Angel, J. (1939) Late Geometric Graves and a Seventh Century Well in the Agora. *Hesperia Supplements* 2, 1–250.

Young, R. S. (1951) Sepulturae Intra Urbem. *Hesperia* 20, 67–134.

Zarkadas, A. (2009) Σκηνές γυναικωνίτη σε "ἄγνωστης χρήσης σκεύος" του τέλους του 5ου αι. π.Χ. In Oakley, J. H. and Palagia, O. (eds.) *Athenian Potters and Painters II.* Oxford.

5. Farewells by the Achilles Painter

Susan B. Matheson

The Shefton Collection is fortunate to have three vases by the Achilles Painter, whose white-ground polychrome lekythoi have established him as one of the pre-eminent artists of the Classical period.[1] With a few exceptions, most notably his name vase in the Vatican, the painter's red-figure work is less renowned, but some of it reaches the highest level for Classical vase-painting, and is productively compared to the sculpture of the period. His work in black-figure is restricted to panathenaic prize amphorae. While continuing the official panathenaic canon of Athena on side A and athletic scenes on the reverse, the athletic scenes offer unusual compositions combining figures in action and at rest, energised athletes and dignified judges, and runners going in all directions to show the painter's skill in foreshortening the figure in motion. The varied turning and twisting poses of the figures are conceived with the enthusiasm of the Pioneers, and push the black-figure technique to its limits. The stately, sculptural figures that the painter achieves in these black-figure prize vases are the norm for his white-ground and much of his red-figure work. The Shefton Collection's three vases in these two techniques – a red-figure amphora and two white-ground lekythoi – will be the focus of this chapter.

I. Red-figure Nolan Amphora with a Departing Warrior

The red-figure amphora in Newcastle was attributed to the Achilles Painter by Brian Shefton, so we will begin with this vase (inv. no. 55, Figs. 5.1 and 5.2).[2] A Nolan amphora, it conforms in shape and ornament to others by the Achilles Painter and to those of the Berlin Painter, his teacher. The neck is undecorated. Below the figures is a band of meander, different on each side, the only ornament on the vase.[3] Also in the spirit of the Berlin Painter and characteristic of the Achilles Painter, the figures are isolated against the glossy black surface, two on the front and a single figure on the back.

A young man and a woman stand facing each other on side A of the vase (Fig. 5.1). The young man, beardless and barefoot, with short curly black hair, wears only a chlamys, pinned at his right shoulder. He is shown in three-quarter view, his right foot frontal and his left in profile. The right knee is twisted slightly inward. His right hand is on his hip, which is bare, revealed by the parted chlamys as is the whole right side of his body. In his left hand he holds a staff or, more likely, a spear, upright, its head down (indicated by the double line above the spear head). He faces to his left, as he looks at the woman, making eye contact. The woman is dressed in a chiton and himation. She faces left, her head and legs shown in profile, her upper body hidden behind the large shield she carries on her left arm. The shield device is a Pegasos, facing left, wings spread in flight. In her right hand she holds a helmet, supported, but not extended; the front of the helmet is hidden behind the shield. On the reverse of the vase, a single man stands facing left, shown in three-quarter view (Fig. 5.2). Enveloped in a long himation that leaves his right shoulder bare, he has black hair and a long black beard. His right arm is extended as he holds a knobbly walking stick.

The scene on side A is part of a large group showing warriors departing (Matheson 2005, 23–36; 2009, 373–413). Many of these departure scenes show armed warriors, often bearded,

Figure 5.1: Red-figure amphora attributed to the Achilles Painter, Newcastle upon Tyne, Shefton Collection 55, side A: young warrior departing and woman. Photograph: Colin Davison.

Figure 5.2: Red-figure amphora attributed to the Achilles Painter, Newcastle upon Tyne, Shefton Collection 55, side B: draped man. Photograph: Colin Davison.

sometimes accompanied by a companion or servant, bidding one or more family members farewell as they depart for battle or military campaign. Some are designated as mythological by the inscriptions naming the figures. Others are scenes of mortals 'heroized' by the addition of names of heroes from Trojan epic. A smaller group shows more youthful figures, beardless and wearing a simple chlamys rather than hoplite armour. I have argued elsewhere that these younger individuals are not hoplites leaving for war but Athenian ephebes, either at the time of their induction into their phratry, the investiture of arms at the end of their first year as an ephebe, or their departure for the peripoloi service (Matheson 2009, 396–403). It is notable that the scenes of the bearded hoplite generally show a libation, while the scenes I would identify as an ephebe show a family member giving the young man a component of the standard hoplite armour (shield, spear, sword and scabbard, helmet, and greaves). Fourth-century literary sources indicate that ephebes were invested with a shield and spear by the state; other sources indicate that their helmet and the remainder of their armour were provided by their family. Fifth-century Athenian vases showing a young man receiving arms emphasise the helmet, shield, and spear. The single figure who bestows arms usually gives a helmet or less frequently a sword, i.e., a component of the hoplite gear that is not provided by the state. Aristotle [*Ath. Pol.* 42] states that

by his time, at least, the chlamys and petasos were the standard attire of the ephebe. The chlamys, the helmet, shield, and spear seen on this vase suggest that the young man shown is an ephebe. The helmet he is receiving suggests that the giver is a family member.

The identity of the woman on the Newcastle vase is suggested by the large group of vases showing women in this role, the counterparts of mature men in civilian dress in related scenes. They are the parents of the warrior. Epic versions bear inscriptions naming the figures. As far back as the Archaic period, Priam and Hekuba are present at arming scenes of Hector, and the name vase of the Hector Painter shows that they continue into the Classical period. These mythical paradigms suggest the woman on the Newcastle vase is the ephebe's mother.

Context for the increased presence of women in this role in the Classical period is provided by the new rules for determining Athenian citizenship instituted by Perikles in 451 BC, which required that a citizen must have a citizen mother as well as the previously required citizen father. The mother's role in literally replenishing Athenian postwar society – have more male citizen children – also argues for increased prominence of the mother in the family structure, a context in which her role in ritual was already important. The ephebe and his mother on the Newcastle vase reflect a strongly civic-minded society in which war and family shared the focus.

The Achilles Painter shows such departure scenes several times, in three instances on a Nolan amphora like this one, elsewhere on a stamnos, a pelike, and standard and squat lekythoi.[4] In some variants, Nike replaces the woman.[5] Elsewhere, a hoplite replaces the ephebe.[6] Closest to the Newcastle vase is an amphora in London.[7] On all these amphorae, there is a single standing man on the reverse, bearded and wrapped in a himation. On the London vase, a woman stands again at right, facing left, holding a shield (device: scorpion) on her left arm, a helmet in her right hand, and a spear, at a slant, again with its head down. She wears a chiton and himation, but in this case her hair is bound in a sakkos, which may indicate that she is older than the woman on the Newcastle vase. The young man at left stands in profile facing the woman, his right hand extended and gesturing toward her. He is nude save for his chlamys, which is rolled and slung over his left shoulder, and held in place with his left hand. The communication between these two figures is more intense than on the Newcastle vase, as indicated by both the young man's hand gesture and the fact that his body is turned to face her.

A third example, in Munich, shows additional variations.[8] Here the woman, again at right, stands frontally. Instead of a shield and helmet, she holds a sword and scabbard. The shield lies flat on the ground between the figures and the helmet stands on top of the shield. The young man again stands at left, facing right, although here he does not stand upright but leans on a walking stick, his weight on his right leg. He is nude, with a chlamys rolled and bunched over his left arm. A petasos is seen behind his left shoulder, completing Aristotle's standard ephebic costume. The young man looks at the woman and gestures slightly toward her with his right hand, while his left hangs rather limply down beside the walking stick. The woman holds the sword out to the young man. She wears a chiton and himation, and her black hair is unbound.

The helmet on the Newcastle vase is a type that is called Thracian or 'pseudo-Attic'.[9] It has the same basic head shape and neck guard seen in Attic helmets, and similarly shaped cheek pieces, but it covers more of the front of the head and has a rim projecting forward and down, adding protection, rather than slanting upward as on Attic helmets, where the rim or visor is seemingly more decorative in intent. The cheek pieces, which are frequently shown folded up on the Attic helmets, even in combat, were "attached by leather hinges to the inside of the helmet" in the Thracian/pseudo-Attic helmets (Everson 2004, 139). These hinges are normally not shown in vase paintings (the Newcastle representation is typical), where the rim seems to cover the tops of

the cheek pieces thereby making it impossible for them to be folded up. Leather hinges may be shown on a fragment of a calyx krater by the Niobid Painter, which depicts a row of short lines along the top edge of the cheek piece that are otherwise unexplained.[10]

This Thracian/pseudo-Attic helmet occurs on two of the three departure scenes discussed here (Newcastle and Munich); the helmet in the third scene (London) is Corinthian. The Thracian/pseudo-Attic helmet type occurs in departure scenes on vases of other shapes by the Achilles Painter, but not exclusively: in one case, a stamnos in London,[11] it is paired with a departure scene in which the helmet is Corinthian. A woman hands an Attic helmet to a departing youth on a red-figure lekythos by the Achilles Painter in Agrigento.[12] The Thracian/pseudo-Attic helmet also appears in battle scenes by the Achilles Painter, for example the loutrophoros in Philadelphia, again in combination with other types, including not only Corinthian but also Attic and Chalcidian.[13] Everson (2004, 139) places the start of the Thracian/pseudo-Attic helmet around 460 BC, and he notes a cluster of representations of it in the decade following.[14]

The Attic helmet was almost unvaryingly worn by Athena,[15] and one would expect that it would be the standard for Athenian hoplites and ephebes. If true, this would suggest that the Thracian/pseudo-Attic helmet was indeed a variant of the Attic helmet. Surviving evidence does not confirm which type of helmet the hoplite commonly used, and since the helmet was provided not by the state but by his family, perhaps individual choice was permitted. More elaborate types of helmets such as the Attic and Thracian/pseudo-Attic may have indicated a wealthy family.[16] There is literary evidence as far back as Homer for varying degrees of opulence in armour. The Corinthian helmet is the most common type in the archaeological record, suggesting that it may have been the helmet of choice in the fifth century for hoplites from families with incomes more in the middle range – more expensive than a pilos helmet but less so than an Attic or Thracian/pseudo-Attic one.

The Pegasos shield device cannot be read as diagnostic of Athens in this context, since it is only one of several different shield devices that occur in such scenes. The Achilles Painter uses it again in the departure on the London stamnos,[17] but in the scene there the warrior wears a Corinthian helmet.

II. White-Ground Lekythos with Two Women, One in a Fancy Tunic

For anyone who has looked at white-ground lekythoi of the Classical period in museums throughout the world, it will be no surprise that scenes showing two women are second only to scenes at the grave as the most common among surviving vases of this type.[18] Once called 'mistress and maid', they are now generally understood as not reflecting any social distinction between the women. They can be read as related to weddings, funerals, or simple activities of domestic life. Much of the joy in looking at white-ground lekythoi comes from the variety of details and anomalies in their subjects. Music, children, animals, and sometimes myths are mixed with scenes of visits to the grave and the preparations made for these visits. Oakley (2004b, 57) argues that what is important in scenes of two women is their being in a domestic setting and doing their duties with moderation and self-control (the Greek concept of sophrosyne).[19]

As demonstrated by recent archaeological finds in Athens, their presence in graves does not indicate the gender of the deceased. Rather, the scenes show the devotion of the members of the family to the deceased, especially as demonstrated in the care of the grave (Pipili 2009, 242–243). A parallel idea has been suggested for earlier black-figure lekythoi with fighting warriors by Mark Stansbury-O'Donnell (2006, 124), who examines them in a funerary context as part of the large number of lekythoi with spectators.[20] He sees the warriors as "an ideal that serves as an

index for the deceased", and the spectators as "the members of family and society who observe and recall the excellence of the deceased". The warriors commemorate the deceased in the same way that sculptural figures do on contemporary grave monuments, making the lekythos a reference to the tomb and a "surrogate picture of the visitation of the dead by family and others".

Oakley (2004b, 57) notes that most of the white-ground lekythoi painted between 450 and 430 BC are by the Achilles Painter or artists in his workshop. The lekythos with two women in the Shefton Collection (inv. no. 54),[21] attributed to the Achilles Painter by Oakley, is characteristic

of the artist in its basic elements, but, as often with this painter, with one particular distinction that sets it apart (Figs. 5.3 and 5.4). On this leykthos, the women face each other, one sitting, the other advancing slowly toward her from the right. Behind the standing woman, a small black oinochoe and a red sakkos used for tying up the hair hang on the wall, suggesting a domestic interior. The form of the oinochoe, footed and with trefoil mouth and painted in black silhouette, indicates, according to Oakley (1997, 29), a relatively early date for this lekythos.[22]

The seated woman, at left and only partly preserved, faces right (Fig. 5.3). Her upper body is damaged, but we can see that she sat on an elegant chair, a klismos, a form characteristic of fifth-century Greece, and famously emulated in the furniture of nineteenth-century England, France, and America. The chair is drawn in brown, the dowels joining its legs to the seat shown as circles.[23] The edge of a striped seat cushion can be seen. The woman sits in a relaxed position with her back resting against the backrest (a bit below shoulder level), her toes resting gently on the floor with her heels raised. She reaches out to the standing woman who faces her, her right hand open and held out to receive the vessel she is being offered. Her left hand rests in her lap, its position suggesting she is holding part of her garment. She wears a long red himation, which is draped around her lower body and across her thighs, revealing a yellow chiton covering her lap and upper body; the yellow chiton is also visible below the hem of the himation. The woman's lower face is visible, although her eyes, the rest of her head, and her hair are not preserved.

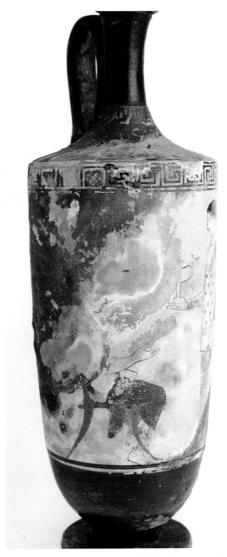

Figure 5.3: White-ground lekythos attributed to the Achilles Painter, Newcastle upon Tyne, Shefton Collection 54, showing seated woman. Photograph: Colin Davison.

The woman at right approaches the seated woman, walking slowly, as is evident from the underdrawing and the trace of the yellow chiton covering the trailing leg. Her upper body is turned in slightly three-quarter view, while her head is in profile facing the seated woman to whom she offers a plemochoe (Fig. 5.4). This vessel, also called a kothon or an exaleiptron, appears frequently in this context on lekythoi by the Achilles Painter.[24] The painter has skilfully drawn the woman's hand gently grasping the foot of the vase. The standing woman, like her seated companion, wears a long yellow chiton. Rather than a standard himation over it, however, here we see a short tunic with striking patterns. From the neckline to below the shoulders is a broad band of solid colour with a saw-tooth (serrated) lower edge. A mirror of this band, with the saw-tooth edge on the top, rises from the tunic's hem. Between them, the body of the garment is covered with a grid of small squares drawn in brown slip (dilute black gloss). Short vertical lines along the lower edge of the tunic suggest a fringe. Traces of solid red on the near shoulder and in the lower band suggest that the broad bands were of this colour. A line at the woman's right wrist (the hand holding the vessel) and the profile of slightly bunched fabric extending for a short distance up the arm suggest the end of a long, tight-fitting sleeve. Traces of red pigment on this sleeve and the other forearm suggest a long-sleeved tunic with red sleeves extending from the broad red band across the shoulders and neck. The colour of the body of the tunic cannot be determined at present.

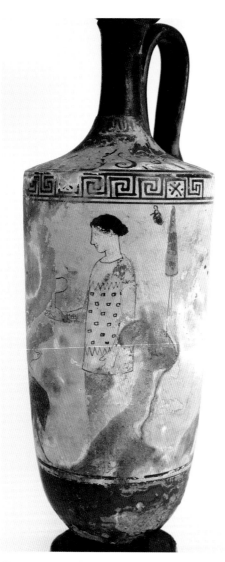

The standing woman's head and face are well preserved. Added white slip was used for the face, with the details of the eye, nose, mouth, and ear drawn on top of the slip. One should imagine that the same was done for the face of the seated woman. The curly black hair is shown as a solid mass; it appears to have been drawn on the reserved clay surface, except for the wavy edge, which, like the ear and eye, was drawn on the white slip, resulting in a golden colour. The added white for the female flesh places this vase in the earlier part of the Achilles Painter's career; Oakley (1997, 140) dates it to 450–445 BC.[25]

Figure 5.4: White-ground lekythos attributed to the Achilles Painter, Newcastle upon Tyne, Shefton Collection 54, showing standing/walking woman. Photograph: Colin Davison.

The fancy tunic has received previous attention, notably from Margaret Miller (1997, 158–160, fig. 67) as part of a body of evidence she cites for the influence of Persian fashion

on Athenian clothing of the mid- to later fifth century BC. Miller describes the tunic as does the present author, i.e., as a sleeved chiton worn over a standard chiton, and she agrees that the sleeves were red. [26] She suggests that the pattern of squares may represent metal attachments. Miller rightly takes exception to earlier proposals that such fancy garments in the 'mistress and maid' scenario and other scenes of women suggested foreign slaves, noting several unassailably Athenian women wearing them in obviously Athenian rituals.[27] There are numerous other examples of such patterned tunics, both sleeved and sleeveless, worn by both men and women, soldiers and civilians, in ritual and other circumstances, who can only be Athenian, including several by the Achilles Painter himself.[28] Whether or not Miller is right that these patterned garments show Persian influence, they are clearly special dress, and the occasions on which they are worn can be understood as special as well. This would support Pipili's proposal that the scenes of two women on white-ground lekythoi show family members devotedly honouring the deceased – here perhaps further idealized by the fancy dress worn by one of the female family members.

III. White-Ground Lekythos with an Old Man Mourning

A severely damaged white-ground lekythos by the Achilles Painter still preserves enough of its drawing to allow us to identify the scene represented (inv. no. 206, Figs. 5.5 and 5.6).[29] Two figures, both standing, flank a tomb that is topped with an ovoid finial. At left, an old man stands facing right (Fig. 5.5). He is completely enveloped in a large, dark red himation, except for his feet and the upper part of his head. His white hair shows above the dark cloak, emphasising his advanced age. His right ear is drawn in outline. The lower part of his face is covered by the himation, from which his left hand rises to cover the visible part of his face. His right hand is muffled under the cloak, holding the top of a walking stick. The hiding of the face as the culmination of the mourning man's wrapping of his body in his himation is a particularly powerful gesture that seems to be associated with old age.[30]

To the right of the grave monument that separates the figures stands a young man wearing a chlamys (Fig. 5.6). His body is in frontal view, his head in profile facing the grave monument and the old man. His chlamys, fastened at his right shoulder by a round disc brooch, covers his left shoulder and arm and drapes down to about his knees. He wears a petasos and is barefoot.

The grave monument is a simple tapering shaft standing on three tall risers.[31] The finial is an oval drawn in outline, pointed at the top, rounded at the bottom. Two horizontal lines appear just below the top of the shaft. Beneath them is a band of egg motif, with three horizontal lines below. Flanking the finial, four tiny eidola fly to left, two on each side.

The remarkable figure of the old man mourning, fully muffled in a long himation except for the glimpse of his white hair (Fig. 5.7), with one hand covering his face, occurs on two white-ground lekythoi by the Achilles Painter in Athens, one from the Athenian Acropolis, the other in the Kanellopoulos Museum.[32] Closely related, but with the mouth and part of the beard showing and hair that is more salt-and-pepper grey than snowy white, is the painter's lekythos in the Dinopoulos Collection in Athens.[33] These better preserved examples help us reconstruct what is shown on the Shefton Collection vase. In each case, the individual mourned is a young man. On two of the three he wears a chlamys pinned at the shoulder, one short, the other extending below the knee, while on the third he wears a himation that leaves his right shoulder bare. Under each of these garments, the nude figure is drawn, the extent of the drawing now visible depending on the degree of preservation of the opaque solid coloured wash used for the garment. A similar drawing exists on the Shefton vase under what once was a solid garment.

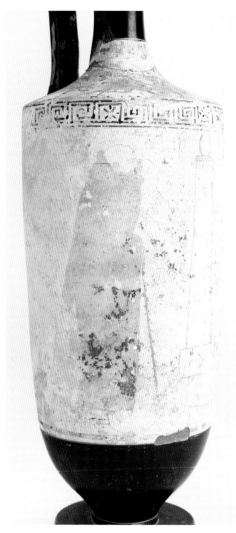
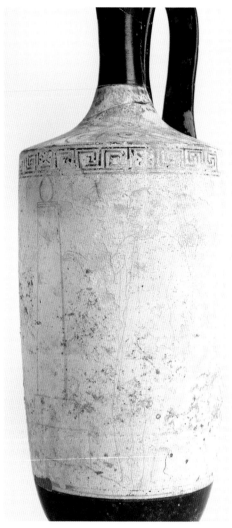

Figure 5.5: White-ground lekythos attributed to the Achilles Painter, Newcastle upon Tyne, Shefton Collection 206, showing muffled mourner. Photograph: Colin Davison.

Figure 5.6: White-ground lekythos attributed to the Achilles Painter, Newcastle upon Tyne, Shefton Collection 206, showing deceased man and grave stele. Photograph: Colin Davison.

Even more consistent are the pose and costume of the old mourning man. Again, an underdrawing records the outline of the nude body on the three lekythoi in Athens, and likely exists on the Shefton vase. The Shefton mourner is closest to the one in the Acropolis Museum in his pose: standing to the left of the monument and facing right, viewed in profile, his right hand, under the himation, holding a walking stick, his left hand, visible, covering his eyes and forehead. His white hair is cropped short on both, his right ear showing prominently. The pose of the figure on the Kanellopoulos Museum lekythos is virtually a mirror image of the old men

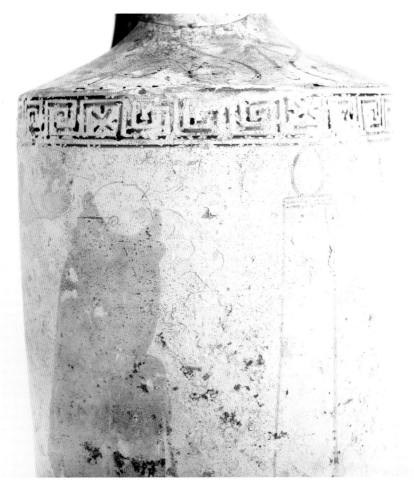

Figure 5.7: White-ground lekythos attributed to the Achilles Painter, Newcastle upon Tyne, Shefton Collection 206, detail showing muffled mourner. Photograph: Colin Davison.

on the Acropolis and Shefton lekythoi. The cloaks on the three Athens vases are dark red; that on the Shefton Collection vase is very worn, but there are traces of solid dark red over the red wash that remains. Another similar scene by the Achilles Painter on a lekythos in the Art Institute of Chicago with a slightly different pose for the old man shows his cloak in deep maroon.[34]

A related lekythos by the Achilles Painter in Berlin shows the same gesture of the hand held to the head in mourning, but in this case the entire face is visible.[35] The old man, with white hair and beard, wears a chiton and himation in the normal way, the himation not covering his shoulder or drawn up to cover all or part of his head and face. The position of the hand allows the eye to be seen. The focus of the drawing is on the face, where the wrinkles of age and the lines of heavy grief merge into a memorable image of sorrow. John Oakley (2005a, 198), in his study of pity in Classical Athenian vase-painting, calls this old mourner "one of the most moving of all figures in Greek vase painting". In a way, the mourners on the Shefton Collection and Athens vases are

even more distraught, huddled in their cloaks to shield themselves from the reality of death and from the image of the deceased son at which they cannot even bear to look.

The style of this lekythos suggests a later date than that assigned to the lekythos with two women, as Oakley (1997, 140 and 151) has seen, dating the first to 450–445 and the second to 440–435 BC. In Oakley's chronology, the lekythos with the two women is at the end of the Achilles Painter's early period, still using the second white of his earliest lekythoi and just beginning to move beyond the relative stiffness of the early figures. On the mourning lekythos, the figures are more relaxed and natural in their poses, and the drapery style is softer. The bodies are heavier, the drawing more fluid. The stylistic influence of the Parthenon frieze has surely intervened. Stretching the bounds of the Classical restraint of the Parthenon, though, is the degree to which the figures interact and show their feelings in the Achilles Painter's later vases: the gazes more intense, the emotion more evident, the sympathy for the mourning elders vividly shown. While on one level showing a cool and austere classicism, the Achilles Painter's mature vases convey a human warmth that should not be ignored.

Notes

1 I am grateful to Dr Sally Waite, for her kind invitation to contribute to this volume in honour of Brian Shefton and for her gracious assistance throughout. I also wish to thank the Keeper of Archaeology at the Great North Museum Andrew Parkin and Monica Hughes for photographic assistance. The fundamental work on the Achilles Painter is the monograph by John H. Oakley (1997), with additions in Oakley (2004a) and Oakley (2005b); see also Tzachou-Alexandri (1998).

2 Height 34.3 cm, diameter 15.8 cm, diameter of foot 8.4 cm. (Oakley): *ARV²* 989, no. 34; *Add²* 311; Foster (1978) 16; Oakley (1997) 6 (as Middle Period III), 120, no. 45, pls. 20B and 49A (dated 440–435 BC), 171 (brooch), 172 (helmet, shield device [Pegasos], spear, staff), 178 (ornamental band); Matheson (2009) 412, 413, fig. 10; *BAPD* 213855.

3 On side A, a band of stopped meander, in groups of three that originate from the bottom, face alternately left and right, the groups separated by dotted saltire squares (originating alternately from the top and bottom). Oakley (1997, 178) shows that it is particularly common in the painter's middle period, although seen throughout his career. A band of simple meander facing right is below the figure on side B.

4 Woman giving helmet (Attic) to ephebe: e.g. red-figure lekythos, Agrigento, Museo Archeologico Regionale 20590: Oakley (1997, 129, no. 111, pl. 71); *BAPD* 19766. This woman wears a hair bag, normally an indication of an unmarried woman, thus perhaps the ephebe's sister, in lieu of the mother, who may be deceased.

5 Nike and departing warrior: e.g. red-figure pelike, London, British Museum E 385: *ARV²* 990, no. 50; Oakley (1997, 123, no. 66, pl. 32); *BAPD* 213871; red-figure lekythos, Paris, Musée du Louvre G 444: *ARV²* 993, no. 91; Oakley (1997, 131–132, no. 131, pl. 81); *BAPD* 213912.

6 A squat lekythos in New York shows the woman with a bearded hoplite, making a libation from a phiale rather than presenting armour: Metropolitan Museum of Art 17.230.13: *ARV²* 994, no. 105; Oakley (1997, 133–134, no. 147, pl. 88A); Matheson (2009, 383, fig. 2); *BAPD* 213926.

7 British Museum E 329: *ARV²* 989, no. 33; Oakley (1997, 120, no. 44, pl. 20A and 48H), as "Achilles and Thetis?"; *BAPD* 213854.

8 Munich, Staatlichen Antikensammlungen und Glyptothek 2336: *ARV²* 989, no. 35; Oakley (1997, 120, no. 46, pl. 20C); *BAPD* 213856.

9 For an overview with additional bibliography, see Everson (2004, 139–40) and Schwartz (2009, 55–59). Examples of Thracian helmets from Classical Greece do not survive in the archaeological record. The term Thracian apparently comes from the similarity in appearance to helmets of the Hellenistic and Roman periods found in Thrace. The term 'pseudo-Attic' was apparently coined

by Dintsis (1986, 113–136); for examples of 'pseudo-Attic' helmets and representations of them in sculpture and on coins, (274–287, nos. 211–242 and pls. 54–62, and 370–371) (Beilage 9, nos. 333–378). As Dintsis (113) notes, they occur on vases as early as the first half of the fifth century BC. The term was adopted by Oakley (1997, 172). Pflug (1989, 24) prefers 'Attic.'

10 Reggio Calabria, Museo Nazionale 27210 (372): *ARV²* 602, no. 25; Prange (1989, 186, no. N 26, pl. 50); *BAPD* 206957.

11 British Museum 1834.1103.1 (E 448): *ARV²* 992, no. 65; Oakley (1997, 126, no. 89, pl. 55); Matheson (2009, 382, figs. 1a–b); *BAPD* 213886. Oakley (1997, 172) lists and illustrates the examples of each type of helmet seen on vases by and near the Achilles Painter.

12 Museo Archeologico Regionale 20590: Oakley (1997, 129, no. 111, pl. 71A–B); *BAPD* 19766.

13 University of Pennsylvania Museum 30.4.1: *ARV²* 841, no. 112; Oakley (1997, 122 no. 59, pls. 25–28); *BAPD* 212260. Theseus and Perithöos fighting Amazons on a calyx krater in Ferrara: Museo Nazionale Archeologico di Spina 2890: *ARV²* 991, no. 53; Oakley (1997, 123–124 no. 70, pls. 34–35); *BAPD* 213874 wear Corinthian and Attic helmets.

14 The present author's research shows that the Altamura and Niobid Painters use it, but not always. Attic and Corinthian helmets also occur on their vases, and all three types are occasionally mixed on a single vase. Polygnotos and the painters in his group use Attic, Thracian, and Corinthian, singly or combined.

15 Athena wearing an Attic helmet with no cheek pieces: e.g. Cambridge, Fitzwilliam Museum GR 29.1937, Athena and Nike: Oakley (1997, 129, no. 110, pl. 70); *BAPD* 213900. An exception by the Achilles Painter showing Athena wearing a Corinthian helmet: fragment of a skyphos in Vienna, University 53d: Oakley (1997, 136, no. 166, pl. 91A, 1); *BAPD* 213939; Athena and Talthybios appear on this fragment; the subject is unexplained.

16 Also suggested by Everson (2004, 139).

17 Supra, n. 11; Oakley (1997, pl. 55).

18 Oakley (2004b, 30), noting that grave scenes "begin to dominate" around 440 BC.

19 On scenes of two women: Reilly (1989, 411–444); Kurtz (1989, 125–130); Oakley (1997, 61–64; 2000, 227–247; 2004b, 30–57), with an extensive list of two women scenes; Pipili (2009, 242–243). Kurtz and Reilly both conclude that there is no social distinction between the two women. Reilly argues that they relate to weddings. Kurtz disagrees. Oakley sees some as wedding related, some funerary, and some purely domestic – just two women. Pipili argues that they should be seen not as memorials to women but as scenes of the care of the grave – "family devotion to the deceased"– whether male or female. Pipili notes that some come from male graves, citing the Maroussi find in 2002.

20 Stansbury-O'Donnell (2006, 124) cites as an example New Haven, Yale University Art Gallery 1993.46.16: Stansbury-O'Donnell (2006, 123, fig. 30); *CVA* Yale 2, Matheson forthcoming, entry no. 19; *BAPD* 9024585.

21 Height 28.0–3 cm; diameter 5.25 cm; diameter base 5.75 cm (Oakley). Langlotz, E., *Sammlung antiker Kunst aus dem Nachlass des verewigten Freiherrn Max vion Heyl, Generalleutnant* à.l.s.: *München, Helbing, 30 Okt. 1930* 18, no. 107, pl. 30, no. 1, as near the Achilles Painter, dating *c.* 450 BC; *ARV¹* 117, as attributed to the Achilles Painter; *ARV²* 996, no. 142; Oakley (1997, 140, no. 193, pl. 103C–D) (as Achilles Painter, dating to 450–445); Tzachou-Alexandri (1998, 51, with n. 200 [=*ARV²* 996, no. 142], 52, 121); Oakley (2004b, 37, no. 71); *BAPD* 213964.

22 Oakley (1997, 29) for the oinochoe as an indicator of date; for the date of this vase (450–445 BC, the transition from the early to middle periods), p. 6. On white-ground lekythoi by the Achilles Painter, see also Tzachou-Alexandri (1998).

23 For a similar but well preserved example of the klismos, see the lekythos by the Achilles Painter in Copenhagen, National Museum 5624, illustrated by Oakley (2004b, 50, fig. 24); *ARV²* 997, no. 150; Oakley (1997, 141, no. 203, pl. 108); *BAPD* 213972. The seated pose of the woman is also similar; she holds the vessel the woman on the Shefton lekythos is about to receive. The pose of the standing or walking figure at right is also similar on these two vases.

24 On the vessel's name and function, see Matheson forthcoming, entry 41 and Rodríguez Pérez in this volume.

25 On the second white as an indicator of date, see Oakley (1997, 25–26).

26 More of the red was preserved at the time the lekythos was sold in Munich in 1930, as is evident in the image from the sale catalogue cited in supra, n. 21. The catalogue entry also describes the sleeves and sakkos as red. On the sleeved chiton, see Miller (1997, 158–165).

27 Ibid., 158–159, with examples.

28 E.g. red-figure lekythos Athens, National Archaeological Museum 1639: Oakley (1997, no. 139, pl. 85A–B); *BAPD* 213919, man wearing a tunic with a victory wreath; departing warrior scene, red-figure squat lekythos New York, Metropolitan Museum of Art, 17.230.13: Oakley (1997, no. 147, pl. 88A); Matheson (2009, 383, fig. 2); *BAPD* 213926; for others, see Oakley (1997, no. 25, pl. 14; no. 43, pl. 19; no. 145, pl. 87).

29 Attributed by J. H. Oakley. Height 30.8–31 cm; diameter mouth. 6.8 cm; diameter base 7.1 cm. Kurtz (1975, 167, fig. 5d) (meander band); Oakley (1997, 151, no. 274, pl. 142a–b; dated to 440–435; 2004b, 159); Pipili (2009, 248, n. 23); *BAPD* 19750 (not illustrated).

30 It is not restricted to funerary scenes. An old man, with short-cropped white hair, a bent posture, and holding a walking stick for support, is shown thus muffled in a scene of a departing hoplite by the Chicago Painter on a volute krater of *c.* 450–440 BC in Ferrara, Museo Nazionale Archeologico di Spina 45685, from Spina, Tomb 19C, Valle Pega: Alfieri and Arias (1958, 46–47, pl. 50–51), detail of this figure: pl. 53; *ARV²* 628, no. 1l, 1662; Beazley, *Para* 399; Alfieri (1979, 42–44, pls. 95–98); *Add²* 272, *BAPD* 207282.

31 Three closely related lekythoi in Athens (Acropolis and Kanellopoulos Museums and the Dinopoulos Collection), discussed below (see notes 32 and 33), show only two steps. The Kanellopoulos and Dinopoulos Collection lekythoi show a wreath attached to the front of the bottom step. The Acropolis Museum vase shows a wreath attached to the front of the stele, near the top. All three show an untied wreath draped around three sides of the bottom of the shaft, resting on the top step and hanging over the front of it. Such items may originally have been shown on the Shefton lekythos as well.

32 Acropolis Museum 6473: Oakley (1997, 150, no. 272, pl. 140C–D) (attributed by M. Brouskari); Tzachou-Alexandri (1998, 79, fig. 16, colour); *BAPD* 8940; Kanellopoulos Museum 725: Oakley (1997, 150, no. 270, pl. 139C–D) (attributed by Oakley and Brouskari); Tzachou-Alexandri (1998, 79 fig. 15, colour); *BAPD* 19735. A related example with a more youthful muffled mourner on a white-ground lekythos in Cambridge: Fitzwilliam Museum GR 36.1937: Oakley (1997, 166, no. L 61, pl. 175 D); *BAPD* 12813 is "loosely connected with the Achilles Painter" by Oakley.

33 Dinopoulos Collection 5: Oakley (1997, 150, no. 269, pl. 139A–B); Pipili (2009, 243, fig. 4) (black and white, but the author notes that the cloak is red); *BAPD* 19740. A fragment of a fourth example in Athens, Dinopoulos Collection 7, from the same tomb as Dinopoulos Collection 5, preserves the lower portion of a draped figure facing right that may be another old man mourning: Oakley (1997, 150, no. 271, pl. 140A) (attributed by Oakley); Pipili (2009, 244 with n. 27) who does not suggest this; *BAPD* 19749.

34 Chicago, Art Institute 1907.20: *ARV²* 1000, no. 199; Oakley (1997, 150, no. 268, pl. 138C–D); *BAPD* 214021. The pose and hair of this figure are close to the old man on Athens, Dinopoulos Collection 5 (supra, n. 19). Earlier mourners huddled in their himations are found on white-ground lekythoi by the Sabouroff Painter: New York, Metropolitan Museum of Art 07.286.40, Kurtz (1975, pl. 29, no. 1); *BAPD* 212338 and the Painter of Athens 2020. Athens, National Archaeological Museum 2021, Kurtz (1975, pl. 29, no. 3); *BAPD* 212451.

35 Antikensammlungen und Glyptothek 1983.1 (attributed by Wehgartner): Oakley (1997, 150–151, no. 273, pl. 141), with earlier references; *BAPD* 8941. A similar figure although seen from the back appears on a lekythos by the Thanatos Painter in London, British Museum D 67, Kurtz (1975, pl. 32, no. 2); *BAPD* 216348. The Thanatos Painter's mourner does not show the same degree of emotion in his face.

Bibliography

Alfieri, N. (1979) *Museo Nazionale Archeologico di Spina* I. Bologna.

Alfieri, N. and Arias, P. E. (1958) *Spina: Die Neuentdeckte Etruskerstadt und die griechischen Vasen ihrer Gräber*. Munich.

Dintsis, P. (1986) *Hellenistische Helme*. Rome.

Everson, T. (2004) *Warfare in Ancient Greece: Arms and Armour from the Heroes of Homer to Alexander the Great*. Phoenix Mill, Thrupp, Gloucestershire.

Foster, P. (1978) *Greek Arms and Armour*. Newcastle upon Tyne, The Greek Museum, University of Newcastle upon Tyne.

Kurtz, D. C. (1975) *Athenian White Lekythoi: Patterns and Painters*. Oxford.

Kurtz, D. C. (1989) Two Athenian White-Ground Lekythoi *Greek Vases in the J. Paul Getty Museum* 4 (*Occasional Papers on Antiquities* 5), 113–30. Malibu, J. Paul Getty Museum.

Matheson, S. B. (1995) *Polygnotos and Vase Painting in Classical Athens*. Madison.

Matheson, S. B. (2005) A Farewell with Arms: Departing Warriors on Athenian Vases. In Barringer, J. M. and Hurwitt, J. M. (eds.) *Periklean Athens and its Legacy: Problems and Perspectives*, 23–36. Austin.

Matheson, S. B. (2009) Beardless, Armed, and Barefoot: Ephebes, Warriors and Ritual on Athenian Vases. In Yatromanolakis, D. (ed.) *An Archaeology of Representations: Ancient Greek Vase-Painting and Contemporary Methodologies*, 373–413. Athens.

Matheson, S. B. (forthcoming 2015) *CVA* New Haven, Yale University Art Gallery, Fascicule 2 (U.S.A. Fascicule 39) Darmstadt/Mainz.

Miller, M. C. (1997) *Athens and Persia in the fifth century B.C.: A Study in Cultural Receptivity*. Cambridge.

Oakley, J. H. (1997) *The Achilles Painter*. Mainz.

Oakley, J. H. (2000) Some 'Other' Members of the Athenian Household: Maids and their Mistresses in Fifth-Century Athenian Art. In Cohen, B. (ed.) *Not the Classical Ideal: Athens and the Construction of the Other in Greek Art*, 227–247. Leiden.

Oakley, J. H. (2004a) New Vases by the Achilles Painter and Some Further Thoughts on the Role of Attribution. In Keay, S. and Moser, S. (eds.) *Greek Art in View: Essays in Honour of Brian Sparkes*, 63–77. Oxford.

Oakley, J. H. (2004b) *Picturing Death in Classical Athens: The Evidence of the White Lekythoi*. Cambridge.

Oakley, J. H. (2005a) Pity in Classical Athenian Vase Painting. In Sternberg, R. H. (ed.) *Pity and Power in Ancient Athens*, 193–222. Cambridge.

Oakley, J. H. (2005b) Neue Vasen des Achilleus-Malers und des Phiale-Malers. In Strocka, V. M. (ed.) *Meisterwerke: Internationales Symposion anlässlich des 150. Geburtstages des Adolf Furtwängler, Freiburg im Breisgau 30. Juni–3 Juli*, 285–298. Munich.

Pflug, H. (1989) *Antike Helme*. Cologne.

Pipili, M. (2009) White-Ground Lekythoi in Athenian Private Collections: Some Iconographic Observations. In Oakley, J. H. and Palagia, O. (eds.) *Athenian Potters and Painters* vol. 2, 241–249. Oxford.

Prange, M. (1989) *Der Niobidenmaler und seine Werkstatt, Untersuchungen zu einer Vasenwerkstatt frühklassischer Zeit*. Frankfurt.

Reilly, J. (1989) Many Brides: 'Mistress and Maid' on Athenian Lekythoi. *Hesperia* 58, 411–444.

Robertson, M. (1992) *The Art of Vase Painting in Classical Athens*. Cambridge.

Schwartz, A. (2009) *Reinstating the Hoplite: Arms, Armour and Phalanx Fighting in Archaic and Classical Greece*. Stuttgart.

Stansbury-O'Donnell, M. (2006) *Vase Painting, Gender, and Social Identity in Archaic Athens*. New York.

Tzachou-Alexandri, O. E. (1998) Λευκες Λήκυθοι του Ζωγράφου του Αχιλλέως στο Εθνικο Αρχαιολογικο Μουσειο. Athens.

6. Note on an Askos in Newcastle

François Lissarrague

A small red-figure Attic askos entered the Shefton Collection[1] in the late 1970s (inv. no. 151, Figs. 6.1–6.4).[2] As with many objects acquired by Brian Shefton for his museum, this small and apparently modest vase raises a number of interesting questions, in terms of shape, and iconography.

Description

The vase is fragmentary; the body and the handle are preserved, while only part of the upper decorated surface is conserved. The diameter is 6.8 cm and the height 6 cm.

Shape

The shape of this askos is not the most common type, which is usually flat and discoidal (type 1); this one is a ring askos (type 2),[3] a circular shape with a central cylindrical hole, and a high belly with a marked shoulder. This type 2 is sometimes called 'macronian';[4] some examples have recently been found in a shipwreck near Gela (Panvini and Giudice 2003, 438); they have been attributed to Epiktetos (ibid.).[5] This shape seems to be earlier than the more frequent type 1, dating to around 500–480 BC.

Decoration

The iconography of our askos is surprising; it represents no human or animal figure, as is usual on askoi, but only a double pair of helmets. The vase is fragmentary, with only one side complete; there, one can see two helmets, face to face: a Corinthian helmet on the left, facing a Chalcidian helmet with a black skull. Both have a low crest. On the other side, only the upper part of the two low crests is preserved; the helmets could be Chalcidian as well as Corinthian.

In his 1977 study of the Attic askoi, Herbert Hoffmann classified their different iconographies according to the orientation and combination of figures, showing the existence of a pattern based on pursuit, sexual or asexual. This askos was a problem for him, as it bears no living figure, and he placed it among his symbols of passage, next to another askos in London showing a shield and a helmet (Hoffmann 1977, 6–7 and 13 no. Pb1). There is no action depicted on this askos, only isolated objects.

This kind of iconographical choice is unusual in Attic vase-painting, where human figures are predominant. The objects selected by the painters are very limited in number, and were chosen not for their aesthetic value (they are not still lives in the modern sense of this term) but for their meaning and importance in material culture. I have tried elsewhere to list these objects (Lissarrague 2006, 11–24), and recently John Oakley (2009, 59–76) has listed the elements isolated on the lids of pyxides (where one finds not only objects but also parts of the body).[6] In that limited corpus, helmets are not infrequent. Here I give a list, probably not complete, of examples I have come across, not only on askoi, but also on different shapes:

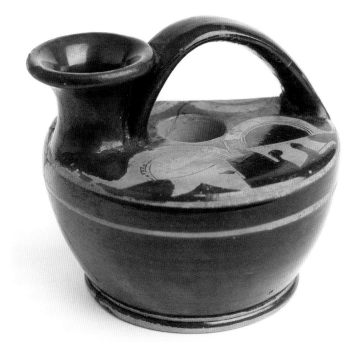

Figure 6.1: Red-figure askos, Newcastle upon Tyne, Shefton Collection 151. Photograph: Colin Davison.

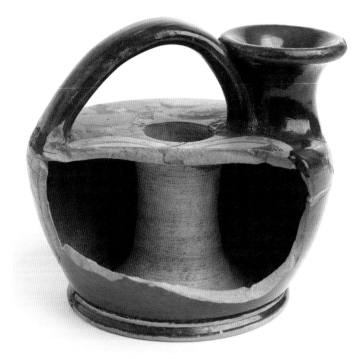

Figure 6.2: Red-figure askos, Newcastle upon Tyne, Shefton Collection 151. Photograph: Colin Davison.

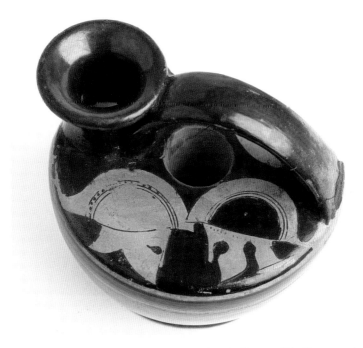

Figure 6.3: Red-figure askos, Newcastle upon Tyne, Shefton Collection 151. Photograph: Colin Davison.

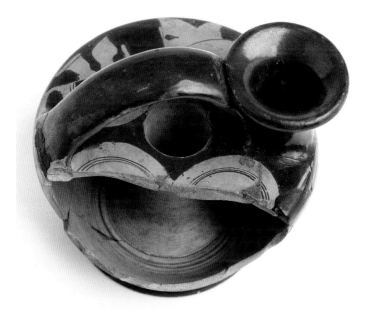

Figure 6.4: Red-figure askos, Newcastle upon Tyne, Shefton Collection 151. Photograph: Colin Davison.

1. Delphi 6582; Proto-Corinthian aryballos; Snodgrass (1964, fig. 14).
2. Boston 1973.9; black-figure olpe (two heraldic panthers, with frontal faces, framing a helmet in profile); *BAPD* 9977.
3. Paris, Louvre CA 823; black-figure lekythos (two heraldic lions, in profile, framing a helmet in profile); *ABV* 12/23, manner of Gorgon painter; *BAPD* 300106.

Isolated helmets appear on the following black-figure vases:

4. Athens 558; black-figure amphora (helmet in profile); *BAPD* 14335.
5. New York, art market; black-figure cup (between eyes); *BAPD* 17731; Sotheby's New York 14.12.2004, no. 253.
6. Emory 2004.008.001; black-figure Chalcidian cup (between eyes, frontal helmet).
7. Philadelphia MS2498; black-figure cup (between eyes, helmet in profile); Lissarrague (2006, 12, fig. 1).
8. Agora P990; black-figure disc (helmet in profile); *BAPD* 30878.
9. Nicosia C1042; black-figure skyphos (between eyes and wings, helmet in profile); *BAPD* 43654; *Bulletin de correspondance hellénique* 1991, 796, fig. 15.
10. Akraiphia 21881; Boeotian skyphos, Six technique (helmet in profile, between palmettes); *BAPD* 24887; *Ephemeris* 1994, 207.
11. Agrigento 1227; black-figure askos (helmet in profile, between palmettes); *BAPD* 25815 (described as a cock); de Miro (2000, no. 65, pl. 125, 133) (described as floral).

Red-figure is less common:

12. Manisa inv. 6161; red-figure cup (tondo, frontal helmet); *BAPD* 25581.
13. Newcastle 151; our askos; *BAPD* 11057.
14. London E 759; red-figure askos (A: helmet, B: shield); *BAPD* 6008.

This last askos in London has been variously interpreted. Hoffmann (1977, 6) takes the suggestion of Snodgrass (1964), who sees a helmet on one side (there is no doubt about this) and what was first seen as a Thracian helmet, finally transformed into a shield on the other side. The problem is to understand what is above the shield; certainly not a fish (as suggested by C. Smith 1896 in the British Museum Catalogue). I would propose that this is a cnemid, but agree that the drawing is not a masterpiece.

Helmets also appear isolated as shield devices; I only know of a few examples:

1. New York, Bastis; black-figure cup; *Para* 24/32ter, C Painter; BA350158.
2. Paris Louvre F284bis (on deposit in Marseilles); black-figure amphora; *ABV* 406/3, group of Vatican G23; BA 330798 (kantharos with a double crest on the handles).
3. Paris, Louvre F388; black-figure amphora; ABL 238/133, Diosphos painter; *BAPD* 7309.
4. Munich 2031; black-figure eye cup; *CVA* Munich 13, pl. 6, 1–7.
5. London market; red-figure cup, Ambrosios painter; *BAPD* 47039; Sotheby's 14/12/1995, no. 84.

Clearly helmets have interested some painters; their choice motivated by the strong symbolic power of the head (one thinks of the Corinthian or Rhodian head-aryballoi in the shape of a helmeted warrior).[7] As noted by Beazley (1921, 329, n. 4) human heads were a fitting motif on an askos, although most of the known examples show women's heads.[8] The helmet is both the most important part of the body and the most prominent piece of the armour, next to the shield. The decoration of the Newcastle askos is not a 'narrative' picture; we just see objects, animated by the way they are displayed, facing each other, as warriors do on the battlefield.

The symbolic value of the head, and of the helmet, is strengthened by the simplicity of the composition: a remarkable visual synecdoche, perfectly fitting the small available space on the surface of the vase. If we need a 'narrative' picture, then we have to look at a lost askos, displaying a set of armour on one side, and showing, on the other side, a kneeling man, arms extended in front of a sword, vertically fixed in the ground: the suicide of Ajax, after the dispute for the arms of Achilles.[9] Heroic armour is indeed a major motif of archaic vase-painting even in its smallest productions.

Notes

1 Brian Shefton was a master of footnotes, and this short paper is only a footnote in fond memory of a wonderful scholar.
2 It was on the Philadelphia art market (Hesperia Arts) before 1977. There is a photograph of it in the Beazley Archive, as mentioned by H. Hoffmann (1977, 13, no. Pb1). The Newcastle askos (151) appears in the Beazley Archive Pottery Database (*BAPD*) as vase number 11057 (but no mention is made of its former location).
3 On this typology, see Beazley *ARV*² *2*, p. L; see also Beazley (1921, 326, n. 3).
4 Cf. Providence 25.074; *ARV*² 2 480/338; *BAPD* 205021 and Athens MN 1671.
5 See also Paleothodoros (2004, pl. 42, 1 and 2).
6 Objects are listed under section v of Oakley's catalogue, no. 104 to 123. Unsurprisingly, no helmets appear on pyxides. Another series of isolated elements appear on the so-called 'spotlight stamnoi'; but only the lyre appears as an object, see Philippaki (1967, 89–93).
7 On these head vases cf. Ducat (1966).
8 For example Oxford 328; *BAPD* 212511 – London BM E761; *BAPD* 212925 – Sydney 48.260; *BAPD* 213107 – Capua 7994; *BAPD* 14035 – Mainz 6075; *BAPD* 2208 – Paphos 1789.1; *BAPD* 8446.
9 Nola, Barone collection, now lost; *Bulletino Napolitano Archeologico*, n. s. 1, 1853, pl. 10, 4–6. Cf. Davies (1985, 85, fig. 2) and Lissarrague (2007, 30, fig. 11).

Bibliography

Beazley, J. D. (1921) An Askos by Makron. *American Journal of Archaeology* 25, 325–336.
Davies, M. (1985) Ajax at the Bourne of the Life in *Eidolopoiia. Actes du Colloque sur les Problèmes de l'Image dans le Monde Méditerranéen Classique*, 83–117. Rome.
Ducat, J. (1966) *Les Vases Plastiques Rhodiens Archaïques en Terre Cuite*. Paris.
Hoffmann, H. (1977) *Sexual and Asexual Pursuit*. Occasional Paper no. 34, Royal Anthropological Institute, London.
Lissarrague, F. (2006) De l'Image au Signe: Objets en Représentation dans l'Imagerie Attique. *Cahiers du CRH* 37, 11–24.
Lissarrague, F. (2007) Ajax, Corps et Armes. In Colpo, I., Favaretto, I. and Ghedini, F. (eds.) *Iconografia 2006, Gli Eroi di Omero*, 21–32. Rome.
de Miro, E. (2000) *Agrigento I*. Rome.
Oakley, J. (2009) Attic Red-Figure Type D Pyxides. In Tsingarida, A. (ed.) *Shapes and Uses of Greek Vases*, 59–76. Brussels.
Paleothodoros, D. (2004) *Epictetos*. Brussels.
Panvini, R. and Giudice, F. (eds.) (2003) *Ta Attika. Veder Greco a Gela*. Rome.
Philippaki, B. (1967) *The Attic Stamnos*. Oxford.
Smith, C. H. (1896) *Catalogue of Greek and Etruscan Vases in the British Museum Volume III*. London.
Snodgrass, A. (1964) *Early Greek Armour and Weapons*. Edinburgh.

7. Some Early Attic Red-Figure Stemless Cups

Brian A. Sparkes

To celebrate Brian Shefton's[1] 90th birthday in 2009 a group of friends and colleagues, at the suggestion of Alan Johnston and under the organisation of Sally Waite, presented him with 'A Serendip of messages from friends'. The message from Jenifer Neils and Carla Antonaccio showed a picture of them holding the 90th fragment of an Attic black-glaze stemless cup that had been unearthed at the Sicilian site of Morgantina. It was a pertinent choice of offering, as Shefton had for decades (and with great success) been chasing that particular shape of black-glaze cup round the inner and outer reaches of the Mediterranean and beyond.[2] He had shown what an important and profitable export item of the Athenian potteries this had proved to be and felt obliged (as it were) to spread their distribution even further and secure three for the Shefton Collection in Newcastle (inv. no. 433, Figs. 7.1 and 7.2).[3] The large numbers he compiled in his search suggested to him that they represented 'scores of thousands', and, as some bore non-Greek graffiti on them,[4] he enjoyed imagining the owners at their native sites wielding these hefty objects as weapons in what he called their 'drunken barbarian banquets'.[5] The pattern of distribution was such that 'the shape was not really meant for home consumption' (Shefton 1990b, 164).

Shefton named the shape the Castulo stemless after the site in Spain that had furnished several instances. Giving it a memorable name was a helpful, indeed necessary, step. Current nomenclature of Greek vase shapes, with its mixture of inappropriate ancient Greek names and modern labels, continues to cause confusion, no more so than with the word 'stemless'. Present-day usage of this word is usually confined to the different varieties of shapes such as the Castulo, with low-set cup handles, but the term is still given too wide a spread.[6] Further, uncertainty arises over the distinction between 'stemless cups' on the one hand and what are now unhelpfully called 'cup-skyphoi' on the other; some shapes of cup-skyphoi are better labelled 'deep stemlesses'.[7]

Neither black-glaze nor red-figure stemless cups were produced in any numbers in the late sixth and early fifth centuries.[8] The few that remain show them to have had small, delicate bowls with a tiny ring or disc foot. The red-figure decoration is confined to the tondo on the inside. Figures 7.3 and 7.4 show a little-known example of the few; it is in the Boston Museum of Fine Arts and has not been attributed to a painter, nor, I think, ever published.[9] It may date as early as 500 BC. It has a simple shape with plain rim, and on the inside a striking helmeted head of Athena bordered by a single circle. A better known small stemless cup, of similar shape and delicacy, dates perhaps a little later to *c.* 480 BC, and has been attributed to the painter Douris,[10] but the numbers of such are few.[11] Consequently, such early shapes of stemless are rare in figured scenes (Fig. 7.5).[12] In the period between the Persian Wars and the middle of the fifth century, stemless cups, both black-glaze and figured, begin to be fashioned in a wider variety of shapes and became increasingly popular. It is in this period that Shefton's heavy Castulo cup is much in evidence, massively different in every way from its dainty predecessors. It is on average 15–20 cm across the bowl and 4–7 cm tall, with a weight of 10 ounces (227 g).

Brian Shefton was very specific in his definition of the black Castulo cup. In the profile drawing (Fig. 7.6)[13] we notice the thick wall, the concave lip, the sturdy handles and the stout

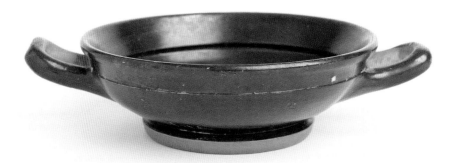

Figure 7.1: Attic black Castulo stemless, c. 450 BC, Newcastle upon Tyne, Shefton Collection 433.
15 × 4.4 cm. Photograph: Colin Davison.

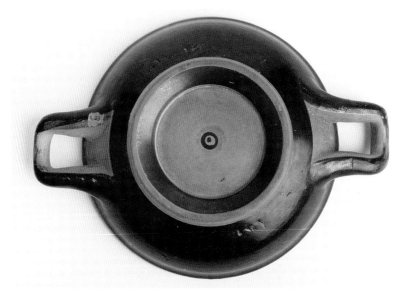

Figure 7.2: Attic black Castulo stemless, c. 450 BC, Newcastle upon Tyne, Shefton Collection 433.
15 × 4.4 cm. Photograph: Colin Davison.

torus foot which is grooved at the top of the outer edge. Inside there is also an offset at a lower
level than the concave curve outside. Shefton called this offset 'out of phase'[14] and suggested
that the deliberate thickening inside was intended to provide the sturdiness essential for their
transport over sea and land and made the cups more robust for those barbarian brawls that he
liked to envisage.

 In his search for black Castulo cups Shefton was naturally concerned to fix their dating
which stretched from the second quarter of the fifth century BC to the beginning of the fourth.[15]
The dates and contexts of discovery are still not clear-cut or precise but suggest that the earliest
examples favoured reserved areas, such as handle panels and outer face of the foot, and also the
underside with a central dot surrounded by one or two circles.

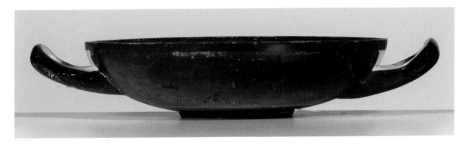

Figure 7.3: Attic red-figure stemless, c. 500 BC. Boston, Museum of Fine Arts 22.678. 11.8 × 3 cm.

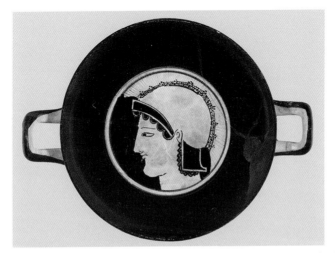

Figure 7.4: Attic red-figure stemless, c. 500 BC. Boston, Museum of Fine Arts 22.678. 11.8 × 3 cm.

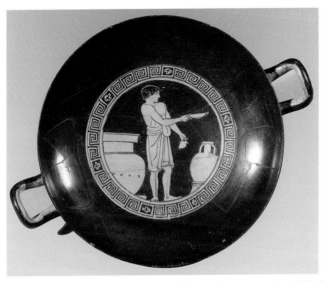

Figure 7.5: Attic red-figure cup, c. 470 BC. Heidelberg, Universität inv. 57/8. 8.2 × 20.7 cm.

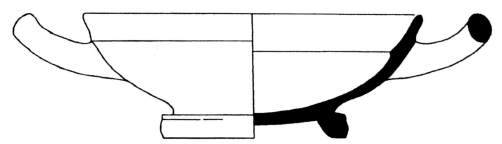

Figure 7.6: Profile drawing of Attic black Castulo stemless, c. 450–425 BC. Oxford, Ashmolean 1885.495 (after Vickers 1979, fig. 7). 21.2 × 7.5 cm.

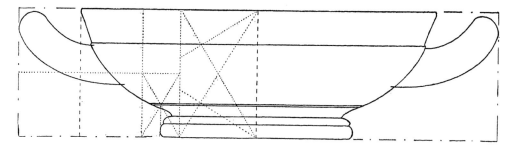

Figure 7.7: Profile drawing of Attic red-figure Castulo stemless, c. 460 BC. Boston Museum of Fine Arts 01.8089 (after Caskey 1922, 206, no. 161). 21 × 7.4 cm.

In his various studies Shefton made reference to some Castulo cups which carried red-figure decoration and so they might be useful in establishing dates and workshop connections. I thought it would be a suitable offering to his memory to look more closely at a few early red-figure pieces. Compared to the large numbers of black-glaze Castulo cups and their distribution, there are far fewer figured pieces and their distribution is much more restricted.[16]

Shefton's detailed definition of the Castulo cup makes tracking down the red-figure Castulos no easy matter. In the list of shapes that precede his inventories of painters, Beazley always directed researchers to Caskey's 1922 profile drawing in *Geometry of Greek Vases* as a template for the type (Fig. 7.7).[17] But Caskey never showed the vase in section, so it is unhelpful for the purposes of matching to individual cups. The drawing fails to reveal whether this particular cup has the necessary thickened 'out of phase' offset on the inside of the bowl and does not show the inner profile of the foot. When autopsy is not possible and we turn to search for published photographs of red-figure Castulo cups, we find that the position is not much better, as photographers have usually been instructed to tilt the cups and concentrate on the painted images to the exclusion of views of the underside, and not infrequently profile views are entirely omitted. The more recent *CVA*s are an honourable exception. Beazley is helpful when he occasionally prefaces his lists of numbers with the words 'shallow, solid, lipped', though this does not necessarily mean that the stemlesses listed are Castulos.

Questions have naturally arisen over the origin of the Castulo shape. When and why did the potters move from the small and delicate to the big and bulky? There had been some experimenting with black cup-skyphoi in the early fifth century but the steep slope of the bowl inside makes the 'out of phase' offset impossible. Even given that Martin Robertson (1976, 40–41) down-dated Epiktetos' cup-skyphoi towards 480 BC and thus brought them nearer to the start of the Castulos, the connection is still not close, and once again the 'out of phase' offset is missing.

Dyfri Williams drew Brian Shefton's attention to what might be seen as a tentative step to the new shape.[18] A stemless cup in the British Museum[19] has long been notorious for its appalling painting of a symposion but fascinating for its badly scratched graffiti. It may date to the end of the Late Archaic period, so *c.* 480 BC. It has many of the hallmarks of the Castulo cup such as the concave lip and the 'out of phase' offset inside, torus foot, and reserved areas outside, but Shefton pointed out that it misses his benchmark in that it is smaller (4.5 × 10.5 cm) and also lighter in weight than the Castulo family. It would indeed be ironic if such a poorly decorated specimen as this were a vital pointer to what turned out to be a grand commercial success story in black-glaze. Indeed, the black-glaze version was so suited to the export trade that it is difficult to believe that its origins lay with any figured predecessors.

Let us now turn to three early red-figure pieces that meet Shefton's requirements. The first has to be the Boston stemless which acted for Beazley as the prototype profile (Figs. 7.8 and 7.9).[20] Though Caskey's profile drawing has been constantly quoted, I have never seen the cup

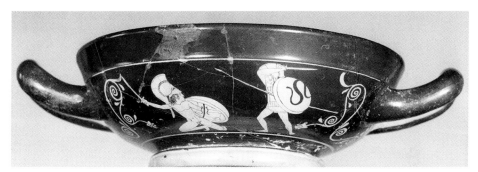

Figure 7.8: Attic red-figure Castulo stemless, c. 460 BC. Boston, Museum of Fine Arts 01.8089. 21 × 7.4 cm.

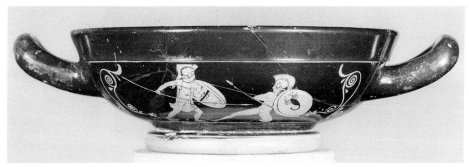

Figure 7.9: Attic red-figure Castulo stemless, c. 460 BC. Boston, Museum of Fine Arts 01.8089. 21× 7.4 cm.

published in photographic images. It proves in fact to be a perfect early example of the Shefton Castulo cup shape, with concave lip, reserved torus foot with groove, reserved areas inside the handles, and it does indeed have the 'out of phase' offset inside the bowl that Caskey's drawn profile failed to show. Though still shallow, the bowl of the cup is fashioned a little deeper than the black shapes. The figures on both sides are undefined hoplite duels which neatly fit the narrow field between open florals, and duels of various sorts (men versus giants, centaurs, etc.) become favourite subjects for the decoration of this shape. The presence of the concave lip means that two or sometimes three small, even, one might say, childlike, figures are really the maximum number that the space below the curve allows. There is no painted scene inside, and the underside has two small circles round the central dot, as we find on some other early black-glaze specimens.

The second example, in the Metropolitan Museum of Art, New York (Figs. 7.10 and 7.11),[21] is precisely similar in shape and size to the Boston cup. The choice of subject is different but perhaps more appropriate for the narrow space. We are no longer faced with battling heroes. We have instead a school scene on both sides with real children this time, between enclosed palmettes. This piece differs in decoration from the Boston Castulo in that it continues the subject on the tondo inside. The underside again is decorated with two small circles and a dot.

The third cup adds an innovative element to the decoration. This Castulo in Giessen (Figs. 7.12–7.14)[22] is close to the Boston and New York cups in shape and size. Like the Boston piece, there is a two-figure arrangement between open florals again, but the two-figure scheme has a different subject: this time the skirmish involves a satyr and a fleeing maenad on one side and a satyr and some heroine of the hunt (most likely Atalante or Artemis) on the other.[23] As before, two circles and a dot mark the underside. However, there is no painted tondo on the inside; instead, the bowl carries a very simple incised pattern of rosettes. The extreme simplicity of this pattern is likely to mean that it is one of the very earliest instances of a technique that is new to Attic pottery decoration at this time. It became increasingly popular as time went on, with more complex motifs that introduced impressed palmettes.[24]

Whenever these and similar cups have been discussed, the emphasis has mainly centred on the red-figure decoration, subject matter and style. The Boston and Giessen cups have been placed close to the Sotades Painter. For these we have to be satisfied with 'in his manner' or 'related to'; the one that Beazley attributed to the Sotades Painter himself has the foot treated differently, with black edge and fancily decorated underside.[25] The New York cup is attributed to the Painter of Munich 2660, a follower of Douris.

These cups and others closely similar raise questions over the number, size and organisation of the potteries in Athens, and over the movement of potters and painters from one atelier to another; it is difficult to be sure who sat at which bench and for how long in the various workshops.[26] The large size of the shops in the mid-fifth century has long been clear from the Penthesilea Painter and his associates, and recent work on the Eretria Painter, the Phiale Painter and the Achilles Painter has emphasised the complexity of the connections between a whole host of craftsmen.[27]

The close similarity in size and shape between the three stemlesses illustrated would tend to suggest that they were all made by one potter who may also have been responsible for fashioning black Castulos. It is hard to deny that this atelier issued the black cups alongside the figured, as the three are also similar in the detail of such painted features as the reserved handle panels, the reserved edge of foot, and the circle and dot on the underside which are found on the black versions. There are other early red-figure Castulos which differ in detail from the three highlighted in that they have the handle panels and the outer edge of foot black and, more

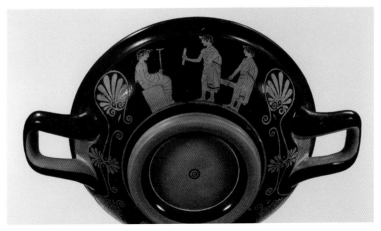

Figure 7.10: Attic red-figure Castulo stemless, c. 460 BC. New York, Metropolitan Museum of Art 17.23.10. 20 × 7 cm.

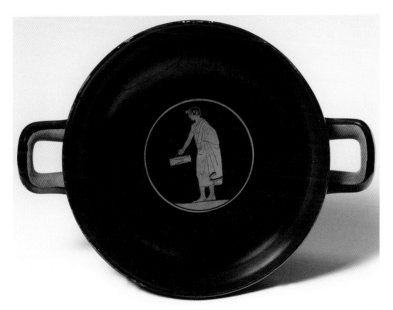

Figure 7.11: Attic red-figure Castulo stemless, c. 460 BC. New York, Metropolitan Museum of Art 17.23.10. 20 × 7 cm.

importantly, are furnished with more elaborately painted undersides, some of them even with a cushioned surface.[28] The fact that the Sotades Painter decorated one of these fancier versions would suggest that it came from the same shop as the three on which we have concentrated, but maybe from the hand of another potter.

The connection with the Sotades Painter and related painters naturally raises the question of whether the potter Sotades himself was responsible for shaping the Castulo cups, indeed maybe even the originator of the shape. No Castulo cup has yet been found with the name of a maker on

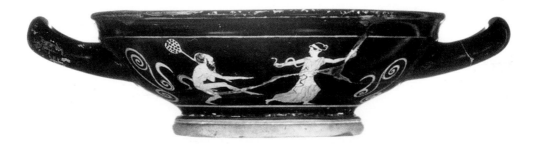

Figure 7.12: Attic red-figure Castulo stemless, c. *460 BC. Giessen, Antikensammlung der Universität inv. KIII-46. 21.5 × 7.1 cm.*

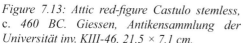

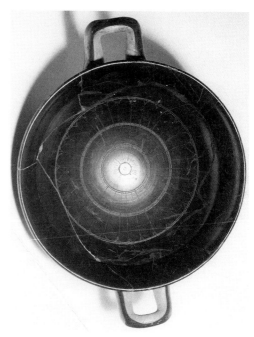

Figure 7.13: Attic red-figure Castulo stemless, c. *460 BC. Giessen, Antikensammlung der Universität inv. KIII-46. 21.5 × 7.1 cm.*

Figure 7.14: Attic red-figure Castulo stemless, c. *460 BC. Giessen, Antikensammlung der Universität inv. KIII-46. 21.5 × 7.1 cm.*

it. A slightly later plain-rimmed stemless cup, a delicate version of the Castulo, carries the name of Sotades incised on the foot,[29] so he was willing to have his name appear on a more run-of-the-mill shape than usual. However, this does not link him directly with the shape with which we are concerned. The problem still needs more investigation.

As the century progressed, the popularity of stemless cups increased; H. R. W. Smith (1943, 23) commented on the 'tendency of Attic cups to run, in the end, to stemlesses' and they appear

more frequently than before in painted scenes.[30] However, the size and proportions of the red-figure Castulo cups become less ample, being furnished with a taller and more elaborate foot, a deeper and smaller body, and tending to lose its 'out of phase' jog inside and its concave lip outside. Less attention was paid to reserving and the quality of the decoration deteriorated, with simple painted scenes on the inside only. Shefton's comments on the deterioration of the black Castulo shape are parallcled in red-figure.[31]

Notes

1 I am grateful to Sally Waite for the invitation to speak at Brian Shefton's memorial gathering in April 2013. For advice and assistance, my thanks go to Charles Arnold, Lucilla Burn, David Gill, Thomas Mannack, Joan Mertens, Matthias Recke, Phoebe Segal, Anja Ulbrich, Sue Willetts and Dyfri Williams. For permission to illustrate, I wish to thank the following museums: Boston, Museum of Fine Arts; Giessen, Antikensammlung, Institut für Altertumswissenschaften/ Klassische Archäologie, Justus-Liebig-Universität; Newcastle, The Great North Museum: Hancock, The Shefton Collection; New York, Metropolitan Museum of Art.

2 1979; 1986; 1989; 1990a; 1990b; 1994; 1995. These dates relate to the years in which the lectures or interventions were delivered.

3 Newcastle, The Great North Museum, The Shefton Collection 433 (15 cm × 4.4 cm). See also two others: 372 (16 cm × 4.6 cm) and 728 (15.4 cm × 5.2 cm).

4 Graffiti: Shefton (1990a, 85–98) (95–97 with J. H. W. Penney) with references.

5 Shefton (1979, 403 and 1990a, 88). 'During much of the fifth century it was the Greek artefact which reached further into the barbarian world than perhaps any other', Shefton (1990a, 86).

6 Some cups that are called stemlesses are very close to their stemmed varieties. The black-figure Segment Class (*ABV* 212–5; *Para* 102–4; *Add*² 57) and the Class of Top-band Stemlesses (*Para* 100–2; *Add*² 56–7) are basically similar to type C cups (see Bloesch 1940, 118–119 'Segmentschalen'; *Agora* XXIII 67–68). The bowl curves into a torus foot.

7 The difficulty in pinning down the cup-skyphos can be shown by following Beazley's trajectory: 'cup-kotyle' (*Attic Red-figured Vases in American Museums*, Harvard, 1918, 202); 'skyphos (kotyle) Form C (Schalen-kotyle)' (*Attische Vasenmaler des rotfigurigen Stils*, Tübingen, 1925, 4); 'kotyle, type C (cup-kotyle)' (*CVA* Oxford 1 (3), 33); 'cup-kotyle' (*Greek Vases in Poland*, Oxford, 1928, 35–36); 'skyphos type C (cup-skyphos)' *ARV¹* 1942, x; 'there are many types' (*ARV²* 1963, li). For black cup-skyphoi, see *Agora* XII, 109–10, and for black-figure and red-figure, see *Agora* XXIII, 59–61 and *Agora* XXX, 66. The name 'cup-skyphos' is even now not universally accepted, and unsurprisingly Beazley in *ARV²* was not immune to inconsistent nomenclature.

8 Late Archaic stemless cups: black-glaze, *Agora* XII 98–99 and *Hesperia* 55 (1986) 15 (Roberts); red-figure, *Agora* XXX 66, n. 2 and cat. nos. 1365–6, pl. 127. For black figure stemlesses, see n. 6.

9 Boston MFA 22.678. Dyfri Williams (by letter) says the cup 'made me think of the Apollodoros group when I saw it on the screen, but I need to give it more thought'. Apollodoros Group: *ARV²* 117–21, 1604, 1627; *Para* 332–3; *Add*² 174–5.

10 Once on loan to the Fogg Museum, Harvard University and to the Ashmolean Museum, Oxford: *ARV²* 445, 252; *Add*² 241; Buitron-Oliver (1995, pl. 83, no. 142); and ibid. 71 for notes on cup-skyphoi and stemlesses.

11 See also for a few slightly later: Athens, Acr: *ARV²* 479, 334 Makron; Kunisch (1997, 219, no. 548) ('saucer-like foot'); Tübingen S/10 1538 (E 22): *ARV²* 332, 34; *Para* 358; *Add*² 217; *CVA* Tübingen 5 (54) pl. 5 (2622) 4–5 Onesimos; London, British Museum E 123: *ARV²* 397, 48 The Painter of the Yale Cup; Athens, Agora P23826, *ARV²* 398, 2 manner of the Painter of the Yale Cup; *Agora* XXX pl. 127, 1367; Berlin inv. 4921: *ARV²* 560, 159 The Pan Painter. The Class of Agora P 10539 (*Agora* XII, 99–100) is a late archaic black (and sometimes coral-red) stemless. Delicate stemlesses continue into the Early Classical period with the work of Sotades,

Hegesiboulos II and The Hesiod Painter (*ARV²* 774) and cf. Rheneia cups (*Agora* XII 100–101) and bolsals (*Agora* XII 107–8 and Gill in this volume).

12 Heidelberg, Universität inv. 57/8: *ARV²* 644, 132 and 1663; *Para* 400; *Add²* 275 The Providence Painter.

13 Oxford, Ashmolean 1885.495: Vickers (1979, 38–41, fig. 7). Vickers (ad loc.) sorted out the contents of the woman's grave at Nymphaeum and dates the pottery to *c.* 430–420 BC. The Castulo cup looks a little earlier than the rest.

14 'Out of phase': Shefton (1990b, 169, n. 17). This 'out of phase' detail is also found on many cups with plain rim but of course they lack the thickening.

15 Shefton (1990a) 'it is not easy to be precise on the chronology of any individual example of these cups'. Shefton had misgivings about the name 'Castulo' as the pieces from that site were late and uncharacteristic: Shefton (1986, 137 ('several peculiar features'), 1989, 196 ('degenerate' and 'may indeed not all be Attic products'), 1990a, 85 ('lapsing from the norm') and 87 ('eccentricities')).

16 See Shefton (1990a, n. 18). Known find-spots are mainly in Greece and Italy, with an outlier found in Naucratis: London, British Museum E 134.5 (1888,0601.602), which may join the fragment in Oxford, Ashmolean Museum G138.24 (*CVA* Oxford pl. 14 (106) 24 and see p. 13 'The style recalls the latest manifestations of the school of Douris, such as the work of the painter of the Munich cup 2660'). There are a few black Castulo cups with over-painting, e.g. London British Museum 1885,1213.36, from the Kamiros cemetery, tomb 132, Rhodes and Moscow, Pushkin Museum (see Shefton 1990b, 174 Pantikapaion (Kerch)).

17 Caskey (1922, 206, no. 161) (see n. 20 below).

18 Shefton (1990a, 169, n. 19) ('still late archaic').

19 London, British Museum 1895,1027.2, from Thebes: Csapo and Miller (1991, pl. 97, a–c); Shefton (1990a, pl. 4).

20 Boston, Museum of Fine Arts 01.8089: *ARV²* 770, 2 (see n. 17 above).

21 New York, Metropolitan Museum of Art 17.23.10: *ARV²* 784, 25; *Para* 417; *Add²* 289.

22 Giessen, Antikensammlung der Universität inv. KIII-46, from Capua: *ARV²* 768, 35, and 1669; *Add²* 287; *CVA* Giessen 1 (70) pls. 38 (3515) 4–6 and 39 (3516) 1–2, Beil. 8, 2; *LIMC* II (1984) 948, no. 96 and pl. 700, Atalante.

23 Satyrs were popular figures on stemlesses, battling with animals and maenads.

24 For early incised patterns, see Ure (1936), and *Agora* XII, 22ff. The Giessen cup was not listed in Ure's article and Beazley in *ARV²* did not mention the incising. I know of no black Castulo cups with incised decoration, see Shefton (1990a, 98).

25 E.g. Naples, Mus. Arch. 2628: *ARV²* 764, 5; Hoffmann (1997, figs. 55–56); Williams (2006, 297–298, figs. 6–7). See also Williams (2004, 112–113).

26 A useful survey of potters and pottery shops in Athens is to be found in Williams (2009). Excavations of the Marathon St. workshop produced black- and red-figure fragments, black pots and lamps, and unglazed pottery (see Williams 2009, 308, n. 39).

27 The Penthesilea Painter and his workshop: *ARV²* 877–971; The Eretria Painter: Lezzi-Hafter (1988); The Phiale and Achilles Painters: Oakley (1990 and 1997). What are named as the Penthesilea Painter's 'cup-skyphoi' are 'deep stemlesses'.

28 See n. 25 above.

29 Madrid, Museo Arqueologico Nacional 1999/99/85: Cabrera (2003, no. 114); Warden (2004, 120–23, no. 26), attributed to the Hippacontist Painter (dated too late).

30 See Warsaw 142464 (ex Czartoryski 79): *ARV²* 797, 142 and 1670; *Para* 419; *Add²* 290 Euaion Painter. See also the fragments in Oxford from Al Mina: Beazley (1939, 13, 37; 16, 43; 18, 49; 21, 54) which spread from *c.* 440 (the Group of Polygnotos) to *c.* 410 BC (not far from the Talos Painter).

31 See n. 15.

Bibliography

Beazley, J. D. (1939) Excavations at Al Mina Sueidia. *Journal of Hellenic Studies* 59, 1–44.

Bloesch, H. (1940) *Formen Attischer Schalen von Exekias bis Ende des Strengen Stils*. Bern.

Buitron-Oliver, D. (1995) *Douris: a Master-painter of Athenian Red-figure Vases*. Mainz.

Cabrera, P. (ed.) (2003) *La Colección Várez FISA en le Museo Arqueológica Nacional*. Madrid.

Caskey, L. D. (1922) *Geometry of Greek Vases*. Boston.

Csapo, E. and Miller, M. C. (1991) The "Kottabos Toast" and an Inscribed Red-Figured Cup. *Hesperia* 60, 367–382.

Hoffmann, H. (1997) *Sotades, Symbols of Immortality on Greek Vases*. Oxford.

Kunisch, N. (1997) *Makron*. Mainz am Rhein.

Lezzi-Hafter, A. (1988) *Der Eretria-Maler*. Mainz am Rhein.

Oakley, J. H. (1990) *The Phiale Painter*. Mainz am Rhein.

Oakley, J. H. (1997) *The Achilles Painter*. Mainz am Rhein.

Oakley, J. H. and Palagia, O. (eds.) (2009) *Athenian Potters and Painters II*. Oxford.

Robertson, M. (1976) Beazley and After. *Münchener Jahrbuch des Bildenden Kunst* 27 (1976), 20–46.

Shefton, B. B. (1979) Discussion. In Niemeyer, H. G. (ed.) *Die Phönizier im Westen. Die Beiträge des Internationalen Symposium* über *'Die Phönizische Expansion im Westlichen Mittelmeerraum'*, Cologne 1979 (Mainz). *Madrider Beiträge* 8 (1982), 403–405.

Shefton, B. B. (1986) Intervention. In *Grecs et Ibères au IVe siècle avant Jésus-Christ (Table Ronde Bordeaux 1986)*. *Revue des Études Anciennes* 89 (1987), 134–138.

Shefton, B. B. (1989) Interventions. In *La Magna Grecia e il lontano Occidente, Atti 29 Taranto Convegno Magna Grecia, Taranto, 6–11 Ottobre 1989* (Taranto, 1990), 195–196.

Shefton, B. B. (1990a) The Castulo cup: an Attic shape in black glaze of special significance in Sicily. In *Atti Convegno Internazionale 'I vasi attici ed altre ceramiche coeve in Sicilia' Catania 1990* (Catania, 1996), Rizza, G.and Giudice, F. (eds.), 85–98.

Shefton, B. B. (1990b) Castulo cups in the Aegean, the Black Sea area and the Near East with the respective hinterland. In *Sur les traces des Argonautes, Proceedings of the 6th International Symposium on the Ancient History of the Black Sea Littoral, Vani, Georgia 1990* (Besançon, Paris and Tbilisi, 1996), 163–186, esp. n. 1.

Shefton, B. B. (1994) Greek Imports at the Extremities of the Mediterranean, West and East: Reflections on the Case of Iberia in the Fifth Century BC. In Social Complexity and the Development of Towns in Iberia, from the Copper Age to the Second Century AD. *Proceedings of the British Academy* 86 (1995), 127–155, esp. 136–8.

Shefton, B. B. (1995) Some special features of Attic import on Phoenician sites in Israel. In *Actas del IV Congresso Internacional de Estudios Fenicios y Púnicos, Cadiz 2 al 6 de octobre de 1995* (Cadiz, 2000), 1121–1134.

Smith, H. R. W. (1943) *Corpus Vasorum Antiquorum. USA Fascicule 10, San Francisco Collections Fascicule 1*. Cambridge, Massachusetts.

Ure, A. D. (1936) Red Figure Cups with Incised and Stamped Decoration I. *Journal of Hellenic Studies*, 56, 20–215

Vickers, M. (1979) *Skythian Treasures in Oxford*, Ashmolean Museum, Oxford.

Warden, P. G. (ed.) (2004) *Greek Vase Painting: Form, Figure and Narrative, Treasures of the National Archaeological Museum in Madrid*. Meadows Museum, Dallas.

Williams, D. (2004) Sotades: Plastic and White. In Keay, S. and Moser, S. (eds.) *Greek Art in View, Studies in Honour of Brian Sparkes*, 95–120. Oxford.

Williams, D. (2006) The Sotades Tomb. In Cohen, B. (ed.) *The Colors of Clay, Special Techniques in Athenian Vases*, 292–298. Los Angeles.

Williams, D. (2009) Picturing Potters and Painters. In Oakley, J. H. and Palagia, O. (eds.) *Athenian Potters and Painters II*, 306–317. Oxford.

8. The Nostell Priory Bolsal

David W. J. Gill

Black-glossed pottery was one of the research interests of Professor Brian Shefton[1] and this is reflected in the important holdings in the Great North Museum. Among the acquisitions is an early example of a 'bolsal' – a two-handled cup type named by Sir John Beazley after figure-decorated examples in Bologna and in Thessalonica (from Olynthos) – once in the Nostell Priory collection. The Newcastle bolsal is similar to a smaller version reportedly discovered in southern Sicily (and now in the British Museum). The study of stamped decoration allows pottery workshops to be identified.

One of the areas of strength in the classical collections in the Great North Museum is the holdings of Attic black-glossed pottery. Two pieces featured in Brian Shefton's report on acquisitions by the then Greek Museum: a 'fruit server' and a rim-rattling cup-kantharos (Shefton 1969/70, 61–62, nos. 15–16). Shefton had acquired a number of unusual pieces through the 1960s, including small bowls decorated with 'coral-red' technique (listed in Sparkes and Talcott 1970, 436).[2] The Greek Museum also received a number of Attic black-glossed pieces from the Wellcome Trustees (de Peyer and Johnston 1986, 290; see also Gill 2005). Shefton researched the distribution of Attic black-glossed pottery and identified the importance of the Attic Castulo cup, found in Spain, Central Europe, North Africa and the Near East (Shefton 1996a; 1996b).[3]

Shefton's interest in this category of plain pottery was pioneering. It probably derives in part from his time as a student at the British School at Athens and in particular working on the finds from the American School's excavations in the Athenian Agora during the late 1940s (Gill in press). This coincided with the work of Peter E. Corbett on material from a well on the Kolonos Agoraios, excavated in 1937, and published in 1949. Corbett's most important publication in this field was a study of the stamps used in the pottery workshops at Athens (Corbett 1955). However it was the monumental two-volume study of Attic black-glossed pottery by Brian Sparkes and Lucy Talcott that provided the definitive outline for studying this prolific category of material (Sparkes and Talcott 1970). This volume had been preceded by the first 'Picture Book' in the Athenian Agora series entitled *Pots and Pans of Classical Athens* (Sparkes and Talcott 1951). Talcott herself had studied black-glossed pottery from the American excavations in the 1930s with a focus on fifth-century material recovered from a well to the south of the later Stoa of Attalos (Talcott 1935). Sparkes, like Corbett, had made a study of figured stamps that appeared on a small number of Attic pots (Sparkes 1968). He also published a study of perfume-pots named in honour of Talcott (Sparkes 1977). Subsequent specialised studies of Attic black-glossed pottery include John Hayes' 1984 catalogue of the black-glossed pottery in the Royal Ontario Museum.

The Use of the Term 'Bolsal'

The focus of this paper is an Attic black-glossed bolsal, acquired by Shefton from the dispersal of the Nostell Priory collection (inv. no. 572, Fig. 8.1). Bolsals are a relatively common shape. They first appear in the second half of the fifth century BC and continued into the early Hellenistic period. They have two horizontal u-shaped handles placed close to the rim, but what makes them

Figure 8.1: Interior of Nostell Priory bolsal, Newcastle upon Tyne, Shefton Collection 572. Photograph: Colin Davison.

distinctive is the concave moulding on the lower part of the wall that leads into a flared foot. The name 'bolsal' was first used by Sir John Beazley in his study of miniature Panathenaics (Beazley 1940/45, 18–19). Beazley was discussing the contents of a grave at Ialysos on Rhodes that contained one of the miniature Panthenaics, and he noted that one of the other pieces was a "black cup-skyphos of a type current in the late fifth century and the first half of the fourth". He noted parallels in Oxford and from excavations in the Athenian Agora. He observed that there were some red-figured examples, one late fifth-century small example in Bologna showing a child's scene, and the other a fourth-century piece found at Olynthos and stored in the collection in Salonica. He continued: "The type needs a name, and might be called Bolsal after Bologna and Salonica". The name was quickly adopted and appears in the study of Attic black-glossed pottery from the Agora published by Corbett (e.g. Corbett 1949, 301). Corbett continued to use it to describe pottery found at Naukratis in the Nile Delta (Corbett and Woodhead 1955, 257, 258, nos. 7 and 12). Franklin P. Johnsons's study of owl skyphoi also referred to bolsals and to Beazley's earlier observations (Johnson 1955, 121). Talcott (1951) in her review of D. M. Robinson's study of pottery from Olynthos, suggested bolsal as an alternative to 'kylix' and cited Beazley's proposed name. Yet Rodney Young (1951, 117, no. 3, 3, 119, no. 5, 2) continued to use the term 'cup-skyphos' qualified with 'Bolsal type'.

The term started to be used widely in excavation reports of the British School at Athens, including the publication of finds made at Old Smyrna (Boardman 1958/59, 179, under no. 202) and at the Dema House in Attica (Jones *et al.*1962, 89–91, nos. 17–22). Shefton (1965, 259) himself corrected Robert M. Cook's definition of the bolsal and noted the "differential characteristic, the concaving just above the foot!".

The Nostell Priory Collection

The Newcastle bolsal was acquired from the dispersal of the contents of the 'Greek and Etruscan vases from Nostell Priory' at Christie's in London, 30 April, 1975 ('Greek and Etruscan Vases from Nostell Priory').[4] The sale of some 80 Athenian and South Italian pots was reported by Geraldine Norman for *The Times* (Norman 1975a; sale illustrated, *The Times* 30 April, 1975, 20). The sale itself realised £63,047 including a record price for a South Italian pot (Norman 1975b). There was little outcry about the 'tragic dispersal' of this historically important collection of Greek pottery (Vaughan 1975). Nostell Priory (Fig. 8.2) is located to the south-east of Wakefield in Yorkshire (Jackson-Stops 1982; Raikes and Knox 2001). The house was remodelled by Robert Adam in the late eighteenth century under Sir Rowland Winn, the 5th Baronet. Sir Rowland had made the Grand Tour between 1756 and 1761, spending part of the time in Rome. The house passed to John Williamson (who took the name Winn) in 1805, but he died young in Rome in 1817. The house passed to his younger brother Charles Winn, and he arranged for John Winn's collection of Greek pottery to be returned from Italy. Charles Winn had expanded the holdings by purchasing part of the collection of Abbé Campbell, formed in Naples, in 1818 for £500 (Campbell 1818). Campbell was a correspondent of Horatio Nelson, and he died in Naples on 20 March, 1830 (*The Morning Post* 16 April, 1830). Nostell Priory was presented to the National Trust in 1955.

Nostell Priory retains some ancient pottery, some bought back subsequent to the sale. The items include an Attic black-figured lekythos attributed to the class of Athens 581,[5] an Attic red-figured cup attributed to the painter of Vienna 155,[6] a Campanian hydria attributed to the Capua painter,[7] and a Lucanian nestoris attributed to the Dawlish painter.[8] Some of these are also known to come from the Campbell collection. There are also Roman sculptures including an inscribed cinerarium. The Newcastle bolsal passed through the Ohly Gallery subsequent to the Nostell Priory sale. Other Nostell Priory vases include an Athenian black-figured amphora,[9] an Attic black-figured miniature belly-amphora,[10] a Campanian hydria attributed to the Fillet group,[11] a Lucanian nestoris attributed to the painter of Naples 1959,[12] and an Etruscan red-figured duck askos attributed to the Clusium group.[13]

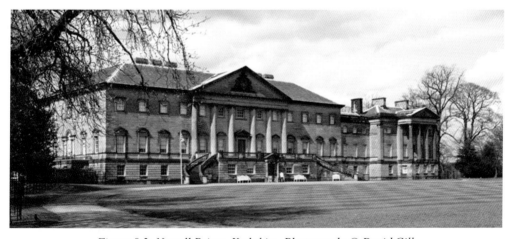

Figure 8.2: Nostell Priory, Yorkshire. Photograph: © David Gill.

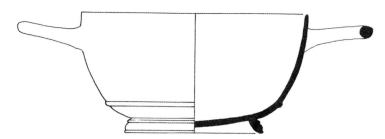

Figure 8.3: Nostell Priory bolsal, Newcastle upon Tyne, Shefton Collection 572. Drawing: © David Gill.

Figure 8.4: Stamped decoration on Nostell Priory bolsal, Newcastle upon Tyne, Shefton Collection 572. Photograph: © David Gill.

The collecting history of the Newcastle bolsal appears to be a notable one. But it raises a wider issue for the study of archaeological material that has passed through private and public collections. The scandals surrounding the so-called Medici conspiracy, and which have seen the return of around 200 items from North American public and private collections, have reminded us of the need to be rigorous in the documenting of classical histories (Watson and Todeschini 2006; Gill 2009). The widespread use of the term 'provenance' (or provenience) disguises two important aspects of an object: the archaeological information about where an item was found, and the post-surfacing history as the piece passes through the hands of collectors and curators (Gill 2010). Too often 'good provenance' can be equated with 'good pedigree' rather than with a clearly documented collecting history that charts the documented movement of an object from collection to collection.

In the case of this bolsal there is a known collecting history but we can only suspect that it was found in southern Italy. Certainly Athenian black-glossed pottery is commonplace in Campania, as well as in the cemeteries of the Greek colonies of southern Italy and Sicily (Gill 1986; see also Gill 1996). There appears to be relatively less Athenian black-glossed material from cemeteries in Etruria. It is a reminder that the loss of archaeological context has intellectual consequences for the study of the past (Gill 2012).

The Nostell Priory bolsal is unusual as it does not have a concave lower wall, the defining feature of the bolsal (Fig. 8.3). Instead it has a raised strip partway down the wall. Such raised areas are found on some of the larger black-glossed stemless cups of the third quarter of the fifth century BC. The bolsal bears stamped decoration inside (Fig. 8.4). This consists of two rings of palmettes around impressed concentric circles. The inner ring consists of nine palmettes resting on a line of impressed ovules, and the outer band is a series of 21 linked palmettes resting on the impressed circles, with a row of impressed ovules on the inside of the impressed rings.

Small Bolsals

The profile of the Nostell Priory bolsal finds a close parallel with a small example now in the British Museum[14] and reportedly part of a collection formed by Douglas Sladen that was derived from Acragas or Selinus in southern Sicily (Figs. 8.5–8.7). Notes in the British Museum accession register urge caution over the reported find-spots for the Sladen collection as some of the material is Egyptian in character. The smaller example is impressed inside with concentric circles. These same circles could have been used as the base for stamped decoration that was never applied. Such circles can be detected on the Nostell Priory bolsal underlying this stamped decoration. A second small example[15] (Fig. 8.8) also with a ridge on the lower wall, but with a ridged splaying foot, comes from one of the cemeteries at Camarina in Sicily (Gill 1986, 398, pl. 74, no. L12).

These two smaller bolsals highlight another important issue as both are small. Would they have been usable or are they representative of larger pieces? Yet for even smaller versions, like these, it is tempting to use the word 'toy'. Are such small-scale items intended for funerary use? Are they found exclusively in children's graves? Again, it is a reminder of the importance of the archaeological contexts to interpret the objects.

Bolsal Parallels from the Athenian Agora

The Nostell Priory and its small counterpart in London, the Sladen bolsal, lack any archaeological context so that it is only possible to suggest a date using stylistic terms. However a comparable bolsal[16] (Fig. 8.9) with a ridge around the lower walls, and decorated with 'a circle of ovules,

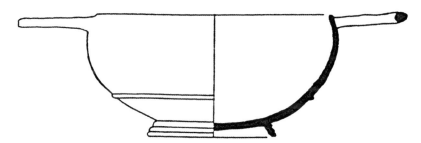

Figure 8.5: Bolsal, London, British Museum 1956.2-16.66. Drawing: © David Gill.

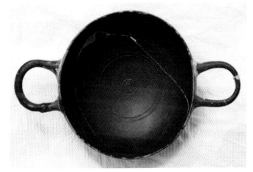

Figure 8.6: Underside of bolsal, London, British Museum 1956.2-16.66. Photograph: © David Gill.

Figure 8.7: Interior of bolsal, London, British Museum 1956.2-16.66. Photograph: © David Gill.

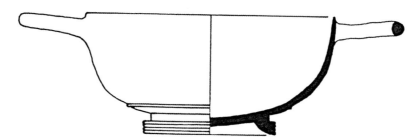

Figure 8.8: Bolsal from Camarina, Sicily, Syracuse, Museo Nazionale 76419. Drawing: © David Gill.

zone of palmettes, two circles of ovules, zone of linked palmettes', was found in the Athenian Agora (Corbett 1949, 319, fig. 1, pl. 94, no. 156; Sparkes and Talcott 1970, 273, fig. 6, pls. 24, 53, no. 534). The comparative material includes a mention of the Nostell Priory bolsal, noting "this early shape with ridged foot and elaborate pattern". The scheme of decoration between the Nostell Priory bolsal and the Agora one is very close, although they do not appear to use the same palmette stamp. This Agora bolsal was found in a well on the north-east slope of the Areopagos. The suggested date of the deposit, based on the black-figured, red-figured and black-glossed pottery found in it, is "ca. 430–420 BC" (Sparkes and Talcott 1970, 395; Moore and Philippides 1986, 334; Moore 1997, 365). This is slightly earlier than the previously suggested date of the "last quarter of fifth century BC" (Howland 1958, 242). Among the later attributed pieces is a red-figured epinetron attributed 'near the painter of Berlin 2624' and dated to "ca. 430–420 BC" (Moore 1997, 351, pl. 154, no. 1646).

A second bolsal[17] (Fig. 8.10) from the Agora was found in a well deposit under the Library of Pantainos (Camp II 2001, 196–197, figs. 190–192), a building constructed at the start of the second century AD (Talcott 1935, 488, fig. 10, no. 17, 502, fig. 20, no. 17, 504). This too has a 'raised ring around the lower body' (Talcott 1935, 504). Although the centre is damaged, it clearly had palmettes, and the two rings of impressed ovules around impressed lines, and then a circle of linked palmettes. The deposit is now dated to "ca. 440–425 BC" (Sparkes and Talcott 1970, 398; Moore and Philippides 1986, 336; Moore 1997, 365), an earlier date than had previously been assigned (Howland 1958, 244: "ca. 430–420 BC"). Attributed pots include a calyx-krater attributed to the group of Polygnotos (Moore 1997, 180, pl. 37, no. 274, "ca. 440 BC"), a squat lekythos attributed to the White-Line class of Squat Lekythoi (Moore 1997, 264, pl. 90, no. 908, "ca. 440–430 BC"), and a pyxis attributed to the Druot painter (Moore 1997, 272, pl. 96, no. 993, "ca. 430 BC"). A third bolsal[18] was derived from a construction filling under the South Stoa I (noted under Sparkes and Talcott 1970, 273, under no. 534). This building seems to have been constructed c. 430–420 BC (Camp II 2001, 127–29, figs. 121–122). These three bolsals from the Agora are reported by Sparkes and Talcott to share "the same pattern and stamp" (Sparkes and Talcott 1970, 273, under no. 534). A fourth bolsal[19] comes from an unused foundation trench associated with the creation of the New Bouleuterion on the west side of the Agora (Thompson 1937, 154, 155, fig. 90, e). Sparkes and Talcott (1970, 273, no. 534) noted that it has the same underside and a slightly less elaborate [stamped] pattern than the others. The New Bouleuterion appears to have been constructed in the second half of the Peloponnesian War, "between 416 and 409" (Camp II 2001, 127).

Identifying Black-Glossed Pottery Workshops

One of the pioneering studies of the impressed stamps on Attic black-glossed pottery was made by Peter Corbett (1955). He observed that the same stamps had been used to decorate a range of pieces found within two deposits in the Athenian Agora dating to the fourth century BC. He noted the important feature that stamps were applied with a circular motion allowing variation in the final appearance. Corbett identified two other important aspects of these fourth-century workshops: the first that a range of shapes could be decorated with a single stamp, and secondly that the variations in a single shape that could suggest a stylistic chronological differentiation were in fact contemporary.

It has been possible to apply Corbett's work for the fourth century, where decoration became more standardised, to stamped pottery of the second half of the fifth century (Gill 1986; 1990). A study of fifth-century Athenian black-glossed pottery from the Fikellura cemetery at Camirus on Rhodes has demonstrated that different shapes were decorated with a common stamp (Gill 1984). One of the best examples is provided by a bolsal[20] and a Rheneia cup[21] (Gill 1984, 105, fig. 2) (Figs. 8.11–8.13). This suggests that a range of pieces were arriving as a batch in a single consignment and were then separated to meet the funerary demands of the local community. Such workshop studies can be used to link, for example, bolsals, amphoriskoi, and feeders.

Figure 8.9: Detail of stamped decoration from bolsal, Athens Agora P9819. Photograph: courtesy of the American School of Classical Studies at Athens.

Figure 8.10: Detail of stamped decoration from bolsal, Athens Agora P2294. Photograph: courtesy of the American School of Classical Studies at Athens.

The Date of the Nostell Priory Bolsal

What is the date of the Nostell Priory bolsal? A convenient *terminus ante quem* is provided by the deposits on Rheneia linked to the Athenian purification of the island of Delos in 426/5 BC when burials were removed and the grave contents placed in a deposit on the island of Rheneia. This contained bolsals with the more standard concave wall (Sparkes and Talcott 1970, 107; see Dugas 1952, pls. 49 and 52). The implication is that bolsals without the concave section were earlier.

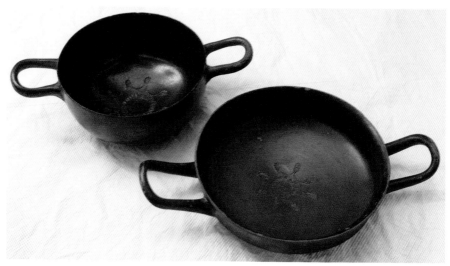

Figure 8.11: Bolsal and Rheneia cup from separate graves in the Fikellura cemetery, Camirus, Rhodes, London, British Museum 64.10-7.1634 and 64.10-7.1598. Photograph: © David Gill.

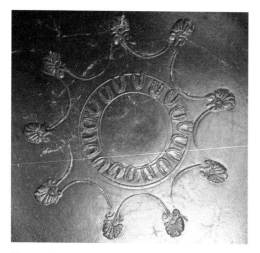

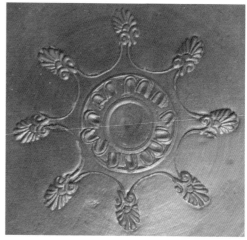

Figure 8.12: Detail of stamped decoration from bolsal, London, British Museum 64.10-7.1634. Photograph: © David Gill.

Figure 8.13: Stamped decoration on Rheneia cup from Fikellura cemetery, Camirus, Rhodes, London, British Museum 64.10-7.1598. Photograph: © David Gill.

A bolsal was found in grave 2 on the north side of the Südhügel in the Athenian Kerameikos (Knigge 1976, 10, 112–113, no. 9, dated to 433/2 BC). This seems to be one of the graves for Thersander and Simylos, envoys from the island of Kerkyra, who died as a result of an accident almost certainly in 433/2 BC; the stele was replaced in the early fourth century BC (Knigge 1991, 97–101, no. 11). The envoys are noted by Thucydides (1.31). This bolsal, like the ones from the

Rheneia pit, also had a concave lower wall. If the identification is correct, and this is indeed the contents of a grave honouring the envoys just prior to the outbreak of the Peloponnesian War, it seems likely that the Nostell Priory bolsal should be earlier in date.

The earliest bolsals seem to have a rounded wall without either a ridge or a concave section. One was found in a grave at Aslaia in Cyrenaica (Vickers and Bazama 1971; Gill 1986, 398, no. L3; Elrashedy 2002, 82, 129, no. 40, pl. 77, 2 [noting the Nostell Priory bolsal] Fig. 8.14). Vickers, who published the group, described it as a proto-bolsal. Elrashedy noted that there was no stamped decoration. The other contents of the grave included a Panathenaic amphora attributed to the Kleophrades painter (Elrashedy 2002, 139, no. 3, pl. 115, 1–2), and an Attic red-figured pelike allegedly attributed by Shefton to the painter of Munich 2335 (Elrashedy 2002, 23, no. 18, pl. 19, 1–2).[22] Two other early bolsals, also without a ridge or concave section, are known. One comes from a grave at Elaious in the Hellespont, excavated during the Gallipoli campaign (Gill 2011), and is marked with a graffito in Greek[23] (Courby *et al.* 1915, 194, no. 45; Gill 1986, 498, pl. 73, no. L4) (Fig. 8.15). The original publication dated it to the end of the sixth century BC or the beginning of the fifth. There were two other black-glossed objects in the grave: an oinochoe and a footed cup. The second bolsal was found in the Fikellura cemetery at Camiros on Rhodes[24] (Gill 1986, 398, pls. 73 and 163, no. L5) (Fig. 8.16). The inside was decorated with a series of palmettes set round an impressed circle. This suggests that the Nostell Priory bolsal and the related pieces should probably be dated to the mid-430s BC.

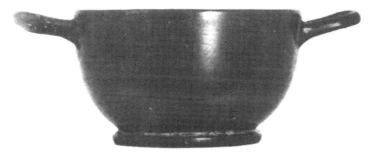

Figure 8.14: Bolsal from Aslaia, Cyrenaica. Source: Libya Antiqua.

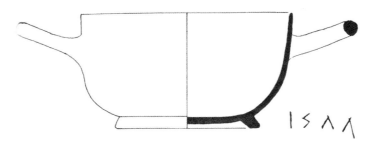

Figure 8.15: Bolsal from Elaious, Paris, Louvre. Drawing: © David Gill.

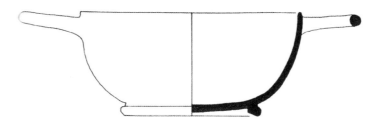

Figure 8.16: Bolsal from Fikellura cemetery, Camirus, Rhodes, London, British Museum 64.10-7.1635. Drawing: © David Gill.

Conclusion

The Nostell Priory bolsal is one of a series of unusual and sometimes unique pieces of Attic black-glossed pottery acquired by Shefton for the then Greek Museum. The collection forms a significant research resource for the study of the plain wares that were created alongside the better known, studied and illustrated figure-decorated pottery from ancient Athens. The bolsal is one of the earliest examples of the shape and can be placed alongside comparable pieces found in the Athenian Agora. It is also a reminder of the historic collections that were formed during the Grand Tour of Italy and that continue to inform contemporary discussion of Attic pottery.

Notes

1 I am grateful to the late Britan Shefton for introducing this bolsal to me. Lesley Fitton and Thomas Kiely were helpful in facilitating a study of the material in the British Museum, and Sally Waite arranged access to the Newcastle bolsal. Brian Sparkes has provided helpful comments on black-glossed pottery and their workshops.
2 See Tsingarida this volume.
3 See Sparkes this volume.
4 Shefton Collection 572; formerly Nostell Priory no. 34. Gill (1984, 103, fig. 1); noted Sparkes and Talcott (1970, 273, under no. 534).
5 Christie's 30 April, 1975, lot 14; Christie's South Kensington 25 April, 2001, lot 541; Beazley Archive 305304.
6 Christie's 30 April, 1975, lot 47; Christie's South Kensington 29 October, 2003, lot 50.
7 Christie's 30 April, 1975, lot 33; Christie's South Kensington 29 October, 2003, lot 125.
8 Christie's 30 April, 1975, lot 23; Christie's South Kensington 25 April, 2001, lot 540.
9 Christie's South Kensington 29 April, 2010, lot 53.
10 Christie's 30 April, 1975, lot 14 or 11; Christie's South Kensington 25 April, 2001, lot 542.
11 Christie's 30 April, 1975, lot 33; Christie's South Kensington 29 October, 2003, lot 124.
12 Christie's 30 April, 1975, lot 23; Christie's South Kensington 25 April, 2001, lot 539.
13 Christie's 30 April, 1975, lot 45; Christie's South Kensington 29 October, 2003, lot 123.
14 London, British Museum 1956.2-16.66.
15 Syracuse 76419, from Camarina, 25.
16 Agora P9819 M 18:8.
17 Agora P2294 R13:4.
18 Agora P23280 O 16:2.
19 Agora P8094 F-G 9–10.
20 London, British Museum 64.10-7.1634, from F269.

21 London, British Museum 64.10-7.1598, from a child's grave, F125.
22 Elrashedy noted that Shefton had not recalled providing the attribution.
23 Paris, Louvre 1915.45, grave S-X.
24 London, British Museum 64.10-7.1635, grave F163.

Bibliography

Beazley, J. D. (1940/45) Miniature Panathenaics. *Annual of the British School at Athens* 41, 10–21.
Boardman, J. (1959) Old Smyrna: the Attic Pottery. *Annual of the British School at Athens* 53/54, 152–181.
Camp II, J. M. (2001) *The Archaeology of Athens*. New Haven.
Campbell, A. H. (1818) *Catalogo di una collezione di vasi Greci ec. Appartenenti all; Abate Campbell del S. O. Gerasolimitano*. Italy.
Corbett, P. E. (1949) Attic Pottery of the Later Fifth Century from the Athenian Agora. *Hesperia* 18, 298–351.
Corbett, P. E. (1955) Palmette Stamps from an Attic Black-Glaze Workshop. *Hesperia* 24, 172–186.
Corbett, P. E. and Woodhead, G. (1955) A Forger of Graffiti. *Annual of the British School at Athens* 50, 251–265.
Courby, F., Chamonard, J. and Dhorme, E. (1915) Corps expéditionnaire d'Orient. Fouilles archéologiques sur l'emplacement de la nécropole d'Éléonte de Thrace. *Bulletin de Correspondance Hellénique* 39, 135–240.
de Peyer, R. M. and Johnston, A. W. (1986) Museum Supplement. Greek Antiquities from the Wellcome Collection: a Distribution List. *Journal of Hellenic Studies* 106, 286–294.
Dugas, C. (1952) *Les vases attiques à figures rouges*. Exploration archéologique de Délos, vol. 21. Paris, École française d'Athènes.
Elrashedy, F. M. (2002) *Imports of Post-Archaic Greek Pottery into Cyrenaica from the End of the Archaic to the Beginning of the Hellenistic Period*. BAR International Series, vol. 1022. Oxford.
Gill, D. W. J. (1984) The Workshops of the Attic Bolsal. In Brijder, H. A. G. (ed.) *Ancient Greek and Related Pottery*. Allard Pierson Series, vol. 5: 102–106. Amsterdam, Allard Pierson Museum.
Gill, D. W. J. (1986) Attic Black-Glazed Pottery in the Fifth century BC: Workshops and Export. D.Phil., Oxford.
Gill, D. W. J. (1990) Stamped Palmettes and an Attic Black-Glazed Oinochoe. *Oxford Journal of Archaeology* 9, 369–372.
Gill, D. W. J. (1996) Greece, Ancient, §V,8: Unpainted Pottery. In Turner, J. (ed.) *The Dictionary of Art*, vol. 13, 536–338. London.
Gill, D. W. J. (2005) From Wellcome Museum to Egypt Centre: Displaying Egyptology in Swansea. *Göttinger Miszellen,* 205, 47–54.
Gill, D. W. J. (2009) Homecomings: Learning from the Return of Antiquities to Italy. In Charney N. (ed.) *Art and Crime: Exploring the Dark Side of the Art World*, 13–25. Santa Barbara.
Gill, D. W. J. (2010) Collecting Histories and the Market for Classical Antiquities. *Journal of Art Crime* 3, 3–10.
Gill, D. W. J. (2011) Excavating Under Gunfire: Archaeologists in the Aegean During the First World War. *Public Archaeology* 10, 187–199.
Gill, D. W. J. (2012) The Material and Intellectual Consequences of Acquiring the Sarpedon Krater. In Lazrus, P. K. and Barker, A. W. (eds.) *All the King's Horses: Essays on the Impact of Looting and the Illicit Antiquities Trade on our Knowledge of the Past*, 25–42. Washington DC, Society for American Archaeology.
Gill, D. W. J. (In press) Shefton, Brian Benjamin (1919–2012) in *Oxford Dictionary of National Biography*. Oxford.
Hayes, J. W. (1984) *Greek and Italian Black-Gloss Wares and Related Wares in the Royal Ontario Museum: a Catalogue*. Toronto, Royal Ontario Museum.
Howland, R. H. (1958) *The Athenian Agora IV, Greek Lamps and their Survivals*. Princeton.

Jackson-Stops, G. (1982) *Nostell Priory, Yorkshire*. London, The National Trust.

Johnson, F. P. (1955) A Note on Owl Skyphoi. *American Journal of Archaeology* 59, 119–124.

Jones, J. E., Sackett, L. H. and Graham, A. J. (1962) The Dema House in Attica. *Annual of the British School at Athens* 57, 75–114.

Knigge, U. (1976) *Der Südhügel*. Kerameikos, vol. 9. Berlin.

Knigge, U. (1991) *The Athenian Kerameikos. History-Monuments-Excavations*. Athens.

Moore, M. B. (1997) *The Athenian Agora XXX, Attic Red-Figured and White-Ground Pottery*. Princeton.

Moore, M. B. and Philippides, M. Z. P. (1986) *The Athenian Agora XXIII, Attic Black-Figured Pottery*. Princeton.

Norman, G. (1975a) Auction of Nostell Priory Vases. *The Times* 21 April 1975, 16.

Norman, G. (1975b) Silver Soup Tureen Fetches Record £103,333. *The Times* 1 May, 1975, 18.

Raikes, S. and Knox, T. (2001) *Nostell Priory, Yorkshire*. Swindon, The National Trust.

Shefton, B. B. (1965) Review of R. M. Cook, Greek Painted Pottery (1960). *Journal of Hellenic Studies* 8, 257–260.

Shefton, B. B. (1970) The Greek Museum, The University of Newcastle upon Tyne. *Archaeological Reports* 16, 52–62.

Shefton, B. B. (1996a) The Castulo Cup: An Attic Shape in Black Glaze of Special Significance in Sicily in *I vasi Attici ed altre ceramiche coeve in Sicilia*, 85–98. Catania.

Shefton, B. B. (1996b) Castulo Cups in the Aegean, the Black Sea Area and the Near East with the Respective Hinterland in *Sur les traces des Argonautes: Actes du 6e symposium de Vani (Colchide)*, 164–186. Besançon and Paris.

Sparkes, B. A. (1968) Black Perseus. *Antike Kunst* 11, 3–16.

Sparkes, B. A. (1977) Quintain and the Talcott Class. *Antike Kunst* 20, 8–25.

Sparkes, B. A. and Talcott, L. (1951) *Pots and Pans of Classical Athens*. Princeton.

Sparkes, B. A. and Talcott, L. (1970) *The Athenian Agora XII, Black and Plain Pottery of the Sixth, Fifth and Fourth Centuries BC*. Princeton.

Talcott, L. (1935) Attic Black-Glazed Stamped Ware and Other Pottery from a Fifth Century Well. *Hesperia* 4, 475–523.

Talcott, L. (1951) Review of D. M. Robinson, Excavations at Olynthus XIII: Vases Found in 1934 and 1938 (1950). *American Journal of Archaeology* 55, 430–431.

Thompson, H. A. (1937) Buildings on the West Side of the Agora. *Hesperia* 6, 1–226.

Vaughan, A. J. W. (1975) Historic Photographs. *The Times* 7 May, 1975, 17.

Vickers, M. and Bazama, A. (1971) A Fifth Century BC Tomb in Cyrenaica. *Libya Antiqua* 8, 69–85.

Watson, P. and Todeschini. C. (2006) *The Medici Conspiracy: The Illicit Journey of Looted Antiquities from Italy's Tomb Raiders to the World's Great Museums*. New York.

Young, R. S. (1951) Sepulturae Intra Urbem. *Hesperia* 20, 67–134.

9. Two Coral-Red Bowls in the Shefton Collection

Athena Tsingarida

Following the interest of Brian Shefton[1] in coral-red and his seminal paper on the distribution of Achaemenid phialai and cups of the Class of Agora 10359 decorated with this special technique (Shefton 1999, 463–480), the study of two small coral-red bowls from the Newcastle Collection seemed an appropriate tribute to his scholarship and a small token of gratitude for his generosity.

It is generally acknowledged that this technique is often associated with cups (both figure-decorated and plain) and phialai of the Achaemenid type. It might occasionally occur on some other vases which seem to be elaborate and exceptional products (Cohen 2006, 44–70),[2] while the use of coral-red on small-sized shapes such as those in Newcastle remains rare and appear as "a strange choice for such a complicated procedure" (Sparkes and Talcott *Agora* XII, 20). In her paper on coral-red, Cohen noted that as the Late Archaic tradition of figure-decorated coral-red cups comes to an end in the beginning of the fifth century BC, the technique is extended to vessels of considerable size and on small delicate shapes influenced by metalwork and related to the Sotades workshop (Cohen 2006, 50).

The two small-scaled vessels in Newcastle (inv. nos. 382 and 169, Figs. 9.1–9.4) belong to a group of various small shapes decorated in coral-red which do not display the same delicate fabric of the contemporary Sotadean products.[3] While earlier literature focused on figure-decorated pieces, little attention was given to these plain wares coated with coral-red. The few studies devoted to them discussed questions of workshop attribution but laid emphasis on the main plain shapes decorated in this special technique: the Achaemenid phialai in clay, the cups of the Class of Agora P10359 (Tsingarida 2014, 263–272), the Rheneia cups and some Vi-cups (Padgett 2009, 220–231). In this chapter I would like to take as a starting point the bowls from Newcastle. Following a close examination of the two vessels, it should be possible to study them in relation to the other known plain shapes in coral-red and provide an updated overview of this distinctive group of vessels that might be the product of a single workshop.

Shefton Collection 382 has a ring foot and a shallow convex wall, incurving at the rim.[4] The latter is in-turned and forms a projecting lip inside (Fig. 9.5). The shape seems closer to the small bowl rather than to the salt cellar, based on its larger size (8.8 cm diameter at the rim), although the distinction between both classes is not always easy to draw (I am using the name given in *Agora* XII, 132–133).[5] Shefton Collection 382 is glazed with coral-red on the outside and inside wall, and on the underside of the foot. The rim, outer and inner faces of the foot are black-glazed while the resting surface of the ring foot is reserved (Fig. 9.1). Although it lacks exact known parallels, it is possible to draw some comparisons.

Among the known small black-glazed or coral-red bowls, the vase from Newcastle displays a similar wall profile to two vessels, one in the Agora[6] and another in the British Museum (Figs. 9.6 and 9.7).[7] While the latter two have a disc foot, the example in Newcastle bears a ring foot. This feature might suggest a later date of production since according to the typology and relative chronology proposed for the coral-red cups from the Agora, the disc foot belongs to the cups Class Agora P10359, generally dated to the first quarter of the fifth century BC, while the ring foot occurs either on transitional shapes such as one in London (Fig. 9.8)[8] or on Rheneia cups,

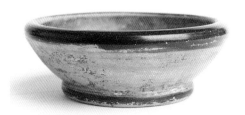

Figure 9.1: Newcastle upon Tyne, Shefton Collection 382. Photograph: Colin Davison.

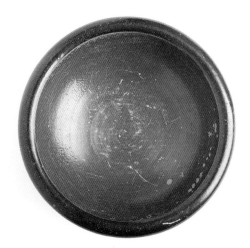

Figure 9.4: Newcastle upon Tyne, Shefton Collection 169. Photograph: Colin Davison.

Figure 9.2: Newcastle upon Tyne, Shefton Collection 382. Photograph: Colin Davison.

Figure 9.5: Profile drawing, Newcastle upon Tyne, Shefton Collection 382. Drawing: author; illustrator: A. Stoll, CReA-Patrimoine, ULB.

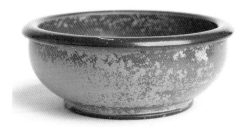

Figure 9.3: Newcastle upon Tyne, Shefton Collection 169. Photograph: Colin Davison.

reservé

Figure 9.6: Profile drawing of the small bowl, London, British Museum 1891.8-6.78. Drawing: author; Illustrator: A. Stoll, CReA-Patrimoine, ULB.

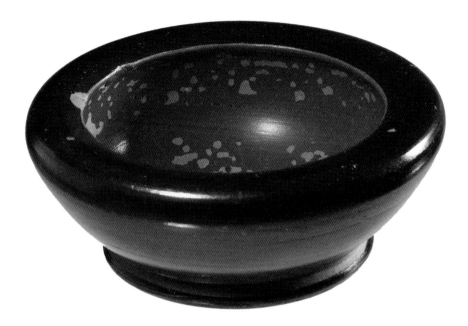

Figure 9.7: London, British Museum 1891.8-6.78. © Trustees of the British Museum.

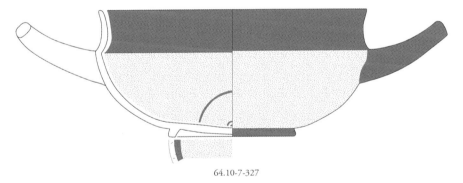

64.10-7-327

Figure 9.8: Profile drawing of the cup, London British Museum 1864.10-7-327. Drawing: author; Illustrator: A. Stoll, CReA-Patrimoine, ULB.

both types dated to the second quarter of the fifth century BC (*Agora* XII, 99, Padgett 2009, 230 n. 66).[9] The shape of the foot on the example in Newcastle closely recalls that of a coral-red Rheneia cup from Marion[10] (Padgett 2009, 226 figs. 15 and 17) and a black-glazed cup from the Athenian Agora (*Agora* XII, 267 no. 456).[11] All have a flat resting surface and a foot which is convex on both sides.

The extensive use of coral-red on the underside of the base might be further considered as a diagnostic feature. Although coral-red on this surface area seems to occur hand in hand with the

development of the ring foot in the second generation of coral-red cups or bowls, the surface is often completed with black-glazed dotted circles. The plain coated surface on the underside of the base in Newcastle may be paralleled with only a few known pieces: the "transitional" cup in the British Museum (Fig. 9.9),[12] three Rheneia cups from Marion (Padgett 2009, 225), [13] two from the Dema House (Oakley and Rotroff 1992, 99–100 no. 158 and fig. 9, pl. 44),[14] a bowl with wishbone handles from the Agora (*Agora* XII, 56 no. 68, pl. 4),[15] one from the Kerameikos (Knigge 1976, 48 fig. 19, 115),[16] a fragmentary skyphos from the Agora (Richter 1954, 133, fig. 7),[17] and the other miniature coral-red bowl in the Shefton Collection, all dated to the second quarter of the fifth century BC. Coral-red is also known on the underside of the base of a stemless cup with a lipped foot attributed to the circle of Sotades (Hölscher 1981, pl. 29.6)[18] and on the underside of the foot of some red-figure stemmed or stemless cups.[19]

The pattern of decoration of Shefton Collection 382 consists of coral-red applied on the outside and inside with a black-glazed rim and foot that is common on this shape but also on the two other important classes of drinking vessels decorated with this special technique, the cups of the Class of Agora P10359 and the Rheneia cups. Few cases vary slightly from this canonical pattern until now, a unique example of a salt cellar from Marion is all red,[20] while a few other cups[21] or bowls[22] might display a foot entirely red-glazed.

Although very few in number, the known coral-red bowls or salt cellars vary in shape types. We have seen that they might have either a disc or a ring foot. Regarding the profile of the wall, the bowls from Marion display a continuous convex profile but without the strongly in-turned projected lip seen on the examples in Newcastle and the Agora, while the one known contemporary example of a larger size from Berlin has an even more distinctive profile.[23] It follows a continuous convex line from the rim to the ring foot, the latter being concave on

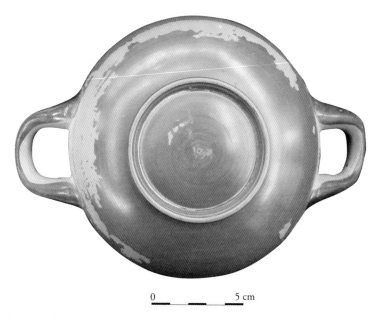

0 5 cm

Figure 9.9: London, British Museum 1864.10-7-327, view of the underside. Photograph: author. © *Trustees of the British Museum.*

the outer side and convex on its inner face. Following the size and type of the bowl (with a flaring foot), the shape falls into the category of bowls defined as "deep wall and convex-concave profile" by Sparkes and Talcott (*Agora* XII, 130), and finds its closest parallel in a black-glazed piece from the Athenian Agora.[24]

Judging by its small size,[25] the second vessel in Newcastle (inv. no. 169, Fig. 9.3) might be considered either a miniature bowl[26] or a salt cellar, although it does not display the distinctive foot and incurving rim profile of the latter shape. Shefton Collection 169 has a disc foot, a convex wall and an offset out-turned rim (Fig. 9.10). Foot and rim are black-glazed and coral-red decorates the outside, inside and the flat surface on the underside of the base (Fig. 9.3). The exterior of this resting surface, that was once extensively covered with coral-red, has been scraped off in its central part following a disc shape (Fig. 9.11). The evidence suggests that this work was undertaken at a later stage, at least, after firing or, most probably, in modern times in order to fix the bowl onto something else.[27] In the middle of this rough surface the trace of a smaller rough surface occurs, also disc-shaped. In this case, it is extremely difficult to understand if it was scraped at the same time as the rest of the area or if it was done before firing.

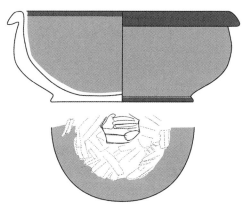

Figure 9.10: Profile drawing, Newcastle upon Tyne, Shefton Collection 169. Drawing: author; Illustrator: A. Stoll, CReA-Patrimoine, ULB.

Shefton Collection 169 seems to be a distinctive piece because of the shape. Exact parallels are unknown either for the profile or for the vessel. Among the salt cellars published in the Athenian Agora, the profile of the wall may be compared with that of Agora P2729 although the latter presents a slightly higher bowl, and has a ring foot and a different rounded thickened rim.[28] Among the miniature shapes, I do not know of any close comparison. A miniature basket displays a similar out-turned rim and a convex wall but the latter becomes concave on its upper part and the bottom of the vase is flat without any foot.[29] No other known miniature can be paralleled.[30]

If the smaller disc-shaped rough surface on the underside of the bottom was scraped at the same time as the vase was made it raises the question of the type of vessel it might have been fitted to. Two types of vessels are known to bear miniature shapes: the multiple

Figure 9.11: Newcastle upon Tyne, Shefton Collection 169, underside. Photograph: Colin Davison.

kernos and the lebes gamikos. Regarding the kernos, three classes have been listed (Mitsopoulou 2010, 145–178): the "Eleusian kernos" (Pollitt 1979, 228), the open-shaped black-glazed kernos (Pollitt 1979, 205–233) and the ring kernos (Bignasca 2000). Shefton Collection 169 does not seem to belong to any of these vessels.

The "Eleusian kernos", named by Pollitt (1979, 207–208), consists of a large stand that bears several small vessels made of a conical base surmounted by a bowl with two distinct sections, a shape very different from that of the vase in Newcastle. The profile cannot be further compared to that of the multiple open-shaped black-glazed kernoi from Attica: all known examples are dated to between the fourth and third centuries BC, and they consist of a large shallow bowl with a thickened rim and flat top on which were fixed shallow wheel-made miniature bowls. The later are stemmed and display a continuous concave profile very different from that of the Shefton Collection example.[31] On the other hand, the ring kernos, known in the Greek world since the Bronze Age, displays a larger variety of figurines and miniature vessels, such as kotyliskoi, mugs, amphorae or hydriai, attached on a hollow ring (Bignasca 2000) but I could not find any vessels bearing small bowls that are close in shape to that of Shefton Collection 169.

Figure 9.12: Profile drawing of lebes gamikos, Brussels, Musées royaux d'Art et d'Histoire A3914 (after the drawing in Skinkel-Taupin 1984, 41 fig. 2).

Shefton Collection 169 also differs from these two types of multiple kernoi in the technique used to fix the miniature vases to the larger vessel. Whilst it was shaped separately and attached from the bottom, the miniatures on the other two types were fixed on the main vessel before firing when the foot or base were modelled to be attached to the main body. Moreover, until at least the early fifth century BC, the vessels and figurines of the ring kernoi connect with the hollow ring through little holes that served as spouts for the liquids, a device absent from our example which is not pierced. Although very different in shape, some South Italian lebetes gamikoi with miniatures on the shoulder or the lid provide us with the closest parallel regarding the technique that might have been used to attach the miniature to a main vessel. A close look at a lebes gamikos in Brussels (Skinkel-Taupin 1984, 39–51)[32] shows that the miniatures were shaped separately and then attached to the lid through a central device in clay that is fixed to the central part of the area on the underside of the foot in a place similar to the surface left rough on Shefton Collection 169 (Fig. 9.12). Athough it does not bear miniatures, it seems important to mention here one of the most unusual occurrences of coral-red which is on a small nuptial lebes decorated with black-

figure and attributed to Douris by Beazley (*ABV* 400 and 696, and Richter 1954, pl. 16c).[33] Nevertheless, whether Shefton Collection 169 was originally meant to be part of a larger vessel for ritual purposes, such as the kernos, cannot be ascertained yet.

The archaeological context of the two vessels in Newcastle is unknown. Other small black-glazed or coral-red bowls and salt cellars are found in a wide variety of places such as funerary and domestic contexts but are especially concentrated in household deposits. According to Sparkes and Talcott (*Agora* XII, 132), they were most probably used to contain salt and other condiments for the symposium but they also served as a measure since they seem to have a constant liquid capacity throughout time. Among the few known small coral-red bowls, Agora P16488 bears on the underside of its bottom an incised single letter 'Kappa'. Such letters are known on other small black-glazed bowls and salt cellars[34] but also on black-glazed or coral-red cups.[35] In a recent study, Lynch (2011, 143) explains these letters as ownership marks for vessels taken for dining out and which needed to be identified. A passage in Athenaeus attests to the practice of taking one's own drinking vessel to the symposium but suggests that it was limited to some cities or geographical areas since it is associated with the Lacedaemonians.[36]

While the patterns of distribution of figure-decorated or plain coral-red cups and phialai of the Late Archaic and Early Classical periods have been studied (Shefton 1999, 466–475; Tsingarida 2008, 193–199; Padgett 2009, 220–231 with an emphasis on Cyprus) little is known of the material assemblages these pieces belonged to. Regarding the Early Classical period it seems however that the delicate Sotadean cups, that combine coral-red and white-ground techniques, were concentrated in Attic graves and addressed a local clientele (Williams 2006, 297; Tsingarida 2008, 199–206; 2012, 44–57), while the plain black and red wares were distributed more widely, towards the eastern Mediterranean in places such as Rhodes or Cyprus.[37]

Regarding the question of workshop attribution, it is important to note that in the Early Classical period coral-red occurs on a wide variety of non-figure decorated shapes even though its use seems limited to very few examples within these different classes. Besides the well attested Late Archaic Achaemenid phialai and cups of the Class Agora P10359 associated to the workshop of the Euphronios potter (Tsingarida 2014, 267–272), Padgett (2009, 225–227) convincingly relates the coral-red Rheneia cups and the few rattling Vi-cups to some plain products attributed to the Sotades and Hegesiboulos workshop.[38] Alongside these shapes, there are a small number of bowls of different sizes and types and a few skyphoi.[39] They are decorated in coral-red and display distinctive features such as the coral-red on the underside and the ring foot (for the bowls) that may also be paralleled with those seen on some vases from the Sotades workshop.[40] The presence in the material from the Dema House in Attika of a, until now, unique stemmed and ribbed coral-red cup that has been associated with a rattling coral-red foot cup, confirms the sophisticated aspect adopted by some of these pieces and might further suggest a link with the elaborate Sotadean products.[41] Nevertheless, following the variety in the profiles and the small number of coral-red pieces known for these shapes, it is difficult, at this stage of the research, to assign them to one workshop's ambit although the coral-red technique might be further seen as a potter's trademark.

Notes

1 I would like to thank Sally Waite for inviting me to contribute to this volume and for her invitation and warm welcome in Newcastle. This paper owes a lot to the stimulating exchanges and discussions I had with Michael Padgett (Princeton University Art Museum) who further shared with me several new references. Any errors that remain are, of course, my own. I am particularly indebted to Alexandra Villing (London, British Museum) for making it possible to study the vases

and for facilitating my work at the British Museum. This chapter was completed during my stay as a T.B.L. Webster Fellow (2014–2015) at the Institute of Classical Studies, University College London. I am most grateful to the Director, Professor Chris Carey, to the Deputy Director, Dr Olga Krzyszkowska, and to the staff of the library for providing help and support during my work at the Institute. Anja Stoll and Nathalie Bloch (CRea-Patrimoine, ULB) improved, with their talent and kindness, the photos and drawings for this article.

2 E.g. black-figure coral-red cup, St Petersburg, State Hermitage Museum B9270, *ABV* 294.22, *Para* 128; *Add*[2] 77, *BAPD* 320368 (Cohen 2006, 54–56 no. 7); large-scaled phialai, J. Paul Getty Museum 76.AE.96.1 and 76.AE.96.3, *BAPD* 5733, 5732 (Cohen 2006, 64–65, no. 11–12); red-figure volute krater, J. Paul Getty Museum 84.AE.974, *BAPD* 16201 (Cohen 2006, 67–68, no. 13).

3 For the coral-red by Sotades see Williams (2006, 292–298) and Tsingarida (2012, 44–57).

4 Bowl intact except a crack and a small chip on the rim. Height: 3 cm; diameter of the rim: 8.8 cm; diameter of the foot: 5.5 cm. The outside surface is worn but coral-red is well preserved inside the bowl.

5 The difficulty of assigning a name is further illustrated by the piece Agora P16448, listed under the heading "salt cellar: variants", *Agora* XII, 303 no. 954.

6 Athens, Agora P16488: *Agora* XII, 303 no. 954, pl. 34.

7 The bowl at the British Museum (1891.8–6.78) is smaller in size, diameter at rim: 7 cm. Under no 954 (*Agora* XII, 303) were listed two other coral-red bowls which I have not seen: Athens, private collection (height: 3 cm; diameter: 8 cm) and Palermo, Museo Archeologico 26229. To them one may also add four coral-red bowls from Marion and a fragmentary foot from a bowl in Perachora: "foot black outside red inside" (Richter 1954, 144, *non vidi*).

8 British Museum 1864.10-7-327.

9 For another example of transitional shape: Athenian Agora P5135, *Agora* XII, 100.

10 R48540/PO1751.

11 Athens, Agora Museum P15015.

12 London, British Museum 1864.10-7-327.

13 Marion, Excavations R48540/PO1751; R27349/PO842; R48523/PO1734.

14 Two coral-red Rheneia cups are mentioned in the entry (Oakley and Rotroff 1992, 100 no. 158) but no inventory number is provided for the second one: "One of two examples in deposit".

15 Athens, Agora Museum P16753, close to the workshop of Sotades.

16 Athens, Kerameikos Museum 106, 2 (Knigge 1976, 115): it has been listed as belonging to the Class Agora P10359 but the ring foot, the shallow bowl and the strongly articulated rim is more related to the Rheneia cups.

17 Athens, Agora Museum P19154 with a spreading foot is mentioned as a parallel to Athens, Agora Museum P15972 (*Agora* XII, no. 333).

18 Würzburg, Martin von Wagner Museum H5388 (Hölscher 1981, 41–42).

19 E.g. Cup of type B, attributed to Euphronios: Athens, Agora Museum P32344; Stemless cup attributed to the workshop of Sotades and Hegesiboulos: Berlin, Antikensammlung, Staatlichen Museen V.I. 3408 (Cohen 2006, 63 no. 10, 70 no. 14).

20 Marion, Excavations R25786/PO725. I would like to warmly thank J. Michael Padgett for sending me a photo and a drawing of this unpublished piece.

21 Athens, Agora Museum P18505, Athens, Agora Museum P25524 (*Agora* XII, no. 454, n°455).

22 Athens, Agora Museum P19480 (Athenian *Agora* XII, no. 955); Berlin, Pergamonmuseum TC7038a (Roehde 1990, 81, pl. 52.6 and 53.2).

23 Berlin, Pergamonmuseum TC7038a: diameter ring 13.9 cm (Roehde 1990 , 81).

24 Athens, Agora Museum P3901 – black-glazed (*Agora* XII, 294 no. 812, pl. 32, and further comparisons, 130, n. 12).

25 Diameter rim: 6.5 cm; diameter foot: 4 cm; height: 2.3 cm. Coral-red peeled off on the outside and better preserved on the inside.

26 This name is already used for the vase in the entry for the Shefton Collection.

27 I would like to thank Isabella Rosetti (conservator at the Musées royaux du Cinquantenaire, Brussels) who saw the piece from photographs and first suggested that the rough surface might have been a modern addition.

28 Athens, Agora P 2729 (*Agora* XII, no. 953, 303, fig. 9, pl. 34). No coral-red but decorated with bands and reserved areas.

29 Athens, Agora P23195 (*Agora* XII, 335 no1409, pl. 45).

30 For a recent survey of miniature vessels, Bergeron and Smith 2011.

31 See for instance, Athens, Agora P815, intact (Thompson 1934, 340, pl. 71c), and *Agora* XII, no. 1364. Most black-glazed versions were found in deposits on or near the west side of the Agora with two exceptions Agora P19522, from a fill under the Stoa of Attalos (P-R 6–12) and Agora P25569, a stray found in a late fill near the Church of the Holy Apostolos (O20). See Mitsopoulou 2010, 156–157 where the author provides a list of the known black-glazed open shapes.

32 Brussels, Musées royaux d'Art et d'Histoire A3914.

33 Paris, Musée du Louvre MNB 2042.

34 E.g. Athens, Agora Museum P32401, *c.* 500 BC: "Omikron Sigma" incised (Lynch 2011, 266, no. 150).

35 For instance the coral-red cup Class of Agora P10359, London, British Museum 1864.10-7.1604 with an incised "Alpha" on the underside of the disc foot.

36 Athenaeus, *Deipnosophistae* XI. 463E [= Critias, *Constitution of the Lacedaemonians*].

37 To the vases listed by Padgett with a Cypriot provenance (Padgett 2009, 224–227, 230 notes 62, 67, 70 and 76), one may now add the coral-red bowl, London, British Museum 1891.8-6.78 that comes from the excavations at Salamis in Cyprus (information from the Archives of the British Museum).

38 The unique plain coral-red bowl with wishbone handles Athens, Agora Museum P16753 (*Agora* XII, 56 no. 68) and Würzburg, Martin von Wagner Museum H5388 (Hölscher 1981, 41–42).

39 Athens, Agora Museum P19154 (Richter 1954, 133 fig. 7); two skyphoi decorated with a coral-red band on the outside wall, Cyrene I.528 and I.1256 (Thorn 2005, no. 77–78).

40 For the ring foot, compare that (thin and vertical) of the delicate white-ground and coral-red cup from the Sotades Tomb (London, British Museum 1892.7-18.3) with that of the transitional cup, Class of Agora P10359 (British Museum 1864.10.7-327).

41 Athens, Agora Museum P31513a (fragment of a ribbed bowl with the base of the stem) and P31678 (fragment of a ribbed bowl and black-glazed rim) and P31590 (rattling coral-red foot) (Oakley and Rotroff 1992, 104 no. 190; updated in the Database of the Americal School of Classical Studies, www.agathe.gr: under P31513).

Bibliography

Bergeron, M. E. and Smith, A. (eds.) (2011) *The Gods of Small Things. Pallas* 86. Toulouse.

Bignasca, A. M. (2000) *I kernoi circolari in Oriente e in Occidente: strumenti di culto e imagini cosmiche,* Freiburg and Göttingen.

Cohen, B. (2006) Coral-Red Gloss: Potters, Painters and Painter-Potters. In Cohen, B. (ed.) *The Colors of Clay. Special Techniques in Athenian Vases,* 44–53. Los Angeles, J. Paul Getty Museum.

Hölscher, F. (1981) *CVA Würzburg, Martin von Wagner Museum* 2. Munich.

Knigge, U. (1976) *Der Südhügel. Kerameikos IX.* Berlin.

Lynch, K. (2011) *The Symposium in Context. Pottery from a Late Archaic House near the Athenian Agora.* Princeton. The American School of Classical Studies, Hesperia supplement 46.

Mitsopoulou, C. (2010) De nouveaux Kernoi pour Kernos. Réévaluation et mise à jour de la recherche sur les vases de culte éleusinien. *Kernos* 23, 145–178.

Oakley, J. H. and Rotroff, S. (1992) *Debris from a Public Dining Place in the Athenian Agora.* Princeton. The American School of Classical Studies. Hesperia supplement 25.

Padgett, M. J. (2009) Attic Imports at Marion: Preliminary Results of the Princeton University Archaeological Expedition to Polis Chrysochous, Cyprus. In Oakley, J. H. and Palagia, O. (eds.) *Athenian Potters and Painters II*, 220–231. Oxford.

Pollitt, J. J. (1979) Kernoi from the Athenian Agora. *Hesperia* 48.3, 205–233.

Richter, G. M. A. (1954) Red-and-Black Glaze. *Netherlands Kunsthistorisch Jaarboeck* 5, 127–135.

Rohde, E. (1990) *CVA Staatliche Museen zu Berlin, Antikensammlung. DDR* I. Berlin.

Shefton, B. B. (1999) The Lancut Group. Silhouette Technique and Coral Red. Some Attic Vth Century Export Material in Pan-Mediterranean Sight. In Villanueva-Puig, M. C. *et al.* (eds.) *Céramique et peinture grecques. Modes d'emploi*, 463–480. Paris.

Skinkel-Taupin, C. (1984) À propos d'un vase italiote: problème de terminologie. *Bulletin des Musées royaux d'Art et d'Histoire*, 55.2, 39–51.

Thompson, H. M. (1934) Two Centuries of Hellenistic pottery. *Hesperia* 3, 311–476.

Thorn, J. C. (2005) *The Necropolis of Cyrene. Two Hundred Years of Exploration*. Rome.

Tsingarida, A. (2008) Color for a Market? Special Techniques and Distribution Patterns in Late Archaic and Early Classical Greece. In Lapatin, K. (ed.) *Papers on Special Techniques in Athenian Vases*, 187–206. Los Angeles, J. Paul Getty Museum.

Tsingarida, A. (2012) White-ground Cups in Fifth-Century Graves. A Distinctive Class of Burial Offerings in Classical Athens? In Bundgaard Rasmussen, B. and Schierup, S. (eds.) *Red-figure Iconography in its Ancient Settings*, 44–57. Aarhus, University Press. Gösta Enbom Monographs 2.

Tsingarida, A. (2014) The Attic Phiale in Context. The Late Archaic Red-Figure and Coral-Red Workshops. In Oakley, J. H. (ed.) *Athenian Potters and Painters Volume III*, 263–272. Oxford.

Williams, D. J. R. (2006) The Sotades Tomb. In Cohen, B. (ed.) *The Colors of Clay. Special Techniques in Athenian Vases*, 292–298. Los Angeles, J. Paul Getty Museum.

10. The Shefton Dolphin Rider

Judith M. Barringer

Brian Shefton[1] had an eye for the unusual. Never was this clearer to me than in my study of this small relief from the Shefton Collection (inv. no. 230, Fig. 10.1). Its iconography is a mixture of things, none of which easily fit together, and has no direct parallels, yet I am convinced that it is genuine. This chapter investigates its iconography and possible function.

Brian acquired the lower portion of this small terracotta relief of a nude male and a dolphin in the 1960s from Sotheby's in London. The surviving portion of the relief measures 18.5 cm from the tip of the dolphin's nose across, and 14.8 cm from top to bottom; its thickness varies between approximately 7 mm and 1 cm. The relief's original edges are clearly visible from the back view, going around the dolphin's head, snout, and downward, while the remainder is broken on all edges (Figs. 10.2 and 10.3). The relief shows a dolphin swimming to our left, and a nude male figure is placed against the dolphin's side, his legs dangling down, the right leg slightly bent and turned outwards. He appears to be descending from the dolphin's back although one could read him as riding side saddle atop the animal. The figure extends his right hand forward but nothing is visible now between the fingertips (Fig. 10.4). Details are rather cursorily done, such as the articulation of the toes and their clumsy positioning (Fig. 10.5), but greater care has been given to the dolphin's face, including the crease on the forehead. The soft yellow to pale yellow clay still bears traces of red paint,[2] as well as the characteristic white used as a base before colour was applied.

The relief is mould-made as can be seen in a back view, where impressions of fingers pushing the clay into the mould are still visible. With such a thin relief, the hollowed-out back, and the finished surface around the dolphin's head, one can see that this was not part of a larger composition, such as a frieze, unless the relief was attached separately, and this is a distinct possibility. The unpainted

Figure 10.1: Terracotta dolphin rider, Newcastle upon Tyne, Shefton Collection 230, front view. Photograph: Colin Davison.

Figure 10.2: Terracotta dolphin rider, Newcastle upon Tyne, Shefton Collection 230, back view. Photograph: Colin Davison.

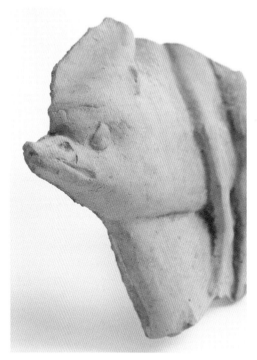

Figure 10.4: Terracotta dolphin rider, Newcastle upon Tyne, Shefton Collection 230, right hand. Photograph: Colin Davison.

Figure 10.3: Terracotta dolphin rider, Newcastle upon Tyne, Shefton Collection 230, vertical edge. Photograph: Colin Davison.

Figure 10.5: Terracotta dolphin rider, Newcastle upon Tyne, Shefton Collection 230, feet. Photograph: Colin Davison.

area on the front side of the extant edge, forming a vertical stripe, suggests that this portion was inserted or at least immediately adjacent to another surface (Fig. 10.6). In spite of the fact that this object comes from a mould, I have found no other examples of this precise composition.

The pose of the figure with respect to the dolphin is not common. One sees females riding side saddle or seeming to descend from dolphins or horses, as is the case with the Amazon akroteria from the Athenian Treasury at Delphi of *c.* 490 BC and the Nereid akroteria from the Temple of Asklepios at Epidauros of *c.* 360 BC (Figs. 10.7 and 10.8).[3] More similar is a fragmentary relief of *c.* 450–425 BC, whose male rider has been posited as Arion because of the find-spot, Corinth (Fig. 10.9);

Figure 10.6: Terracotta dolphin rider, Newcastle upon Tyne, Shefton Collection 230, lower edge. Photograph: Colin Davison.

Figure 10.7: (left) Parian marble, Delphi, Museum 848, c. 490 BC. Photograph: Hans Rupprecht Goette.

Figure 10.8: (right) Pentelic marble, Athens, National Museum 157, c. 380 BC. Photograph: Hans Rupprecht Goette.

Figure 10.9: Terracotta relief, Corinth, Museum KT-27-11, c. 450–425 BC. Photograph: American School of Classical Studies at Athens, Corinth Excavations.

Herodotos (1.24.1–8) relates that Arion was taken there by the tyrant Periander. But, unlike the Shefton relief, the example from Corinth is reddish brown, the legs are poised somewhat differently, the dolphin does not have a bulging forehead, and the male is clearly seated on the dolphin.[4] The Shefton rider is not perched but sliding off his mount. Likewise, a warrior dismounting from his horse on a large terracotta shield of *c.* 490–480 BC from Stelai Shrine A at Corinth offers a similar pose (Fig. 10.10).[5] But the figure's legs are outstretched further, and not only is the animal a horse, but also the figure is armed, and the clay is light tan.

Our relief's clay and iconography, as we shall see, point to south Italy and reliefs of cavaliers. A terracotta relief from the necropolis in Tarentum (I use the Latinised form of the name to refer to the ancient Greek city of Taras to avoid confusion with the personification of

the city, who will shortly enter this discussion), now in the Museo Archeologico, in Taranto, for example, depicts a cavalier in a similar position although the rider's right hand grasps the reins rather than resting on his horse (Fig. 10.11).[6] He is one of a number of horse riders on terracotta reliefs of the classical period from Tarentum (Poli 2010). The riders, who are often identified as Dioskouroi because of their peculiar hats (often piloi) and shields associated with the twin heroes, are depicted in different stages of dismounting horses and are sometimes referred to as 'apobates' (Fig. 10.12).[7] A great cache of terracottas depicting horsemen from Pizzone in Tarentum may have been dedications at initiation rites – including hippic competitions – for young males (Poli 2010, 66). This bent-leg motif of the descending horseman first appears on Tarantine coins at the turn of the fifth to fourth centuries BC (ibid., 50; Fig. 10.13) although one should also note the appearance of nearly the same motif *c.* 410 BC on coins from Kelenderis in Cilicia (Kraay 1962).[8] A relief from Centocamere in Locri also depicts a nude male in a related position: both legs on one side of an animal, more riding than slipping off, but not well-seated (Fig. 10.14).[9] Comparanda are also found in large scale in the Parian marble Dioskouroi from the Temple of Locri-Marasà dated to the late fifth century BC, now in Reggio (Figs. 10.15 and 10.16).[10] These figures formed the west akroteria or west pedimental figures, of the Ionic temple. There is a slight difference in the positioning of the extended leg, but the pose is otherwise close except, of course, that the Dioskouroi ride horses, not dolphins. Yet it is interesting that the horses are supported by one type of sea creature, Tritons.[11] Here, the Dioskouroi ride horses, but they are supported by marine creatures, although not dolphins.[12] There is clearly an iconographical relationship between the cavalier reliefs from Taranto and the Shefton dolphin rider with the

Figure 10.10: Terracotta shield, Corinth, Museum KN-1, c. 490–480 BC. Photograph: American School of Classical Studies at Athens, Corinth Excavations.

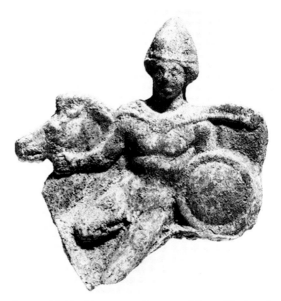

Figure 10.11: Terracotta, Taranto, Museo Nazionale Archeologico. (After Lippolis 2001, 251 fig. 9.)

Figure 10.12: Terracotta, Taranto, Museo Nazionale Archeologico 20005. (After Lippolis 1995, Tav. XIII: 4.)

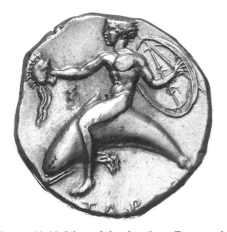

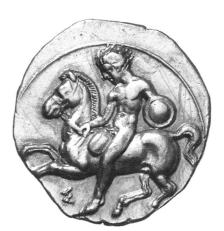

Figure 10.13:Silver didrachm from Taranto, Münzkabinett, Staatliche Museen zu Berlin, 18214526 (1885/114), c. 415–390 BC. Photograph: Dirk Sonnenwald. Münzkabinett, Staatliche Museen zu Berlin.

akroteria from Locri that combine something of both – marine sphere and equine rider, but whether the Shefton rider held anything in his left hand or wore anything on his head cannot be determined.

Let us turn to the dolphin itself. The rendering of the gently curving underside; distinctive face with a slight bulge of the head between the eyes; rounded, disc-like eyes; projecting, upturned snout; incised horizontal line descending left to right for the mouth; large nostril; and the

Figure 10.14: Terracotta relief, inv. 1979/38 from Centocamere, end of fifth century–beginning of fourth century BC. (After Barra Bagnasco 2009, 292, no. 579 Tav. CX.)

basically horizontal orientation (as opposed to diving downward) have no direct parallels. But the dolphin supporting a youth found in a domestic context from Centocamere at Locri Epizefiri in South Italy is somewhat similar (Fig. 10.17), and the projecting flat portion below the dolphin might offer a comparison to the peculiar curving projection beneath the dolphin on our relief (to reiterate: part of this is the original, unbroken edge).[13]

Who is the youth atop the dolphin on the Shefton relief? There is no shortage of males riding dolphins in ancient Greek iconography. The motif of youth and dolphin immediately brings to mind Eros, Arion, Melikertes (or Palaimon), Taras, and Phalanthos.[14] Eros rides dolphins in many, many contexts, including Attic vase paintings,[15] Sicilian reliefs,[16] Hellenistic clay sealings[17] and lead reliefs from Delos.[18] But unlike our youth on the Shefton relief, Eros is usually depicted straddling the dolphin – sometimes grasping the reins, other times holding musical instruments. However, there is one good match for the rider's pose on a small south Italian terracotta from the Campana collection in the Louvre (12 cm high),[19] but one can easily see that the dolphins are quite different: the more sinuous, energetic dolphin belongs to a later period (Fig. 10.18).

The poet Arion of the late seventh and early sixth centuries BC was rescued at sea by a dolphin, which delivered him to Cape Tainaron, according to Herodotos (1.23–24). A statue of the poet riding a dolphin was erected there in his honour. This sculpture does not survive, and instead, Arion appears on a handful of coins. On a diobol of *c.* 330–250 BC and a much later Roman imperial coin, he rides 'side saddle' comparable to the male on our relief, but is unlike our rider in that Arion holds a kithara in one hand, while the other arm is outstretched.[20] We cannot exclude the possibility that our figure is Arion since we know nothing of the positioning of his left arm save that his torso was turned towards us but the fact that Arion is always shown clothed and our figure is nude militates against this identification.

Melikertes was a son of Ino, a grandson of Kadmos of Thebes. Ino and Melikertes were transformed into the sea deities Leukothea and Palaimon respectively, when they leapt into the sea to escape their certain deaths. In other sources, Melikertes was rescued from the sea by a dolphin, who deposited him at Isthmia, where he was worshipped at an altar.[21] Of the few clearly identifiable representations of Melikertes seated on a dolphin, the hero straddles the animal.[22]

Taras and Phalanthos are more promising possibilities. Both were credited with the foundation of the city of Tarentum in southern Italy although Phalanthos is the name most frequently mentioned in ancient written sources and may be a historical personage,[23] while Taras is regarded as the eponymous, mythical hero.[24] In describing a Tarantine dedication that he saw at Delphi, Pausanias (10.13.10) reports that Phalanthos was rescued at sea by a dolphin, a tale that recalls

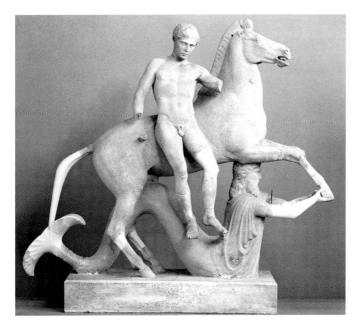

Figure 10.15: Dioskouros from the Temple of Locri-Marasà, Parian marble, Reggio di Calabria, Museo Nazionale 10471, late fifth century BC. Photograph: DAI-Rom.

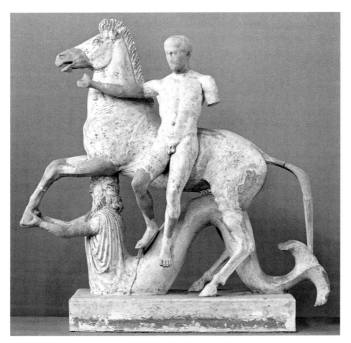

Figure 10.16: Dioskouros from the Temple of Locri-Marasà, Parian marble, Reggio di Calabria, Museo Nazionale 10471, late fifth century BC. Photograph: DAI-Rom.

Figure 10.17: Terracotta relief, Centocamere, Locri Epizefiri. Photograph: Soprintendenza per i Beni Archeologici della Calabria.

Arion's adventure. Hundreds, if not thousands, of Tarantine coins were ornamented with Phalanthos – not Taras as sometimes claimed in earlier literature (e.g. Lacroix 1965, 89–96) – riding a dolphin.[25] On most of them of *c.* 415–380 BC, the hero straddles the back of a dolphin, one hand (usually his left) steadying himself on the mammal, the other outstretched, sometimes holding an object, such as a torch or kantharos, sometimes weapons or armour (Fig. 10.19).[26] Other, later Tarantine coins of *c.* 340–325 BC show a dolphin rider seated as the Shefton rider but the legs are crossed as the figure twists to his left to spear fish with a trident (Fig. 10.20).[27] In some instances, the legs are uncrossed but unlike the terracotta rider, the figure holds a shield, helmet, vase, or trident in his upraised hand or hands.[28] On a very few coins of *c.* 443–400 BC, all from the same die, we see Phalanthos riding side saddle on a dolphin, his legs side by side, his arms unencumbered and close to the dolphin; the pose is related to that of the Shefton figure, but the legs

Figure 10.18: Terracotta, Paris, Musée du Louvre Cp. 5105 (coll. Campana) from Santa Maria Vetere di Capua, third–second century BC. Photograph: Réunion des musées nationaux.

are nearly straight and held together.[29] In addition, one series of Tarentine coins from *c.* 415–340 BC are noteworthy because they have the usual dolphin rider (facing our left) on one side but on the other is a nude cavalier dismounting from his horse, like the apobates on the terracotta reliefs discussed above (Figs. 10.11 and 10.12).[30] Although the horse rider does not have the same pose as our dolphin rider, the juxtaposition of the two animal riders on the single coin is curious. However, several coins of *c.* 355–340 BC underscore the visual comparison of the two riders – horse and dolphin – by employing the same position of the legs for each.[31] At least

one scholar wishes to recognise the cavalier as Phalanthos, the dolphin rider as Taras or vice versa (Evans 1889, 14) and if the identities may be interchangeable, then perhaps we should think of the mounts in the same fashion. Based on the closest comparisons we have seen – the Locri riders, the terracotta reliefs from Tarentum, and the Tarantine coins, we can date our relief in the last portion of the fifth or the early fourth century BC and target south Italy as its place of origin.

Cults to Taras and Phalanthos were located in Tarentum's agora (Nafissi 1995, 271–273, 276, 277, 292–299; Malkin 1994, 127–133), but it has been difficult to definitively determine whether the individual figures received cult or if they were worshipped as one. As we have already noted, differentiating one from the other was also a problem with coinage (Lippolis 1995, 91; Malkin 1987,

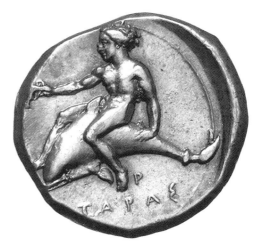

Figure 10.19: Silver didrachm from Taranto, Münzkabinett, Staatliche Museen zu Berlin, 18214710 (1885/121), c. 390–380 BC. Photograph: Dirk Sonnenwald. Münzkabinett, Staatliche Museen zu Berlin.

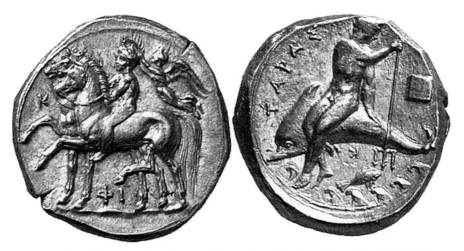

Figure 10.20: Silver didrachm from Taranto, Zürich, Leu Numismatik, c. 340–325 BC. Photograph courtesy of Wolfgang Fischer-Bossert.

216–221; Lippolis 1982, 93). But Pausanias (10.13.10) distinguishes the two when he describes a votive monument with statues by Onatas of Aigina, dated in the first half of the fifth century BC.[32] The monument was erected at Delphi to commemorate the Tarantine victory over the Peuketians in Apulia. Curiously, Pausanias describes Phalanthos as being "of Lakedaimonia", not Tarentum and that a dolphin was placed near Phalanthos (οὐ πόρρω τοῦ Φαλάνθου δελφίς). The inscribed base with cuttings for some of the statues remains intact, prominently placed immediately to the east of the Temple of Apollo and adjacent to the Plataian tripod; the base and inscription were retouched in the fourth century BC.[33] Lippolis (1982, 96–97) offers a political reading to explain the presence of both heroes: that Phalanthos represents the old aristocratic order of the Spartan colony, which was transformed after a democratic revolution in Tarentum in 473 BC; subsequently, Taras became the new hero. One figure did not replace the other, but instead, they co-existed.

Thus, images of the Dioskouroi descending from horses in marble and terracotta of the late fifth century BC and those of Phalanthos riding a dolphin on Tarentine coins of the late fifth and fourth centuries BC provide the closest parallels for the Shefton rider. That Taras/Phalanthos and the Dioskouroi might use similar visual motifs is not so surprising when we remember that the cult of the Dioskouroi was transferred from the mother city Sparta to its colony, Tarentum (Malkin 1994, 115–142; Davis 1967, 180),[34] when the latter was founded *c.* 706/705 BC by the Lakedaimonian Phalanthos in response to the Delphic oracle (Arena 1998, 19; Malkin 1987, 47–52). Perhaps the Dioskouroi rider motif was adopted and transformed by Tarentum for its local hero to reflect the colony's maritime setting and concerns, and this may, of course, have been an innovation of Lakonian artisans working in Tarentum. As a further iconographical link between Lakonia and Tarentum, we can note that the motif of riders dismounting from horses, which we already observed on the terracotta reliefs from Tarentum, occurs on several votive terracotta reliefs of the fourth century BC from Amyklai. Like the Tarantine cavaliers, the Amyklai riders appear in a variety of positions, signifying different stages of dismounting.[35] Indeed, Salapata (1992, 320), who studied the Amyklai reliefs states, "Of all extant plaques, only those from Amyklai and Taras represent dismounters".

Further evidence for the artistic connections between Lakonia and Tarentum comes from a terracotta sima belonging to the sixth century BC anaktoron at Torre di Satriano in southern Italy, which helps piece things together. The reverse of the terracotta plaques comprising the geison were incised with numbers (written out, e.g. δεύτερος). The dialect has been identified "senza dubbio" as Lakonian-Tarantine, and the alphabet is Lakonian (Capozzoli 2009), which suggests that the manufacturers of these architectural terracottas were Lakonians living in south Italy.[36] Although the Shefton rider certainly dates later than the sima inscriptions, the ties between Tarentum and Sparta were strengthened with Tarantine support for Sparta in the Peloponnesian War and from the mid-fourth century BC onward, when the Spartan military commanders went to Tarentum after a Tarantine appeal to its mother city (Malkin 1994, 57; Brauer 1986, 62).

Based on stylistic comparisons with the Locri marble riders and the Tarantine coins, the date of the relief is in the late fifth or early fourth century BC. The figure is almost certainly Phalanthos riding on a dolphin, as is so common on the Tarantine coins. The relief's function is unknown but there are limited possibilities. Because of the lack of a squared lower surface or any obvious means of attachment at the bottom, the plaque is unlikely to have been an antefix but, as suggested above, it may have been part of a frieze or revetment. Although the provenance of most of the terracotta reliefs from Tarentum cannot be fixed precisely, some showing the

Dioskouroi as apobates derive from votive contexts at cult places to the Dioskouroi. We might posit that the Shefton dolphin rider may also derive from a frieze or revetment in a cult place to Phalanthos, the founding hero of Tarentum. If, as I have argued here, the Shefton dolphin rider is a product of south Italy, probably Tarentum, under the influence of Lakonian motifs, perhaps even made by a Lakonian workshop, he offers yet more visual evidence for close ties between the mother city and its *apoikia*.

Notes

1 I offer heartfelt thanks to Sally Waite, who invited me to participate in the delightful symposion in honour of Brian Shefton in 2013. Andrew Parkin, Sally, and I examined and discussed the relief at great length, and consultations with Nancy Bookidis, Mario Iozzo, and Aliki Moustaka helped narrow my scope and improved my knowledge of terracotta sculpture. Wolfgang Fischer-Bossert patiently advised on dolphin riders on coins and provided images and bibliography, Hans Goette read and commented on the text and supplied photos, and Gianfranco Adornato carefully read the manuscript and offered many excellent suggestions and valuable bibliographical references to better this text. For additional photographs, I am indebted to Dr. Karsten Dahmen (Münzkabinett, Staatliche Museen zu Berlin), the Deutsches Archäologisches Institut Rom, and Dott.ssa Simonetta Bonomi (Soprintendenza per i Beni Archeologici della Calabria). I am grateful to all of them and, of course, am responsible for all errors and omissions.

2 Munsell 7.5YR 7/3–7/4.

3 Delphi akroterion: Coste-Messelière (1957, 183–185). Epidauros akroterion: Kaltsas (2002, 176 no. 344).

4 5.2 cm high × 4.7 cm wide. Stillwell (1952, 153 no. 9, pl. 33, xxi, 9), who dates it to the third quarter of the fifth century BC.

5 Inv. KN 1, diameter 0.21 m, height 0.035 m. Poli (2010, 56, fig. 21) mentions the Corinth shield in conjunction with a larger discussion of the apobates (54–58); Maul-Mandelartz (1990, 158–160, Taf. 37:2); Stillwell (1952, 227–228 no. 5, pls 48–49).

6 Lippolis (2001, 251 fig. 9); Lippolis (1995, Tav. 54, xiii:1); cf. Kekule (1903, vol. 1, 209 no. 8).

7 E.g. Taranto, Museo Nazionale Archeologico 1121 and 20005. See Lippolis (1995, Tav. xiii nos. 3–4); Iacobone (1988, 120). Inventory 20005 was found at V. di Palma 57 in 1923 (Iacobone 1988, 161). Cf. Amsterdam, Allard Pierson Museum 893 and Taranto Museo Nazionale Archeologico 5793 and 4133 (from a votive deposit to the Dioskouroi in Salinella, a quarter in Taranto) in Stefanelli (1977, 346–347, Tav. lxxxii–lxxxiii.1), all identified as Dioskouroi (cf. also Lippolis 2009, 120, fig. 2; Salapata 1992, 324). Cf. also the terracottas from the Pizzone deposit at Tarentum presented by Poli (2010, 57–58, figs. 10–14), as well as an iconographically related set from the same place that shows children or adolescents, sometimes carrying shields, poised in the same way on a variety of animals in Poli (2010, 52–53, figs. 16–19).

8 I thank Wolfgang Fischer-Bossert for alerting me to this material.

9 13.4 cm high, 9.2 cm wide. Barra Bagnasco (2009, 292, no. 579 Tav. cx), who dates it to the end of the fifth or beginning of the fourth centuries BC.

10 Reggio di Calabria, Museo Nazionale 10471. See Danner (1997, 63–68); Barringer (1995, 143, 232–233 no. 378, pls 134, 136); Costabile (1995).

11 Cf. horse riders from Locri supported by sphinxes: see Danner (1997, 44–48).

12 Danner (1997, 67–68) dissociates the female figure sometimes reconstructed between the two riders from this composition.

13 6.2 cm high, 4.8 cm long. Barra Bagnasco (2009, 100 no. 28, Tav. v), who dates it to the end of the fourth or beginning of the third centuries BC.

14 There are also dolphin riders on Attic vases, whose identity cannot be established with certainty. See, e.g. Kurtz and Boardman (1995, 88–89, pls 25–27).

15 E.g. the tondo of an Attic red-figure kylix in Palermo (Museo Nazionale 1518) of *c.* 520 BC. See Greifenhagen (1957, 33, Abb. 33).
16 E.g. part of an askoid vase, Rome, Museo Etrusco di Villa Giulia 25116, *c.* 575–550 BC. See Stampolidis and Tassoulas (2009, 101 no. 31).
17 Delos, Archaeological Museum no. 74/6005b, 74/6813b from the House of the Sealings. See Stampolidis and Tassoulas (2009, 101 no. 32, 117 no. 59).
18 Delos, Archaeological Museum B18644 from east of the Sacred Lake. See Stampolidis and Tassoulas (2009, 102 no. 33).
19 Besques (1986, 17 no. D3404, pl. 12i); Kekule (1903, vol. 2, 312 no. 5).
20 *LIMC* II, s.v. Arion [H. Cahn], 602–603.
21 *LIMC* VI, s.v. Melikertes [E. Vikela and R. Vollkommer] 437.
22 *LIMC* VI, s.v. Melikertes [E. Vikela and R. Vollkommer] 437–444.
23 Malkin (1987, 216–219); *LIMC* VIII, s.v. Phalanthos [R. Vollkommer] 978.
24 Russo (2004) summarizes the written evidence for the foundation of Taranto. Fischer-Bossert (1999, 410–423) challenges the conventional view that the name of the river Taras precedes that of the hero, who is a later development and initially has no connection with the dolphin, whereas Phalanthos has this association from at least the fifth century BC onward.
25 E.g. *LIMC* VIII, s.v. Taras I [R. Vollkommer] 1185–1186; Fischer-Bossert (1999); Giannelli (1963, 21–22). Cf. Garraffo (1995, 148–149); Nafissi (1995, 292–299). Dolphin riders occasionally appear on other coinage as well, such as that from early fifth century BC Skopelos (Peparethus). See Σάμψων (2000, 176–177, εικ. 50:6); Head (1911, 313).
26 Fischer-Bossert (1999, Taf. 18 nos. 310–313, 412–416). Phalanthos is also sometimes shown holding a lyre, which has led some scholars to link him to Apollo. See Russo (2004, 81 n.6).
27 Fischer-Bossert (1999, Taf. 40 nos. 706–708).
28 Fischer-Bossert (1999, Taf. 39 nos. 696–702); *SNG* ANS 1 nos. 908–909, 935–937, 953, 962–964, 1108.
29 Fischer-Bossert (1999, 116 nos. 283a, 284d, 284f); Ravel (1947, 33 nos. 251–253, pl. IX).
30 Fischer-Bossert (1999, Taf. 18–19 nos. 317–342, Taf. 35 nos. 629–631, Taf. 36–38 nos. 644–670).
31 Fischer-Bossert (1999, Taf. 36 nos. 642–643).
32 Russo (2004) sifts through the literary testimony to date the two Tarantine dedications at Delphi. See Kansteiner, Lehmann, and Hallof (2014, 429–431 no. 508).
33 E.g. Jacquemin (1999, 192–194, 217–218, 353 no. 455); Bommelaer (1991, 163–164 no. 409).
34 For the cult of the Dioskouroi in Tarentum, see Lippolis (2009); Nafissi (1995, 226–228).
35 Salapata (1992, 301, 320–327, 746–748 nos. A6152/35, A6152/5, A6152/42).
36 On the Tarentine use of the Lakonian alphabet, see Arena (1998, 19–20). Lakonian pottery has also been found in Taras, but this could be imported; importation is far less likely for the sima.

Bibliography

Arena, R. (1998) *Iscrizioni greche arcaiche di Sicilia e Magna Grecia* V. Milan.
Barra Bagnasco, M. (2009) *Locri Epizefiri V: Terrecotte figurate dall abitano.* Alessandria.
Barringer, J. (1995) *Divine Escorts: Nereids in Archaic and Classical Greek Art.* Ann Arbor.
Bencze, A. (2001) Terres cuites votives de Tarente: propositions de méthode. *Bulletin du Musée hongrois des beaux-arts* 94–95, 41–64.
Besques, S. (1986) *Catalogue Rainsonné des figurines et reliefs en terre-cuite grecs, étrusques et romains* IV. Paris.
Bommelaer, J.-F. (1991) *Guide de Delphes: le site.* Paris.
Brauer, G. (1986) *Taras: Its History and Coinage.* New Rochelle, NY.
Capozzoli, V. (2009) Le Iscrizioni incise sui rivestimenti fittili el tetto di prima fase: un esame preliminare. In Osanna, M., Colangelo, L. and Carollo, G. (eds.) *Lo Spazio del potere: La residenza ad abside, l'anaktoron, l'episcopio a Torre di Satriano,* 177–182. Venosa.

Costabile, F. (1995) Le Statue frontali del tempio Marasà a Locri Epizefiri. *Mitteilungen des Deutschen Archäologischen Instituts, Römische Abteilung* 102, 9–62.

Coste-Messelière, P. de la. (1957) *Fouilles de Delphes IV: IV: Sculptures du trésor des Athéniens*. Paris.

Danner, P. (1997) *Westgriechische Akrotere*. Mainz.

Davis, N. (1967) *Greek Coins & Cities*. London.

Evans, A. (1889) The 'Horsemen' of Tarentum. *Numismatic Chronicle* third series, 9, 1–211.

Fischer-Bossert, W. (1999) *Antike Münzen und geschnittene Steine XIV: Chronologie der Didrachmenprägung von Tarent 510-280 v. Chr.* Berlin.

Garraffo, S. (1995) La Documentazione numismatica in Lippolis, E., Garraffo, S. and Nafissi, M. *Taranto*, 131–151. Taranto.

Giannelli, G. (1963) *Culti e miti della Magna Grecia*. Florence.

Greifenhagen, A. (1957) *Griechische Eroten*. Berlin.

Head, B. (1911) *Historia Numorum*, Second Edition. Oxford.

Iacobone, C. (1988) *Le Stipi votive di Taranto (Scavi 1885–1934)*. Rome.

Jacquemin, A. (1999) *Offrandes monumentales à Delphes*. Paris.

Kaltsas, N. (2002) *Sculpture in the National Archaeological Museum, Athens*, Hardy, D. (trans). Los Angeles.

Kansteiner, S., Lehmann, L. and Hallof, K. (2014) *Der neue Overbeck* 1. Berlin.

Kekule, R. (1903) *Die antiken Terrakotten: die Typen der figürlichen Terrakotten*. Berlin.

Kraay, C. (1962) The Celenderis Hoard. *Numismatic Chronicle* 2, 1–15.

Kurtz, D. and Boardman, J. (1995) An Athenian Red-figure Neck-Amphora by the Athena-Bowdoin Painter. In Cambitoglou, A. (ed.) *Classical Art in the Nicholson Museum, Sydney*. Mainz.

Lacroix, L. (1965) *Monnaies et colonization dans l'occident grec*. Brussels.

Lippolis, E. (1982) Le Testimonianze del culto in Taranto Greca. *Taras* 2, 81–135.

Lippolis, E. (1995) La Documentazione archeologica. In Lippolis, E., Garraffo, S. and Nafissi, M. *Taranto*, 29–129. Taranto.

Lippolis, E. (2001) Culto e iconografie della coroplastica votiva. *Mélanges de l'École française de Rome, Antiquité* 113, 225–255.

Lippolis, E. (2009) Rituali di Guerra: i Dioscuri a Sparta e a Taranto. *Archeologia classica* 60, 117–159.

Malkin, I. (1987) *Religion and Colonization in Ancient Greece*. Leiden.

Malkin, I. (1994) *Myth and Territory in the Spartan Mediterranean*. Cambridge.

Maul-Mandelartz, E. (1990) *Griechische Reiterdarstellungen in agonistischem Zusammenhang*. Frankfurt.

Nafissi, M. (1995) La Documentazione leteraria ed epigrafica. In Lippolis, E., Garraffo, S. and Nafissi, M. *Taranto*, 153–334. Taranto.

Poli, N. (2010) Terrecotte di cavalieri dal deposito del Pizzone. *Archeologia classica* 61, 41–73.

Ravel, O. (1947) *Descriptive Catalogue of the Collection of Tarentine Coins Formed by M. P. Vlasto*. London.

Russo, F. (2004) I Donari Tarantini a Delfi. *Annali della Scuola normale superiore di Pisa* series 4:9:1, 79–102.

Salapata, G. (1992) *Lakonian Votive Plaques with Particular Reference to the Sanctuary of Alexandra at Amyklai*. PhD. dissertation. University of Pennsylvania.

Sampson, A. (2000) Σκόπελος: Ιστορική και αρχαιολογική αφήγηση. Skopelos.

Stampolidis, N. and Tassoulas, Y. (2009) *Eros: From Hesiod's Theogony to Late Antiquity*. Athens.

Stefanelli, L. (1977) Tabelle fittili Tarantine relative al culto dei Dioscuri. *Archeologia classica* 29, 310–398.

Stillwell, A. (1952) *Corinth XV: II: The Potters' Quarter, The Terracottas*. Princeton.

11. Lydian Gold to Newcastle

Dyfri Williams

Brian Shefton's[1] collection is not only contained within the walls of the museum that as a result of his extraordinary acquisitive instincts once bore his name, but it is, in a sense, also made up of all the objects that his keen insights and wide interests brought out of obscurity or gave sudden clarity of meaning to – a good example being the extraordinary bronze griffin in the J. Paul Getty Museum, for it was Brian Shefton who realised what it was, arguing persuasively for its Tartessian origin.[2]

His range of interests was enormous and was fed by his friendly curiosity, utter openness and transparent honesty. His published writings and lectures reveal a deep knowledge of pottery, bronze vessels, iconography, wall-painting and mosaics. This, and more, is reflected in his collecting for what was to become the Shefton Museum of Greek Art and Archaeology, for there we find Greek and Etruscan pottery of all periods, as well as bronze vessels, terracotta and bronze figurines, and even some larger sculpture. Sadly Athenian pottery was all too often beyond his reach financially, but there are some interesting and important pieces – one cannot help noting an extraordinary little gem, a small red-figure amphora of Panathenaic shape with a cult scene clearly connected with the Panathenaic festival.[3] What stands out in Brian Shefton's publications and in his acquisitions, however, is his remarkable "pan-Mediterranean sight", as he once called it, a vision that reached from Iberia to Iran (Shefton 1999).

Here, in his honour, and thanks to the generous help of Sally Waite, I wish to turn to the eastern end of the Mediterranean, to the zone of interaction between the Greek, Lydian and Achaemenid worlds, a region and theme that fascinated Brian Shefton and on which he himself wrote (Shefton 1971). My focus will be Lydia and the time frame the period between the fall of Sardis to the Persians in 547/6 BC and the King's Peace of 387 BC which fixed the balance of power in western Anatolia for another 50 years.[4] I will look at two items of gold jewellery from Brian Shefton's *mouseion* that he generously placed on loan in what is now the "Great North Museum: Hancock". They are only fragments, but the quality is superb and have what one might call a "cultural reach" of particular interest.

I begin with two small gold elements that come from a necklace (inv. no. 765 a–b, Fig. 11.1).[5] They take the form of corrugated tubes, each with nine ridges, and a myrtle seed pod (made in two halves) soldered centrally below. The underneath of the seed pods is decorated with a six-petal rosette. A series of 12 such elements were purchased by Alfred Lawson in 1892 and sold on to Augustus Wollaston Franks, who bequeathed them to the British Museum in 1907 (Fig. 11.2).[6] They were said to come from a find of jewellery at Phokaia, the most northerly of the Ionian cities, on the border with Aeolis. A further series of fourteen examples were excavated at Lydian Sardis a few years later, between 1910 and 1914, in H. C. Butler's Tomb 232, while a scrap was found in another tomb.[7] The nine examples that were purchased for the Brooklyn Museum in 1971 unfortunately have no recorded find-spot, but they most probably came from a looted tomb somewhere in Asia Minor in the later 1960s (Fig. 11.3).[8]

An example from Sardis that lacks the rosette under the seed pod, but is otherwise identical, consists of two fragments found in Tomb 75 along with a pair of earrings.[9] The earrings are

Figure 11.1: Gold necklace fragments, Newcastle upon Tyne, Shefton Collection 765 a–b. Photograph: Colin Davison.

of a type closely paralleled in a pair from Nymphaion (Crimea) which contained an Attic red-figure askos and three Attic black-glaze vessels, all dated to the last quarter of the fifth century.[10] From this we may suppose that the necklace type represented by the Shefton fragments belongs to the fifth century, perhaps even to its second half.

This date is further confirmed by a more elaborate version, which has the myrtle seed pods attached to plaques in the form of a

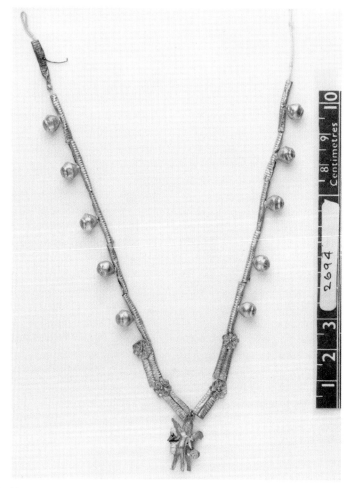

Figure 11.2: Gold necklace elements, British Museum, GR 1917,0601.2694. Photograph: courtesy of the British Museum.

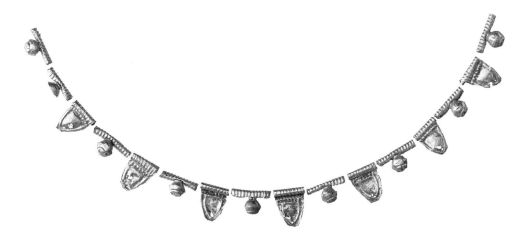

Figure 11.3: Gold necklace elements, Brooklyn 71.79.4-55. Photograph: courtesy of Brooklyn Museum.

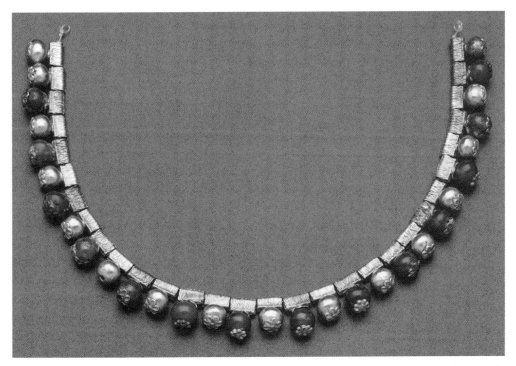

Figure 11.4: Gold and cornelian necklace, Boston, Museum of Fine Arts 1982.413. Photograph: courtesy of the Museum of Fine Arts, Boston.

Lesbian *cyma reversa* and decorated with an egg and dart pattern rather than a simple ribbed tube. This piece is a wonderful polychrome necklace, now sadly divided between the Museum of Fine Arts, Boston (Figs. 11.4 and 11.5), and the Manisa Museum of Archaeology and Ethnography (Fig. 11.6). It came from a tomb near Kendirlik (Bin Tepe) that was excavated by the Manisa Museum in 1976, following the report of the recent looting of the tomb in early March of that year. The necklace has myrtle seed pods, alternately of gold and cornelian (or perhaps rather red glass), attached to the elaborate plaques above.[11] The glass beads are held in place by means of a rosette, with a hollow tube pointing downwards, soldered to the plaque and a second rosette with tube pushed up from below.

Finally, in connection with these necklaces, it is also worth noting a related type on which the tubular element was adorned with a different sort of pendant seed. On this type the myrtle seed pods have been substituted with almond-shaped ones. The earliest example would seem to be a piece from Ephesos excavated by Hogarth: it is of silver and is presumably early sixth century in date.[12] The most elaborate example of this type is a necklace from the so-called "Lydian Treasure", material illicitly excavated in the neighbourhood of Uşak (*c.* 1965–6), mostly acquired by the Metropolitan Museum of Art between 1966 and 1973, and finally returned to Uşak in 1993.[13] There are identical elements in the Indiana University Art Museum in Bloomington and they must in fact come from one and the same necklace.[14] The Bloomington necklace is a pastiche and also includes five pomegranate pendants on short chains that clearly go with six elements in the "Lydian Treasure", while the faience tube beads are modern.[15]

In conclusion, it seems very likely, therefore, that such tube and seed necklaces began to be produced in the Lydian sphere long before the Persian capture of Sardis and continued to be made throughout the fifth century. It is a native form, one not found in the Achaemenid repertoire.[16]

The second gold item from Shefton's collection is a single gold earring (inv. no. 763, Figs. 11.7 and 11.8).[17] This earring is of the boat- or leech-shaped form common to many cultures and periods. The strong central ridge or carination, however, seems to be characteristic of the Lydian world and, indeed, bronze punches or formers used to produce just this type of earring are to be found in the "Lydian Treasure".[18] The Shefton example also has elaborate wire decoration in

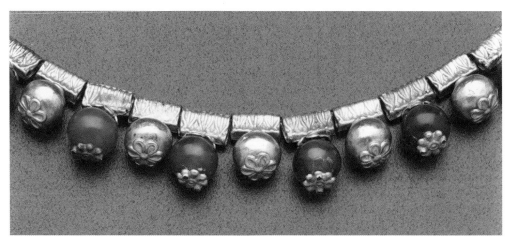

Figure 11.5: Gold and red glass necklace detail, Boston, Museum of Fine Arts 1982.413. Photograph: courtesy of the Museum of Fine Arts, Boston.

the form of four spirals, each with a central globule, and a dozen or more loosely arranged triangles of granulation below; above this is a ring of larger globules and four more triangles of granulation that are attached to the thick wire hoop of the earring.

Plain examples of this shape are known from Sardis and Bayındır (northern Lycia), while several pairs without provenance are known, including gold and silver examples once in the collection of Norbert Schimmel in New York, two gold and one silver pair in Kassel (Staatlichen Antikensammlungen and private collections), and a group acquired by the San Antonio Museum of Art in 1989 (Fig. 11.9).[19] In addition, two pairs of gold earrings of this type are in the "Lydian Treasure" and a singleton was confiscated in 1970 perhaps from a tomb at Gökçeler.[20]

Other more elaborate examples decorated with granulation and filigree wire spirals are known from tombs in Sardis (Tomb 50), Tilkitepe near Caberkamara (Cogamus river valley, east of Sardis) and Kızöldün (northeast Troad, near the mouth of the Granicus river on the Sea of Maramara); and there is a pair in a private collection once on loan in Kassel and said to be from Asia Minor. The Sardis pairs have triangles of granulation but also trails of granulation that lead horizontally across the surface of the body of the earrings and three small seed-like pendants attached below, the centre one plain, the flanking ones covered with granulation.[21] The Tilkitepe jewellery, recovered from looters in 2000, included a single plain carinated earring, four with added filigree spirals (two figures of eight) and three triangles of granulation (fewer than on the Shefton earring), and three with the same decoration but with additional pomegranate pendants on short chains below.[22] The pair once on display in Kassel also have two figure of eight spirals with three triangles of granulation below (Naumann 1980, no. 38).

The four identical pairs of decorated earrings from the Kızöldün tumulus and their

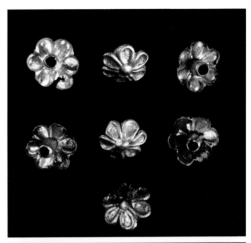

Figure 11.6: Gold necklace fragments, Manisa Museum of Archaeology and Ethnography 6284-6. (After Cahill 2010.)

undisturbed context are worthy of a closer look. The tumulus contained the famous Polyxena sarcophagus, which was buried 6 m below the summit of the mound but had been looted.[23] Only 3 m away, and barely half a metre below the surface, was, exceptionally, an undisturbed plain marble sarcophagus.[24] This contained the bones of a child, aged 8–9 years: it seems likely that she had suffered from malaria. Near the head of the deceased were placed a small painted wooden female protome and a wooden pyxis with four compartments, a glass aryballos, a terracotta alabastron with a black neck and mouth and three black bands, and one or two ovoid lekythoi. In the area of the pelvis, probably held in the hands, were a silver ladle and a simple silver phiale. At the feet were three alabaster alabastra. Of

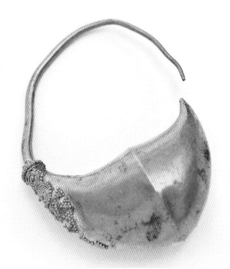

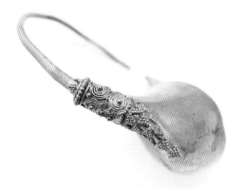

Figure 11.7: Gold earring, Newcastle upon Tyne, Shefton Collection 763. Photograph: Colin Davison.

Figure 11.8: Gold earring, Newcastle upon Tyne, Shefton Collection 763, detail. Photograph: Colin Davison.

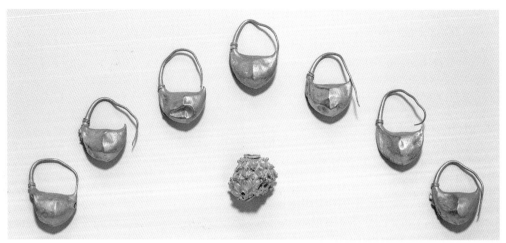

Figure 11.9: Gold earrings and bead, San Antonio Museum of Art, 89.98 a–h. Photograph: Peggy Tenison, Brooklyn Museum.

the fine jewellery that accompanied the child on either arm was a gold bracelet with antelope head terminals, at the neck four pairs of earrings and an articulated necklet, and across the chest a necklace with pendants of gold and beads of red glass.

The most important object for dating the child's tomb, no doubt that of a girl, is the glass aryballos, which is of a well-known type, found in both the eastern Mediterranean and the west (Sevinç *et al.* 1999, 493, fig. 4).[25] Two very similar aryballoi have subsequently been found in an undisturbed chamber tomb in the extramural cemetery of Sardis (Tomb 03.1)[26] This burial also contained a glass alabastron and oinochoe of the same class, three ovoid lekythoi (two with the same profile as those in the girl's tomb), an alabaster alabastron (very similar to that from the girl's tomb – with the same profile and dimensions), a small Attic black-glaze dish datable to 425–400 BC and a red-figured askos of the same date. We can, as a result, quite confidently date the burial of the girl's sarcophagus to the last decades of the fifth century BC.

The necklet takes the form of an articulated band made up of stamped gold sheets decorated with lotus palmette flowers and palmettes ending in a fine lion head (Sevinç *et al.* 1999, 499–500, figs. 15–18). The necklace is missing one element and shows signs of repair. Its form closely recalls a simplified version of the same type from a Cypriot find complex once on the antiquities market.[27] This is, however, only a piece of funerary jewellery, more flimsily made and less carefully stamped and cut out, and, moreover, designed to be sewn onto the deceased's garment rather than strung as a necklace. There were clearly connections between Cyprus and Lydia in terms of jewellery – indeed, I have suggested elsewhere that the pendant in the centre of a Cypriot necklace found at Amathus (Tomb 256) is a Lydian heirloom.[28] Furthermore, since this type of jewellery, using thin hammered sheets does not seem common in Lydia, it is possible, therefore, that the necklet in the Kızöldün burial is a Cypriot import, an idea which, since jewellery was rarely exported for trade, might indicate that a female member of the girl's family was ethnically Cypriot; but this should not be pressed.

The other necklace with melon-shaped spacer beads of red glass trimmed with gold wire and seed-shaped gold pendants covered with six levels of feathers punctuated with tiny gold balls is particularly splendid. The decoration of the seed pendants, which are attached to the necklace by plain spherical beads, match a bead in the San Antonio Museum of Art, which may well have been found with the plain boat-shaped and carinated earrings in the same museum, noted above (Fig. 11.9, lower).[29] With these beads should also be compared the pendant beads on the famous hippocamp brooch from the "Lydian Treasure", the beads wrongly strung on a necklace from Sardis (Tomb 836), and the similar pendants on two necklaces, both pastiches once in private hands to be associated with the "Lydian Treasure".[30] The spacers on the acorn necklace from the Lydian Treasure also recall this group (Özgen and Özturk 1996, no. 108). The necklace from the girl's tomb, thus, fits very well among the best Lydian jewellery, no doubt because nearby Daskyleion was part of the Lydian empire before it became part of the Persian.

To return to the girl's earrings, they have a pair of figure of eight spirals with areas of granulation below – here three triangles and two small rhombuses (Sevinç *et al.* 1999, 501; Rose 2014, 107 and 108 fig. 4.6). They are, however, smaller than the Shefton earring (height 2.9 cm, width 1.8 cm) so that the spirals are reduced in complexity, and there is less use of granulation. The earrings show no signs of wear, unlike the necklaces and bracelets (not even a matching pair), suggesting that they were the child's own, and the other items placed there by her family and so probably earlier in date, probably before the middle of the century.

The girl's burial may be dated, as we have seen, to the last decades of the fifth century, not the middle of the century as the excavators had thought (Sevinç *et al.* 1999, 502), and this is

presumably the date of the Shefton earring, which would seem to belong to the same workshop tradition as the earrings found in it. The additional jewellery placed in the tomb might belong, by reason of its worn, damaged and repaired state some years earlier, perhaps in the second quarter of the fifth century, but this is no more than a guess.

Much recent work has been done looking at Lydia and other areas of western Anatolia under Persian rule and trying to understand better some of the wider cultural issues. In the realm of jewellery, however, we are constantly handicapped by the paucity of our evidence and run the risk at times of oversimplifying the continual, two-directional craft exchange that occurred over the centuries, first with the Assyrians, then the Phrygians and finally the Greeks of Ionia.[31] Our understanding of the jewellery produced in Lydia after the fall of Sardis currently depends very heavily on the poorly documented material from the early excavations at Sardis and the spoils of looters, especially the so-called "Lydian Treasure". In the case of Sardis some of the more recent work done there under the inspiring, lifelong guidance of the late Crawford H. Greenewalt Jr. can offer greater definition. In addition, some undisturbed tombs have been found and I have tried to make as much use of them above as possible. Nevertheless, we are greatly hampered by the lack of material clearly earlier than the middle of the sixth century.

As a result, the time is still not right for a full appreciation of the Lydian jeweller's craft. As the looting of archaeological sites continues in western Turkey (and elsewhere), clearly a local winter "occupation" (as it was in the nineteenth century in Etruria),[32] what we can try to do is unscramble the material that eventually filters through to museums by trying to ascertain its probable companions and context. The work of İlknur Özgen and Jean Öztürk on the "Lydian Treasure" was exemplary in this regard, but we need to combine it with Greenewalt's work at Sardis and that of Christopher Roosevelt in charting as much of the physical contexts as possible across Lydia. Such an approach is, of course, far from perfect, but it remains practical and is perhaps better than regarding any "unprovenanced" material as simply non-existent. It certainly pays proper respect to the work of the ancient craftsman, something that was very close to Brian Shefton's heart.

Notes

1 I am very grateful to Sally Waite for organising the wonderful event in Newcastle to celebrate Brian Shefton and his work, at which I spoke at length on Athenian pottery with a coral-red slip, including "the Shefton salt cellars". My presentation was too long and too diffuse, rather in the Shefton manner, some might say, and so I felt I could not include it in the proposed volume, for which the timescale seemed too short. When Sally kindly informed me later that I could still offer a short piece, I found I had to choose another topic. I should also like to thank most warmly Penny Shefton for permission to include the two pieces of gold jewellery that had been acquired by Brian and placed on loan in the Museum. For images and other help, I owe particular thanks to Dr Christine Kondoleon (MFA Boston) and Professor Chris Roosevelt (Boston University), Dr Judith Swaddling, David Hurn and Charles Arnold (British Museum), and Dr Jessica Powers and Kimberly Mirelez (San Antonio Museum of Art), and Dr Edward Bleiberg and Kathy Zurek-Doule (Brooklyn Museum).
2 Malibu, J. Paul Getty Museum 79.AC.140, Shefton (1990, 189–193, pl. 2).
3 Newcastle, Shefton Collection 210, Shapiro (2001, 120, with 201 no. 75, and pl. 33, 3–4).
4 On the history and archaeology of Lydia see Roosevelt (2009); Kerschner (2010); Roosevelt (2012).
5 Length 0.75 cm; height. 0.65 cm; no recorded provenance.
6 London, British Museum GR 1917,0601.2694 (part: as published a pastiche of three objects, of different dates; the necklace was not available for new photography): Marshall (1911, no. 2694); Williams (2005, 105–106, fig. 2).

7 Curtis (1925, 19 no. 31 part, pl. 3 fig. 13) (inv. 4569; tube, 7.5 mm long; seed, seven-petal rosette); cf. also 24 no. 44. pl. 4 fig. 2 (tubes 7 mm long; no rosette underneath); and no. 61, pl. 6, fig. 7b (inv. 765b; tube 7.5 mm long; seed, six-petal rosette). See also the reports of a tomb that contained Curtis (1925, 28 nos. 57–60): "One small gold bead or pendant with cross-ribbed neck and a spherical body, on the underside of which is a six-petal rosette in relief. Height 7 mm; diameter spherical portion 5 mm." Curtis studied the items in Constantinople in 1923; for a manuscript catalogue in New York, Metropolitan Museum of Art by Bell, H. W. – see Curtis (1925, 9–10).

8 New York, Brooklyn Museum 71.79.40–55: Davidson and Oliver (1984, no. 16 part) (1971 is the date of purchase by the museum using funds donated by Mr and Mrs Thomas S. Brush).

9 Curtis (1925, 24 no. 44. pl. 4 fig. 2 (tubes 7 mm long); earrings, no. 69, pl. 7 fig. 8) (also found with two pairs of small lions on rectangular bases).

10 Nymphaion (Crimea), Grave II, female (see Vickers 2002, 8–9), Oxford, Ashmolean Museum 1885.494, Vickers (2002, 26 and lowest image on pl. 7). Askos, 1885.499: *CVA* Oxford 1, pl. 45, 2; Vickers (2002, 28–29, pl. 8). Black-glaze vases: 1885. 495–7, *CVA* Oxford 1, pl. 48, 2, 3 and 19; Vickers (2002, 30–33, pls 9–10). The black-glaze Castulo cup has the graffito "Achaxes" (of Achaxe) in Ionian script. For further discussion and parallels for the type of earring see Rudolph (1995, 89–91); Williams (2005, 112 n. 13).

11 Boston Museum of Fine Arts 1982.413, said to be from Asia Minor (30 elements; length *c.* 20 cm), unpublished. Manisa Museum inv. 6284-6 (two elements, 6284, preserve the cyma reversa plaque with gold myrtle seed; four elements, 6285, preserve the plaque with rosette and tube below to hold a glass bead; 6286 is seven petal fittings for the bottom), Roosevelt (2009, 210 no. 3, fig. C.1); Cahill (2010, 505 with plate on 506); Dusinberre (2013, 150 fig. 74).

12 London, British Museum GR 1907,1201.241, Marshall (1911, no. 1081). Cf. also Özgen and Öztürk (1996, no. 137) (silver; triple seeds); and the larger single elements nos. 142 (silver) and 141 (gold).

13 Özgen and Öztürk (1996, no. 134) (purchased by the Metropolitan Museum of Art, New York in two portions (33 elements and 7 elements), one in 1968, the other in 1969). On the "Lydian Treasure" see also Williams (2005, 107–110). Note that the brooch in the form of a hippocamp (Özgen and Öztürk 1996, no. 112) was sold off by the Director of the Uşak Museum in about 2006 to pay his gambling debts, but was recovered in Germany late in 2012.

14 Bloomington, Indiana University Art Museum 70.56.2 (11 elements): Deppert-Lippitz (1985, 95 fig. 48); Rudolph (1995, 66–71, no. 11). The total length of a necklace that combined all the elements would be 57.3 cms.

15 Özgen and Öztürk (1996, no. 135). The total of 11 pomegranate elements must have been combined with spacer beads, perhaps even with the spherical beads of no. 138 (perhaps along with the spherical and pointed ovoid pendants without chains).

16 Cf. the range of jewellery discussed by Rehm (1992).

17 Height 4.3 cm; width 2.9 cm; no recorded provenance.

18 Cf. Özgen and Öztürk (1996, 164); for the punches/formers, 228–30, nos. 214–7 (for the problem of their find-spot see p. 61).

19 Sardis, three pairs and a small singleton from one tomb: Curtis (1925, 28 nos. 57–60). Bayındır, T B4 (silver): see for the tumulus, Özgen and Özgen (1992, 32–49, figs. 29–62); Özgen and Öztürk (1996, 164). Schimmel earrings: Muscarella (1974, no. 69 a–b) (probably acquired between 1965 and 1975); Sotheby's New York, 16 December 1992, lot 76. Kassel, Naumann (1980, nos. 35–36 and 37). San Antonio Museum of Art, 89.98a–g: unpublished (7 gold earrings) – for the bead (fig. 11.9, lower) acquired with the earrings, see below. For a pair on the New York market in 1998: Deppert-Lippitz (1998, no. 28).

20 "Lydian Treasure": Özgen and Öztürk (1996, nos. 113–4); Cahill (2010, 543). Gökçeler (?), Manisa Museum, inv. 5290, Roosevelt (2009, 241, cat. 14.1 D, fig. C 20); Cahill (2010, 547–8 and 552) (image).

21 Curtis (1925, no. 61 (inv. 4547), pl. 6, 7 a); Karagöz (2013, 148–9, nos. 120 (inv. 5149) and 121 (inv. 4547), figs. 120–1).

22 Roosevelt (2009, 239–240, fig. C.19) (Uşak Museum). The pendants on the end of the chains are the same as the elements on Istanbul inv. 4554 (Karagöz 2013, no. 135; Curtis 1925, no. 32) and the one that has strayed onto inv. 4567 (Karagöz 2013, no. 136; Curtis 1925, no. 41).

23 Polyxena sarcophagus: Sevinç (1996); and most recently Rose (2014, 72–103) (302 fn. 17 for bibliography).

24 Child's tomb: Özgen and Öztürk (1996, 56 and 57, fig. 126); Sevinç, Rose and Strahan (1999); Rose (2014, 104–115).

25 See Harden (1981, 89) (Mediterranean Group I aryballoi, type ii), especially nos. 226–236; note no. 229 from the fourth-century cemetery at Mikro Karaburun near Thessaloniki and no. 233 from Rhodes Fikellura grave 133, dated 450–400.

26 Cahill (2010, 554–560, with 283–4) (E. Baughan).

27 As noted by Sevinç, Rose and Strahan (1999, 500). For the Cypriot group see Deppert-Lippitz (1985, figs. 87, 88 (pl. 8), 91 (the necklace; pl. 9b), 96, 101, 108 (pl. 9a) – Sotheby's 8 December 1980; Münzen und Medaillen, Basel, Sonderliste T (1981) no. 14. Group dated by Deppert-Lippitz to 475–450 BC).

28 London, British Museum GR 1895,1101.454-6, Marshall (1911, no. 1957); Williams and Ogden (1994, no. 166); Williams (2005, 110).

29 Bead, San Antonio Museum of Art 89.98h.

30 Hippocamp brooch: Özgen and Öztürk (1996, no. 112). Sardis pendant beads: Curtis (1925, no. 51); Karagöz (2013, 156 no. 138 (inv. 4645), fig. 299). For the two necklaces in private hands see Williams (2005, 109–110) – Borowski collection, on loan to Bible Lands Museum, Jerusalem, see Reeder (1995, 174–6, no. 29) (C. Benson) and Christie's New York 13 June, 2000, lot 415, see Williams (2005, colour pl. 2).

31 Özgen and Öztürk (1996, 57–60); Meriçboyu (2010). See also brief comments in Dusinberre (2003, 146–159); Dusinberre (2013, 152–4).

32 See Roosevelt and Luke (2006).

Bibliography

Cahill, N. D. (ed.) (2010) *The Lydians and Their World*. Istanbul.

Curtis, C. D. (1925) *Sardis XIII: Jewelry and Gold Work, Part I, 1910–1914*. Rome.

Davidson, P. F. and Oliver, A. (1984) *Ancient Greek and Roman Jewelry in the Brooklyn Museum*. New York.

Deppert-Lippitz, B. (1985) *Griechischer Goldschmuck*. Mainz.

Deppert-Lippitz, B. (1998) *The Gift of the Gods: Jewelry from the Ancient World*. New York, for Fortuna Fine Arts, Ltd.

Dusinberre, E .R. M. (2003) *Aspects of Empire in Achaemenid Sardis*. Cambridge.

Dusinberre, E. R. M. (2013) *Empire, Authority, and Autonomy in Achaemenid Anatolia*. Cambridge.

Harden, D. B. (1981) *Catalogue of Greek and Roman Glass in the British Museum: Volume I, Core- and Rod-formed vessels and pendants and Mycenaean cast objects*. London.

Karagöz, Ş. (2013) *Kleinasiatisch-Gräko-Persische Kunstwerke im Archäologischen Museum von Istanbul*. Tübingen.

Kerschner, M. (2010) The Lydians and their Ionian and Aiolian Neighbours. In Cahill, N. D. (ed.) *The Lydians and Their World*, 247–265. Istanbul.

Marshall, F. H. (1911) *Catalogue of the Jewellery, Greek, Etruscan and Roman, in the Department of Antiquities, British Museum*. London.

Meriçboyu, Y. A. (2010) Lydian Jewelry. In Cahill, N. D. (ed.) *The Lydians and Their World*, 157–176. Istanbul.

Muscarella, O. W. (ed.) (1974) *Ancient Art: The Norbert Schimmel Collection.* Mainz.

Naumann, F. (1980) *Antike Schmuck. Vollständiger Katalog der Sammlung und der Sonderaustellung Staatliche Kunstsammlung Kassel.* Kassel.

Özgen, E. and Özgen, İ. (1992) *Antalya Museum.* Ankara.

Özgen, İ and Özturk, J. (1996) *Heritage Recovered: The Lydian Treasure.* Istanbul.

Reeder, E. (1995) *Pandora. Women in Classical Greece.* Princeton.

Rehm, E. (1992) *Der Schmuck der Achameniden.* Münster.

Roosevelt, C. H. (2009) *The Archaeology of Lydia, from Gyges to Alexander.* Cambridge.

Roosevelt, C. H. (2012) Iron Age Western Anatolia: The Lydian Empire and Dynastic Lycia. In Potts, D. (ed.) *A Companion to the Archaeology of the Ancient Near East*, vol. 2, 896–913.

Roosevelt, C. H. and Luke, C. (2006) Mysterious Shepherds and Hidden Treasures: the Culture of Looting in Lydia. *Journal of Field Archaeology* 31 (2), 185–198.

Rose, C. B. (2014) *The Archaeology of Greek and Roman Troy.* Cambridge.

Rudolph, W. (1995) *A Golden Legacy: Ancient Jewelry from the Burton Y. Berry Collection at the Indiana University Art Museum.* Bloomington.

Sevinç, N. (1996) A new sarcophagus of Polyxena from the Salvage Excavations at Gümüşçay. *Studia Troica* 6, 251–264.

Sevinç, N., Rose, C. B. and Strahan, D. (1999) A Child's Sarcophagus from the Salvage Excavations at Gümüşçay. *Studia Troica* 9, 489–509.

Shapiro, H. A. (2001) Red-Figure Panathenaic Amphoras: Some Iconographic Problems. In Bentz, M. and Eschbach, N. (eds.) *Panathenaïka: Symposion zu den Panathenäischen Preisamphoren, Rauischholzhausen 25.11.–29.11.1998*, 119–124. Mainz.

Shefton, B. B. (1971) Persian Gold and Attic Black Glaze: Achaemenid influences on Attic pottery of the fifth and fourth centuries BC. *Annales archéologiques arabes syriennes* 21, 109–111.

Shefton, B. B. (1990) Intervento in *La Magna Grecia e il lontano, Atti di ventenovisimo convegno di studi sulla Magna Grecia, Taranto 6–11 Ottobre 1989*, 189–193. Taranto.

Shefton, B. B. (1999) The Lancut Group, Silhouette Technique and Coral Red. Some Attic Vth century Export Material in Pan-Mediterranean Sight. In Villanueva Puig, M. C., Lissarrague, F., Rouillard, P. and Rouveret, A. (eds.) *Céramique et Peinture grecques. Modes d'emploi*, 463–479. Paris.

Vickers, M. (2002) *Scythian and Thracian Antiquities in Oxford.* Oxford.

Williams, D. (2005) From Phokaia to Persepolis: East Greek, Lydian and Achaemenid Jewellery. In Villing, A. (ed.) *The Greeks in the East,* 105–114. London.

Williams, D. and Ogden, J. (1994) *Greek Gold: Jewellery of the Classical World.* London.

12. Three Etruscan Mirrors in the Shefton Collection

Andrew Parkin

One of Brian Shefton's[1] main research interests was in the metalwork of the Greeks and Etruscans. This is reflected in many of his publications as well as in the significant number of metal objects in the Shefton Collection. Of particular note are three engraved Etruscan mirrors: one depicting the rape of the Trojan princess Kassandra, one representing the abduction of Tithonos by Eos and a third with an image of a winged female, identified as a Lasa figure. Shefton published both the Eos with Tithonos and the Kassandra mirrors in *Archaeological Reports* (1969–70), but this was a survey article, which was not intended to provide an in-depth analysis of either mirror.[2] The Lasa mirror is unpublished. These mirrors provide an insight into the use of mythological imagery, either from the Greek world or of local origin, in an Etruscan setting.

Engraved mirrors are a significant product of the Etruscan world with approximately three thousand surviving examples (De Puma 1983, 290). These are hand-held mirrors, often referred to as grip mirrors, made of cast or beaten bronze and consisting of a slightly convex disc that was highly polished on one side and with engraved decoration on the other. Grip mirrors could have a handle cast in one piece with the disc. Alternatively they were made with a tang that was intended for a handle of ivory, bone or wood (de Grummond 1982, 8ff.). Mirrors with engraved figure scenes range from the late sixth century BC (ibid., 140) to at least the third and possibly the second century BC (ibid., 154).

It is impossible to state with any certainty who used engraved grip mirrors. There are examples occurring in male graves (Haynes 2000, 241) and some of the names inscribed on mirrors indicate male ownership (van der Meer 1995, 22–26) but the majority of evidence suggests that the primary audience for them was female (ibid.; de Grummond 1982, 166–168; Izzet 2007, 45). These mirrors were likely to be the property of women of relatively high status and it has been suggested that they were given as wedding gifts (Haynes 2000, 241). They are commonly found among grave goods, but it is unlikely that they were made specifically for the tomb. In fact the presence of the word suthina ('for the tomb') inscribed in Etruscan on the polished side of mirrors to render them unusable indicates that they were dedicated after they had been used in life (Beazley 1949, 16; Haynes 2000, 243).

Eos and Tithonos (inv. no. 311)

The oldest engraved mirror in the Shefton Collection, dating to *c.* 460 BC, represents the abduction of the Trojan prince Tithonos by Eos, goddess of the dawn (Figs. 12.1 and 12.2). The mirror was a gift from James Bomford who, along with his wife Brenda, was a prominent collector of antiquities, including bronzes, in the 1960s and 70s. Bomford's collecting interests were varied but he is known to have acquired a number of Etruscan mirrors (Moorey and Catling 1966, 74). Unfortunately no further details about the provenance of this mirror are known. It would have entered the Shefton Collection sometime before Brian Shefton published it in 1970 but the exact date is not recorded in the museum's documentation.

The mirror is in a fragmentary condition, with the top half of the mirror disc missing. The surface of the mirror is pitted and there is considerable corrosion to the tang and rim. The patina

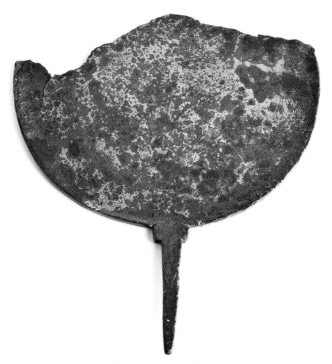

Figure 12.1: Fragmentary engraved bronze mirror showing the abduction of Tithonos by Eos, Newcastle upon Tyne, Shefton Collection 311. Photograph: Colin Davison.

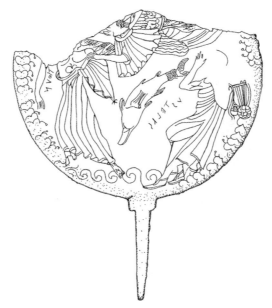

Figure 12.2: Drawing of the Eos and Tithonos mirror, Newcastle upon Tyne, Shefton Collection 311. Drawing: Mary Hurrell.

is predominantly of a reddish brown colour, although there are also traces of green. On the front or polished side there is a lyre-shaped palmette with scrolls extending to either side directly above the tang that would have held the handle. On the engraved side are patches of a golden surface, although much of this has been lost through modern scraping. Shefton (1970, 56) believed that this golden surface was necessary to make the engraving, which is very light, fully legible. Unfortunately, in its current state, much of the detail of the engraving is difficult to distinguish and elements of the composition are impossible to see. A stacked ivy pattern runs around the sides of the engraved scene, with a line of waves along the bottom. Tithonos (inscribed: TITHUN), wearing a himation is to the left of the scene. Winged Eos, wearing a chiton and short cloak swoops down on Tithonos, touching his shoulder with her hand. Beneath her a dolphin leaps above the waves. On the right hand side is a seated individual, wearing a himation and holding a lyre. Between the dolphin and this figure is the inscription USTELES, which is probably the name of the owner of the mirror rather than a reference to the dolphin or the figure to the right (van der Meer, 1995, 40). On this reading the name Usteles is the genitive form of the male name Ustele. This would be entirely consistent with a number of other mirrors where the owners' names are inscribed on the engraved surface of the disc (Bonfante 1990, 29–30; van der Meer 1995, 13ff.).[3]

This mirror represents a version of the myth where Tithonos, son of the Trojan king Laomedon is abducted by Eos, the goddess of the Dawn. The individual holding the lyre and raising his right arm in horror is likely to be Tithonos' brother Priamos. The subject of Eos and a young lover was popular in Etruria in the fifth century BC (Goldberg 1987, 607). Representations of Eos carrying off a youth occur on different objects, including handle attachments and antefixes (ibid.). There are several examples of engraved mirrors where Eos is depicted carrying off a youth. These include a mirror in Berlin[4] and one in the Vatican[5] (De Puma 1983, 294). In some cases another of Eos' lovers, Kephalos, is likely to be represented and it is often impossible to distinguish between the two, particularly if there is no inscription to help identification (ibid., 297).

Scenes of erotic pursuit, including representations of Eos and Tithonos, were common on Attic painted pottery of the late sixth and fifth centuries BC and it is likely that the engravers of Etruscan mirrors were influenced by abduction imagery on Attic vases (van der Meer 1995, 28). There are certainly plenty of Attic red-figure examples, of Eos in pursuit of a youth, from Italian contexts (Weiss 1986, 747ff. and Lefkowitz 2002, 326).[6]

Shefton (1970, 56) believed that the representation of Eos descending, perhaps from her chariot, on the Newcastle mirror, is without parallel. Representations of the goddess on Attic painted pottery tend to depict winged Eos, on foot, pursuing Tithonos.[7] Eos is sometimes represented in a similar way on Etruscan mirrors. An engraved mirror in Berlin, for instance, shows a winged Eos running after a youth who is likely to be Tithonos (Osborne 2001, 287).[8] There is also a potential representation of Eos and Tithonos in her chariot on a Faliscan volute-krater[9] by the Aurora painter (ibid.), although this could be Eos and Kephalos (Bloch and Minot 1986, 794). The Newcastle mirror represents a different phase in the abduction of Tithonos, portraying the moment when Eos swoops down to carry him away. It is not unusual for Etruscan engraved mirrors to adapt the iconography of a particular episode from Greek mythology for their own purposes and this scene is an excellent illustration of this process. In Attic imagery Eos is often depicted in her chariot with a dolphin swimming below. The lyre held by Priamos is also frequently present in Attic red-figure pottery, although it is usually held by Tithonos or even snatched away from him by Eos. However the powerful image of a descending Eos is unknown on Attic painted pottery (van der Meer 1995, 41). The Newcastle mirror has taken iconographical elements from Attic red-figure pottery and created a unique scene.

Scenes of erotic pursuit are frequently found in both Greek and Etruscan imagery, but the representation of a female goddess in pursuit of a man is unusual, with Eos providing the only popular example found in vase-painting (Stansbury-O'Donnell 2009, 364). We can only speculate as to the meaning such images held for an Etruscan audience, but they may have served as a reminder of the precariousness of human existence (Lefkowitz 2002, 326). The figure, identified as Priamos, with his arm held up in horror, can be seen as an indication of the powerlessness of mortals to prevent the gods from carrying out their will. These images may also have held a funerary significance showing an individual being snatched from their mortal life and taken to another realm. They can perhaps also be read as a consolation in the time of death (ibid.). Nevertheless a funerary reading of this image should not be taken as evidence that mirrors with erotic pursuits on them were specifically intended for the grave (Beazley 1949, 16; Haynes 2000, 243). This is likely to have been a secondary meaning and the erotic nature of the imagery should be given the greater prominence when interpreting their significance.

Kassandra and Aias (inv. no. 110)

The second engraved mirror held by the Shefton Collection is another fragmentary mirror from the end of the fourth century BC, depicting the rape of the Trojan princess Kassandra by the Greek hero Aias (Figs. 12.3 and 12.4). Only the right hand part of the mirror disc with most of the figure of Kassandra is preserved. This mirror is a permanent loan from the collection of the Society of Antiquaries of Newcastle upon Tyne (Shefton 1970, 57). The mirror is first referred to in the *Bulletino dell'Instituto di Corrspondenza Archeologica* (1852, 41), which states that it was found in Orbetello in Tuscany. Subsequently it was published by Gerhard (1867, 56, pl. 400, 2) in his survey of Etruscan mirrors, where he identifies it as belonging to R. de Wit. Gerhard's illustration implies that the mirror was complete at this time, with the left hand side displaying Aias still preserved (Fig. 12.5). This section is now lost. At some point the mirror became the property of Robert Blair of South Shields who showed it to the Society of Antiquaries of Newcastle upon Tyne on 25 March 1891 (Anon, 1891). Blair was a prominent local collector of antiquities, as well as being the joint secretary of the Society of Antiquaries of Newcastle upon Tyne and the editor of the Society's journal *Archaeologia Aeliana* (Oxberry 1923, 202). On Blair's death in 1923 his collection, including the mirror, was given to the Society. There is no indication in the *Proceedings* of the Society as to the condition of the mirror when Blair showed it to them in 1891, which makes it difficult to know when the mirror was broken. Recent use wear analysis[10] suggests that the break may well be ancient since the edge is covered in the same green and red patina as the rest of the mirror. A more recent break, occurring after the mirror was found in the nineteenth century, would not show the same patina as the rest of the mirror. There are also traces of black coloured glue around the edge of the break which implies that at some stage something was attached to the mirror along the break. This could well have been the missing half of the mirror depicting Aias, which Gerhard (1867, pl. 400, 2) illustrated.

The fragment is of cast bronze and represents slightly under half of the original mirror. The tang where the handle would have been attached is missing but the remains of a hole, perhaps for one of the rivets to attach a handle, are still visible. Engraved on the front is a floral ornament in the area of transition (talon) between the mirror disc and handle, while the rim is decorated with a tongue pattern. On the reverse is an engraving depicting the rape of Kassandra by the Greek hero Aias, son of Oileus, who is often referred to as the Lesser Aias. Most of Aias is missing but Kassandra, wearing a chiton and a mantle over her shoulders, is clearly depicted

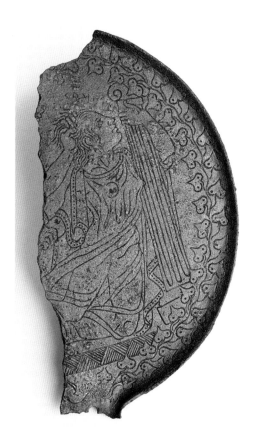

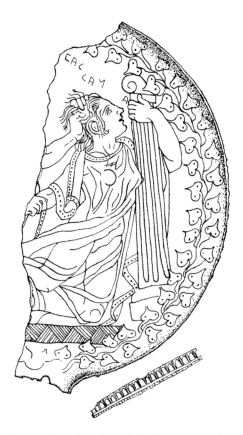

Figure 12.3: Fragmentary engraved bronze mirror showing Kassandra clinging to a column, Newcastle upon Tyne, Shefton Collection 110. Photograph: Colin Davison.

Figure 12.4: Drawing of the Kassandra mirror, Newcastle upon Tyne, Shefton Collection 110. Drawing: Mary Hurrell.

desperately holding on to a column as Aias tries to drag her away. One of Aias's hands is visible grabbing her hair, while the other can be seen holding on to her right arm. An inscription is located above Kassandra's head evidently identifying her, although its authenticity has been doubted (Touchefeu 1981, 346). There is also part of an inscription that possibly refers to Aias. The letters … IAS are visible above the Kassandra inscription.[11] The edge of the scene is decorated with a border of ivy leaves (Parkin 2014, 194).

According to myth, during the sack of Troy, Kassandra sought refuge from the attacking Greeks in the temple of Athena. She grasped the goddess's statue, the Palladion, in the hope of gaining Athena's protection. Aias, however, burst into the temple and dragged her from the statue, an exploit that antagonised the goddess and brought disgrace on the Greeks. This impious act is an iconographic theme that is frequently seen in Antiquity (Touchefeu 1981, 339ff.), although once it was an established motif artists varied it considerably (Woodford 1993, 110). It occurs on Attic red-figure vases, including many found in Italian contexts, and would have

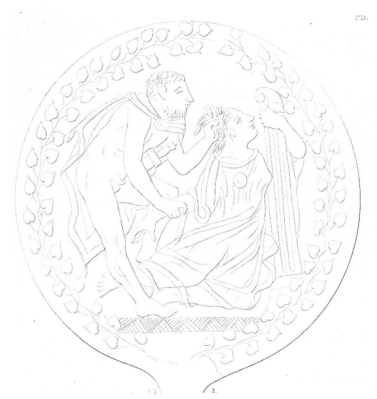

Figure 12.5: Illustration of the Kassandra mirror. (After Gerhard 1867 Etruskische Spiegel IV, pl. 400, 2.)

been known to Etruscan audiences.[12] The scene is also found in Etruscan art, for instance on a wall painting dating to 320–310 BC, from the François tomb at Vulci (Andreae 2004, 188). In addition several engraved mirrors depict this scene. Examples from Paris[13] and Milan[14] show Aias dragging Kassandra by the hair from the cult statue of Athena (Oleson 1975, pl. 37, fig. 5; Touchefeu 1981, 346, no. 82).

The Newcastle mirror differs significantly from all of these examples. Kassandra, instead of clinging to the Palladion, holds on to a column, something that is without parallel in representations of this episode. Brian Shefton (1970, 57), following Gerhard's (1867, 56) interpretation, believed that the column was surmounted by a Phrygian cap which functioned as a short-hand for the statue of Athena. Phrygian caps are undoubtedly associated with Easterners and on many occasions more specifically with Trojans, while a Paestan amphora in Vienna[15] depicts Kassandra clinging to a statue of Athena wearing what appears to be a Phrygian cap (Davreux 1942, 166). This might be seen as evidence for reading the column on the Newcastle mirror as an abbreviated symbol for the statue of Athena, with the fact that she is worshipped in the Eastern city of Troy suggested by the Phrygian cap placed on top of the column. All the same there are problems with this interpretation. First of all representations of Athena in a Phrygian cap are unusual and columns surmounted by one are rarer still. In fact the only possible example

I have come across is on the Newcastle mirror. Secondly Trendall (1987, 261) casts significant doubt over the evidence of the Vienna amphora, which has been heavily over-painted obscuring much of the original drawing.

An alternative reading would see the column surmounted by an Ionic or Aeolic capital. It has not been engraved particularly well but this is a far simpler explanation than one that tries to create a connection to the statue of Athena by means of a Phrygian cap. One of the capital's volutes is clearly visible, while the other is partly hidden by an ivy leaf. Furthermore the column is shown standing on a clearly defined base, another feature of Ionic and, to a lesser degree, Aeolic columns. There are several examples where Ionic columns have been associated with the rape of Kassandra. On an Etruscan amphora in the British Museum, for instance, Kassandra is shown holding on to an Ionic column on top of which is a statue of Athena[16] (Touchefeu 1981, 345–6, no. 79). Ionic and Aeolic columns are often associated with the East Greek World, and it is not implausible to see the column adding an Eastern, or Trojan, ambience to the scene. There are examples on South Italian red-figure pottery where Kassandra is shown in religious structures with Ionic columns (Trendall and Cambitoglou 1983, 151, no. 21a; Touchefeu 1981, 343, no. 56)[17] and these can be seen as elements that set the episode in the East. Finally there is a red-figure cup[18] from Orvieto attributed to the Telephos Painter that represents Aias in pursuit of Kassandra (Touchefeu 1981, 344, no. 64; Mangold 2000, 53–54). The image has no cult statue of Athena, instead Aias chases Kassandra past an isolated Aeolic column. Here the scene has been reduced to its bare essentials with the column acting as the only indication of the setting within a sanctuary (Mangold 2000, 53). Judging from the number of images of the rape of Kassandra that feature Ionic or Aeolic columns it is plausible to suggest that the engraver of the Newcastle mirror was influenced by them and chose to represent Kassandra clinging to one rather than representing the Palladion in the scene.[19]

Lasa (inv. no. 242)

The final engraved Etruscan mirror in the Shefton Collection is a complete example from the third century BC, with an engraving of a naked winged female on the reverse side (Fig.12.6). The mirror was acquired in 1983, but the details of how this particular mirror came into the collection are not fully recorded in the card catalogue, although it is hoped that some form of documentation will be discovered once Brian Shefton's personal archive is catalogued.[20]

The mirror itself is a thin circular disc of hammered bronze (15.2 cm wide; 22.4 cm high). The polished side of the mirror has an indented edge that continues as far as the level of the tang, while the incised side has a raised edge. The handle area is broad and square with a narrower blunt tang below it. The back of the mirror is almost completely filled with the engraved figure of a naked winged female stepping to the left. Her wings are open and dominate the circular space of the disc. In her left hand she holds an alabastron while in the right she holds a long thin object with a rounded tip which is likely to be a perfume applicator. Her hair is bound with a narrow fillet. She also wears a necklace and an elaborate earring. Her feet are obscured by what is probably a large stylised flower.

The Shefton Collection card catalogue refers to the female figure as a 'Lasa', although this identification might not be strictly correct. The name Lasa occurs on 12 engraved mirrors, as well as one gold ring and the bronze model of a sheep's liver from Piacenza (Rallo 1974, 18–41; de Grummond 1982, 114–115). These representations of Lasa reveal that portrayals are varied and there is little consistency in the iconography. "Lasa is usually but not always winged, often but

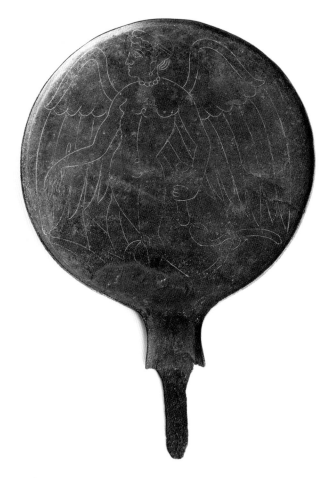

Figure 12.6: Engraved bronze mirror with winged female 'Lasa' figure, Newcastle upon Tyne, Shefton Collection 242. Photograph: Colin Davison.

not always nude; sometimes a Lasa may be male rather than female. The alabastron and perfume applicator are relatively frequent attributes, but other objects ... may also be present" (De Puma 1985, 47).

Lasa figures occur in a variety of contexts and this also makes the identification of figures without an accompanying inscription problematic. On a mirror in London,[21] for instance, a winged Lasa is shown standing between two seated heroes: on the left Hamfiare (Amphiaraos) and on the right Aivas (Aias). Lasa holds a book scroll which lists Lasa, Aivas and Hamfiare. She faces Aivas who bends his head in a sorrowful manner. Here Lasa has been seen as a deity of fate who announces the destiny of the two heroes (van der Meer 1995, 222; Swaddling 2001, 44). The scroll Lasa is holding is normally an attribute of Vanth, the female demon of death, and Lasa can be seen as performing a similar role in this context. More usually Lasa is associated with Turan (Aphrodite) and her retinue. There are frequent representations of Lasa figures

holding perfume applicators and alabastra in the company of Turan (de Grummond 1982, 115) and a figure associated with the goddess of love is an ideal image to adorn a mirror used in female beautification. However there are occasions where Lasa is associated with other deities and she is certainly not confined to the realm of Aphrodite. There are real problems in securely identifying Lasa figures and the only occasions where there can be any certainty are those where an accompanying inscription secures her identity.

Nevertheless there is a distinct group of naked winged figures that display the same characteristics as the Newcastle mirror and it is possible to interpret these together (De Puma 1985, 49ff.). Examples include a winged figure on a mirror in Copenhagen,[22] another in Leiden[23] and one in Missouri.[24] Each of these mirrors represents a single naked female figure with wings unfurled to cover most of the surface of the disc and usually moving to the left. They all have a similar cross-stepped pose (Kreuzschritt) and there is frequently some kind of floral ornament in the background. None of the mirrors has any form of decoration around the border. The mirrors all have similar diameters, between 13 and 16.7 cm, thin disc sections and a tang for the handle (ibid., 50). All the mirrors in this group that have been found in datable contexts, come from the third century BC. The Newcastle mirror shares all of these characteristics and can be particularly closely paralleled with a mirror in Toronto.[25] Clearly the mirror in the Shefton Collection belongs with this group and a date sometime in the third century BC can be securely assigned to it.

Conclusions

The three engraved Etruscan mirrors in the Shefton Collection illustrate the way in which Brian Shefton acquired items that he felt were out of the ordinary or raised interesting research questions. In many respects the imagery of the 'Lasa' mirror is the most straightforward to interpret. It belongs to a well-defined group of third-century-BC mirrors and the appeal of a figure associated with Turan (Aphrodite) and carrying attributes associated with female toilette is self-evident on mirrors that in all likelihood were used by a woman. Lasa figures may have had a further significance. On several mirrors Lasa is depicted alongside pairs of lovers, such as Turan and Atunis (Adonis) and it is quite possible that she may have been considered as the patron and protector of lovers (De Puma 1985, 53). On a mirror from Chiusi[26] Lasa is present standing to the right of Eos and Tithonos, while Eos's son Memrun (Memnon) stands to their left.

The other Shefton Collection mirrors are more complex, involving figure scenes that are derived from Greek mythology. In both the case of the Kassandra mirror and Eos with Tithonos there are models from the Greek world, particularly Attic red-figure pottery that may have served to inspire Etruscan artists. Certainly scenes from the Trojan cycle of myths and especially those involving the Trojan royal house, which includes Kassandra and Tithonos, were very popular between *c.* 480 and *c.* 300 BC (van der Meer 1995, 30). This may reflect an interest in these myths amongst the Etruscan elite who were the most likely consumers of engraved bronze mirrors and their images. The Etruscans appear to have taken Greek myths like these and then adapted or changed them to suit their own needs (Spivey and Stoddart 1990, 101–103; Osborne 2010, 288). This process of "myth-manipulation" may explain some of the differences between Etruscan imagery and that of the Greek World, which have been read by some as mistakes on the part of Etruscan artists (Spivey and Stoddart 1990, 103). For example on the Kassandra mirror the Ionic/Aeolic column that she clings to possibly has a local meaning that would explain the engraver's decision to include it. There are plentiful illustrations of Etruscan artists changing Greek imagery to suit their own needs. On a mirror now in Berlin[27] Apulu (Apollo) and his

sister Artumes (Artemis) sit facing each other. In this scene Artemis is represented holding a lyre, inverting the Greek convention that makes the lyre Apollo's attribute. In a similar way on the Shefton Collection's mirror representing the abduction of Tithonos it is Priamos, rather than his brother, who holds the lyre. Here many of the elements of Greek representations are present but they are not necessarily deployed in the same manner as on, for instance, Attic red-figure pottery. The Kassandra mirror also inverts the norms of Greek representations of this story. Usually Kassandra is shown naked, while Aias is depicted in full armour, often with his sword pointed aggressively at Kassandra. This highlights Kassandra's vulnerability in the face of a heavily armed warrior. However on the Newcastle mirror Kassandra is fully clothed and, if we are to believe Gerhard's (1867, 56, pl. 400, 2) illustration Aias is naked and his sword remains in its scabbard by his side. Gerhard's drawings have been criticised for lacking precision (de Grummond 1982, 4) but a clothed Kassandra is still an unusual variant of Greek iconography.[28]

It is not always clear why Etruscan artists chose to adapt particular Greek myths. Sometimes changes may have been made for simple reasons. De Puma (1983, 293ff.), for example, believes portrayals on mirrors of Eos carrying off her dead son Memnon from the field of battle have been adapted for an Etruscan audience. On Etruscan mirrors Memnon is occasionally shown wearing armour,[29] something that does not occur in Greek imagery. The armour is probably there to differentiate Memnon, a heroic warrior, from Eos' mortal lovers Tithonos and Kephalos. It may even be that what we see on Etruscan mirrors might be the end product of the oral communication of myths occurring when Greeks came into contact with the Etruscans (Vlassopoulos 2013, 147). This might explain some of the differences between Greek and Etruscan versions of the same myth, but it is hard to avoid assigning any influence to the sheer volume of Greek imagery that was imported into the Etruscan world.

The Shefton mirror fragments representing Eos with Tithonos and Kassandra can be seen as Etruscan adaptations of popular Greek mythical subjects. Greek versions of these myths, mostly on painted pottery, were taken and changed to suit the needs of an Etruscan audience. At the same time the mirrors reveal something of the preoccupations of an Etruscan audience. Osborne (2001, 288) observes the Etruscan fondness for pairs on their engraved mirrors and goes on to discuss the way in which many mirrors focus on heterosexual encounters (ibid., 291). Certainly both Eos and Tithonos and Kassandra and Aias fall into this category and can be seen as images that would bring to mind a meeting with the opposite sex. In a similar way a Lasa, holding an alabastron and carrying a perfume applicator, could well have prepared the viewer for a sexual encounter.[30]

Notes

1 I would like to thank Tony Spawforth, Monica Hughes and Sally Waite for providing helpful suggestions. I am indebted to Brian Shefton for sharing knowledge of his Collection and communicating his enthusiasm for all things Etruscan.

2 These two mirrors have been further published; Eos and Tithonos by van der Meer (1995, 39–40) and Kassandra by Parkin (2014, 194–196).

3 For example a mirror inscribed with the name Thancvil Fulni, London, British Museum GR 1868.5-20.55, *CSE* Great Britain no. 26.

4 Berlin, Antikensammlung Fr.15 and Fr.27, *CSE* Deutschland 4, nos. 3 and 12.

5 Vatican, Museo Gregoriano Etrusco 12241.

6 Such as an Attic red-figure cup from Vulci and now in the Museum of Fine Arts, Boston 95.28; *BAPD* 205036, attributed to the Telephos painter, which has an image of Eos and Tithonos on the tondo.

7 Examples include a red-figure amphora attributed to the Pig painter in the Fitzwilliam Museum, Cambridge (GR 22.1937; *BAPD* 206466) and a red-figure kylix in the British Museum, London (E72; *BAPD* 211658) attributed to the Penthesilea painter.
8 Berlin, Antikensammlung Fr. 27.
9 Rome, Villa Giulia Museum 2491.
10 I would like to thank Raphael Hermann for carrying out this work.
11 The recent drawing of the mirror does not capture this detail accurately, while Gerhard's picture misses it altogether.
12 One of the best known examples is a red-figure hydria from Nola now in the Museo Archeologico, Naples (81699; *BAPD* 201724) attributed to the Kleophrades Painter. This depicts the sack of Troy and includes Kassandra clinging to the Palladion while Aias grabs her by the hair.
13 See Gerhard (1867, 55–56, pl. 399).
14 Private Collection.
15 Vienna, Kunsthistorisches Museum IV 724.
16 London, British Museum 1948, 10–15.2.
17 Private collection, formerly the Zürich art market and Naples, Museo Archeologico 82.923.
18 St. Petersburg, The State Hermitage Museum B2068, *BAPD* 210103.
19 Alroth (1992, 12ff.) charts the way in which the representation of the statue of Athena changes on Greek painted pottery. Over time the goddess's image becomes smaller, more statue-like and she is frequently shown standing on a high base or high column. Athena becomes uninterested in the fate of Kassandra and the protective force of the goddess is reduced. A noteworthy example of a representation of the rape of Kassandra with the Palladion on a short ionic column can be seen on a Campanian red-figure bell krater in Jena (Friedrich Schiller University 194, Trendall 1970, 56, no. 75 and pl. xii.3).
20 Brian Shefton's extensive archive has been recently acquired by Newcastle University.
21 London, British Museum GR 1847.9-9.4, *CSE* Great Britain 1, no. 28.
22 Copenhagen, National Museum 581, *CSE* Denmark 1, no. 12.
23 Leiden, Rijksmuseum van Oudheden K1951/8.1, *CSE* Netherlands, no. 22.
24 Columbia, University of Missouri Museum of Art and Archaeology 83.224, *CSE* United States 1, no. 18.
25 Toronto, Royal Ontario Museum 919.26.1.
26 Florence, Museo Archeologico Nazionale (63)8.
27 Berlin, Antikensammlung (Fr.22). *CSE* Deutschland 4, no. 7.
28 A naked Aias and clothed Kassandra are not entirely unknown. An Attic red-figure cup by the Marlay Painter includes a representation of a fully clothed Kassandra fleeing towards the Palladion with a naked Aias in pursuit (Mangold 2000, 57). Ferrara, Museo Archeologico Nazionale 2482 (T 264), *BAPD* 216252.
29 An illustration of this is a mirror in Cleveland, Museum of Art 52.259, *CSE* United States 1, no. 15.
30 For a discussion of the potential significance of the alabastron see Waite (this volume).

Bibliography

Alroth, B. (1992) Changing Modes in the Representation of Cult Images. In Hägg, R. (ed.) *The Iconography of Greek Cult in the Archaic and Classical Periods.* Centre d'Étude de la Religion Grecque Antique, Athènes – Liège.

Andreae, B. (2004) Die Tomba François. Anspruch und Historische Wirklichkeit eines Etruskischen Familiengrabes. In Andreae, B., Hoffman, A. and Weber Lehmann, C. (eds.) *Die Etrusker: Luxus für Jenseits, Bilder vom Diesseits– Bilder vom Tod*, 176–207. Munich.

Anonymous (1852) *Bulletino dell'Instituto di Corrspondenza Archeologica.* Rome.

Anonymous (1891) *Proceedings of the Society of Antiquaries Newcastle upon Tyne.* New Series 5, 15.

Barker, G. and Rasmussen, T. (1998) *The Etruscans*. Oxford.

Beazley, J. D. (1949) The World of the Etruscan Mirror. *Journal of Hellenic Studies* 69, 1–17.

Beazley, J. D. (1974) *The Kleophrades Painter*. Mainz.

Bloch, R. and Minot, N. (1986) Thesan. *Lexicon Iconographicum Mythologiae Classicae (L.I.M.C.)* 3, 789–797. Zürich, Munich, Dusseldorf.

Bonfante, L. (1990) *Etruscan*. London.

Davreux, J. (1942) *La légende de la prophétesse Cassandre*. Paris.

De Puma, R. (1983) Three Etruscan Mirrors in Cleveland. *The Bulletin of the Cleveland Museum of Art* 70, 290–302.

De Puma, R. (1985) An Etruscan Lasa Mirror. *Muse: Annual of the Museum of Art and Archaeology* 19, 44–55.

de Grummond, N. T. (ed.) (1982) *A Guide to Etruscan Mirrors*. Florida.

Fischer Graf, U. (1980) *Spiegelwerkstätten in Vulci*. Berlin.

Gerhard, E. (1867) *Etruskische Spiegel* IV. Berlin.

Goldberg, M. Y. (1987) The 'Eos and Kephalos' from Caere: Its Subject and Date. *American Journal of Archaeology* 91, 605–614.

Haynes, S. (2000) *Etruscan Civilization. A Cultural History*. London.

Izzet, V. (2007) *The Archaeology of Etruscan Society*. Cambridge.

Lambrechts, R. (1992) Lasa. *Lexicon Iconographicum Mythologiae Classicae (L.I.M.C.)* 6, 217–225. Zürich, Munich, Dusseldorf.

Lefkowitz, M. (2002) Predatory Goddesses. *Hesperia* 71, 325–344.

Mangold, M. (2000) *Kassandra in Athen. Die Eroberung Trojas auf Attischen Vasenbildern*. Berlin.

Moorey, P. R. S. and Catling, H. W. (1966) *Exhibition of Ancient Persian Bronzes Presented to the Department of Antiquities by James Bomford, Esquire and other Selected Items of Ancient Art from the Collection of Mrs Brenda Bomford*. Ashmolean Museum, Oxford.

Oleson, J. P. (1975) Greek Myth and Etruscan Imagery in the Tomb of the Bulls at Tarquinia. *American Journal of Archaeology* 79, 189–200.

Osborne, R. (2001) Why Did Athenian Pots Appeal to the Etruscans? *World Archaeology* 33, 277–295.

Oxberry, J. (1923) Robert Blair, M.A.F.S.A. An Obituary Notice. *Archaeologia Aeliana* third series 20, 187–204.

Parkin, A. (2014) An Etruscan Mirror from the Collection of the Society of Antiquaries of Newcastle upon Tyne. In Collins, R. and McIntosh, F. (eds.) *Life in the Limes. Studies of the People and Objects of the Roman Frontiers*. Oxford and Philadelphia.

Rallo, A. (1974) *Lasa. Iconografia e Esegesi*. Florence.

Shefton, B. B. (1970) The Greek Museum, University of Newcastle upon Tyne. *Archaeological Reports* 16, 52–62.

Spivey, N. and Stoddart, S. (1990) *Etruscan Italy. An Archaeological History*. London.

Stansbury-O'Donnell, M. (2009) Structural Differentiation in Pursuit Scenes. In Yatromanolakis, D. (ed.) *An Archaeology of Representations. Ancient Greek Vase Painting and Contemporary Methodologies*. Athens.

Swaddling, J. (2001) *Corpus Speculorum Etruscorum. Great Britain 1. The British Museum 1*. London.

Touchefeu, O. (1981) Aias II. *Lexicon Iconographicum Mythologiae Classicae (L.I.M.C.)* 1, 336–51. Zürich, Munich, Dusseldorf.

Trendall, A. D. (1970) *The Red-Figured Vases of Lucania, Campania and Sicily. First Supplement*. London.

Trendall, A. D. and Cambitoglou, A. (1983) First Supplement to the Red-Figured Vases of Apulia. *Bulletin of the Institute of Classical Studies Supplement* 42.

Trendall, A. D. (1987) *The Red-Figured Vases of Paestum*. Rome.

van der Meer, L. B. (1995) *Interpretatio Etrusca. Greek Myths on Etruscan Mirrors*. Amsterdam.

Vlassopoulos, K. (2013) *Greeks and Barbarians*. Cambridge.

Weiss, C. (1986) Eos. *Lexicon Iconographicum Mythologiae Classicae (L.I.M.C.)* 3, 747–789.

Woodford, S. (1993) *The Trojan War in Ancient Art*. London.

13. Brian Benjamin Shefton and the Etruscan Bronze Funnels

Alessandro Naso

In the Shefton Collection[1] there are two Etruscan bronze funnels (infundibula), which were once part of wine drinking sets. There are more than a hundred examples of such funnels and a comprehensive overview is lacking, it is therefore useful to discuss the typology and the geographical distribution of these distinctive implements.

Etruscan Funnels

In his invaluable career Brian Shefton wrote several contributions on ancient pottery and bronzes, especially bronzes from pre-Roman Italy.[2] New acquisitions in the Greek museum at Newcastle University, now the Shefton Collection, have been described by him, including one infundibulum (inv. no. 139, Fig. 13.1).[3] A second piece (inv. no. 667, Fig.13.2), is still unpublished, but Brian Shefton with his great generosity spoke to me about it and provided me with some photographs. In my opinion the handle of this piece was attached to the strainer at a later date, because the bronze patina has two different colours, green on the strainer and dark brown on the handle. This type is the commonest form of funnel handle, but the related strainers always have a figured hinge and a funnel; whereas the Newcastle example has no hinge.[4]

Around the end of the seventh century BC in Etruria a new implement was developed as part of the wine drinking set. Modern scholars named it with the Latin word infundibulum, which is just convention (Sauer 1937; Zuffa 1960). An infundibulum is a very elaborate funnel, consisting of a solid cast bronze horizontal handle and a funnel. The funnel is made up of a hammered cup with several holes and a cast solid tube with a central boring and is decorated with horizontal lines on the external side. A strainer, with rivets, was attached to the handle by a hinge. Both hinge and strainer could be raised backwards and the funnel used alone. The long handles of the infundibula often end in a duck's head with a long bill, more rarely they end in a ram's head.

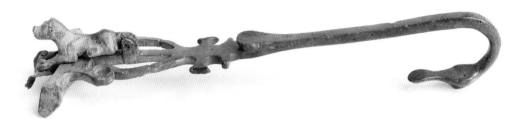

Figure 13.1: Handle of an infundibulum type 1, Newcastle upon Tyne, Shefton Collection 139. Photograph: Colin Davison.

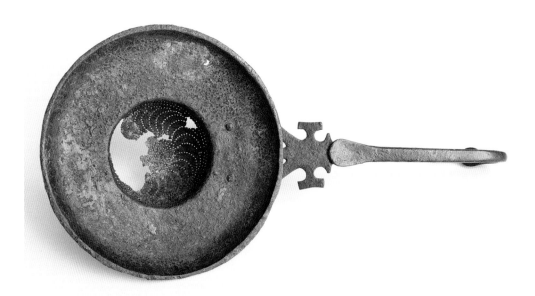

Figure 13.2: Handle of an infundibulum type 1, Newcastle upon Tyne, Shefton Collection 667. Photograph: Colin Davison.

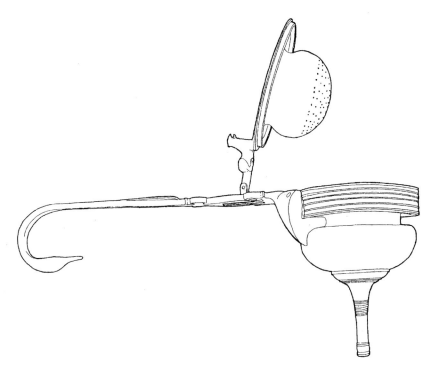

Figure 13.3: Infundibulum type 1. (After Zuffa 1960, fig. 1.)

Infundibula were used to pour wine, for instance from a krater into an oinochoe or from an oinochoe into a kantharos. Before them other bronze implements were used to pour wine, as shown by the rare bronze filter-bowls from the Near East (Montanaro 2010, 510–511, fig. 18) and the unique silver filter from Praeneste (Curtis 1919, 49 no. 30 pl. 26.2). Bronze hinges in animal form are documented in the sixth century BC in Ionia (Özgen and Öztürk 1996, 118–119 no. 73 for an incense burner), although they probably have an older origin in this region.

- Funnel type 1 is the most popular type of infundibulum with 74 exemplars, it is lyre-handled and always has a hinge attaching the strainer to the handle (Fig. 13.3). The hinge, which has a cross-hole and a cut-away to fit a tang, can have the shape of a T, or, if it is figured, a couchant lion, or a frog or more rarely a sphinx. The lions' head is quite cursory, the style of the sphinx on the other hand is elaborate.
- Funnel type 2 (nos. 75–82) consist of a simple funnel with a long handle, without hinge (Fig. 13.4).
- Funnel type 3 (nos. 83–86) may have various forms, but there is always a palmette on the handle (Fig. 13.5).
- Funnel type 4 (nos. 87–96) comprises various shapes, including the most elaborate funnel of all, found at Capua in Campania, but actually preserved in three different museums.[5] The strainer is shaped as a bearded man's head. On the top of the strainer are a lion and two rabbits, both couchant. The funnel is missing. The handle includes a kouros statuette, whose legs are in the jaws of a snake, and ends in a ram's head (Fig. 13.6).

In Italy the main provenance for infundibula is southern Etruria, but some have also been found in Campania, Umbria, ancient Picenum (corresponding to the modern-day southern Marche and northern Abruzzo) and in the Veneto. A special role has been played by Sicily, where Etruscan

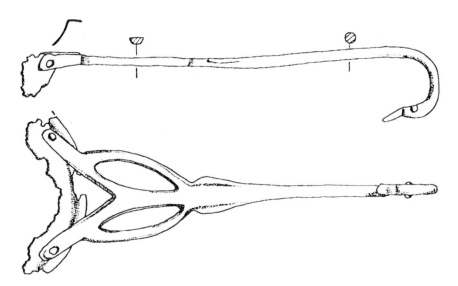

Figure 13.4: Infundibulum type 2. (After La Romagna tra VI e IV sec. a.C. 1981, pl. 93.)

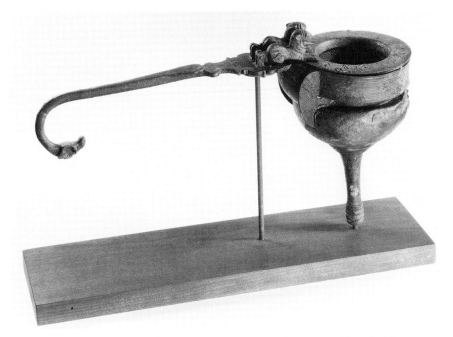

Figure 13.5: Infundibulum type 3. (Courtesy J. Mertens, New York.)

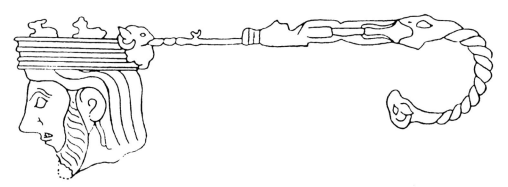

Figure 13.6: Infundibulum type 4. (After Sauer 1937, fig. 14.)

imports are known in Selinunte, Gela and in the indigenous site of Monte Bubbonìa, where some local products inspired by Etruscan originals have also been found.

In the second half of the sixth century BC the Etruscan funnels of the types Vulci-Volsinii and San Martino in Gattara were the most widespread Etruscan bronze objects in the Mediterranean; distributed from Spain to the northern shore of the Black Sea, from Switzerland to North Africa, and with the highest concentration in the Italic peninsula (Fig. 13.7).

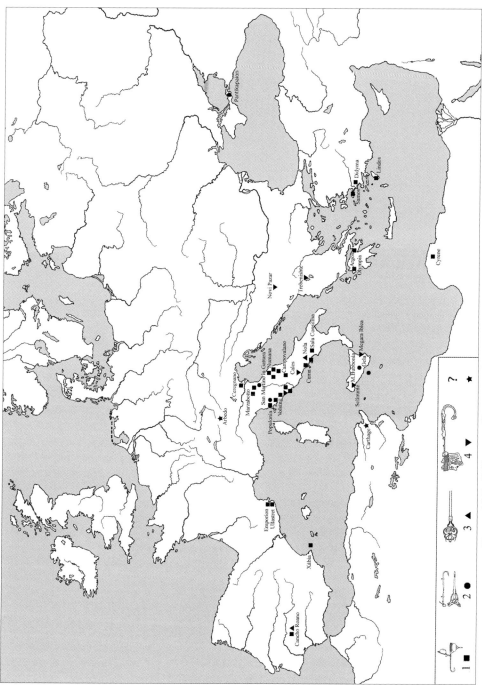

Figure 13.7: Diffusion of bronze infundibula. Drawing: L. Attisani, ISMA-CNR.

Five examples of the Vulci-Volsinii type have been found in Spain, one in Cyrene, four in Olympia (one with a Greek inscription), one in Argos, one in Ialysos on Rhodes, two in the Heraion of Samos and one in the sanctuary of Apollo at Didyma. An example belonging to the San Martino in Gattara type reached the Milesian colony of Panticapaion on the northern shore of the Black Sea: according to its Greek inscription, the implement is a votive offering to Ephesian Artemis. Remains of an Etruscan funnel were found in Switzerland in the Arbedo hoard. Two bronze fragments representing a duck's head from Carthage and from Didyma may belong to infundibula or to ladles, which have also been found in Greece.

From this perspective we can consider infundibula in the second half of the sixth century BC to be the counterpart in bronze of the Etruscan bucchero kantharoi in the first half of the same century: the funnels are a real marker of Etruscan culture, one of the appreciated tyrrhenoí chalkoí celebrated in ancient Greek literature (Mansuelli 1984).

This wide distribution and the provenance of many pieces from illegal excavations of the nineteenth and twentieth centuries seems to be enough to locate the workshop in southern Etruria. According to current opinion, the workshop was presumably situated in Volsinii, which corresponds to modern-day Orvieto. However the different shapes (or sub-types) of the lyre-handled implements are enough to postulate the existence of more than one workshop. One of these may have been located in Vulci where the most famous Etruscan bronze workshops flourished. These workshops were responsible both for masterpieces, such as the rod tripods found on the Athenian Acropolis and in a Celtic grave in Bad Dürkheim near Speyer in Germany, as well as everyday vessels, such as the countless Schnabelkannen, which were destined for long distance trade (Vorlauf 1997). These have been found mostly in Central Europe, but not in Greece, like the Etruscan bronze stamnoi studied by Brian Shefton.

Some local imitations of Etruscan bronze funnels are known (nos 97–104) in Greece as well as in the Iron Age culture of what is now modern-day Serbia. Hinges in the form of a lion found in the Greek sanctuaries at Olympia and Samos are stylistically different from the Etruscan ones, so that one can presume the existence of Greek infundibula, imitating the Etruscan prototypes.

This detail is important to stress, because the Etruscans are usually thought to be the recipients of Greek ideas imitating them in their own 'barbarian' way. Recently Christoph Ulf (2014) pointed out that in each cultural contact the main producer receives something from the receiver and the main receiver can become a producer. One can conclude that sometimes the cultivated Greeks received and imitated objects from the 'barbarian' Etruscans.

Catalogue

Type 1 Lyre-handled or Volsinii-Vulci (1–72)

1a Lyre-handled with the hinge in the shape of a T (1–9)

1a1 Lyre-handled with the hinge in the shape of a T and the handle ending in a duck's head (1–8)

Populonia (Livorno)
1. Tomba dei Flabelli di Bronzo. Florence, Archaeological Museum, Inv. no. 89332.
 Naso 2006a, 195, no. 1; Naso 2006b, 380, no. 1.

Campovalano (Campli, Teramo)
2. Tomba 2. Chieti, National Museum, Inv. no. 5146.
 Naso 2006a, 195, no. 21; Naso 2006b, 384, no. 22.

Olympia (Greece)
3. Sanctuary of Zeus. Olympia, Museum, Inv. no. Br 12894.
 Naso 2006a, 196, no. 49; Naso 2006b, 388 no. 51.

From the sea at Xàbia (Alicante, Spain)
4. Museu Arqueològic i Etnòlogic 'Soler Blasco', Xàbia, Inv. no 5765-A.
 Naso 2006a, 196, no. 55; Naso 2006b, 389, no. 57; Vives-Ferrándiz Sánchez 2007; Bardelli, Graells 2012, 32–33, no. 3.

Provenance unknown
5. Wien, Kunsthistoriches Museum, Inv. no. VI, 2962.
 Naso 2006a, 196, no. 36; Naso 2006b, 387, no. 38.

6. Wien, Kunsthistoriches Museum, Inv. no. VI, 4637.
 Naso 2006a, 196, no. 37: Naso 2006b, 387, no. 39.

7. New York, Metropolitan Museum of Art, Rogers Fund 1965, Inv. no. 65.11.1.
 Probably the same as no. 8.
 Unpublished, courtesy J. Mertens (New York).

Provenance and whereabouts unknown
8. Antiquity market, Rome 1929; DAI Rom, Inst. Neg. 29.441-29.443. The three images are of the same piece, *pace* Terrosi Zanco 1974, 162–163.
 Probably the same as no. 7 in New York.
 Naso 2006a, 195, no. 26: Naso 2006b, 386, no. 28.

1a2 Lyre-handled with the hinge in the shape of a T and the handle ending in a ram's head (9)

Cancho Roano (Estremadura, Spain)
9. Badajoz, Museo Arqueológico Provincial.
 Naso 2006a, 196, no. 54; Naso 2006b, 389, no. 56; Vives-Ferrándiz Sánchez 2007, 157–158. fig. 3.1; Bradelli, Graells 2012, 33, no. 4.

1b Lyre-handled with the hinge in the shape of an animal (10–72)

1b1 Lyre-handled with the hinge in the shape of a couchant lion and the handle ending in a duck's head (10–23)

Populonia (Livorno), tomb dei Colatoi
10. Florence, Archaeological Museum, Inv. no. 92589.
 Naso 2006a, 195, no. 3; Naso 2006b, 380–381, no. 3.

11. Florence, Archaeological Museum, Inv. no. 92590.
 Naso 2006a, 195, no. 2; Naso 2006b, 380, no. 2.

Castelgiorgio (Terni)
12. Florence, Archaeological Museum, Inv. no. 82892.
 Naso 2006a, 195, no. 6; Naso 2006b, 381, no. 6.

Todi or Orvieto (Perugia)
13. Florence, Archaeological Museum, Gift Corsini, 1873, Inv. no. 70808.
 Naso 2006a, 195, no. 5; Naso 2006b, 381, no. 5.

Falerii Veteres (Civita Castellana, Viterbo)
14. Tomb 34 (LIII). Rome, Villa Giulia Museum, Inv. no. 371.
 Cozza, Pasqui 1887, 175d; Cozza, Pasqui 1981, 170 no. 8 (tomb XLVIII); Naso 2006a, 195, no. 8; Naso 2006b, 381–382, no. 8.
 This is probably the same funnel, which was seen by A. Furtwängler (Furtwängler 1890, 196, ad nos. 1267, 1267a) and later lost (Sauer 1937, 296; Zuffa 1960, 181 footnote 37).

Castro (Ischia di Castro, Viterbo)
15. Tomba della Biga, female burial, 530–520 BC. Viterbo, Archaeological Museum.
 Naso 2006a, 195, no. 9; Naso 2006b, 382, no. 9.

Todi (Perugia)
16. Rome, Villa Giulia Museum. Antiquarium, Inv. no. 24594.
 Naso 2006a, 195, no. 11; Naso 2006b, 382, no. 11.

Numana (Sirolo, Ancona)
17. Tomba della Regina. Ancona, Archaeological Museum, Inv. no. 50769.
 Naso 2006a, 195, no. 20; Naso 2006b, 384, no. 21.

Cuma (Naples)
18. Naples, Archaeological Museum, Inv. no. 86069.
 Naso 2006a, 195, no. 23; Naso 2006b, 385, no. 25.

Provenance unknown
19. Florence, Archaeological Museum, Antiquarium, Inv. no. 1537.
 Naso 2006a, 195, no. 27; Naso 2006b, 386, no. 29.

20. Milan, Archaeological Museum, Inv. no. 1055.
 Naso 2006a, 195, no. 30; Naso 2006b, 386, no. 32.

21. Newcastle upon Tyne, Newcastle University, Shefton Collection, Inv. no.139.
 Naso 2006a, 196, no. 39; Naso 2006b, 387, no. 41.

22. Swiss private collection.
 Naso 2006a, 196, no. 44; Naso 2006b, 387, no. 46.

Provenance and whereabouts unknown
23. Antiquity market.
 A couchant lion on the handle and two couchant lions on the strainer are a modern pastiche.
 Naso 2006a, 196, no. 42; Naso 2006b, 387, no. 44.

1b2 Lyre-handled with the hinge in the shape of a couchant lion and handle ending in a ram's head (24–34)

Whereabouts unknown
Ceregnano (Rovigo)
24. Found in eighteenth century and then dispersed, probably the same as no. 26 at Manchester.
 Naso 2006a, 195, no. 14; Naso 2006b, 383, no. 15.

Provenance unknown
25. London, British Museum, Inv. no. GR 1937.10-21.1.
 Naso 2006a, 195, no. 34, fig. 10b; Naso 2006b, 387, no. 36.

26. Manchester, Museum, Inv. no. 29973.
 Probably the same as no. 24, found at Ceregnano in eighteenth century.
 Naso 2006a, 196, 43; Naso 2006b, 387, no. 45.

Isolated lyre-handles and hinges in the shape of a couchant lion
Tolentino (Macerata)
27. Tomb of Porta del Ponte. Tolentino, Museum, Inv. no. 1854/1.
 Naso 2006a, 195, no. 19; Naso 2006b, 384, no. 20.

Provenance unknown
28. Leipzig, Antikenmuseum der Universität, Inv. no. MB 4, M 53a.
 Naso 2006a, 196, no. 35; Naso 2006b, 387, no. 37.

Marzabotto (Bologna)
29. Marzabotto, Museum P. Aria, Inv. no. B 7.
 Couchant lion, burnt by a fire in the museum, probably belonging to the same piece
 of a cast solid tube (no. 69).
 Muffatti 1969, 251–252, no. 356, pl. XLIX a 3.

Vetulonia (Grosseto)
30. Collection Stefani (?).
 Naso 2006a, 195, no. 13; Naso 2006b, 383, no. 13.

Selinunte (Agrigento)
31. From the city, sector K 2007, Inv. no. SL 25230.
 Unpublished, courtesy H. Baitinger (Mainz).

Provenance unknown
32. Collection Benedetto Guglielmi (from Vulci?). Vatican City, Museo Gregoriano Etrusco,
 Inv. no. 34864.
 Naso 2006a, 195, no. 31; Naso 2006b, 386, no. 33.

33. Florence, Archaeological Museum, Antiquarium (room XIV, showcase IV).
 Naso 2006a, 195, no. 29; Naso 2006b, 386, no. 31.

34. Stuttgart, Württembergisches Landesmuseum, Inv. no. 3. 190.
 Unpublished, courtesy V. Paul-Zinserling (Jena).
 Mentioned by Naso 2006a, 196, no. 46; Naso 2006b, 388, no. 48.

1b3 Lyre-handled with the hinge in the shape of a sphinx and the handle ending in a ram's head (35–36)

Sala Consilina (Salerno)
35. Paris, Musés du Petit Palais, Inv. no. DUT 1564.
 Naso 2006a, 195, no. 25; Naso 2006b, 385–386, no. 27.

Isolated hinge in the shape of a sphinx
Provenance and whereabouts unknown
36. Once H. Cahn, Basel.
 Naso 2006a, 196, no. 42; Naso 2006b, 387, no. 43.

1b4 Lyre-handled with the hinge in the shape of a frog and the handle ending in a duck's head (37–46)

Avella (Avellino), tomb 1/1995
37. Avella, Antiquarium, Inv. nos. 142192, 142232. Female burial, first half sixth century BC.
 Cinquantaquattro 2006–2007, 127, figs. 31–32.

Bisenzio (Capodimonte, Viterbo), tomb 74, 540–520 BC
38. Viterbo, Archaeological Museum, Inv. no. 57165/3.
 Naso 2006a, 195, no. 4; Naso 2006b, 381, no. 4.

Belmonte Piceno (Ascoli Piceno), tomb 163 del Duce
39. Ancona, Archaeological Museum, Inv. nos.: tube 12563, handle 12581.
 Rocco 2004, 48–49, figs. 2–3; Naso 2006a, 195, no. 17; Naso 2006b, 383, no. 18.

Provenance unknown
40. Florence, Archaeological Museum, Antiquarium, Inv. no. 1538.
 Naso 2006a, 195, no. 28; Naso 2006b, 386, no. 30.

41. Turin, Archaeological Museum, Inv. no. 933.
 Naso 2006a, 195, no. 32; Naso 2006b, 386, no. 34.
42. Perugia, Archaeological Museum, Guardabassi Collection, Inv. no. 600.
 Naso 2006a, 195, no. 33; Naso 2006b, 386, no. 35.

43. London, British Museum, Inv. no. 2009, 5021.4.
 Once in the collection Louis-Gabriel Bellon (1819–1899) at Saint Nicolas les Arras. http://www.britishmuseum.org/research/search_the_collection_database/search_object_details.aspx?objectid=3274254&partid=1&searchText=strainer&fromADBC=ad&toADBC=ad&numpages=10&images=on&orig=%2fresearch%2fsearch_the_collection_database.aspx¤t Page=11 (12.11.2013).

Isolated hinges in the shape of a frog

Argos, sanctuary of Hera

44. Naso 2006a, 196, no. 48; Naso 2006b, 388, no. 50.

Cyrene, sanctuary of Demeter and Persephone

45. Naso 2006a, 196, no. 53; Naso 2006b, 389, no. 55.

Emporion, Palaiopolis

46. Empuries, Museu d'Arqueologia de Catalunya.
 Aquilué, Castanyer, Santos, Tremoleda 2003; Bardelli, Graells 2012, 32, no. 2.

Uncompleted lyre-handles types 1a–1b (47–62)

Adria (Rovigo)

47. Collection Bocchi. Adria, Archaeological Museum, Inv. no. I.G. 20989.
 Naso 2006b, 383, no. 14.

Belmonte Piceno (Ascoli Piceno)

48. Once in Ancona, Archaeological Museum.
 Naso 2006a, 195, no. 18; Naso 2006b, 384, no. 19.

Casal Fiumanese (Bologna)

49. Bologna, Museum.
 Naso 2006a, 195, no. 16; Naso 2006b, 383, no. 17.

Castel San Mariano (Perugia), tomb del Carro

50. Perugia, Archaeological Museum, Inv. no. 1433.
 Naso 2006a, 195, no. 10; Naso 2006b, 382, no. 10.

Todi (Perugia)

51. Rome, once Villa Giulia Museum, Antiquarium, Inv. no. 24595, now in the Museo delle
 Antichità Etrusche e Italiche, University Sapienza.
 Naso 2006a, 195, no. 12; Naso 2006a, 382–383, no. 12; Michetti 2007, 265–267, no. 194.

Colle del Forno (Montelibretti, Rome), tomb XI

52. Copenhagen, Ny Carlsberg Glyptotek, Inv. no. HIN 568.
 Unpublished, courtesy P. Santoro (Rome), mentioned by Naso 2006b, 385, no. 24. On the
 grave group: Santoro 2006.

Castellamare di Stabia (?)

53. Unpublished.
 Naso 2006a, 195, no. 24; Naso 2006b, 385, no. 26.

Provenance unknown (Italy?)

54. Once in the collection E. Gorga. Rome, National Roman Museum.
 Naso 2006a, 196, no. 45; Naso 2006b, 388, no. 47.

55. Once in the collection E. Berman. Civita Castellana, Archaeological Museum.
 Naso 2006a, 196, no. 47; Naso 2006b, 388, no. 49.

56. Newcastle upon Tyne, Newcastle University, Shefton Collection, Inv. no. 667.
 Unpublished: Naso 2006a, 196, no. 40; Naso 2006b, 386, no. 42.

Olympia, sanctuary of Zeus
57. Olympia, Museum, Inv. no. B 286.
 Naso 2006a, 196, no. 50; Naso 2006b, 388, no. 52.

58. Olympia, Museum, Inv. no. B 1707.
 Unpublished, courtesy B. Schweitzer (Tübingen).

59. Olympia, Museum, Inv. no. B 4574.
 Naso 2006a, 196, no. 51; Naso 2006b, 388, no. 53.

Two isolated tubes from Olympia, Inv. nos. B 96 and B 11601, may belong to the handles nos. 59–61.

Lindos (Rhodes, Greece), sanctuary of Athena Lindia
60. Istanbul, Archaeological Museum, Inv. nos. 3495 m, 3503 m.
 Part of the lyre-handle.
 Naso 2006a, 196, no. 52; Naso 2006b, 388, no. 54.

Didyma (Turkey), sanctuary of Apollo
61. Berlin, SMPK, Inv. no. 32636; Didyma 16.
 Part of the lyre-handle.
 Unpublished, courtesy N. Franken (Berlin).

62. Arbedo (Switzerland), hoard.
 One tube and one handle ending in a duck's head.
 Naso 2006a, 196, no. 56; Naso 2006b, 389, no. 58.

Isolated solid cast tubes (63–72)
Orvieto (Terni)
63. Crocefisso del Tufo, tomb 17. Orvieto, Archaeological Museum.
 Naso 2006a, 195, no. 7; Naso 2006b, 381, no. 7.

64. Crocefisso del Tufo, tomb SG 02. Orvieto, Archaeological Museum, Inv. no. B 1676; F 475; el. gen. 317).
 Bruschetti 2012, 67 no. 21, pl. XXI a.

65. Crocefisso del Tufo, tomb SG 05. Orvieto, Archaeological Museum, Inv. no. B 1888; F 185; el. gen. 366.
 Bruschetti 2012, 77, no. 24, pl. XXVII h.

66. Crocefisso del Tufo, tomb SG 08. Orvieto, Archaeological Museum, Inv. no. B 1278; el. gen. 365.
 Bruschetti 2012, 97 no. 38, pl. XLIII f.

Marzabotto (Bologna)
67. Marzabotto, Museum P. Aria, Inv. no. B 9.
 Probably belonging to the same piece as no. 26.
 Muffatti 1968, 154, no. 316, pl. XXI, b 3; Naso 2006a, 195, no. 15; Naso 2006b, 383, no. 16.

Poggio Sommavilla (Magliano Sabina, Rieti)
68. Tomb II; whereabouts unknown.
 Bellelli 2006, 94; Naso 2006a, 195, no. 22; Naso 2006b, 384–385, no. 23.

Val Berretta, Tomb 56 (sixth century BC) (Castiglione della Pescaia, Grosseto)
69. Vetulonia, Museum I. Falchi, Inv. no. 239956.
 Unpublished, courtesy dr. S. Rafanelli (Vetulonia).

Provenance unknown
70. Bruxelles, Musées Royaux d'Art et d'Histoire, Inv. no. R 1217.
 Two tubes have been reused in a modern pastiche.
 Meester de Ravestein 1884, 350, no. 1217.

Ullastret (Spain)
71. Room 1, layer VI.
 Bardelli, Graells 2012, 32, no. 1.

Samos, sanctuary of Hera (Greece)
72. Vathy, museum.
 The tube has been wrongly united to a belt clasp of local type (Fellmann 1984).
 Unpublished, courtesy Dr B. Schweitzer (Tübingen).

Type 2 San Martino in Gattara (73–80)

San Martino in Gattara (Ravenna), tomb 15, 530–520 BC, male burial
73. Ravenna, National Museum, Inv. no. 32422.
 Naso 2006a, 196, no. 57; Naso 2006b, 389–390, no. 59.

Populonia (Livorno), once collection Gasparri
74. Populonia, antiquarium, Inv. no. 1237.
 Naso 2006a, 196, no. 59; Naso 2006b, 391, no. 62.

Sicily
Gela (Caltanissetta), archaic wreck (500–480 BC)
75. Gela, Archaeological Museum, Inv. no. 38303.
 Naso 2006a, 196, no. 61; Naso 2006b, 391, no. 63.

Monte Bubbonìa (Mazzarino, Caltanissetta), tomb 13/1971 (550–500 BC)
76. Caltanissetta, Archaeological Museum, Inv. no. 34981.
 Naso 2006a, 196, no. 62; Naso 2006b, 391, no. 64.

Monte Bubbonìa (Mazzarino, Caltanissetta), tomb 10/1955
77. Gela, Archaeological Museum, Inv. no. 9302.
 Naso 2006a, 196, no. 63; Naso 2006b, 391–392, no. 65.
 Shape of local production, imitating the Etruscan type.

Panticapeum
78. Moscow, Pushkin State Museum of Fine Arts, Inv. no. GMII. M 410.
 Naso 2006a, 196, no. 58; Naso 2006b, 390, no. 60.

Provenance unknown
79. Genf, Musée d'Art et d'Histoire, Inv. no. MF. 1170.
 Fol 1874, 252 no. 1170; Naso 2006a, 196, no. 60; Naso 2006b, 390–391, no. 61.

80. Art market.
 http://www.edgarlowen.com/a44ar.shtml, 15.04.2013, Etruscan and Roman Art, B 3051.
 Courtesy Nadine Pantaleon (Bochum).

Type 3 Palmette-handled (81–84)

Nola (?)
81. Bruxelles, Musées Royaux d'Art et d'Histoire, Collection Ravestein, Inv. no. R 1127.
 Naso 2006a, 196, no. 64; Naso 2006b, 392, no. 66.

Provenance unknown
82. Vienna, Kunsthistorisches Museum, Inv. no. VI-932.
 Naso 2006a, 196, no. 65; Naso 2006b, 392, no. 67.

83. New York, Metropolitan Museum of Art, Fletcher Fund 1934, Inv. no. 34.11.8.
 The hinge has the shape of two lions.[6]
 Naso 2006a, 196, no. 38; Naso 2006b, 387, no. 40.

Cancho Roano (Estremadura, Spain)
84. Badajoz, Museo Arqueológico Provincial.
 Vives-Ferrándiz Sánchez 2007, 160, fig. 3.2; Bardelli, Graells 2012, 33, no. 5.

Type 4 Various shapes (85–94)

Bisenzio (Capodimonte, Viterbo), tomb Olmo Bello 80
85. Rome, Villa Giulia Museum, Inv. no. 57177/4.
 Naso 2006a, 196, no. 67; Naso 2006b, 392–393, no. 69.

Bazzano (L'Aquila), tomb 1566
86. Celano, Museo della Preistoria dell'Abruzzo.
 Weidig 2014, 445–446, 1290 no. 9, Taf. 433.

Trevignano Romano (Rome), tomb Annesi Piacentini
87. Trevignano Romano, Museum.
 Naso 2006a, 196, no. 69; Naso 2006b, 393, no. 71.

Provenance unknown
88. Rome, Villa Giulia Museum, Collection Castellani, Inv. no. 51370.
 Naso 2006a, 197, no. 70; Naso 2006b, 393, no. 72.

Trestina (Città di Castello, Perugia)
89. Once at Florence, Archaeological Museum, Inv. no. 77813, now at Cortona, Museum.
 Naso 2006a, 197, no. 71; Naso 2006b, 393–394, no. 73; Naso 2009.

Cales (Calvi Risorta, Caserta), tomb 89, early sixth century BC
90. Naples, Archaeological Museum, Inv. no. 282602.
 Gilotta, Passaro 2012, 125 no. 107, 134, pl. CXI.

Santa Maria Capua Vetere (Caserta), tomb at Quattordici Ponti
91. Berlin, SMPK, Inv. no. 6332; Munich, Antikensammlungen, Inv. no. 3556.
 Bellelli 2006, 41–54; Naso 2006a, 197, no. 73; Naso 2006b, 394–395, no. 75.

92. Capua, in 1963 at the antiquarium of Teano.
 Naso 2006a, 197, no. 74; Naso 2006b, 395, no. 76.[7]

Provenance unknown
93. Rome, Villa Giulia Museum, Antiquarium, Inv. no. 24689.
 Naso 2006a, 197, no. 75; Naso 2006b, 395–396, no. 77.

94. Warsaw, National Museum, Inv. no. 147078.
 Naso 2006a, 197, no. 76; Naso 2006b, 396, no. 78.

Not Etruscan (95–104)
Already W. Dehn and B. B. Shefton classified the piece from Novi Pazar as Eastern Hallstattian production (Dehn 1970, 76; Shefton 1970, 55–56).

Megara Hyblaea, ancient city
95. Hinge in form of a couchant lion with the head looking left.
 Gras *et al.* 2004, 129 fig. 133.

Olympia, sanctuary of Zeus
96. Olympia, museum, Inv. no. Br 14030.
 Naso 2006a, 396, no. 80; Naso 2006b, 396–397, no. 82.

97. Olympia, museum, Inv. no. Br 12866.
 Naso 2006b, 396, no. 81; Naso 2006b, 397, no. 83.

Rhodes, sanctuary of Apollo Erethimios
98. Rhodes, museum.
 Naso 2006a, 197, no. 77; Naso 2006b, 396, no. 79.

Samos, sanctuary of Hera
99. Berlin, SMPK, Inv. no. Sa 43.
 Hinge in form of a couchant lion with the head looking left.
 Unpublished, courtesy N. Franken (Berlin).

Trebenishte, tomb VII
100. Once at Sofia, Archaeological Museum, probably destroyed during the Second World War (kind information of Dr Pavlina Ilieva and Dr N. Theodossiev, both Sofia).
 Naso 2006a, 197, no. 78; Naso 2006b, 396, no. 80.

Novi Pazar, tomb
101. Naso 2006a, 197, no. 79; Naso 2006b, 396, no. 81; Krstić 2007, 79 no. 26.

Pod, settlement
102. Ćović 1983, 153, no. 7, pl. XXXVII, 33; Naso 2006b, 397, no. 84.

Provenance unknown
103. Berlin, SMPK, Inv. no. Misc. 8582.
 Unpublished, courtesy N. Franken (Berlin).

104. Berlin, SMPK, Inv. no Ü 675.
 Hinge in form of a couchant lion, looking left.
 Unpublished, courtesy N. Franken (Berlin).

Notes

1 I first met Brian Shefton in 2000 at a conference in Venice (Adriatico 2001). I knew him thanks to his contributions to the study of Greek and Italic bronzes and we spoke in German about some aspects of them. After the conference in Venice he wanted to go to Ancona to see the new permanent exhibition at the museum, one of his *Lieblingmuseen* in Italy. I asked how he thought he would reach Ancona, because the train connections between Venice and Ancona are not so good. "Per autostop" was his answer! After our first meeting we were constantly in touch. For me it became quite usual to receive a call from him, asking about new literature or planned conferences in Italy and elsewhere or archaeological news. I often discussed the results of my research into Etruscan and Italic bronzes with him, always receiving new ideas or interpretations, thanks to his invaluable and deep knowledge both of finds and literature. It was a huge pleasure for me to present the main paper about Etruscan finds in Greek sanctuaries at the conference organised at the university of Cologne on 3 November 2009 for his 90th birthday. This conference in Cologne was my last meeting with Brian.

2 One can cite the book about the *Schnabelkannen* (Shefton 1979) and the main articles about Etruscan stamnoi, vases of the Recanati Group and hydriai (Shefton 1988, 1992, 2004).

3 Shefton (1970, 55–56, fig. 1).

4 Brian Shefton was not convinced of my interpretation, of course!

5 Catalogue 91.

6 Dr J. Mertens on 8.6.2007 kindly answered by email my doubt about the authenticity of the two hinges: "I have looked at our example 34.11.8 and see no reason to doubt the two lions".

7 Johannowski (1983, 72) mentioned infundibula from Capua datable to the end of sixth–fifth century BC. When I asked, on 31 March 2005 the late W. Johannowski didn't remember the existence of these finds.

Bibliography

Adriatico (2001) L'Adriatico, i Greci e l'Europa. Atti dell'incontro di studio, Venezia, 22–23.2.2000, Anemos 2. Padova, Esedra.

Aquilué, X., Castanyer, P., Santos, M. and Tremoleda, J. (2003) *Deu anys d'arqueologia a l'entorn d'Empúries. Actuacions efectuades entre 1993 i 2002*, Monografies Emporitanes 12. Empúries, Museu d'Arqueologia de Catalunya.

Bardelli, G. and Graells, R. (2012) Wein, Wein, Weib und Gesang. A propósito de tres apliques de bronce arcaicos entre la Península Ibérica y Baleares. *Archivo Español de Arqueología* 85, 23–42.

Bellelli, V. (2006) *La tomba "principesca" dei Quattordici Ponti nel contesto di Capua arcaica*. Rome.

Cinquantaquattro, T. (2006–2007) Rituale funerario e dinamiche di genere nel mondo indigeno della mesogaia campana: il caso di Avella. *Annali dell'Istituto Orientale di Napoli. Archeologia e Storia Antica* 13–14, 111–134.

Ćović, B. (1983) Importation of Bronze Vessels in the Western Balkans (seventh to fifth century). In *L'Adriatico tra Mediterraneo e penisola balcanica nell'antichità*. Atti del convegno, Lecce 1973, 147–154. Taranto, Istituto per la storia e l'archeologia della Magna Grecia.

Cozza, A. and Pasqui, A. (1887) Civita Castellana (antica Faleria). Scavi nella necropoli falisca in contrada La Penna. *Notizie degli Scavi*, 170–176.

Cozza, A. and Pasqui, A. (1981) *Carta archeologica d'Italia (1881–1897). Materiali per l'agro falisco*. Florence.

Curtis, C. D. (1919) The Bernardini Tomb. *Memoirs of the American Academy in Rome* 3, 9–91.

Dehn, W. (1970) Ein keltisches Häuptlingsgrab aus Hallstatt. In *Krieger und Salzherren. Hallstattkultur im Ostalpenraum*, 72–81. Mainz, Römisch-Germanisches Zentralmuseum.

Fellmann, B. (1984) *Frühe olympische Gürtelschmuckscheiben aus Bronze, Olympische Forschungen 16*. Berlin.

Fol, W. (1874) *Catalogue descriptif du Musée Fol, I.* Geneva.

Furtwängler, A. (1890) *Die Bronzen und die übrigen kleineren Funde von Olympia, Olympia IV.* Berlin.

Gilotta, F. and Passaro, C. (2012) *La necropoli del Migliaro a Cales.* Pisa, Rome.

Gras, M., Tréziny, H. and Broise, H. (2004) *Mégara Hyblaea 5: la ville archaïque.* Rome, École Française.

Johannowski, W. (1983) *Materiali di età arcaica dalla Campania.* Naples.

Krstić, V. (2007) Novi Pazar. In Cvjetićanin, T., Gentili, G. Krstić, V. (eds.) *Balkani. Antiche civiltà tra il Danubio e l'Adriatico*, 48, 65–93. Milan.

Mansuelli, G. A. (1984) Tyrrhenoi philotechnoi. Opinioni degli antichi sull'arte etrusca in *Studi di antichità in onore di Guglielmo Maetzke*, 355–365. Rome.

Michetti, L. M. (2007) Le produzioni in bronzo e ferro dall'età arcaica all'ellenismo. In Benedettini, M. G. (ed.) *Il Museo delle Antichità Etrusche e Italiche II. Dall'incontro con il mondo greco alla romanizzazione*, 245–272. Rome.

Montanaro, A. C. (2010) Una patera baccellata in bronzo da Altamura (Bari): confronti e produzione. *Archeologia Classica* 61, 491–524.

Muffatti, G. (1968) L'instrumentum in bronzo. Parte I. *Studi Etruschi* 36, 119–156.

Muffatti, G. (1969) L'instrumentum in bronzo. Parte II. *Studi Etruschi* 37, 247–272.

Naso, A. (2006a) Etruscan and Italic Finds in North Africa, 7th–2nd century BC. In Villing, A. and Schlotzhauer, U. (eds.) *Naukratis: Greek Diversity in Egypt. Studies on East Greek Pottery and Exchange in the Eastern Mediterranean*, 187–198. London, British Museum.

Naso, A. (2006b) Anathemata etruschi nel Mediterraneo orientale in *Gli Etruschi e il Mediterraneo. Commerci e politica* (Orvieto, 16–18.12.2005), Annali della Fondazione per il Museo Claudio Faina 13, 351–416. Rome.

Naso, A. (2009) Infundibulum. In Lo Schiavo, F. and Romualdi, A. (eds.) *I complessi archeologici di Trestina e di Fabbrecce nel Museo Archeologico di Firenze*, Monumenti Antichi dell'Accademia Nazionale dei Lincei s. Miscellanea, vol. XII, 57–63 no. 36. Rome.

Özgen, I. and Öztürk, J. (1996) *Heritage recovered. The Lydian Treasure.* Istanbul.

Rocco, G. (2004) Alcune osservazioni sulla presenza di hydriai di tradizione laconica nelle tombe del Piceno. In Guggisberg, M. (ed.) *Die Hydria von Grächwil. Zur Funktion und Rezeption mediterraner Importe in Mitteleuropa im 6. und 5. Jahrhundert v.Chr.* Akten des Internationales Kolloquium, 47–54. Bern, Bernisches Historisches Museum.

Santoro, P. (2006) Tomba XI di Colle del Forno: simbologie funerarie nella decorazione di una lamina di bronzo. In Adembri, B. (ed.) *Aeimnestos. Miscellanea di studi per Mauro Cristofani*, 267–273. Florence.

Sauer, H. (1937) Ein etruskisches Infundibulum in Kopenhagen. *Archäologischer Anzeiger,* 285–308.

Shefton, B. B. (1970) The Greek Museum, University of Newcastle upon Tyne. *Archaeological Reports* 16, 52–62.

Shefton, B. B. (1979) *Die "Rhodischen" Bronzekannen.* Mainz.

Shefton, B. B. (1988) Der Stamnos. In Kimmig, W. (ed.) *Das Kleinaspergle. Studien zu einem Fürstengrabhügel der frühen Laténezeit bei Stuttgart*, 104–160. Stuttgart.

Shefton, B. B. (1992) The Recanati Group. A study of some archaic bronze vessels in central Italy and their Greek antecedents. *Römische Mitteilungen* 99, 139–162.

Shefton, B. B. (2004) The Grächwil hydria. The object and its milieu beyond Grächwil. In Guggisberg, M. (ed.) *Die Hydria von Grächwil. Zur Funktion und Rezeption mediterraner Importe in Mitteleuropa im 6. und 5. Jahrhundert v.Chr.* Akten des Internationales Kolloquium, 29–45. Bern, Bernisches Historisches Museum.

Terrosi Zanco, O. (1974) Possibili antiche vie commerciali tra l'Etruria e la zona interna in *Aspetti e problemi dell'Etruria interna.* Atti dell'VIII convegno nazionale di studi etruschi e italici, 161–184. Florence.

Ulf, C. (2014) Rethinking cultural contacts. In Rollinger, R. and Schnegg, K. (eds.) *Kulturkontakte in antiken Welten: vom Denkmodell zu Fallbeispiel.* Kolloquium aus Anlass des 60. Geburtstages von Christoph Ulf, Innsbruck, 26.–30.1.2009, 507–565. Leuven.

Vivés-Ferrándiz Sánchez, J. (2007) A propósito de un infundibulum etrusco hallado en aguas de la bahía de Xàbia (Alacant). *Madrider Mitteilungen* 48, 154–173.

Vorlauf, D. (1997) *Die etruskischen Bronzeschnabelkannen. Eine Untersuchung anhand der technologisch-typologischen Methode*. Espelkamp, Leidorf.

Weidig, J. (2014) *Bazzano, ein Gräberfeld bei L'Aquila (Abruzzen). Die Bestattungen des 8.–5. Jhs. v. Chr. Untersuchungen zu Chronologie, Bestattungsbräuchen und Sozialstrukturen im apenninischen Mittelitalien*. Mainz, Römisch-Germanischen Zentralmuseums.

Zuffa, M. (1960) Infundibula. *Studi Etruschi* 28, 165–208.

14. The Newcastle Gems

John Boardman

Brian Shefton's enterprise in creating a collection of classical antiquities for Newcastle did not stop at the obvious categories but included a number of representative examples of the (wrongly called) 'minor arts' such as gem-engraving. His choice included specimens of the Greek Bronze Age and Classical periods, as well as Etruscan and Greco-Phoenician – as fine and broad a selection as might be wished.

Minoan

Non-Greek Minoan Crete offers one of the most distinguished series of engraved gems of Antiquity, with devices ranging from pure pattern, to inscriptions and figure decoration in a distinctive semi-realistic style. Sources of inspiration were the east and Egypt but the Minoan styles are original and unmistakable. The latest prime source for their study is O. Krzyszkowska, *Aegean Seals, an Introduction* (Institute of Classical Studies, London, 2005).

1. Inv. no. 276 (Fig. 14.1)
Dark grey steatite stamp seal in the form of a disc with a pierced handle. 1.6 × 1.6 × 1.0 cm (height).

Two large triple circles with centre dot, and three small single circles with centre dot, making the whole resemble a face.

Middle Minoan II (about 1800 BC). Compare for the shape an example from Knossos (Krzyszkowska 2005, 88f., fig. 141) of a group in which compass-drawn motifs are common.

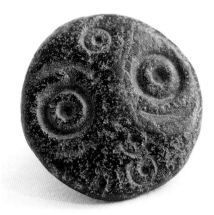

Figure 14.1: Steatite stamp seal, Newcastle upon Tyne, Shefton Collection 276. Photograph: Colin Davison.

2. Inv. no. 277 (Fig. 14.2)

Red jasper lentoid seal, pierced. 1.95 × 1.8 cm.
The stick figure of a running stag, in softer material than that used for finer seals. Probably Late Minoan II/III, fifteenth/fourteenth century BC.

Figure 14.2: Jasper lentoid seal, Newcastle upon Tyne, Shefton Collection 277. Photograph: Colin Davison.

3. Inv. no. 278 (Fig. 14.3)

Carnelian amygdaloid (almond-shaped) seal, pierced, part broken away. 1.9 × 1.6 × 0.8 cm (thickness). The kneeling figure of a goat, its body, limbs and head summarily rendered. Triple ground line. A very summary rendering of a popular motif. Probably Late Minoan/Mycenaean II/III, fifteenth/fourteenth century BC.

Figure 14.3: Carnelian amygdaloid seal, Newcastle upon Tyne, Shefton Collection 278. Photograph: Colin Davison.

Greek

4. Inv. no. 282 (Fig. 14.4)

Carnelian scarab. 1.3 × 1.1 × 0.75 cm (height).

The scarab is simply cut, so this is more probably Greek than Etruscan.

A cock with one leg raised, in a line border. About 500 BC.

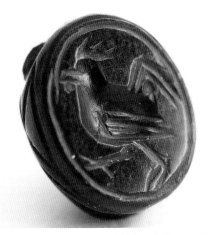

Figure 14.4: Carnelian scarab, Newcastle upon Tyne, Shefton Collection 282. Photograph: Colin Davison.

5. Inv. no. 549 – a loan by Lionel Jacobson (Fig. 14.5)

Blue chalcedony scaraboid. 2.5 × 1.1 × 1.9 cm (height). A bull standing on a ground line.

The shape is typical of the fifth to early fourth centuries BC when the stones were commonly decorated with animal studies such as this. The type of stone is also a common one for the period, and was used for such gem studies both in Greece and Asia Minor, then dominated by the Persians, but where Greco-Persian styles of gem-engraving flourished. The stones were generally too large to be set on finger rings but could be hung on necklets or set on bracelets.

Figure 14.5: Blue chalcedony scaraboid, Newcastle upon Tyne, Shefton Collection 549. Photograph: Colin Davison.

Etruscan

The Etruscans of Central Italy learned to cut gems in scarab form – an Egyptian/Phoenician shape adopted by Greek engravers before 550 BC. Etruscan engravers soon created a distinctive style of their own, which remained strongly Archaic but eventually developed into one much dependent on globular cutting of natural forms (*a globolo*). They paid more attention than the Greeks to the cutting of the scarab backs and ornament along the sides of the base, and retained the scarab form for centuries while the Greeks soon abandoned it in favour of the larger scaraboid. The preferred material was red carnelian, whose rich colour could be enhanced by heating. The scarabs were set on swivel rings, often of gold, with the beetle facing up.

6. Inv. no. 281(Fig. 14.6)
Carnelian scarab. 1.3 × 1.05 × 0.8 cm (height).

The scarab back is elaborately cut, with winglets and an ovolo pattern along the sides of the base.

A winged goddess wearing a helmet and carrying a spear. She is dressed and has across her chest a patterned shawl in the form of the Greek goddess Athena's goatskin 'aegis'. A snake (detached from the aegis) rises behind each leg.

The Etruscans commonly embellished Greek models for deities in this way (here an Athena; Menerva to the Etruscans). About 500 BC. Cf. Zazoff (1968 pls 9–11) and Krauskopf (1995, 47).

Figure 14.6: Carnelian scarab, Newcastle upon Tyne, Shefton Collection 281. Photograph: Colin Davison.

7. Inv. no. 279 (Fig. 14.7)
Carnelian scarab. 1.2 × 1.05 × 0.8 cm (height).

The scarab back is simply cut with pairs of lines for the 'winglets' and hatched border to the base. A kneeling warrior with shield and spear, wearing only a helmet, indicated by the plume. Hatched border.

Early fourth century BC.

Figure 14.7: Carnelian scarab, Newcastle upon Tyne, Shefton Collection 279. Photograph: Colin Davison.

8. Inv. no. 284 (Fig. 14.8)

Carnelian scarab. 1.2 × 0.9 × 0.4 cm (height).

The scarab back has hatched borders and hatching on the edges of the base. A kneeling satyr, his feet lifted off the ground line, is holding a bunch of grapes, squeezing them over a stemmed cup. Hatched border.

A similar version in Alnwick Castle ('Beverley gems'): Knight (1921, no. 184). Also as Furtwängler (1900, pl. 21.30), but facing the other way.

Third century BC.

Figure 14.8: Carnelian scarab, Newcastle upon Tyne, Shefton Collection 284. Photograph: Colin Davison.

Greco-Phoenician

The Greeks adopted the scarab beetle shape for gems probably from Phoenician usage in Cyprus (originally from Egypt). In Phoenicia itself there developed in the fifth century BC a series of scarabs usually cut in green jasper and widely disseminated in the Mediterranean world (e.g. to Carthage, Ibiza and Sardinia, where many have been found). Their subject matter is often oriental with a strong Egyptian element, but also sometimes Greek, acknowledging the prolific new Greek production. They are studied in J. Boardman, *Classical Phoenician Scarabs* (Oxford, Beazley Archive, 2003).

9. Inv. no. 283 (Fig. 14.9)

Green jasper scarab. 1.25 × 1 × 0.7 cm (height).

The head of a youth, his hair rendered as a network. For comparable heads see Boardman (*op.cit.*, pls 37–39).

Fifth century BC.

10. Inv. no. 280 (Fig. 14.10)

Green jasper scarab. 1.6 × 1.1 × 0.7 cm (height).

A 'gryllus' composed of three bearded heads, the one at the top of a satyr, and the forepart of a boar, set on bird legs. A popular subject on this series, see Boardman (*op.cit.,* 112–113), and on its eastern origins (Boardman 2003b, 123–131).

Fifth century BC.

Figure 14.9: Green jasper scarab, Newcastle upon Tyne, Shefton Collection 283. Photograph: Colin Davison.

Figure 14.10: Green jasper scarab, Newcastle upon Tyne, Shefton Collection 280. Photograph: Colin Davison.

Bibliography

Boardman, J. (2003a) *Classical Phoenician Scarabs.* Oxford, Beazley Archive.

Boardman, J. (2003b) Disguise and Exchange in Eastern Imagery in *Culture through Objects* (Studies in honour of P. R. S. Moorey) Potts, T. *et al.* (eds.) 123–131. Oxford.

Furtwängler, A. (1900) *Die antiken Gemmen.* Leipzig/Berlin.

Knight, A. E. (1921) *The Collection of Camei and Intagli at Alnwick Castle.* Privately printed.

Krauskopf, I. (1995) *Heroen, Götter und Dämonen auf Etruskischen Skarabäen.* Mannheim.

Krzyszkowska, O. (2005) *Aegean Seals, an Introduction.* Institute of Classical Studies, London.

Zazoff, P. (1968) *Etruskische Skarabäen.* Mainz.